"Cam Anderson has read a lot of good books, and that's part of what makes *this* book so rich and rewarding. But, far more importantly, this book represents a lifelong engagement with the arts and a deep faithfulness to Anderson's roots in the evangelical church. So this is a personal book in the best possible sense. It is, to quote Eugene Peterson, evidence of 'a long obedience in the same direction.'"

**Gregory Wolfe,** editor, *Image*

"Cam Anderson's vision inspires, challenges and encourages me. He is wise about creativity, faithful about imagination and provocative about beauty. We are invited into a deeper humanity and a greater faithfulness to the Artist who made us. I am so grateful for this book and believe many other readers will be too!"

**Mark Labberton,** president, Fuller Theological Seminary

"This is a thoughtful, remarkable book that will help evangelical Christians face their history of shunning modern art. As a convinced follower of Jesus Christ, Anderson lovingly laments the past evangelical practice of pitting binary opposites against one another: soul against body, word against image, church ministry against being an artist. Anderson shows how the millennia of church history and a fresh biblical stance can overcome these polarities. Through his writing, which is extremely well researched and gives evidence of many years of wide reading, he convincingly shows how visual culture can be central to piety and how artistry is a worthy occupation for believers. This work is exciting, people friendly, deeply faithful and wise."

**Calvin Seerveld,** professor emeritus of philosophical aesthetics, Institute for Christian Studies, Toronto

"From the perspective of his longtime dual residency in both the modern art world and the evangelical church, my good friend Cam Anderson is uniquely qualified to lead evangelicals and artists to understand and love one another. As I encountered a wide range of modern art in his book (Manet, Monet, Newman, Rothko, Warhol, Pollock and many others) I experienced a sense of wonder at the power and elegance of work that I had not noticed or appreciated before. For Christians seeking an aesthetic adventure in the modern art world and for Christian artists working to fulfill their God-given vocation, this book provides excellent guidance from one who is a faithful Christian and a gifted artist."

**Walter Hansen,** professor emeritus of New Testament interpretation, Fuller Theological Seminary, author of commentaries on the New Testament, coauthor of *Through Your Eyes*

"Cam Anderson's *The Faithful Artist* is the most probing analysis ever written on the roots of the negative attitude of twentieth-century evangelicals toward the visual arts. Anderson knows evangelicalism from the inside. What greatly enhances his analysis is that it is set within the context of a broad, deep and sympathetic understanding of developments in the world of the visual arts in the twentieth century. The book reaches its climax with an eloquent, biblically based appeal to evangelicals to engage the visual arts, both as creators and as viewers. We have needed this very book for a long time."

**Nicholas Wolterstorff,** Noah Porter Professor Emeritus of Philosophical Theology, Yale University; senior research fellow, Institute for Advanced Studies in Culture, University of Virginia; honorary research professor, Australian Catholic University

"In this detailed overview and synthesis, Cameron Anderson opens up the mysteries of contemporary art, describing how works of art may operate as lenses through which to view the seen and unseen within culture. This illuminating book allows the double foci on faith and art to converge, introducing us to the worldview of the Ultimate Artist."

**Luci Shaw,** poet, writer in residence, Regent College, author of *Thumbprint in the Clay*

"In *The Faithful Artist* Cam Anderson extends an intellectual welcome to readers who may feel that modern and contemporary art are an exclusive party, a private conversation for an artistic elite. By skillfully unpacking cultural factors leading to the modernist rejection of traditional artistic forms, he reveals some of the reasons for art's estrangement from educated laypersons. Anderson then clarifies for Christians why art still matters in the midst of tensions between traditional religious belief and modern aesthetic sensibility—issuing a compelling call for artists to rediscover their accountability and calling within the body of Christ, broken afresh for the life of the world. Additionally he makes a vital argument for why the church needs art and artists, providing genuine answers for how these might once again find their way into healthy communion with one another."

**Bruce Herman,** Lothlórien Distinguished Chair in Fine Arts, Gordon College

"An engaging and carefully researched summation of where Christian faith and visual art have been and where they may be headed. Artists are invited to take a seat at a wedding feast where binary opposition withers and an enriched complexity emerges. Observing how conviction and restless longing coexist in 'the faithful artist,' Anderson sets out to illuminate a way forward."

**Lynn Aldrich,** artist and 2014 Guggenheim Fellow

STUDIES *in*
THEOLOGY
*and the* ARTS

# THE
# FAITHFUL
# ARTIST

## A VISION FOR
## EVANGELICALISM
## AND THE ARTS

Cameron J. Anderson

IVP Academic
An imprint of InterVarsity Press
Downers Grove, Illinois

*InterVarsity Press*
*P.O. Box 1400, Downers Grove, IL 60515-1426*
*ivpress.com*
*email@ivpress.com*

*InterVarsity Press® is the book-publishing division of InterVarsity Christian Fellowship/USA®, a movement of students and faculty active on campus at hundreds of universities, colleges and schools of nursing in the United States of America, and a member movement of the International Fellowship of Evangelical Students. For information about local and regional activities, visit intervarsity.org.*

*Scripture quotations, unless otherwise noted, are from the New Revised Standard Version of the Bible, copyright 1989 by the Division of Christian Education of the National Council of the Churches of Christ in the USA. Used by permission. All rights reserved.*

*Cover design: David Fassett*
*Interior design: Dan van Loon*
*Images: Abstract landscape: © CSA-Printstock/iStockphoto*
*        Painting of a face: BETH (Study II) by Wayne Forte*

*ISBN 978-0-8308-5064-8 (print)*
*ISBN 978-0-8308-9442-0 (digital)*

*Printed in the United States of America* ∞

**Library of Congress Cataloging-in-Publication Data**
*Names: Anderson, Cameron J., 1953- author.*
*Title: The faithful artist : a vision for evangelicalism and the arts /*
*  Cameron J. Anderson.*
*Description: Downers Grove, IL : InterVarsity Press, [2016] | Includes*
*  bibliographical references and index.*
*Identifiers: LCCN 2016011843 (print) | LCCN 2016017505 (ebook) | ISBN*
*  9780830850648 (pbk. : alk. paper) | ISBN 9780830894420 (digital) | ISBN*
*  9780830894420 (eBook)*
*Subjects: LCSH: Christianity and art—United States. | Evangelicalism—United*
*  States. | Vocation—Christianity.*
*Classification: LCC BR115.A8 A53 2016 (print) | LCC BR115.A8 (ebook) | DDC*
*  261.5/7—dc23*
*LC record available at https://lccn.loc.gov/2016011843*

**P**  24  23  22  21  20  19  18  17  16  15  14  13  12  11  10  9  8  7  6  5  4  3  2  1

**Y**  36  35  34  33  32  31  30  29  28  27  26  25  24  23  22  21  20  19  18  17  16

To Cynthia (C. K.) Anderson,

my constant companion on the journey

*If you want to know how all this comes about, inquire of grace, not of learning; ask your desire, not your intellect—the sigh of prayer rather than the hunger to read, the bridegroom rather than the teacher, God, not man. Ask obscurity rather than clarity; not light but the fire that enflames our whole being and buries it in God, with his sweet anointing and ardent love.*

SAINT BONAVENTURE, *ITINERARY OF THE MIND IN GOD*

# Contents

# List of Images

## COLOR INSERT

# Acknowledgments

If my parents had lived long enough to hold *The Faithful Artist* in their hands, Mom would have read it from cover to cover, saved up observations and questions for me, and sent off a few copies to friends. Some kind of Anderson family celebration would have followed. The prospect of acknowledging all those who helped me finish this project is not a little daunting, but my parents are surely the first in an assembly of family, friends and mentors who encouraged me to start and ultimately complete this project.

Here is why. *The Faithful Artist* focuses on postwar America, with a spotlight on the evangelical movement, and the piety and passion of conservative Protestantism is what animated my parents' lives. Kenneth and Marjorie Anderson embodied the best of that world. Somehow, amid their dual careers, deep involvement in their church and raising six children, they left just enough space for me to be a young artist. Conditions might have been otherwise. In their day, our Christian world had no particular vision for the arts, except music. Nonetheless I completed undergraduate and graduate degrees at secular universities, and at each juncture Mom and Dad cheered me on. For this and so much more, I am and will remain in their debt.

Early on, history professor David Thomas responded to the decidedly rough manuscript of this book with a thorough reading and pages of thoughtful suggestions. In the years that followed I benefited from rich conversations with friends like Bill Dyrness, Erica Grimm, Walter Hansen, Bruce Herman, Terry Morrison, Joel Sheesley, Linda Stratford, Albert Pedulla, Ted and Cathy Prescott, Wayne Roosa, Luci Shaw, John Skillen, Timothy Van Laar and many others.

Continuing this list, two people merit added mention. More than any, poet and InterVarsity staff colleague Bobby Gross dogged me until I finished this project. Nearly every phone call or personal meeting with Bobby began with something like, "How's your book coming?" or "When do you think you will finish?" One summer he and I retreated for a week to his parents' vacation home on the Gulf of Mexico just to write. Bobby published his book *Living*

*the Christian Year: Time to Inhabit the Story of God* with InterVarsity Press in 2009. Along with Bobby, I am grateful for the encouragement of my brother, Garwood (Woody) Anderson. He and I also retreated to write, in our case three separate weeks to north woods cabins. Though mischief-making and music-listening were always close at hand, during those days together we also accomplished a great deal. Garwood's book, *Paul's New Perspective*, also with InterVarsity Press, is being released concurrent with mine.

Many other friends cheered me on. Gregg Bergman, Laura Cootsona, Galen and Grace Hasler, Pat Jones, Bill Montei, Barry Sherbeck, Scott and Donna Wilson, and Mike Winnowski all come readily to mind.

In the Christian community there are always a few good souls whose work goes mostly unheralded. Their calling is spiritual direction. It seems to me that these men and women possess an uncanny, God-given gift to peer benevolently into souls. In my case, Jay Sivits, Marilyn Stewart and Richard Ganz, SJ, each met me at critical points along my journey, helping me to hear and see God's invitation.

Though unintended, this project stretched on and on to become a kind of life's work. Nearing the end and sensing that I had given it my all, I was glad to pass the baton to the capable folks at InterVarsity Press. Copyeditors and proofreaders tuned up the manuscript. Rebecca Carhart merits special mention for her labors tracking down the image files, permissions and attributions needed to produce a book that would be meaningful to visual artists (a world of work unto itself). And my editor, David McNutt, cheered me on all the way to the finish line. I'm grateful for his great vision for the entire Studies in Theology and the Arts series.

In the closing months of this project, it was my privilege to serve as the Senior Visiting Scholar at the M. J. Murdock Charitable Trust. I thank president Steve Moore for the support that the Trust provided for this project and Alexander Spalding, an intern at the Trust, for his good help tracking down the images needed to make this book a success.

Finally, I have dedicated this book to my wife, Cynthia (C. K.) Anderson, my constant companion on the journey for more than forty-one years. She is also a capable editor, and aided in the completion of this book by working her way clear through the manuscript not once, but twice, with red pen in hand. Love personified.

# Introduction

I had seen color images of Pablo Picasso's *Guernica* (1937) projected on a screen in the darkened room of an art history seminar and as a black-and-white reproduction in H. H. Arnason's *History of Modern Art*. But one spring afternoon in 1977 I encountered the artist's work firsthand. Nearly twelve feet high and more than twice as wide, the monumental canvas occupied an entire wall in New York's Museum of Modern Art. As I stood before the contorted shapes and strained, sweeping lines of *Guernica*, it beckoned me to enter the brutality and slaughter of the Spanish Civil War (1936–1939)—a conflict that, until that moment, I was entirely ignorant of.

My encounter with *Guernica* was arresting, but as a kind of aesthetic experience it was hardly unique. From my late teens onward, I came to the world of visual art *expectant*, believing that paintings, sculptures, prints, drawings and photographs could cast fresh light on deeper things. I was fascinated by artists and their ability to ply visual media to express thought and emotion. More than that, their imaginative labors produced objects and spaces that I could study with my eyes, examine with my hands and encounter with my body. Today, this earlier sense that art could be a means to apprehend beauty and meaning is my deep and settled conviction, the lens that frames the whole of my aesthetic vision.

Like most vocations, becoming an artist entails important choices, not least the pursuit of credible training. With that goal before me, I completed a BFA in painting and drawing at the University of Wisconsin–Eau Claire, an MFA in painting and drawing from Cranbrook Academy of Art and, some years later, a smattering of graduate courses at the University of Wisconsin–Madison, mostly in art history and art criticism.

My decision to pursue the visual arts made sense. After all, I had "eyes to see," considerable facility with a variety of media and a fertile imagination. But

offsetting these talents were serious misgivings about the legitimacy of art as a vocational endeavor. The primary source of this doubt was the conservative Protestant community to which I belonged.

The root of my spiritual life taps deep into the soil of American evangelicalism. I was reared by devout Christian parents who sought to live what they believed at home, at church, and in their professions. To friends and co-workers alike, Kenneth and Marjorie Anderson modeled commitment, generosity and kindheartedness. In my eagerness to emulate my parents, these same church communities became *my* spiritual home, the place where I learned Bible stories, hymns and gospel choruses. Along the way, extra-curricular activities like Daily Vacation Bible School, summer Bible camp and youth rallies augmented weekly church attendance. The earnest zeal of church leaders—especially visiting missionaries who, it seemed, had "counted the cost" to follow Jesus wherever and however they sensed he had led them—never failed to impress me.

I remain grateful for this upbringing. Nonetheless, in the course of my own formation a number of evangelical attitudes and practices have left me uneasy, sometimes even angry or ashamed. Scholars such as Randall Balmer, James Davison Hunter, George Marsden and Mark Noll have thoughtfully chronicled the merits and demerits of this dynamic subculture, and traces of my own story abound in their various accounts. And here I note my intimate and ongoing affiliation with American evangelicalism to highlight this fact: the postwar evangelical subculture to which I belonged, in combination with the art world that I sought to enter, presented three nearly insurmountable barriers to my vocational pursuit of the visual arts.

The first of these was the absence of a mentor. By the age of seventeen, I had yet to meet one other Christian who maintained a regular studio practice, exhibited his or her work in a gallery, collected art or even visited art museums. The adult believers in my world were teachers, farmers, salesmen, tradesmen, business owners, health care providers and Christian ministers—men and some women who purposed to use their gifts and talents in service to God. I shared this desire, but beyond that the common ground of our faith seemed to erode. In fact, my decision to study art was inscrutable to my Christian elders and even to some of my peers. Perhaps more troubling, I lacked a ready apologetic (it seemed to me then that one needed to make one's case for any

endeavor that invited fraternization with "the world") for *how* or *what* such an enterprise might contribute to the church and its mission.

The second barrier that I faced was my church's disregard for the visual arts. This was manifested on two fronts: the church's ignorance of art history—notably, Christian art—and its palpable disdain for modern art. Put differently, the posture of my Christian community toward art oscillated between ambivalence and hostility. While multiple factors contributed to this view, chief among them was the keen desire of conservative Protestants to remain separate from the "world." Like their fundamentalist forebears, twentieth-century evangelicals regarded personal holiness as a hallmark of Christian maturity, and for many setting oneself apart from the world appeared to be a direct means to achieve this. If Christian character could be measured by the degree to which one kept one's distance from worldly enterprises, then it made sense to shun temptations such as Hollywood and movie going, popular music and dancing, smoking and drinking.

In a similar vein, modern dance, contemporary fiction, jazz, painting, poetry and sculpture were also scorned, but with added vitriol since these ventures appeared more secular, elite and bizarre than their popular counterparts. Let me add that from the early 1940s onward, Protestant conservatives were not alone in taking offense at modernism and its provocateurs. Certainly the most vicious attacks against avant-garde artists during the Cold War came at the hands of Wisconsin US Senator Joseph McCarthy and the related investigations of the House Un-American Activities Committee (HUAC), established in 1938. In the decade that followed, many actors, directors, painters, poets and screenwriters were accused of communist subversion, or blacklisted, and the careers of some were devastated. The larger point is this: where God and country was concerned, artists were often thought to be subversive, and on occasion this charge was warranted.

For those eager to build a case against modern and contemporary art, it is not difficult to locate artists or works of art that scoff at or belittle the kind of piety that conservative Christians cherish. Figures like Jackson Pollock and Andy Warhol, whom we will consider in chapter one, often served this purpose. In recent decades, controversial works like Robert Mapplethorpe's (1946–1989) homoerotic photographs and Andres Serrano's (b. 1950) *Piss Christ* accomplished the same. Experience confirms that "offensive" artists and their "transgressive" works can be leveraged to incite unparalleled moral rage.

However, when nonpolitical art is politicized in this manner, almost without exception its actual content and meaning is passed over.

The third barrier that I encountered—one decidedly not contrived by my evangelical community—was the art world's hostility to religious belief. This antagonism was fueled in equal parts by the church's ignorance of art, its sense of moral superiority to so-called bohemian artists and the corresponding disdain of artists for the sanctimony and hypocrisy they associated with the church. While it can be demonstrated that a guarded openness to spirituality in the art world existed throughout the twentieth century, the tone and *telos* of the new community that I hoped to enter in the 1970s derived smug satisfaction from placing itself at far remove from the piety and politics of conservative Christianity.

This trio of barriers notwithstanding, in my late teens I swam against the current of my evangelical community to embrace the arts. The decision was aided, in no small part, by an eagerness to break free of the moral legalism that pervaded conservative Protestantism in the 1960s and 1970s, and it was surely abetted by the scintillating rise of the American counterculture. In fairness, my Christian community did not belittle this decision, and I enjoyed my parents' support throughout college and graduate school. At the same time, pursuing the visual arts meant forgoing the affirmation that I might have enjoyed had I, say, entered seminary to prepare for the pastorate.

The conditions that I have described left me with a great deal to sort out. The art department and, later, the art academy where I studied were stimulating places. In both settings I gave myself to the work at hand and learned a great deal. But neither institution was a spiritual home. Moreover, the worry that my pursuit of art amounted to nothing more than a hobby or, worse still, a capitulation to carnal desire continued to dog me. But I pressed ahead hoping and praying that I had given myself to a holy calling.

Thus far, the opening pages of this introduction read like a memoir, an essay that might go on to explore the awkward convergence of my evangelical faith and my secular training in the visual arts. But developing that narrative is not my primary reason for writing. Rather, the personal experience I have rehearsed sets the stage for a more considered examination of the impasse between modern art and the evangelical church in America's postwar period. Midway through the second decade of the twenty-first century, much of this schism remains—albeit in a variety of new guises.

*art as message*

I write fully persuaded that art, in its most exalted form, can be used by God to transform women and men, to extend his common grace to the world and to lead the church to worship. I believe with equal conviction that the content and character of contemporary art could gain the gravitas that it seeks if the artists who produce it were able to discover or recover the deep things of God. Throughout history and in everything from monumental Gothic cathedrals to diminutive prayer chapels, from vividly colored Fra Angelico frescoes to sepia-toned Rembrandt etchings, this pair of possibilities *has* been realized in stunning ways. From time to time instances of transcendence also surface in the contemporary secular arena. It seems to me a public monument such as Maya Lin's much-acclaimed *Vietnam Veterans Memorial* (1982) confirms this.

Properly conceived, a vision for the visual arts wherein serious art and serious faith are woven into whole cloth is a glorious contemporary possibility. But for this goal to be realized, the obstacles, conundrums and heartbreak that have kept too many Christians from embracing a biblically and theologically robust understanding of the visual arts must be not only identified but also overcome.

As early as 1941, British essayist and mystery writer Dorothy Sayers observed, "They [art and religion] are now hopelessly at loggerheads. Artists, on the whole, get from the church no strong backbone of religious faith to direct and inspire their work. They are brought up, of course, on the same doctrinal pabulum as the common man, which is mostly vague and sloppy."[1] Likewise, twentieth-century American evangelicals mostly ignored visual art and mistrusted those who produced it. To underscore their reservations, they relied on shoddy biblical exegesis, false dichotomies and the anecdote of scandal. Consider this comment by Harold O. J. Brown: "People no longer become educated and acquire cultivation in order to appreciate music, literature, and art; what passes for such things floods in upon the young and immature, interfering with education and supplanting cultivated tastes with *primitivism* and *decadence*."[2]

To sort out this impasse, chapter one sets the stage by describing two movements—one religious and the other secular—that gained zenith-like ascendancy in postwar American life and culture. The first of this pair is Protestant

---

[1]From a letter to Rev. W. T. Robinson, quoted in Dorothy Sayers, *The Letters of Dorothy L. Sayers: 1937-1943, From Novelist to Playwright,* ed. Barbara Reynolds (New York: St. Martin's, 1998), 328.
[2]Harold O. J. Brown, "The Crisis in the Arts," in *The Sensate Culture: Western Civilization Between Chaos and Transformation* (Dallas: Word, 1996), 25-48.

evangelicalism, a movement determined to "guard the gospel" from increasingly liberal interpretations of the Bible, the abandonment of traditional moral values and the rising tide of secular thought and practice.[3] The second is the world of modern art, an enterprise substantially given to the radical renunciation of tradition or, as art historian Robert Hughes termed it, "the shock of the new."[4] If evangelicals labored to maintain the status quo and even to pine for halcyon days—idealizations of the New Testament church and the founding of Christian America, for instance—then modernists sought to distance themselves from what they regarded as conventional and, therefore, arcane notions of religion, politics, morality and aesthetics. Scholars and popularizers alike have gone on to sharpen the contrast between these movements as the basis for jury-rigging a "culture war." But as we shall see, neither movement was monolithic with respect to its ideology or leadership, and, contrary to received opinion, one was hardly isolated from the other. Having employed a broad brush to compare and contrast the postwar development of these two movements, in the chapters that follow I examine these differences in greater detail.

Chapter two explores the meaning of our corporeal being with a particular focus on the time-honored yet controversial practice of drawing, painting and sculpting the nude. While it may be tempting to make the honor or dishonor of the unclothed body the sole focus of this inquiry, the greater significance of our embodiment must not be passed over. It is in and through our bodies that we locate ourselves in this world. The stakes are still higher for Christians, since a biblical understanding of spiritual life requires one to embrace one's whole being and, not least, to account for instances of extreme physical pain and pleasure.

Chapter three considers the primacy of the human body's five senses and the corresponding conceptions of piety that have caused Christians to mistrust them. It is not possible, of course, to ignore our sensate nature, and an attempt to do so minimizes our greater delight in the goodness of God's creation. Rightly appropriated, these tactile, haptic encounters engage our imagination, which in turn leads us to wonder, worship and mystery—states of mind and being that seek, ironically perhaps, to transcend the very material

---

[3]My reference here is to the title of a commentary by John R. W. Stott, *Guard the Gospel: The Message of 2 Timothy* (Downers Grove, IL: InterVarsity Press, 1978), 47.
[4]Robert Hughes credits art critic Ian Dunlop as the source of this term in Hughes's book *The Shock of the New* (New York: Knopf, 1981), 7.

conditions that sponsor them. Aesthetic experience fires the artist's creativity and moves her toward action. To the degree that the evangelical church has either dismissed or forbidden these kinds of encounters, the artist becomes less a sanctuary for creativity and more the site of discouragement and defeat.

Chapter four wades into the bitter and long-standing dispute surrounding the use of images. This debate has two critical dimensions. First, thoroughgoing iconoclasts find themselves caught in the swirl of controversy surrounding the place and meaning of religious images, especially attempts to represent God. While evangelicals rightly abhor the production and use of idols, these same Christians increasingly call on a broad range of visual media to aid them in corporate worship. Further complicating the matter, a notable number of evangelicals have turned to Catholic, Orthodox and mainline Protestant traditions, which, in contrast to Protestant communities that hold fast to varying degrees of sixteenth-century iconoclasm, regard visual art as a source of spiritual solace and inspiration.

On the heels of this controversy is the fluid, charged and mostly oppositional relationship between word and icon, or text and image. Chapter five describes the manner in which the primacy of words and God's Word within evangelicalism has often deepened the chasm that separates the verbal from the visual. It goes on to assess the impact of this pitched battle on the artist and the church. In our contemporary and thoroughly mediated world, corporations, politicians, marketing agencies and celebrities have long embraced both text and image as essential means to advance their respective agendas. It is therefore reasonable to ask which medium offers the most persuasive account of reality.

Having considered the practical outworking of verbal and visual communication, especially in reference to evangelicalism, in chapter six I move toward theoretical territory to explore what is frequently described as the postmodern challenge of language. In recent decades, some artists and philosophers have claimed that language is so porous and malleable that the possibility of constructing a coherent or meaning-filled metanarrative is disallowed. While one very modest chapter is surely not equal to the task of plumbing the depths of this discourse, the challenge of language and its deconstruction merits serious attention simply because it affects the whole of contemporary art, especially the art world's penchant for irony and its corresponding disdain for sincerity, and the church's confidence in the Bible, especially the manner in which the Bible is read and studied.

From time to time, heightened personal angst and social disequilibria stimulate extraordinary creativity. But unreconciled polarities can also be highly destructive. Here the tragic account of painters like Vincent van Gogh and Mark Rothko comes to the fore. It is well known that both men felt called to pursue painting as a primary means to communicate deeper spiritual realities. Tragically, in this quest each grew despondent and eventually took his own life in response to what they deemed their failure to realize this lofty goal.[5] In a sense, the struggle that van Gogh and Rothko endured illustrates why the tensions outlined in chapters two through six beg for resolution. To that end, chapter seven advances an ambitious line of reasoning: our desire for rewarding aesthetic encounters reveals our deeper longing for a connection to something or someone Other. The most tangible evidence of this quest is our ongoing and unending pursuit of beauty or the beautiful.

Any serious embrace of beauty will face vigorous resistance from at least two quarters. First, the contemporary and mostly secular debate concerning beauty continues to generate considerable attention. Too frequently, beauty's pleasures have been harnessed to dubious, debased and even oppressive ends. Because of this, some find invocations of the beautiful politically naive or aesthetically repugnant, and for those eager to embrace this negative critique, any positive reassessment of beauty will be a hard sell. Second, pragmatic-minded evangelicals will struggle to locate the relevance of a discourse that is so freighted with theory. But consider a typical contemporary evangelical Sunday service wherein worshipers earnestly sing praise choruses that extol "the beauty of the Lord." What exactly do these repeated references to beauty (as well as to glory, majesty and awe) represent? These songs of praise and the abundant images that they summon are at least intended to be rich aesthetic encounters. Meanwhile, a somewhat different and growing quarter of the evangelical community is drawn to contemplative practices that are nothing less than meditations on the character of divine beauty.

Like her companions goodness and truth, beauty discloses order and transcendence and as such delivers meaning and connection. Some secular observers regard the recovery of beauty as an antidote to the vulgarity, violence and meaninglessness of Western culture. At the same time, many Christians

---

[5]It should be noted that there is disagreement within the scholarly community regarding the true cause of van Gogh's suicide.

realize or at least intuit that beauty has a higher, even ultimate, obligation to behold the glory of God. As colleague Gregory Wolfe puts it, "Beauty is the handmaiden of mystery." Therefore, those who wish to affirm beauty's virtue must rise to defend her.

When taken as a whole, chapters two through seven recast the collision of faith and art to reveal a third way, a great vista where biblical and theological reflection—especially the doctrines of creation and incarnation—become the wellspring of inspiration. It is in this place—what artist Makoto Fujimura refers to as the "third space"—that artists who are Christians can be released to fruitfully pursue their craft and vision.

The final chapter of this study offers counsel to all of us, but especially to believing artists, who hope to see a day when they, their churches and the culture in which they "live, move and have their being" begin to flourish. To that end I offer my thoughts regarding three more-practical concerns: culture, vocation and praxis.

I began this introduction describing three barriers that, in my late teens and early twenties, nearly caused me to abandon the visual arts. Nearly four decades have passed since I wrestled with that decision, and during those intervening years conditions in the church have changed. For instance, it is no longer difficult to find devout evangelicals seriously engaged with the visual arts and, with this, a growing number who believe that art is somehow important to the mission and program of the church. Many of today's evangelicals—especially the rising generation and their more progressive elders—find the Christ-against-culture paradigm that once dominated American fundamentalism too severe and even bizarre. For much good and little ill, they no longer carry the depth of anxiety about worldliness that was part and parcel of the conservative mindset in previous generations. Rather, they have embraced a new spirit of freedom, one that earlier iterations of Christian legalism disallowed, and this, in several respects, is surely good news. Consequently, earlier signs of hostility or ambivalence toward the visual arts continue to subside.

But shifting attitudes toward Christian piety are not the sole cause of this new openness of evangelicals to the arts. A corresponding set of institutional commitments is also in play. For instance, in the last two decades the number and quality of visual art and design programs at Christian college and universities have increased significantly; a coterie of local gallery programs at schools

and churches continues to grow; thoughtful articles and books about the visual arts make regular appearance in Christian publications and presses; a wide range of arts-related regional and national conferences are being held; and the presence of what might be best described as arts-oriented parachurch organizations continues to increase.

Support within the evangelical church for the visual arts is on the rise, and this gain should be celebrated. All the same, two elephants are left standing in the room, and, as the metaphor suggests, we dare not ignore them. The first of the pair is the current level of financial support for the visual arts within the evangelical community. It is meager at best and represents but a fraction of what these communities spend annually on musical worship and all the technology that is needed to support it. Indeed, institutional patronage for the visual arts in an evangelical church is highly unusual. Meanwhile, the quality of work on view in evangelical settings is often substandard since little attention is being paid to the training and credentials of either the artists who are invited to exhibit their work or to those who curate and install the exhibits.

The second elephant is the nature of the art world itself. In all of its brilliance and hubris, it will remain a marvelous yet disturbing enterprise. It is the art world. It is a world that advances a particular intellectual discourse and with this wields considerable cultural capital. The art world is particularly antagonist to Bible-believing Christians. That is, any nonironic embrace of religious belief—especially Christian belief—that bears traces of sentimentality, intolerance or fundamentalist conviction is considered toxic. And it follows that any artist who holds to such a confession will not be regarded as "serious."

As my work on this project nears completion, neither the writing nor the research it represents is likely to drive either elephant from the room. What I do hope is that some portion of the bewildered head scratching and frenetic note taking that led me to tackle this project will equip others who remain eager, as am I, to make sense of the perplexing and frequently conflicted relationship of art to faith and faith to art. If some find that kind of encouragement from this effort, then these years of labor will have found their reward.

# A Double-Consciousness

*It is simply not possible to act in good faith toward people one does not respect, or to entertain hopes for them that are appropriate to their gifts.*

MARILYNNE ROBINSON, *WHEN I WAS A CHILD I READ BOOKS*

*Tradition is the living faith of the dead, traditionalism is the dead faith of the living.*

JAROSLAV PELIKAN, *THE VINDICATION OF TRADITION*

*I am nature.*

JACKSON POLLOCK

On entering college, the first art survey course that I elected to take introduced art majors to the modern and late modern periods. Since our syllabus began with abstract expressionism, it made sense to study Willem de Kooning's controversial painting *Woman II* (1952) early in the semester (see plate 1).[1] I loathed de Kooning's painting. Projected larger than life on the screen before us, the sneering grin of de Kooning's subject, the painting's aggressive sexuality, its looming chaos and simmering rage affronted my sensibilities.

---

[1]The creation of *Woman I* marked a seminal moment in de Kooning's career. It took the painter three years to complete the painting to his satisfaction, and this was only possible after he received insight and encouragement from art historian Meyer Schapiro. Mark Stevens and Annalyn Swan, *De Kooning: An American Master* (New York: Knopf, 2004), 315-43. For de Kooning's own comment regarding his struggle to complete the paintings in his *Woman* series, see David Sylvester, "Willem de Kooning," in *Interviews with American Artists* (New Haven: Yale University Press, 2001), 43-57.

And a rapid sequence of questions followed. Why had our professor granted de Kooning's painting such elevated status? Was the painter advancing some new female archetype, or was he just a misogynist? In fact, the answers to these kinds of questions interested me, but they paled in comparison to my growing worry that I was being played the fool. To gain a sense of the anxiety I felt as an incoming art major early in the 1970s, a bit more biography will help.

The medium-sized state university that I attended was located in a small Midwestern town. At the time my notions about art were admittedly romantic. Art, I thought, was primarily about self-expression, and the images and objects that held my interest ranged from Monet paintings to Maxfield Parrish illustrations and from psychedelic head shop posters to wheel-thrown pottery (it was the 1970s, after all). While conceptual projects held some interest, it was realism—the verisimilitude generated by a skilled hand moving in concert with a keen eye—that impressed me most. I had yet to genuinely consider artists such as Jasper Johns, Louise Nevelson, Barnett Newman, Georgia O'Keefe, Jackson Pollock, Robert Rauschenberg, Mark Rothko, Richard Serra and Andy Warhol. Moreover, the irreverence of the New York art scene, the authority of critics such as Clement Greenberg and Harold Rosenberg, and the radical departure of modern art from the traditional canon existed for me at some far reserve either in the pages of *Artforum* or on the walls of museums that I had yet to visit. In brief, I was ill-equipped to give an account for my intense dislike of de Kooning's *Woman II*.

As the semester advanced, however, my initial foreboding turned to curiosity. I largely credit my professor for this change. Sporting wire-rimmed glasses and a flowing beard, he embodied what I liked most about the American counterculture. My professor's congenial nature and wry wit drew me in, and before long his enthusiasm for "difficult" art disarmed my skepticism. I was coming to understand and then believe that challenging modern and contemporary work could be a critical point of entry into substantially larger conversations about personal and cultural meaning.[2] I was intrigued.

---

[2]"Difficulty" has been a hallmark of much contemporary art. On one hand it communicates disdain for undereducated viewers. On the other, it acknowledges the artist's perplexity about art and life and is often further delimited by the deeply personal nature of process, product and display. Authors Leonard Diepeveen and Timothy Van Laar suspect that when viewers encounter this kind of art, one or more of the following questions will naturally follow: "Why is so much contemporary art difficult to understand? Is making art that is difficult to understand something that artists have

## A FALSE CHOICE

Learning to draw, comprehending color theory and grasping the elements of basic design, not to mention the intellectual discourse that surrounds them, are formidable tasks. But for evangelicals who came of age during America's postwar years, there was an added pair of challenges. On entering most secular art academies or university art departments, these Christian students quickly discovered that their religious convictions were thought to be hopelessly naive. And to the degree that these same students exhibited signs of religious devotion—something weightier than mere assent to creeds, traditions and stories—they would almost certainly encounter art world scorn. By the close of the twentieth century, this pattern remained largely in force. Writing in 2014, art historian James Elkins simply confirms the ongoing presence of this secular bias: "Straightforward talk about religion is rare in art departments and art schools, and wholly absent from art journals unless the work in question is transgressive. Sincere, exploratory religious and spiritual work goes unremarked."[3] Sadly, this discriminating spirit was paired to another: the Christian community's ambivalence toward or disapproval of the visual arts. Postwar conservatives regarded the visual arts as a curious vocation at best and a capitulation to worldliness at worst.

However, as Dutch historian and philosopher Gerardus van der Leeuw points out, the edgy tension that existed between evangelical religion and the art world is hardly new. This, he explains, is because "religion is always *imperialistic*. No matter how vague or general it may be, it always demands everything for itself."[4] Critics of religion will eagerly agree. But, cautions van der Leeuw, "Science, art, and ethics are also imperialistic, each in its own right, and also in combination with the others."[5] Van der Leeuw's point is that practitioners of religion, science, art and ethics each believe that *their* discourse offers the most comprehensive and, therefore, superior picture of reality. And so it follows that in the modern development of professional disciplines, art is no more eager to

---

intentionally done? Why does difficult art make me feel uncomfortable? Will work that is difficult for me right now always seem difficult? Is difficulty central to twentieth-century art, or is it a by-product?" See Leonard Diepeveen and Timothy Van Laar, *Art with a Difference: Looking at Difficult and Unfamiliar Art* (New York: McGraw-Hill, 2001), 93-121.

[3]James Elkins, *On the Strange Place of Religion in Contemporary Art* (New York: Routledge, 2004), xi.

[4]Gerardus van der Leeuw, *Sacred and Profane Beauty: The Holy in Art*, pref. Mircea Eliade, trans. David E. Green (New York: Holt, Rinehart and Winston, 1963), 3.

[5]Ibid., 4.

submit to religion than religion is willing to yield to art. Within this opposi-
tional framework, each camp exerts pressure on its practitioners to abandon
pursuits that lie beyond the parochial interests of their guild.[6]

The most tragic fact about the conflict, which we will explore in this book,
is that it is based on a *false choice*. Again, as van der Leeuw explains it, "The
paths of religion, art, ethics, and science not only cross, they also join."[7] In
this same spirit, philosopher Nicholas Wolterstorff insists, "Art and religion
are inextricably bound."[8] Material culture bears witness to this reality. Across
time, the business of fashioning things, crafting narratives, inventing rituals
and designing spaces has been the domain of both art and religion. A casual
stroll through the collection of any major art museum confirms that, since the
beginning of recorded history, art and religion have been partners in an on-
going dialogue on everything from the character of vocational pursuits and
the demands of daily life to more lofty speculations concerning the nature of
suffering and evil, love and beauty, and transcendence and eternity. Simply
put, there is ample reason to insist that the modern antagonism between art
and faith is a late nineteenth- and twentieth-century aberration.

In his review of *Seeing Salvation: The Image of Christ*, a major exhibit at the
National Gallery in London in 1997, Bryan Appleyard argued, "Western art was
Christian, is Christian and, for the foreseeable future, can be only Christian; we
cannot evade the Gospel's continuing presence in our culture. Their meanings,
their imagery, have determined the way we think, the way we create."[9] It is not
difficult to locate the genesis of the long period that Appleyard points to. Con-
stantine's conversion to Christianity early in the fourth century turned the
whole of the Roman Empire from polytheism and secularism toward Christian
theism.[10] Because of his edict, the minority voice and standing of the Christian
community—the one that we learn of in the book of Acts and the Pauline
Epistles—was reversed so that Christianity would grow to become the official
religion of the Roman Empire. For at least thirteen centuries this worldview

[6]In recent decades, interdisciplinary pursuits have become more common and in some institutions
even regarded as a greater good.

[7]Van der Leeuw, *Sacred and Profane Beauty*, 4.

[8]From a lecture given on March 1, 2012, at Biola University, La Mirada, CA.

[9]Bryan Appleyard, "A Review of the Exhibition of Seeing Salvation: The Image of Christ at the
London National Gallery," *Sunday Times of London*, February 13, 2000.

[10]Robert Hughes, "Pagans Versus Christians," in *Rome: A Cultural, Visual, and Personal History*
(New York: Knopf, 2011), 136-64.

galvanized Western thought and practice. Secular thinker Alain de Botton characterizes the long-standing reciprocity between art and the church like this: "Intriguingly, Christianity never expected its artists to decide what their works would be about; it was left to theologians and doctors of divinity to formulate the important themes, which were only then passed on to painters and sculptors and turned into convincing aesthetic phenomena."[11]

As already indicated, contemporary experience has led many to conclude something quite different than what van der Leeuw, Wolterstorff, Appleyard or even de Botton have described. Modernism signaled an end to a long and widely held conviction that the universe is best understood as a *created* unity. But as Daniel H. Borus points out, "The more the world resembled a multiverse rather than a universe, the greater the appeal of heterogeneity became in explanations and interpretations."[12] As philosopher Charles Taylor explains in his masterful study *The Secular Age,* moderns came to regard the universe as a disenchanted place.[13] With this move from the sacred to the secular, the larger narrative that once made it possible to discuss the meaning of human life in relation to the whole of created reality vanished entirely. Art historian Kathleen Pyne describes the contours of the modern mind that emerged: "The modern cosmos is usually construed as a world in which the center no longer holds things together. It is a world that only capriciously reveals its true reality to humankind, with the consequences that human experience is often contradictory and irrational, and uncertainty rules moral and religious life."[14]

Those who believe that Appleyard's claim about art and religion in the West is correct lament the loss of enchantment in our secular age. Nonetheless, and while it is ever tempting to romanticize the past, it would be foolhardy to deny the checkered history of the West: its savage ideological conflicts, immeasurable bloodshed and manifold abuses of power. In more than a few instances, it was

---

[11]Alain de Botton, *Religion for Atheists: A Non-Believer's Guide to the Uses of Religion* (New York: Pantheon, 2012), 237.

[12]Daniel H. Borus, "The Armory Show and the Transformation of American Culture," in *The Armory Show at 100: Modernism and Revolution,* ed. Marilyn Satin Kushner and Kimberly Orcutt (New York: New York Historical Society, 2013).

[13]Taylor's explication of enchantment and its loss, for which he credits Max Weber, is a critical concept in this important work. Charles Taylor, *A Secular Age* (Cambridge, MA: Harvard University Press, 2007), 25.

[14]Kathleen Pyne, "Resisting Modernism: American Painting in the Culture of Conflict," in *American Icons: Transatlantic Perspectives on Eighteenth- and Nineteenth-Century American Art,* ed. Thomas W. Gaehtgens and Heinz Ickstadt (Santa Monica, CA: Getty Center, 1992), 289.

the church that sponsored these horrors. And along the way some of its clerics and theologians viciously assaulted artists in spirit and sometimes in body. Meanwhile, it would be equally foolish to propose that prior to modernism the West was populated by a whelming throng of religiously devout Christians who loved the visual arts. It is more reasonable to propose that, where art and religion are concerned, a multitude of diverging theories and opinions regarding the meaning and practice of each in relation to the other is standard fare.

These cautions notwithstanding, it surely is the case that modernism was conceived and advanced by public intellectuals and cultural elites who were eager to embrace nontheistic thought. Political analyst David Brooks summarizes this secular project as follows:

> During the nineteenth and early twentieth centuries, religion lost influence, but the religious impulse lingered on. Some people sought salvation in the secular religions of politics—in Communism, fascism and various utopian experiments. Others saw artists, musicians and writers as Holy Men, who could provide transcendence and meaning, revealing timeless truths on how to live.[15]

The radical change that Brooks describes was evident as early as 1911 in an exhibit organized by Wassily Kandinsky, Franz Marc and Gabriele Münter. Other modernist participants in the exhibit included the recently deceased Henri Rousseau and musical composer Arnold Schoenberg, a talented amateur painter. As historians readily point out, the "essential idea" that lay behind this group known as Blau Reiter (Blue Rider) "was Nietzsche's dictum that 'Who wishes to be creative . . . must first blast and destroy accepted values.'"[16] According to historian Allan Megill, Friedrich Nietzsche (1844–1900) conceived "of 'nature' and of 'the natural' as human creations. In his view, the world in which we live is a work of art that is continually being created and recreated; what is more, there is nothing either 'behind' or 'beyond' this web of illusion. . . . The world is 'a work of art'—but one that, as a consequence of the crisis of God's death, 'gives birth to itself.'"[17] And here I add poet Christian Wiman's prescient observation: "As belief in God waned among late-nineteenth- and early-twentieth-century artists, death became

---

[15]David Brooks, "Without Gods," *New York Times Book Review*, March 18, 2012, 30.
[16]Ian Chilvers, *A Dictionary of Twentieth-Century Art* (Oxford: Oxford University Press, 1999), 77.
[17]Allan Megill, *Prophets of Extremity: Nietzsche, Heidegger, Foucault, Derrida* (Berkeley: University of California Press, 1985), 32-33.

their ultimate concern. . . . Postmodernism sought to eliminate death in the frenzy of the instant, to deflect it with irony and hard-edged surfaces in which, because nothing was valued more than anything else, nothing was subject to ultimate confirmation or denial."[18]

Artist by artist and movement by movement, early modernists ushered in what art historian Robert Hughes termed "the shock of the new."[19] As Brooks suggests, the artist and her vocation would supplant the long-standing cultural agreement that God's divine agency and rule was the prime moving force behind the universe. As nineteenth- and twentieth-century secularists jettisoned religion, they embraced aesthetics as their means to establish a cultural foothold. In service to this cause, a struggle for creative emancipation ensued, during which time-honored virtues such as truth, goodness and beauty were subject to considerable scrutiny and then either relativized or discarded. Whether by design or default, this position left twentieth-century artists operating at the forefront (hence the term *avant-garde*) of cultural chaos. The artists' aggressive dismissal of absolutes—in every form—anticipated the social and intellectual realities of the postmodern condition that would follow.

Protestant conservatives, meanwhile, steeled themselves against these radical developments. To that end, American evangelicals chose the language of theology and especially the Bible to maintain what they regarded as moral and spiritual high ground. Moreover, while upholding their Reformational commitment to *sola scriptura* (Scripture alone), they maintained its aesthetic—a fundamental hostility to the use of painting and sculpture in their houses of worship.[20] By mid-century the schism between modern art and evangelical piety was simply assumed. In the decades that followed, this standoff might be caricatured as follows: If to the secular mind the art world appeared clever, visionary and provocative, then to evangelicals it was the personification of narcissism, profanity and godlessness. And if to pious Christians the church-gathered felt like a safe

---

[18]Christian Wiman, *My Bright Abyss: Meditation of a Modern Believer* (New York: Farrar, Straus and Giroux, 2013), 50.

[19]Robert Hughes, *The Shock of the New* (New York: Knopf, 1981).

[20]During this period it was liberal Protestantism that demonstrated the most openness to modern art, and among its several champions, neo-orthodox theologian Paul Tillich was surely the most prominent. See Paul Tillich, *On Art and Architecture*, ed. John Dillenberger and Jane Dillenberger (New York: Crossroad, 1989).

haven of mercy, moral stability and spiritual succor, then to artists it seemed xenophobic, pedantic and hypocritical.

The balance of this chapter describes the shared cultural context during America's postwar period, wherein both the art world and the evangelical church "came of age." Notably, leaders in both movements championed utopian visions even as they faced innumerable dystopian realities that threatened to undo their respective programs. If one group hoped to navigate the yawning spiritual gap that lay between the shining city of God and the depraved condition of humanity, the other wrestled in the liminal space that existed between the brilliance of the creative spirit and the nagging desire for existential significance.

## POSTWAR AMERICA

In the aftermath of two world wars and the financial upheaval of the Great Depression, from 1945 onward America enjoyed a season of peace and prosperity. Veterans on the GI Bill filled college classrooms to capacity, suburban development sprawled, home ownership burgeoned and the boomer generation was born. American enterprises in business, industry, education and science prospered, first at home and then abroad. The early postwar years gave rise to sleek automobiles, streamlined appliances, towering skyscrapers, interstate highways—all built, so it seemed, from Bakelite, plastic, concrete, chrome and steel.[21] As fresh brands sought greater market share, new logos, billboards and advertisements generated vivid icons befitting the modern age. Aided by an explosion of newsstand tabloids and radio, a meteoric ascendancy of popular culture would follow. A new class of celebrity athletes, artists, movie stars, musicians and politicians gained an admiring public, and it seemed as if their skyrocketing fame, dramatically accelerated with the advent of television, would know no bounds.

More than any other artist of the day, Andy Warhol (1928–1987) memorialized the rapid growth of this broad-reaching, celebrity-obsessed, visual culture. Warhol possessed the uncanny ability to capture the place where popular culture, commerce and art intersect. Images like his serigraph *Marilyn* (*31*) (1967) depicted the glitz and glam of the Hollywood spectacle, all the while hinting at the existential void that lay beneath it (fig. 1.1).

---

[21]For a humorous and often poignant account of childhood during these years, see Bill Bryson, *The Life and Times of the Thunderbolt Kid: A Memoir* (New York: Broadway, 2006).

But as US citizens pursued the "good life," a lurking menace challenged the promise of the American dream—Soviet communism. Indeed, the theaters of war had opened new commercial markets, the heightened possibility for international cultural exchange and unprecedented opportunities for nation building. But these global conflicts also occasioned new threats. And so, even as America's bombing of Nagasaki and Hiroshima had signaled an end to World War II, the presence of this weaponry subsequently launched an arms race between superpowers, and the atomic age was born. In short order the Soviets armed themselves with nuclear warheads and intercontinental missiles, and within a decade every corner of the globe was susceptible to the threat of annihilation. With the escalation of the bitter and protracted Cold War between the United States and the Soviet Union, a disquieting version of Marshall McLuhan's "global village" settled in.

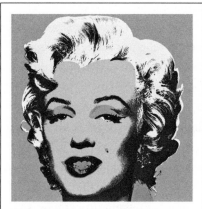

**1.1.** Andy Warhol, *Marilyn (31)*, 1967

The desire of the Soviets for world domination was especially troubling to the Christian community and for good reason: not only was communist aggression another hideous iteration of the very totalitarianism that had been vanquished in the Allied defeat of Hitler's Third Reich, but its ideology was atheistic in every respect. In fact, Stalinists and the Soviet regime that followed would torture, imprison and kill tens of thousands of believers. This persecution extended far beyond Soviet borders to the Eastern bloc, China, North Korea, Southeast Asia and even Cuba. While Marxist theorizing established the careers of some armchair academics, the real-life use of communism to oppress common folk in the second half of the twentieth century was unprecedented. It is small wonder that many patriotic churchgoers understood America to be God's nation on a mission to protect the world from "godless" communism.

This commingling of politics and religion in America had direct bearing on the art world. For even as many artists had fled three decades of European

mayhem and violence for the promise of creative freedom and relative peace in the United States, at the height of the Cold War, political conservatives— most notably, US Senator Joseph McCarthy—routinely discredited contemporary artists by branding them as communists. Some were.[22] Sadly, a battle line was drawn between those who welcomed the alignment of evangelical religious belief with right-wing political rhetoric over against more liberal-minded citizens who did not. And almost without exception, artists belonged to the latter.

As Cold War rhetoric and tactics continued to dominate US foreign policy, unrest at home began to stir. The catalyst for this turmoil was multifaceted: growing tension in black/white relations, ambitious new social programs outlined by Lyndon Johnson's Great Society, an ill-defined and ultimately failed war in Vietnam, and the overreach of the nation's powerful military industrial complex. Emerging from this was a vocal youth culture that "partied" beneath the banner of "sex, drugs, and rock 'n' roll" even as it embraced radical, left-leaning social and political ideals that had been gathered up in the classrooms of America's leading universities. In ways that might not have been predicted, theory had moved to praxis so that whether one belonged to the establishment, the radical left, or the ambivalent middle, by the early 1970s dynamic social change encompassed the whole of American culture, including the precincts of art and religion.

If in the early decades of the twentieth century the modern art movement and the evangelical church were both cultural outliers, by the century's end they would come to occupy a place of prominence in contemporary American life.[23] For their part, many evangelicals believed that they had awakened the conscience of a so-called moral majority, others built megachurch congregations and still others entered headlong into conservative politics. Meanwhile, art world aesthetes personified high culture. Their

---

[22]See Michael Brenson, *Visionaries and Outcasts: The NEA, Congress, and the Place of the Visual Artist in America* (New York: The New Press, 2001); and Herbert R. Lottman, *The Left Bank: Writers, Artists, and Politics from the Popular Front to the Cold War* (Chicago: University of Chicago Press, 1998).

[23]"For decades the dominant story of postwar American religious history has been the triumph of evangelical Christians. Beginning in the 1940s, the story goes, a rising tide of evangelicals began asserting their power and identity, ultimately routing their more liberal mainline Protestant counterparts in the pews, on the offering plates and at the ballot box." Jennifer Schuessler, "A Religious Legacy, with Its Leftward Tilt, Is Reconsidered," *New York Times*, July 24, 2013, C1, 1.

wealthy patrons constructed or expanded contemporary museums in urban centers worldwide, and blue-chip artists enjoyed record sales and commissions. Remarkably, the elasticity of the American democratic ideal—its toleration—allowed both to prosper. And as the United States grew to become the world's sole superpower, both its art and its religion commanded international attention.

Having acknowledged the dynamic social and political change that swept America during the postwar period, let us press on to explore the posture of the secular art world and the conservative Protestant church regarding their respective cultural standings, religious beliefs and convictions about personal and social transformation.

### High or Low

In 2006, hedge-fund manager Steven Cohen acquired Willem de Kooning's *Woman III* (1952–1953), a painting belonging to the series mentioned in the opening paragraph of this chapter, for $137.5 million. If the sum of Cohen's investment was remarkable, it was not out of step with art market trends. In her book *Seven Days in the Art World*, Sarah Thornton notes, "In 2007, Christie's sold 793 artworks for over $1 million each."[24] When patrons like Cohen purchase works of art for record-setting amounts, the value and critical importance of these objects increase. While it may be that the art world is defined more by market forces than aesthetics, wealthy financiers are not the sole arbiters of taste. Rather, their judgments are enmeshed with the assessments of a small coterie of prominent visual artists, gallery dealers, auction-house experts, art historians, critics and publishers. Together they comprise what is commonly termed the "art world." According to Thornton, this world is "structured around nebulous and often contradictory hierarchies of fame, credibility, imagined historical importance, institutional affiliation, education, perceived intelligence, wealth, and attributes such as the size of one's collection."[25]

Pertinent to the concern of this book, the lineaments of the art world invite at least three observations. First, consider its bearing on individual artists. Of the hundreds of thousands of artists hoping to attract serious

---

[24]Sarah Thornton, *Seven Days in the Art World* (New York: W. W. Norton, 2008), xvi.
[25]Ibid., xii-xiii.

critical attention, most will never enter the sitting rooms, galleries and col-
lections of the powerful, and fewer still will be awarded exhibits in important
venues, handsome exhibit catalogs or six-figure sales. Artists with MFAs
from reputable schools, productive studio practices and solid but mid-level
exhibition records will not make the cut.

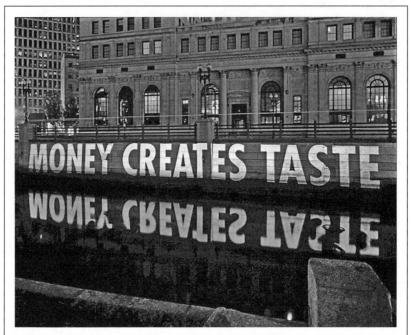

**1.2.** Jenny Holzer, *Money Creates Taste*, projection

Second, these art world machinations are not appreciably distinct from the
elitism that exists in business, education, entertainment, law, medicine and
professional sports. At their best, these guilds advance talent, innovation and
excellence; they encourage the cream to rise. At their worst, these same guilds
(formal and informal) perpetuate self-interest and haughty disregard for those
who do not belong to their tribe—the uninitiated, unlearned and uninformed.
In this respect the "exceptionalism" of the contemporary art scene can seem
especially bizarre since it appears ever ready to sponsor projects that many
citizens find esoteric, ugly or even profane.[26]

---

[26]Leonard Diepeveen and Timothy Van Laar, *Artworld Prestige: Arguing Cultural Value* (New York:
  Oxford University Press, 2013).

This leads to a third observation: if queried, most Americans would claim that the art world has no bearing on their daily lives; the enterprise does not summon their regular conscious concern or attention. In fact, galleries, museums and patrons join other elites in shaping the civic fabric of the world's most vital urban centers. William Deresiewicz writes:

> After World War II in particular, and in America especially, art, like all religions as they age, became institutionalized. We were the new superpower; we wanted to be a cultural superpower as well. We founded museums, opera houses, ballet companies, all in unprecedented numbers; the so-called culture boom. Arts councils, funding bodies, educational programs, residencies, magazines, awards—an entire bureaucratic apparatus.[27]

Whether it is provocative new museums, edgy contemporary exhibits or monumental commissions, the architects, artists and curators who envision these, in tandem with their sponsors, are caught up in a whirl of creative and commercial ventures that affect everything from graphic design to fashion and from product development to the contours of urban life. Consider, for instance, Alain de Botton's reflection on the social and even religious function of today's art museums: "The best architects vie for the chance to design these structures [art museums]; they dominate our cities; they attract pilgrims from all over the world and our voices instinctively drop to a whisper the moment we enter their awe-inspiring galleries. Hence the analogy so often drawn: our museums of art have become our new churches."[28]

The trio of realities described above underscores the *top-down* nature and operation of the art world. By contrast, evangelical programs are essentially *bottom-up*, and in this regard their broadly conceived mission embodies three cardinal convictions that are substantially distinct from those held by the art world.

First and foremost, evangelicals long to see the unchurched and unconverted place their faith in Jesus Christ. In their view, the only cure for "sin sick" souls is Christ's atoning death on the cross. Typically, they regarded this gift of salvation—God's gracious pardon from sin—as a personal transaction between God and an individual person.

[27]William Deresiewicz, "The Death of the Artist—and the Birth of the Creative Entrepreneur," *Atlantic*, January/February 2015, www.theatlantic.com/magazine/archive/2015/01/the-death-of-the-artist-and-the-birth-of-the-creative-entrepreneur/383497.
[28]De Botton, *Religion for Atheists*, 208.

Second, evangelicals believe that all who confess Christ are welcome at the foot of his cross. The good news, God's "amazing grace," extends to every tribe, tongue and nation so that in Christ "there is no longer Jew or Greek, there is no longer slave or free, there is no longer male or female; for all . . . are one in Christ Jesus" (Gal 3:28).

And third, since evangelicals believe that the eternal destiny of each person hangs on their response to God's gracious invitation and that this message is good news for all people, there can be no more urgent task than to bear witness to this new life in Christ. Indeed, before he ascended to heaven, Jesus instructed his disciples to "make disciples of all nations" (Mt 28:19). Postwar evangelicals embraced this command—the Great Commission—as their own.

Generally speaking, evangelicals' eagerness to convert the lost oscillated between their deep desire for family, friends and neighbors to enter into a life-giving relationship with Christ and strategies intended to reverse secularism and re-Christianize America. Following World War II, the challenge of sharing Christ grew to become a global concern that stimulated a generous outpouring of finances and fervent prayer. These words from Harold Ockenga's convocation address at Fuller Theological Seminary in 1947 capture the spirit of these years as well as any:

> Listen to me, my friends, the quickest way to evangelize the world, the quickest way to enter the open field, the quickest way to do God's work in the period of respite before us, before another holocaust takes place that everybody is predicting now, and only a few did some time ago, is to have divinely called, supernaturally born, spiritually equipped men of unction and power to go forth. We will not default. God help us, we will occupy till he comes.[29]

To carry out this evangelical vision, passion for evangelism was paired with American know-how, confidence and techne. Adding yet more urgency to this endeavor was the widely held belief that Christ's return could be hastened if the task of world evangelization were "completed in this generation."

As I have described it, the art world is largely an elitist enterprise centered on the wealth, talent and aesthetic preferences of a few, and later in this chapter

---

[29]From Harold John Ockenga's opening convocation address to Fuller Seminary October 1, 1947, "The Challenge to the Christian Culture of the West," *Fuller Theological Seminary: Theology, News & Notes*, Spring 2014, 13.

I examine the mind and motives of several prominent modernist artists. In sharp contrast to that social order, postwar American evangelicalism was a grassroots, populist movement. To understand something of the contours of the evangelical mission during those years, consider the life and practice of Billy Graham and Bill Bright, two men who epitomized the effort.

By any standard, Billy Graham (b. 1918) was the twentieth century's most famous *evangelist*—perhaps the century's most famous *citizen*. He sought nothing less than to preach the gospel to all men, and to that end he filled stadiums and arenas with tens of thousands of listeners the world over. It is estimated that during Graham's years of active ministry the evangelist reached more than two billion people both in person and via radio and television. Hollywood stars, high-profile athletes and US presidents sought his counsel, and not infrequently even his detractors admired him. Graham was handsome, well-spoken, and the picture of integrity, all of which added to his appeal. Ironically, the evangelist's sharpest critics seemed to be Christian fundamentalists who regarded his fraternization with liberal Protestants and Catholics the evidence of worldly compromise.

Businessman Bill Bright (1921–2003), founder of Campus Crusade for Christ, shared Graham's commitment to world evangelization. In 1952 Bright created the *Four Spiritual Laws*, a gospel booklet designed to present the logic of the Christian message in simple terms, initially to college students (fig. 1.3). The tract's central point was this: "We must individually receive Jesus Christ as Saviour and Lord; then we can know and experience God's love and plan for our lives." The form and content of Bright's *Four Laws* were not appreciably different from a booklet of coupons inserted in one's Sunday paper. Millions of copies were printed and, largely because of Bright's charismatic leadership and business acumen, hundreds of thousands of persons were trained to present this outline to friends and strangers alike. Enthusiasts of the *Four Laws* are eager to point out that Bright's tract has been used by God to lead many to Christ.[30]

---

[30]Throughout the twentieth century a vast publishing industry produced popular and often sentimental tracts, sheet music, Sunday school materials, posters and devotional aids (these later items are sometimes referred to as "Jesus Junk")—material evidence that highlights the disconnection between high and low culture. See David Morgan, *Protestants and Pictures: Religion, Visual Culture, and the Age of American Mass Production* (New York: Oxford University Press, 1999), and Betty Spackman, *A Profound Weakness: Christians and Kitsch* (Carlisle, UK: Piquant, 2005).

Where cultural elites are concerned, two responses to these kinds of evangelical efforts are worth noting. Whether it was Graham's simple plea at the end of each crusade to "come forward and receive Christ" or Bright's low-brow gospel tract, these approaches to witness supplied ample evidence to elites that evangelical Christianity was surely *not* for them. Added to this, the insistence by these same evangelicals that Jesus was the *only* way to the Father was and remains intolerable to the liberal mind.

**1.3.** Cover of *Have You Heard of the Four Spiritual Laws?* by Bill Bright, 1965

Meanwhile, though evangelicals like Graham and Bright enjoyed considerable popular success, a good many evangelical leaders grew increasingly frustrated by their exclusion from centers of cultural power. If some regarded this rejection as "suffering for the sake of Christ," others could not mask their longing to "take back the White House," "transform the secular university," "redeem Hollywood," and so on. Remarkably, in their desire to amass cultural capital, neither fundamentalists nor evangelicals demonstrated any appreciable interest in the visual arts.

In their desire to reach the world for Christ, almost without exception, early postwar evangelical strategies for witness failed to anticipate the advent of pluralism. By the close of the century, however, the realities of an emerging global culture necessarily affected every aspect of the evangelical mission both at home and abroad.[31] The new heterogeneity took up residence not only in America's urban centers but also in its suburbs. To their credit, more progressive evangelicals responded by contextualizing their message and methods, and their sensitivity to matters of race, gender, traditional cultures and even social class increased. It followed that apologetic arguments would, more and more, be intentionally paired with what was surely the most unimpeachable aspect of the evangelical witness—feeding, clothing, housing and educating millions of children, women and men, and often at considerable cost. But even

---

[31]Lesslie Newbigin, *The Gospel in a Pluralist Society* (Grand Rapids: Eerdmans, 1989).

this responsible social action would not diminish the long-standing tension between the conservative church and the dynamic world-changing culture that seemed to flourish beyond its doors.

More than six decades ago, H. Richard Niebuhr's (1894–1962) book *Christ and Culture* outlined this dilemma. Niebuhr proposed five possible relationships: Christ against culture, the Christ of culture, Christ above culture, Christ and culture in paradox, and Christ the transformer of culture.[32] Whether one's posture toward culture is primarily top-down or bottom-up, the range of Niebuhr's positions confirms the breadth and complexity of the situation.

Though they themselves would have been disinclined to read the work of this neo-orthodox theologian, twentieth-century fundamentalists and some of their evangelical heirs are best described by Niebuhr's first position, Christ against culture. This view was well matched to their separatist doctrine, and it had compelling biblical warrant. That is, beginning with the people of Israel and their emancipation from the land of Egypt and continuing on to the early church in the New Testament, God frequently commanded his people to be distinct in belief, character and behavior from the pagan nations that surrounded them. Jesus' own teaching concerning the kingdom of God and the kingdom of this world effectively underscores the idea of two cultures in conflict. It was Jesus, after all, who described Satan as the "ruler of this world" ( Jn 12:31).

However one assesses Niebuhr's Christ-against-culture position, the most persuasive aspect of this position is its capacity to call evil "evil." Whether high or low, human culture never ceases to generate dubious, harmful and even blasphemous things. Even the most ardent, irreligious person must concede that "worldly temptations" such as alcohol, drugs, gambling, infidelity, pornography and tobacco have devastated millions of lives and that the "idols" of fame, money and power have been the ruin of countless families, communities, guilds and nations. The biblical antidote to this unrighteous mayhem is to resist evil or, in Old Testament language, to separate what is "clean" from that which is "unclean." Consider the words of James 4:4: "Adulterers! Do you not know that friendship with the world is enmity with God? Therefore whoever wishes to be a friend of the world becomes an enemy of God." But how is this separation to be accomplished?

---

[32]H. Richard Niebuhr, *Christ and Culture* (1951; New York: Harper and Brothers, 1956), 45-82.

In his day, and desiring to cleanse Florence of its worldliness and to reform the church, the fifteenth-century Dominican friar Girolamo Savonarola gathered up thousands of objects that he regarded as immoral—everything from pagan texts and art to mirrors and cosmetics that only the city's wealthiest citizens could have afforded—and set the entire pile ablaze. The event known to us now as the Bonfire of the Vanities occurred on February 7, 1497.[33] Curiously, the actions of this Catholic friar who knew and highly regarded the work of Fra Angelico would foreshadow the evangelical proclivity, centuries later, to ban or burn books, record albums and CDs; boycott offensive Hollywood films; and protest the exhibition of blasphemous works of art—works they had not personally viewed that were created by artists whom they did not know.

The evangelical desire for personal piety merits a bit more comment. Twentieth-century Protestant conservatives rightly understood that any meaningful Christian doctrine must find palpable connection to daily life. They reasoned that the relativism of the day could be countered only by a renewed commitment to the Bible as truth. Meanwhile, in the secular world, traditional conceptions of family and morality, especially sexuality, were being overturned at an alarming rate. In other words, even as private spiritual practices such as prayer, Bible reading and personal holiness were belittled, it seemed that moral absolutes were slipping away. If secularists and liberal Christians had stridently embraced worldliness, evangelicals would stand their ground. Some conservative Protestants were content simply to "be separate." Others, however, prepared for battle, and to that end they assembled a moral arsenal composed of censorship, mediated social pressure and political action. From the mid-1980s onward, Christian and secular social observers would note (sometimes with considerable delight) the ever-widening gulf between these two camps, and the postulation of a great "culture war" became a handy and fashionable means to describe it.[34]

Whether evangelical acts of resistance were prudent must be evaluated, but in every age the church has needed to embrace internal reform even as it steels

---

[33]Some speculate that even noted artists, such as Sandro Botticelli, destroyed a portion of their own more-pagan work in sympathy with this movement of reform.

[34]The most well-known account of this conflict is that of sociologist James Davison Hunter, *Culture Wars: The Struggle to Define America* (New York: Basic Books, 1991). Other conservative, yet secular, critics also voiced their concern. See Robert Hughes, *Culture of Complaint: The Fraying of America* (New York: Oxford University Press, 1993).

itself against its external challengers. In modern America it was religious sects such as the Amish and certain Catholic orders that managed to separate themselves most completely from the world. But these measures were too austere for most postwar evangelicals, who instead advanced the idea that one could participate *in* the world while somehow managing not to be *of* it. On first impression this approach appeared practical and even wise. But almost without fail, implementation of this "in but not of" strategy generated a graceless legalism. As fundamentalists and evangelicals upheld their doctrine of separation, they faced the challenge of working out this separation in a world where the assumptions of Christendom rapidly receded as the social and ideological complexities of pluralism gained ascendancy.

Again, while there is much to commend the Christ-against-culture position, it contains a deeply flawed conception of culture (not a flaw in Niebuhr's reasoning, but rather in the reasoning of those who held the position he described). As a synonym for *worldliness*, Christian conservatives have understood culture to be a Babylon given to the worship of false deities, the pursuit of godless passions and a safe haven for the enemies of our soul (Rom 1:18-32). Viewed through this lens, culture becomes an artifact of human activity used to describe those who live opposed to God and decidedly not the natural outcome of our being creatures whose domain is creation. Theologically speaking, the oppositional view of human culture is entirely postlapsarian: culture is the result of Adam and Eve (humanity) reaping their just reward for their rebellion against God rather than a mandate given by God to the man and the woman to rule and be fruitful amid Eden's paradise (Gen 1:26-27).

In sharp contrast to evangelical hand-wringing about purity and holiness, the art world has never been much troubled by its relationship to culture: its primary task is to *create culture*. It is at this point in our discussion that the deep sociological divide between art world elites and the evangelical church becomes most apparent. Whether liberal or conservative, both were well practiced at separating sheep from goats as a means to advance their respective causes.

It is, for instance, no secret that secular elites delighted in discrediting evangelicals. To this end they constructed truncated histories of conservative Christianity in America. Such a history might begin by citing Jonathan Edwards's sermon "Sinners in the Hands of an Angry God" (1741), go on to celebrate William Jennings Bryan's defeat in the Scopes (Monkey) Trial (1925)

and chortle at televangelist Jim Bakker's moral and financial indiscretions (1989). Predictably, these narratives and their endless iterations culminate with an expression of disdain for James Dobson and his organization, Focus on the Family. That these "bad histories" span nearly three centuries and feature protagonists who exist in no particular relationship to each other did not undermine the overarching goal of this effort, which was to demonstrate that evangelicals are plain folk, simple in mind, lacking urbanity and foolishly devoted to superstitious belief.

Meanwhile, evangelicals were no less swift to judge. In their view, secular elites were blithely unconcerned about the needy, given to habitual self-aggrandizement and rushing pell-mell on the "wide way" to their own destruction. Evangelical pronouncements concerning the art world have been equally vicious: artists are rebellious bohemians, collectors are hoarders of art-world treasure, and patrons are narcissists who spare no expense to erect extravagant monuments to themselves.[35]

Fortunately, postwar America was both more complicated and more interesting than simple binary schemes like *high* and *low* might suggest, and from time to time these tidy classifications collapsed entirely. For instance, in the late 1970s, Christian Reformed pastor Robert H. Schuller (1926–) commissioned world-renowned architect Philip Johnson (1906–2005) to take the lead in designing what would become the Crystal Cathedral (fig. 1.4). Schuller's decision to commission Johnson—founder of the Department of Architecture and Design at the Museum of Modern Art in 1930 and the leading proponent of the International Style—aroused not a little curiosity in the art world and considerable skepticism from his evangelical counterparts.[36] But on September 14, 1980, Schuller dedicated his completed edifice "To the Glory of Man for the Greater Glory of God."

There are several ways to assess Schuller's selection of Johnson, a secular Jew, to build a house of Christian worship in Orange County, California. Perhaps it was Schuller's penchant for pageantry or even his vanity. Perhaps it was his insight into the worship needs and greater witness of his congregation. No matter

---

[35]See Carol Duncan, "Something Eternal: The Donor Memorial," in *Civilizing Rituals: Inside Public Art Museums* (London: Routledge, 1995), 72-101.

[36]Notably, in Schuller's day many evangelicals and most fundamentalists would not have counted him as belonging to their fraternity.

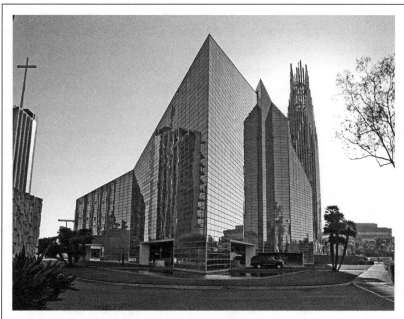

**1.4.** Philip Johnson (architect), Crystal Cathedral, 1980

how one understands the purpose of this high-culture megachurch collaboration, it demonstrated the ability of an elite secular architect to partner with a high-profile religious leader to respond to the fluid cultural matrix of their day.

In the end, the premise that culture can be understood as something separate from regular life is both untenable and false. No matter what ism or creed one heeds, to the extent that one shares economies, language, symbols and technologies with one's neighbor, one will find oneself swimming in some region of the same cultural pond. In the end, whatever combination of cultural perspectives one may hold to, the shared space and place that we call "culture" is where we all endure threats and encounter limits, even as we seek sustenance and strive to flourish.

## SECULAR OR SACRED

In 2003 reporter Sarah Boxer interviewed painter Hedda Sterne (1910–2011). Ninety-three years old, Sterne recounted a story that she once shared with the celebrated abstract expressionist painter and sculptor Barnett Newman (1905–1970). "A little girl is drawing and her mother asks her 'What are you drawing?'

And she says, 'I'm drawing god.' And the mother says, 'How can you draw god when you don't know what he is?' And she says, 'That's why I draw him.'" According to Sterne, Newman liked the story so well that he wanted to adopt it as the motto for abstract expressionism.[37]

As this exchange between Sterne and Newman confirms, it would be wildly inaccurate to suggest that modernism and its proponents held no interest in metaphysical or spiritual matters.[38] To the contrary, artists such as Constantin Brancusi, Paul Klee, Kazimir Malevich, Isamu Noguchi and a host of others were powerfully drawn to spiritual practices and ideas.[39] For many, this fascination had been catalyzed by Wassily Kandinsky's 1911 essay *Concerning the Spiritual and Art*.[40] Kandinsky, whose affiliation with the Blau Reiter group is cited earlier in this chapter, had been trained as a lawyer and was a practicing theosophist. He believed that abstract color and form could express the spiritual nature of being. In this regard, his painting and writing held considerable sway, but none greater that his posthumous influence on abstract expressionism and in particular the work of Barnett Newman and Mark Rothko (1903–1970). In this regard, Newman's *Stations of the Cross* (1958–1966)— fourteen large paintings on view in the East Building of the National Gallery in Washington, DC—is exemplar. Though a Jew and not a Christian, Newman's minimalist work employs an austere modernist form to explore the central Christian doctrine of Christ's passion.

On the heels of Newman's achievement, patrons John and Dominique de Menil commissioned Mark Rothko to create work for the interfaith de Menil

---

[37]Sarah Boxer, "The Last Irascible," *New York Review of Books*, December 23, 2010, www.nybooks .com/articles/2010/12/23/last-irascible.

[38]Kathleen Pyne writes: "In search of mystical experience in which the self becomes unified with the universe, abstract painters such as Barnett Newman, Mark Rothko, Ad Reinhardt, and Jackson Pollock, probed sources as diverse as the writings of mystics—from Emanuel Swedenborg to Emerson to Mme Blavatsky, William James, and Rudolf Steiner; the ritualistic objects of Native American culture, for example, masks, carvings, and pictographs; or the paintings of Albert Pinkham Ryder. These painters no doubt publicly refuted any overt religious meaning for their art in order to escape attachment to a belief system and didactic verbalization of the image that would in turn rob the image of its power. In place of verbalization, the paintings of Rothko typically call for an atmosphere of silence in their offering the viewer a surrogate spiritual experience, much as the landscapes of John Twachtman do" (Pyne, "Resisting Modernism," 309). See also Roger Lipsey, *An Art of Our Own: The Spiritual in Twentieth-Century Art* (Boston: Shambhala, 1989).

[39]Eric Franz, *In Quest of the Absolute* (New York: Peter Blum Editions, 1996).

[40]Kandinsky's book was originally published in 1911 as *Über das Geistige in der Kunst* and then was translated by M. T. H. Sadler in 1914 and published as *The Art of Spiritual Harmony*. Contemporary artists such as the late Keith Haring (1958–1990) were also influenced by Kandinsky's treatise.

Chapel in Houston (1971). Rothko's paintings—also fourteen in number—would become his most important achievement.[41] By design, Rothko's color fields were luminous and ethereal. Since the work contained no symbols or images, the artist's intention remained highly enigmatic. Fortunately for us, Rothko's ample commentary rescues the meaning of his work from obscurity and poignantly so: "I'm interested only in expressing basic human emotions—tragedy, ecstasy, doom and so on. And the fact that a lot of people break down and cry when confronted with my pictures shows that I can communicate these basic human emotions. . . . The people who weep before my pictures are having the same religious experience as I had when I painted them."[42] Tragically, Rothko would not witness the final installation of his dark-hued paintings in the de Menil chapel. In the aftermath of a painful divorce from his wife and struggling with failing health, on February 25, 1970, the artist committed suicide. He was sixty-six.

In their quest to probe spiritual reality, other modernists explored the vitality of the Christian story more directly than either Newman or Rothko. Consider, for instance, the tongue-in-cheek work of Andy Warhol, most notably his *Last Supper* series (1986). The Christian themes in Warhol's work were hardly happenstance. According to art historian Jane Daggett Dillenberger, the primary source of Warhol's Catholic devotion was his much-beloved mother, Julia Warhola:

> Before leaving home each day, Andy knelt and said prayers with her [Julia], in Old Slavonic. Andy wore a cross on a chain around his neck under his shirt and carried a pocket missal and rosary with him. His mother kept crucifixes in the bedroom and kitchen, and she went to services regularly at St. Mary's Catholic Church of the Byzantine Rite. In Julia's yellowed and frayed Old Slavonic prayer book there is a commemorative card with a cheap reproduction of Leonardo da Vinci's *Last Supper* which Andy must have seen. This is a sentimentalized version of Leonardo's masterpiece, which Warhol recreated, using other copies of the original, in over a hundred paintings and drawings in the last years of his life.[43]

---

[41]Dominique de Menil, *The Rothko Chapel: Writing on Art and the Threshold of the Divine* (New Haven, CT: Rothko Chapel/Yale University Press, 2010).

[42]Chilvers, *Dictionary of Twentieth-Century Art*, 530.

[43]Jane Daggett Dillenberger, *The Religious Art of Andy Warhol* (New York: Continuum, 1998), 21.

Consistent with his earlier practices, Warhol created his *Last Supper* by reproducing and then altering images from Leonardo da Vinci's *Last Supper*, a mural painted by the fifteenth-century artist in the chapel of the Church of Santa Maria della Grazie. In due course, Warhol's appropriation of this sacred art and the biblical story that it contained was exhibited at Credito Valtellinese, a bank in Milan located directly across the street from the Santa Maria della Grazie. There is a sense in which the initial exhibit of Warhol's facsimiles in a secular space juxtaposed to the sacred sanctuary that housed da Vinci's original painting mirrored his troubled relationship to Catholicism.[44] It is claimed, for instance, that while Warhol attended daily Mass with some regularity throughout his life, he refrained from partaking of the Eucharist. The *Last Supper* series was Warhol's final major work before his untimely death in 1987. He was fifty-eight.

Whether allusion, art historical trope or ironic treatment, Warhol's appropriation of da Vinci's *Last Supper*, as well as the countless riffs on this theme by other artists throughout the modern and contemporary periods, demonstrates the resilience of the biblical story in the history of Western art.[45] Indeed, from Antoni Gaudí's (1852–1926) *Expiatory Church of the Holy Family*, a monumental Roman Catholic Basilica in Barcelona, to Georges Rouault's (1871–1958) *Misère* series depicting the sufferings of Christ, to Marc Chagall's (1887–1985) biblical narratives in prints and stained glass, the imprint and gravity of the Christian narrative endured throughout the twentieth century.[46]

In their day, few evangelicals would have been aware of seminal artists like Newman, Rothko and Warhol. For the most part, the spiritual interests of these painters existed quite apart from formalized religion and especially Christian dogma. Rather, modernist fascination with the spiritual gravitated to the numinous and the liminal—matters of soul, states of consciousness and approaches to the Absolute that found their source in modern psychology, literature, philosophy and, not infrequently, non-Western religion. The

---

[44]Anthony Haden-Guest, "Warhol's Last Supper," Artnet, August 3, 1999, www.artnet.com/maga zine_pre2000/features/haden-guest/haden-guest8-3-99.asp.

[45]Leo Steinberg, *Leonardo's Incessant Last Supper* (New York: Zone Books, 2001).

[46]As early as 1883 the Catalan architect Antoni Gaudí was charged to oversee the construction of the magnificent Basílica i Temple Expiatori de la Sagrada Família. From 1915 to the end of his life, he gave himself to this project. Meanwhile, construction of the basilica continues, with completion now estimated at 2026 and beyond, and popular support for Gaudí's canonization continues.

overarching desire of these twentieth-century artists, writers and philosophers was to locate some evidence of existential meaning and, with that goal before them, they sought sublime aesthetic encounters.

Ironically perhaps, the imprint of traditional religious practice was not easy for modernists to shed. In pursuit of the spiritual, more than a few likened their studio practice to priestly labor: their material acts of making turned to ritual, and their aesthetic experiences became revelation. According to Alain de Botton, the museum itself would become a secular house of worship:

> Like churches, they are also the institutions to which the wealthy most readily donate their surplus capital—in the hope of cleansing themselves of whatever sins they may have racked up in the course of accumulating it. Moreover, time spent in museums seems to confer some of the same psychological benefits as attendance at church services; we experience comparable feelings of communing with something greater than ourselves and of being separated from the compromised and profane world beyond.[47]

And, as Sarah Thornton explains, this questing continues: "For many art world insiders and aficionados of other kinds, concept-driven art is a kind of existential channel through which they bring meaning to their lives. It demands leaps of faith, but it rewards the *believer* with a sense of *consequence.*"[48] As conscious beings, the meaning question will not go away; it dogs us.

To professing, Bible-believing Christians, the kind of *secular spirituality* outlined in the previous paragraphs will seem mostly misguided and far afield from any kind of saving faith. Historically, Christians have generally equated *spirituality* with ways of being that are practiced by those seeking to follow God and *the spiritual*, that transcendent realm where God exists. According to this view, neither spirituality nor the spiritual finds its source in human understanding, since these realities cannot be summoned from within. Rather, knowledge about God comes to men and women as revelation, first as the book of creation and second as the book of Scripture. Just as creation—the works of God—bears witness to God's invisible power and eternal nature, Holy Scripture—the Word of God—tells of his true nature and being.

---

[47]De Botton, *Religion for Atheists*, 208-9.
[48]Thornton, *Seven Days*, xiv (italics mine).

Early in the twentieth century and fearing admixtures of Protestant liberalism, religious syncretism and secular unbelief, conservative Protestants sought to protect their doctrine of revelation and to that end waged a "battle for the Bible."[49] The outcomes of this century-long effort to defend the Bible were various. In some instances this impassioned effort galvanized disparate factions in the conservative movement. On other occasions it fostered intense parochial disagreement and dissent. Pertinent to the concerns of this book, the crusade for biblical truth inflicted collateral damage on those who entertained other genuine ways of knowing—knowledge born of narrative, symbol, mystery and haptic experience—ways held by the majority of artists in the church.

As noted, some modernists maintained a keen interest in the spiritual, but this fact notwithstanding, the general direction of the movement is best characterized as a centuries-long migration from an earlier vision that had once been nurtured and then groomed by a life-giving connection to Christian theology to one that found its primary inspiration in secular thought. The sources of this roiling intellectual revolution were seminal figures including Karl Marx, Charles Darwin, Sigmund Freud, Karl Jung and Friedrich Nietzsche—men with capacious minds who were eager both to capture the spirit of their age, its *Zeitgeist*, and to diminish or obliterate Christian beliefs and especially the institutions that housed them. With that goal before them, they recast their respective disciplines—economics, the natural sciences, psychology and philosophy—in nontheistic forms that would directly challenge Christendom, the grand narrative of the West.[50] If some in the nineteenth century had begun to entertain agnosticism, the twentieth-century rush toward atheism was swift and bold. Roger Lundin explains it like this:

> We have learned to live with unbelief in our midst and, in many cases, our hearts. Yet when it first broke upon the scene in the mid-nineteenth century, a sense of disruption and disorientation was palpable, even overwhelming for some, as within a matter of decades unbelief went from being an isolated experience on the cultural margins to becoming a central facet of modern life.[51]

---

[49]Harold Lindsell, *The Battle for the Bible* (Grand Rapids: Zondervan, 1976).

[50]If some like Marx, Freud and Nietzsche set out to dismantle Christianity directly, the motives of others like Darwin and Jung were more opaque. See Mark Lilla, *The Stillborn God: Religion, Politics, and the Modern West* (New York: Knopf, 2007).

[51]Roger Lundin, *Believing Again: Doubt and Faith in a Secular Age* (Grand Rapids: Eerdmans, 2009), 5.

To illustrate this dramatic shift, consider the atheism espoused by esteemed British mathematician and political activist Bertrand Russell (1872–1970) in his pamphlet *Why I Am Not a Christian* (1927). In the late 1920s, Russell's pronouncements may have seemed either scandalous or brave. But on entering the twenty-first century, views such as Russell's appear commonplace and, with that, any popular worry about one's eternal destiny became a hopelessly antique concern.

While it is beyond the scope of this book to give either agnosticism or atheism its serious due, it is not difficult to understand the modern collapse of confidence in God's providence. In light of the human carnage of trench warfare in World War I, the Nazi genocide of six million Jews and other ethnic minorities in World War II, and America's eventual and pointless war in Vietnam, there was ample cause for despair. If human progress—especially the marvels of science and technology—was an understandable occasion to display a bit of twentieth-century hubris, the horrors loosed on humanity by its inventions were unspeakable. The long shadow of modern violence and savagery compelled many to ask, "If God is powerful and compassionate, then why did he allow this?" And under these circumstances more than a few artists were left to wonder what justification there could be for continuing to make art.[52] These penetrating questions remain, and, in my view, the most fitting first response before them is silence.

By mid-century the footings for the modernist scaffolding had been poured deep into disenchanted ground. In the face of Cold War moralizing and rigidity, a new retinue of artists, critics, galleries and museums would parade aesthetic anarchy. And as old deities and weary traditions were exorcised, daily studio practice, high-minded theorizing and the art market rose up to occupy the vacancy. Sufficient unto itself, the art world came of age, and its fraternity of bohemian artists, aesthetes and collectors could herald the movement's final triumph: *l'art pour l'art* (art for art's sake).[53]

Thus far in this chapter we have examined the contrasting postwar approach of the art world and the evangelical church first to culture and then, in this section, to religious belief. To the secular mind, the abiding gnosticism, piety

---

[52]I thank Bruce Herman for introducing me to Theodor W. Adorno, "Meditations on Metaphysics: After Auschwitz," in *The Adorno Reader*, ed. Brian O'Connor (Oxford: Blackwell, 2000), 86-87. I also thank Cecilia Gonzalez-Andrieu for directing me to Von Ogden Vogt, *Art and Religion* (New Haven, CT: Yale University Press, 1921).

[53]The phrase "art for art's sake" was coined by Victor Cousin (1792–1867) in a lecture given at the Sorbonne in Paris.

and fundamentalism of evangelicalism—its failure to meaningfully engage immanence, groundedness and freedom—placed it dramatically out of touch with the interests of contemporary artists, who saw no tangible relation between the aesthetic pleasures and freedoms they sought and the church's long-standing commitment to revelation, authority and fidelity. Consequently, artists who came of age in the 1960s and beyond found it difficult—even impossible—to see any virtue in an earlier conception of the world wherein the biblical narrative guided art in the West, Christian symbols and metaphors prospered, and stories of simple faith announced the sacred character of ordinary life.

Without question, modernism was a secular project. Nonetheless, some of the movement's leading artists were animated by a fascination with the metaphysical and the spiritual. Christians who are keen cultural observers might take encouragement from this report. But alas, the intellectual pitch of America's elite art museums, galleries and academies, in partnership with the publishing houses and academic departments that supported them, remained hostile to traditional Christianity.[54] In this regard the exoticism of such things as Zen Buddhism, shaman rituals, Islamic art and Jewish art were welcome. In rare moments the academic study of Christian themes was tolerated. But in secular academic and cultural centers, "heartfelt" orthodox Christian belief was considered quaint, naive and irrelevant.

## AESTHETES OR DISCIPLES

Though it may seem altogether strange, in postwar America the evangelical church and the modern art movement did share one patch of common ground: an all-consuming desire to effect personal and cultural transformation. That is, the leaders of both movements were unabashed zealots, eager proselytizers. If conservative Protestants labored to disciple a generation of godly people to evangelize the globe, then the art world schooled young aesthetes to embark on a daunting material and ideational struggle. Put differently, even as many evangelicals longed to return America to the narrow path of biblical truth and traditional mores, the art world campaigned for artistic freedom and advanced a new, radical understanding of the self. Each was, in its way, hardwired to be a witnessing presence.

---

[54]For an in-depth account of the rise of secular thought in America's elite universities, see George Marsden, *The Soul of the American University: From Protestant Establishment to Established Non-Belief* (New York: Oxford University Press, 1994).

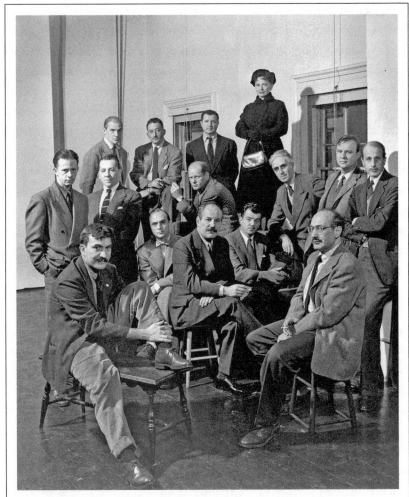

**1.5.** Nina Leen, portrait of "The Irascibles," *Life* magazine, 1950

The modernist movement was promulgated by avant-garde artists in leading cultural centers like Barcelona, London, Paris and Zurich in the late nineteenth and early twentieth centuries. From its inception, modernism—and its disruptive submovements cubism, Dada, expressionism, fauvism, futurism, impressionism, surrealism, to mention a few—was marked by its pursuit of new plastic forms and utopian ideals, and these were frequently enumerated in edgy manifestoes. Predictably, public reaction to these avant-garde ventures was usually shock or outrage. But almost without exception, these early provocations went

on to gain critical, institutional and even popular support, and with this the art-
ist's role as modern prophet and muse grew in scope.

Following World War I and well into the postwar period, European artists
found safe harbor in New York: a metropolis soon to become the hub of the
international art scene.[55] A striking emblem of this historic recentering is an
image that first appeared on the January 15, 1951, cover of *Life* magazine (fig.
1.5). It features a group of New York artists who, because of their protest against
the exhibition policies of the Metropolitan Museum of Art in 1950, had come
to be known as the Irascibles. This artist collective included abstract expres-
sionist painters such as Franz Kline, Willem de Kooning, Barnett Newman,
Jackson Pollock and Mark Rothko, who, in partnership with other luminaries
such as Hans Hoffman and Arshile Gorky, would form the center of what
came to be known as the New York School. Notably, three of the fifteen were
émigrés, and at least three more were first-generation sons of émigrés. Only
one, Hedda Sterne (noted earlier), was a woman. Many of these artists lived
in cold-water flats, surviving on whatever odd jobs they could find. A favorite
watering hole was the Cedar Tavern in Greenwich Village, where they frater-
nized with Beat poets such as Allen Ginsberg, Jack Kerouac and Frank O'Hara.
Known to us now as the icons of American modernism, most of these painters
and writers went on to enjoy celebrated careers. But none, not even Rothko,
would rise as high as Jackson Pollock (1912–1956).

Born in Wyoming and the son of a shiftless sheep rancher, Pollock's
persona was perfectly suited to the swagger and machismo of American
culture. Pollock's America—a nation that would spare no expense to place
the first man on the moon—was a nearly ideal environment in which to
launch unfettered aesthetic exploration. While studying at the Art Students
League in New York City, Pollock met Thomas Hart Benton.[56] Benton,
known to be "a virulent, truculent, hard-drinking macho-man," quickly
became Jackson's mentor.[57] Although the young painter rejected his men-
tor's realist aesthetic, Pollock's temperament resembled Benton's, and by age
twenty-five Pollock was being treated for alcoholism. Two years later he
entered into Jungian psychoanalysis.

---

[55]Jed Perl, *New Art City: Manhattan at Mid-Century* (New York: Knopf, 2005).
[56]Holland Cotter, "America's Portraitist," *New York Times Book Review*, July 1, 2012, 10-11.
[57]Chilvers, *Dictionary of Twentieth-Century Art*, 481.

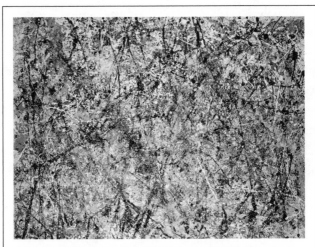

**1.6.** Jackson Pollock, *Number 1, 1950 (Lavender Mist)*, 1950

Early in his career, Pollock was fascinated by mythopoetic symbols, likely a debt to his clinical exposure to Carl Jung. But the mainstay of his oeuvre quickly became "drip" or "action" paintings—expansive works such as *Autumn Rhythm (No. 3)*, now in the Metropolitan Museum of Art in New York, or *Number 1, 1950 (Lavender Mist)* (fig. 1.6), in the National Gallery of Art in Washington, DC. To some viewers, these large canvases suggest everything from complex neural networks to rapidly expanding cosmic dioramas. Viewed in this manner, they invite visceral engagement. To others, Pollock's marks appear to be nothing more than drizzled paint. While Pollock's mature work may now seem de rigueur, in its day it was provocative and without precedent and since the late 1950s has occupied an exalted place in the modernist canon.

If any artist in the postwar period personified the conviction that art is primarily an expression of the self, surely it was Pollock. Describing his creative practice, Pollock once volunteered, "The thing that interests me is that today painters do not have to go to a subject matter outside of themselves. Most modern painters work from a different source. They work from within."[58] Painter Lee Krasner, the artist's wife, recounts the time that she brought the celebrated color field painter Hans Hofmann to visit Jackson.

---

[58]Pepe Karmel, ed., *Jackson Pollock: Interviews, Articles, and Reviews* (New York: Museum of Modern Art / Abrams, 1998), 20.

Hoffman queried, "Do you work from nature?" Pollock famously replied, "I am nature."[59]

On first impression, Pollock's declaration might appear entirely romantic. That is, summoned by the grandiosity of nature and quickened by the special ability of artists to divine spiritual meaning from it, proponents of romanticism regarded their efforts as a counterproposal to rationalism. Romantic poets, musicians and painters believed that their collective enthrallment could challenge the burgeoning optimism of the Enlightenment and its confidence in the ability of science to define, manage and improve the world. Simply put, if science had disenchanted the universe, art could restore it.

Unwittingly perhaps, Pollock and his ilk had taken their cue from Nietzsche, who claimed, "Nature, artistically considered, is no model. It exaggerates, it distorts, it leaves gaps. Nature is chance."[60] The ascendancy of Darwinian thought had demystified the natural world, displacing earlier celebrations of *creation* as the shining evidence of God's handiwork with cooler conceptions of *nature* as randomly generated evolutionary effects. But matters would evolve (or devolve) even further. As Lundin points out, "By the end of the eighteenth century" romantically inclined artists and intellectuals "were crying out for a world that could match in its external splendor the marvels created by the imagination in its internal wonder."[61] If a Spirit-hosted universe did not exist, then the numinous and the transcendent would need to be born afresh by the creative powers of the artist. From this point forward, the flame igniting artistic passion could be lit only from within.

Pollock was an immense talent. His Promethean drive, coupled with the expressive freedom and critical endorsement of the New York scene, contributed to the artist's meteoric rise in the art world. But Jackson was also a troubled, demon-haunted soul. Drunk behind the wheel and with his mistress Ruth Kligman at his side, he met his end in a fatal car crash. Pollock was forty-four. Kligman survived.

As Pollock's rise and demise suggests, the ascent of modernism signaled an extravagant new estimation of the self—a contemporary "self-consciousness"

---

[59]John Golding, *Paths to the Absolute: Mondrian, Malevich, Kandinsky, Pollock, Newman, Rothko, and Still*, A. W. Mellon Lectures in the Fine Arts, 1997 (Princeton, NJ: Princeton University Press, 2000), 137. See also Arthur C. Danto, *What Art Is* (New Haven, CT: Yale University Press, 2013), 13.
[60]As cited by Lundin, *Believing Again*, 47.
[61]Ibid., 45.

that would go on to form the basis of nearly every conception of personal identity. This emerging notion of the self was rooted in the older Renaissance conviction that humanity is the measure of all things. Indeed, the Renaissance was enamored of the possibility of human genius, an idea that, though much debated, persists in all the arts through to our present day.[62] But even this understanding of the self—informed substantially by the Enlightenment—would be cast aside by modern philosophy and the rising social sciences.

> The modernists found themselves in opposition to their world for reasons which were continuous with those of the Romantics. The world seen just as mechanism, as a field for instrumental reason, seemed to the latter shallow and debased. By the twentieth century the encroachments of instrumental reason were incomparably greater, and we find the modernist writers and artists in protest against a world dominated by technology, standardization, the decay of community, mass society, and vulgarization.[63]

As well as any, the words of Barnett Newman capture the moment: "We are freeing ourselves of the impediments of memory, association, nostalgia, legend, myth or what have you, that have been the devices of Western European painting. Instead of making cathedrals out of Christ, man, or 'life,' we are making [them] out of ourselves, out of our own feelings."[64]

The art world's dynamic migration toward individual expressive freedom underscores the true nature of the aesthetic revolution that had unfolded. These ascending notions of intellectual, moral and aesthetic emancipation were bolstered by everything from Walt Whitman's *Song of Myself* (1855) in the nineteenth century to Jack Kerouac's stream-of-consciousness epistle *On the Road* (1957) in the twentieth.[65] And it was on this frontier of new freedoms that artists staked their claim. To the secular mind, genuine personal emancipation would release the human spirit from religious superstitions and oppressive hierarchies, and the idea of "self-determination"—a virtue principally

---

[62]In large part, this exaggerated sense of the self was built atop earlier romantic understandings. See Jacques Barzun, *The Use and Abuse of Art*, A. W. Mellon Lectures in the Fine Arts, Bollingen Series 35 (Princeton, NJ: Princeton University Press, 1975).

[63]Charles Taylor, *Sources of the Self: The Making of the Modern Identity* (Cambridge, MA: Harvard University Press, 1989), 456. Christopher Lasch, *The Culture of Narcissism: American Life in an Age of Diminishing Expectations* (New York: W. W. Norton, 1991).

[64]Franz, *In Quest of the Absolute*, 49.

[65]Jack Kerouac, *On the Road* (New York: Viking, 1957).

linked to nation building and international diplomacy—came to form the
basis of a new and radical individual autonomy.

The desire for personal emancipation is a thoroughly American ideal and the
foundation of religious liberty itself. Indeed, the nation was settled by immigrants
seeking release from the authority of the church and the crown. Conservatives
and liberals would be allied in the commitment to the virtue and exercise of
personal freedom. But this shared commitment then leads us to observe that the
postwar conflict surrounding freedom was not about its *possibility* but rather its
essential *nature*, and at this point a great divide opens.

For artists at least, this new, radical freedom was bent on dismantling tra-
dition in at least three forms.[66] First, it rejected conventional creeds, confes-
sions and polity—any tangible connection of art to traditional Christian doc-
trine and practice. Second, it abandoned academic art—classical ideals such
as proportion, symmetry, harmony and beauty derived primarily from the
study of the human figure. Third, artists paired their new aesthetic freedom
with moral license, throwing off any constraint—be it from the church or
within the academy or the larger culture—that might abate pleasure. In effect,
Rothko, Pollock and others had embraced the Nietzschean project "to replace
Christian morality with a secular ideology revolving around philosophy,
music, and art."[67]

But in vanquishing tradition, dispatching legitimate authority and re-
moving personal boundaries, communal norms essential to daily life would
also be swept away. In the aftermath of modernism's heyday, America's
Christian manners and mores would be forever altered as the nation uncriti-
cally embraced what Christopher Lasch termed "the culture of narcissism."[68]

Meanwhile, artists and other cultural elites imagined that all "born-again,"

---

[66]"Ultimately, however, tradition will be vindicated for us, for each of us as an individual and for us
as communities, by how it manages to accord with our own deepest intuitions and highest aspira-
tions. . . . Those intuitions and aspirations tell us that there must be a way of holding together what
the vicissitudes of our experience have driven apart—our realism about a fallen world and our
hope for what the world may still become, our private integrity and our public duty, our hunger
for community and our yearning for personal fulfillment, what Pascal called 'the grandeur and the
misery' of our common humanity." Jaroslav Pelikan, *The Vindication of Tradition* (New Haven, CT:
Yale University Press, 1984), 60.

[67]De Botton, *Religion for Atheists*, 283.

[68]Christopher Lasch, *The Culture of Narcissism: American Life in an Age of Diminishing Expectations*
(New York: W. W. Norton, 1991).

"Bible-believing" Christians belonged to the fundamentalist tribe.[69] For these elites, Christian fundamentalism could be understood only as the antithesis to artistic freedom. In response, conservative Protestants seldom advanced an equally robust biblical understanding of freedom. They understood freedom first and foremost as liberation from sin and the subsequent physical and spiritual death that sin proffered. It was freedom from the tyranny of evil and freedom to be ones who bear the image of God. In fact, this kind of teaching was present even in the most conservative settings, but it was often eclipsed or negated by legalism. More generous, though sometimes controversial, meditations on the meaning of grace would come later.[70]

Patterns of advance and retreat are native to all cultural change. Although the New York School functioned as a loose affiliation, and its members—such as Gertrude Stein's Parisian Salon (c. 1905–), the Bloomsbury Group (c. 1905–1932) in Britain, the German Bauhaus (1919–1933) and Black Mountain College (1933–1956) in North Carolina—were modest in number, its measure of cultural influence outpaced the wildest imaginings of its founders.[71] It was humble yet visionary beginnings such as these, alongside others in Chicago and on the West Coast, that spawned a vibrant network of art schools and departments, galleries and museums. From the 1960s onward the modernist aesthetic gradually secured its place as the core curriculum of nearly every secular art department in America and, for that matter, most church-related colleges and universities.[72] At its zenith modernism impacted every corner of the art world, even the more traditional academies that railed against it. Aided by the powerful engine of commerce, this new aesthetic captured mainstream America and found expression in a raft of cultural goods, including popular music, cinema, design, fashion and architecture.

---

[69]Steven Pressfield, "Resistance and Fundamentalism," in *The War of Art* (New York: Grand Central, 2002), 33-37.

[70]E.g., Philip Yancey, *What's So Amazing About Grace?* (Grand Rapids: Zondervan, 1997), and Rob Bell's controversial *Love Wins: A Book About Heaven, Hell, and the Fate of Every Person Who Ever Lived* (New York: HarperOne, 2011).

[71]Janet Bishop, Cécile Debray and Rebecca Rabinow, eds., *The Steins Collect: Matisse, Picasso, and the Parisian Avant-Garde* (San Francisco: San Francisco Museum of Modern Art; New Haven, CT: Yale University Press, 2011); Nicholas Fox Weber, *The Bauhaus Group: Six Masters of Modernism* (New York: Knopf, 2009); Helen Molesworth, *Leap Before You Look: Black Mountain College 1933-1957* (Boston: Institute of Contemporary Art; New Haven, CT: Yale University Press, 2015).

[72]See Howard Singerman, *Art Subjects: Making Artists in the American University* (Berkeley: University of California Press, 1999).

But modernism would pay a steep price for its success. As historian Stuart D. Hobbs observes, by the end of the century postwar intellectuals actually rejected bohemianism: the "cultural outsiders became insiders."[73] In the closing decades of the twentieth century, it seemed that Rothko's, Warhol's and Pollock's bold acts—their canvasses—would surface most often as mere illustrations ornamenting the covers of psychology and philosophy textbooks. Leeched of its vitality, the "shock of the new" had been domesticated.

Modernism's move inside, its general acceptance in American life and culture, hardly signaled an end to avant-garde thought and practice. To the contrary, the radical freedoms gained early in the postwar period would be repositioned in the 1980s to express postmodern acts of aesthetic, social and political transgression.[74] And it was from this point forward that any popular or critical resistance to this advance would be branded "intolerant."

---

This introductory chapter has attempted to cover considerable ground. To set the table for the chapters to follow, a fitting summary might be this: if, during the postwar years, modernists struggled to make sense of the artist's role with respect to tradition, the elusive quest for meaning and the necessary freedoms to pursue both, evangelicals found their focus in defending biblical truth, upholding personal piety and advancing the gospel.

Sadly, while many of us have gained a clearer picture of art and faith in American life and culture in the latter half of the twentieth century, this does not diminish the profound sense of alienation that was experienced by a modest cadre of Christians in the visual arts during those decades. In their day, they faced a pair of sad alternatives: either privatizing their religious identity in the art world or producing sentimentalized art for the church. In other words, assuming a dual identity was the only way that these artists could secure a foothold in both communities. It is, quite simply, the kind of dilemma that marginalized people face. Here the words

---

[73]Stuart D. Hobbs, *The End of the American Avant Garde* (New York: New York University Press, 1997), 16.

[74]In its most extreme iteration, "transgression" became code for queer politics; see Brian Wallis, Marianne Weems and Philip Yenawine, eds., *Art Matters: How the Culture Wars Changed America* (New York: New York University Press, 1999), and Anthony Julius, *Transgressions: The Offences of Art* (Chicago: University of Chicago Press, 2002).

of sociologist W. E. B. Du Bois (1868–1963), the first African American to earn a PhD from Harvard University, are most fitting: "It is a peculiar sensation, this *double-consciousness*, this sense of always looking at one's self through the eyes of others, measuring one's soul by the tape of a world that looks on in amused contempt and pity."[75] To be both a practicing Christian and a practicing artist seemed not to be a legitimate option.

Having reached the end of this chapter, one could easily imagine that the movements we have examined were self-contained, monolithic subcultures fundamentally opposed to each other. To many political pundits and social observers, this apparent conflict between the art world and the church was a kind of perfect storm. Indeed, those hoping for this to be true will find no shortage of anecdotal evidence. But apart from rabid and polarizing media attention, it was less *hostility* and more *ambivalence* that characterized the relationship. That is, during America's postwar period, artists and evangelicals behaved less like contestants slugging it out in the ring and more like ships passing in the night.

---

[75]W. E. B Du Bois, "The Souls of Black Folk," in *W. E. B. Du Bois: Writings*, ed. Nathan Huggins, Library of America (New York: Viking, 1986), 364 (italics mine).

# The Body They May Kill

*The body is the emblem of our common humanity.*

ARTHUR C. DANTO, *THE BODY/BODY PROBLEM*

*'Twas much that man was made like God long before;*
*But that God should be made like man, much more.*

JOHN DONNE, *DIVINE MEDITATIONS*

*The human body was made to be the vehicle of human personality ruling*
*the earth for God and through his power. Withdrawn from that function*
*by the loss of its connection with God, the body is caught in the inevitable*
*state of corruption in which we find it now.*

DALLAS WILLARD, *THE SPIRIT OF THE DISCIPLINES*

In his 1972 novel *My Name Is Asher Lev*, Chaim Potok introduces readers to a simmering conflict that is soon to boil over between a prodigy named Asher and his pious Jewish parents and their Hasidic community. While Asher's parents, especially his mother, possess deep affection for him, Potok's readers quickly learn that the boy's aesthetic vision does not comport with his family's traditional values. As Asher's passion for art rises, so also does his alienation from those whom he loves, and in due course his body and spirit are marked by anxious struggle.

Midway through the novel, the young painter meets Jacob Kahn—a seasoned artist and a secular Jew—who introduces sheltered Asher to the

Museum of Modern Art, the nude and even Christian iconography. As Kahn begins to mentor Asher, he urges him to draw directly from the model:

> The human body is a glory of structure and form. When an artist draws or paints or sculpts it, he is a battleground between intelligence and emotion, between his rational side and his sensual side. You do understand that. Yes. I see you do. The manner in which certain artists have resolved that battle has created some of the greatest masterpieces of art. You must learn to understand the battle.[1]

Asher embraces Kahn's challenge, understanding that this decision to paint the nude and, eventually, the body of Christ will fully and finally estrange him from his Orthodox community. Nearly released from the burden of his conservative upbringing and with the prospect of an artist's life before him, Asher is confronted by his father, who makes one final plea: "Do not forget your people, Asher. That is all I ask of you, that is all that is left for me to ask you."[2]

In the third section of Potok's novel, Asher travels to Florence, where he, like many before him, is deeply moved by Michelangelo's towering *David* and the sculptor's more tender *Pietà*. Asher's encounter with these marble carvings stimulates a new body of work, including two large paintings that his dealer, Anna Schaeffer, titles *Brooklyn Crucifix I* and *Brooklyn Crucifix II*. Schaeffer proceeds to exhibit Asher's new work in her New York gallery, and reviews of the same are published in the *New York Times*, *Time* and *Newsweek*. To the horror of his now-estranged community, this critical attention includes photographs not only of the paintings but also of Asher and his parents. The family's unsolicited association with Asher's Christian imagery, now on public view in the secular art world, is seemingly an unforgivable offense.

The final episode in Potok's novel features yet another conversation, this time between Asher and a distraught rabbi who has failed to persuade the artist to attend a yeshiva in Paris. The teacher laments, "You have crossed a boundary. I cannot help you. You are alone now, I give you my blessings."[3] The artist's decision to paint and draw the nude is especially problematic. In the end, Asher's religious community—once a source of spiritual succor, an island of certainty in an uncertain world—is neither able nor willing to nurture his creative vision.

---

[1]Chaim Potok, *My Name Is Asher Lev* (New York: Knopf, 1972), 229.
[2]Ibid., 234.
[3]Ibid., 367.

In reading the novel, many artists hailing from evangelical and fundamentalist Christian communities find that Potok's coming-of-age account dramatically parallels their own. Like Asher, their pursuit of the visual arts has required them to reassess familial and ecclesial obligations, the attendant costs and benefits of entering the secular art world, and the relative merits of painting and drawing the nude. Most Christian students drawn to the arts either have or will sort through these challenges in a college or university art department.

It is not uncommon for faculty, administrators and trustees at church-related colleges and universities to engage in long and vexing debates over the prospect of students drawing unclothed models in the schools' art studios and the exhibition of the same in their galleries. For art faculty on these campuses, the failure to provide a meaningful figure study program is thought to be substandard. Meanwhile, efforts to offer these courses invariably summon powerful and competing concerns, not least the fiduciary interests of the institution's board of directors, the piety of its undergraduates and the secular training of the school's art department faculty. If these parties manage to find common ground, it is usually the fruit of considerable compromise. But when agreement cannot be reached, this unsettled business often stirs up ongoing discord between faculty and administrators, which in turn negatively affects art department instruction and morale.

The battle at church-related institutions surrounding the human body and its representation is just one telling of a larger story. Many Christian undergraduates also pursue fine-art programs at secular schools or academies where degree plans routinely require at least one course in drawing or painting the nude. I suspect that many, in the face of the challenge of this standard obligation, have or will have an experience similar to mine.

On entering my first figure-drawing session, the sexual undertone and related vulnerability of our disrobed model was undeniable, and my awareness of this lingered throughout the semester. But it quickly became apparent that the actual practice of drawing the nude figure bore no tangible relationship to the tawdry world of pornography or, for that matter, the salacious sex scenes offered up in contemporary cinema. Moving beyond my initial apprehension, it took no more than one or two class sessions to recognize the greater challenge of this discipline: just as our model struggled through stiffness and discomfort to maintain the pose assigned to him, I too, perched at one of the drawing boards circled

about the room, would need to face the steep demand of these ninety-minute sessions. In fact, rendering the human form requires exceptional hand-to-eye coordination and careful attention to the nuances of the male and female form, differences most novices fail to perceive. If I hoped to realize any success, it would require all that my mind and hand could summon.

As the months passed, a further realization settled in: having submitted myself to the rigors of drawing the nude, I was apprenticing myself to an enduring classical tradition. Like the bodies of the student artists, the bodies of our male and female models bore fingers and forearms, abdomens and breasts, calves, ankles and buttocks. To study the live model is to observe her or his body as she or he breathes in and then out, to notice the pattern of light as it casts shadow shapes across her or his form. In fact, we had been granted permission to study an embodied spirit, the beauty and the poetry of the human form coupled with its unwanted blemishes, awkwardness and even pain. In other words, during my undergraduate studies any awkward feelings I may have had about the discipline of figure drawing gave me only slight pause when compared to the demands of the task itself.

What I found more troubling was the obligation that I sensed to persuade the Christian community that my classroom obligation to draw the nude was not a wholesale capitulation to worldliness. But my apologetic, slim and unpersuasive as it was, fell mostly on deaf ears, even to some in the campus fellowship to which I belonged.

Having recounted Asher Lev's decision to pursue his artistic vision and my first experience drawing the figure, I should mention one concern before pressing on to the larger topic at hand. From time to time students, usually from more conservative religious backgrounds, feel compelled by conscience or conviction to ask their art department (whether at a secular institution or a church-related school) to waive its figure drawing requirement. In an age of rampant sexual abuse and exploitation, it seems prudent to agree that drawing, painting or sculpting the nude might pose, for some, a moral, psychological or spiritual dilemma. Since it is impossible to know the inner workings of another person's mind or heart, I believe that any student who requests an exemption should be excused from the rigors of this discipline and without stigma or retribution. At the same time, just as the study of anatomy and physiology in a nursing or premed program is a standard requirement, it is my

conviction that every art major should be expected to successfully complete
at least one or more courses in drawing or painting the figure.

Depicting the body, with its much-vaunted significance in the visual arts
and the controversy that accompanies it, is the central concern of this chapter.
For many Christians the study of the nude human form represents highly con-
tested territory, and the reason for this seems straightforward: in American
life and culture the presence of an unclothed male or female body is freighted
with sexual baggage. For many Christians this matter is further complicated
by the tendency of so many to adopt a gnostic spirituality wherein Christian
life, in its most elevated state, is not only thought to be unhinged from material
reality, but goes further to deny the reality of embodiment. Since the purpose
of this book is to make some sense of the relationship—or lack thereof—be-
tween the evangelical church and the art world during America's postwar
period, it is crucial to sort out the nature and meaning of our physical bodies
with respect to the visual arts and Christian discipleship.

## IDEAL FORM

From culture to culture and epoch to epoch, the manner in which the clothed
and unclothed body has been treated in the visual arts varies dramatically. In
most Western countries, it is the classical Greek tradition and its powerful
reappearance during the Italian Renaissance that forms the basis of modern
and contemporary understanding of the body. In the opening pages of *The
Nude: A Study in Ideal Form*, Sir Kenneth Clark delineates the difference be-
tween *nudity* and *nakedness*:

> To be naked is to be deprived of our clothes, and the word implies some of the
> embarrassment most of us feel in that condition. The word "nude," on the other
> hand, carries, in educated usage, no uncomfortable overtone. The vague image
> it projects into the mind is not of a huddled and defenseless body, but of a bal-
> anced, prosperous and confident body; the body re-formed.[4]

Clark goes on to explain that the depiction of the nude in Western art orig-
inated in ancient Greece (c. 500 BC), where the beauty of the perfected body
was celebrated. In the Greco-Roman world, the body in its ideal form was
often expressed in mathematical formulae, and the resulting ratios became the

---

[4]Kenneth Clark, *The Nude: A Study in Ideal Form* (New York: MJF Books, 1956), 3.

basis for everything from the design of columns, doorways and temples to a means to comprehend the divine.[5] "The Greeks perfected the nude in order that man might feel like a god, and in a sense this is still its function, for although we no longer suppose that God is like a beautiful man, we still feel close to divinity in those flashes of self-identification when, through our own bodies, we seem to be aware of a universal order."[6] Indeed, the actual measure of the human body is our basis for determining the intimacy that we sense while seated in a neighborhood café or, conversely, the monumentality that overcomes us in the grand space of a Gothic cathedral. Our corporeal being locates and then grounds us in space and time, and apart from this we would truly be lost in the cosmos.[7]

In the early church, representations of the body, especially images of gods and goddesses, were associated with pagan practices. In the centuries that followed, similar depictions of the Christian Godhead were created to cultivate profound theological and spiritual truths.[8] But at the zenith of medieval asceticism, realistic

[5]The only surviving text from this period that articulates the relationship between ideal human beauty and architecture is Vitruvius's *Ten Books on Architecture*, ed. Ingrid D. Rowland, with commentary and illustrations by Thomas Noble Howe (Cambridge: Cambridge University Press, 1999). See also Philippe Comar, *Images of the Body*, trans. Dorie B. Baker and David J. Baker (New York: Abrams, 1999), 21.

[6]To the extent that modern men and women seek to perfect their bodies, they may be revisiting the ancient idea that it is possible to become the very measure of all things. See Clark, *The Nude*, 370.

[7]It is crucial to note that Clark's categories have met substantial resistance. For instance, John Berger asks, "What does a nude signify?" To which he responds, "It is not sufficient to answer these questions merely in terms of the art-form, for it is quite clear that the nude relates to lived sexuality. To be naked is to be oneself. To be nude is to be seen naked by others and not recognized for oneself. A naked body has to be seen as an object in order to become a nude." Berger goes on to develop the social and political meaning of the nude, especially as it pertains to gender. John Berger, *Ways of Seeing* (London: Penguin, 1972), 53-54.

Margaret R. Miles makes the related observation that "in Clark's distinction between 'nakedness' and 'nudity' the nude body is a representation of a naked body from which subjectivity, along with moles and lumps, has been elided. At the same moment when the naked body was 're-formed' to render it pleasingly balanced and proportioned without blemishes, it lost its ability to express the personal character of the person whose body it is. 'The transition from naked to nude,' Annette Kuhn has written, 'is also the transformation of woman into object.' In Clark's description, the naked body becomes 'a nude' by having its feeling ('embarrassment') removed along with the visible symbols of its individuality and personality ('wrinkles, pouches and other small imperfections'). The nude achieves universality at the expense of particularity." Margaret R. Miles, *Carnal Knowing: Female Nakedness and Religious Meaning in the Christian West* (Boston: Beacon, 1989), 14.

[8]"In the collective memory of early Christianity, representations of the body must have retained idolatrous connotations, not least because many had died for their faith when they refused to sacrifice before statues of the ancient gods or of the deified emperor." Timothy Verdon, "The Body Sacred: The Representation of Man in Christian Art," in *Images of the Body: Sacred, Personal and Public* (Presentations from the CIVA Conference, 2003), 10.

renderings of the nude faded almost entirely from view. And it was generally the case that steady Christianization of the West signaled the decline of the figurative tradition. However, a notable exception to this pattern emerged. As art historian Timothy Verdon points out, "It was in Italy and by the end of the twelfth and the middle of the thirteenth centuries, that a dramatic and—for the West—decisive process of change began. Art rediscovered the body in fully religious terms, as a privileged vehicle of spiritual experience, the *locus* of a uniquely Christian sanctity."[9] For two centuries or more, the Italian Renaissance stimulated an unprecedented revival of the nude, and to that end the church and the art world found common cause. Marsilio Ficino, a leading humanist in fifteenth-century Florence, "taught that the human figure occupied a central position between heaven and earth. By turning toward earthly love, one could descend to the lower state, or by turning in love toward God, one could ascend to his likeness. The body, therefore, was central—it could lead one toward or away from God."[10] Stimulated by the resurgence of Greek thought and the flourishing of humanist studies, the nudes rendered during the Italian Renaissance reached unprecedented levels of verisimilitude at the hand of celebrated artists such as Michelangelo, da Vinci, Bellini, Botticelli and Caravaggio. Suffice it to say, in fourteenth- and fifteenth-century Italy, the classical ideal of humanity as a demigod regained its public standing.

In due course, papal policies grew more austere, and eventually new commissions featuring nude figures or pagan themes, as well as the installation of these works in religious spaces, were forbidden.[11] But as church interest in this endeavor grew tepid and cautious, in the art world the function and meaning of the unclothed human form continued to be a central concern. Consequently, in survey classes devoted to Western art, students are likely to encounter everything from Leonardo da Vinci's *Vitruvian Man* (c. 1487) (fig. 2.1)—wherein an idealized male form is placed within the pure geometry of a circle and a square—to the mythology of Sandro Botticelli's *Birth of Venus* (c. 1484), and from the politics of Ferdinand Victor Eugène Delacroix's *Liberty Leading the People* (1831) to the impudence of Francisco Goya's *Naked Maja* (1797–1800).

---

[9]Ibid., 12.

[10]William A. Dyrness, *Visual Faith: Art, Theology, and Worship in Dialogue* (Grand Rapids: Baker Academic, 2001), 49. Clark notes that "in mid-century, Cosimo de Medici invited Marsilio Ficino to found an academy in Florence that would make the city into a new Athens." Clark, *The Nude*, 352.

[11]Paul Johnson, *The Renaissance: A Short History* (New York: Modern Library, 2000), 185-86.

A mindful consideration of the figurative tradition reveals something further: study of the nude was hardly limited to the narrower interests of aesthetics and religion. For many centuries this discipline was allied with science so that the line separating the *forensic* from the *aesthetic* or the clinical from the visual was hardly visible. Artists were often among the first to examine human musculature and skeletal systems, internal organs, the development of the fetus in the womb and so on. Consider, for instance, da Vinci's nu-

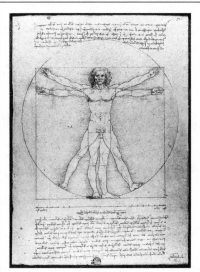

**2.1.** Leonardo da Vinci, *Vitruvian Man*, c. 1490

merous anatomical studies and paintings by Rembrandt such as *The Anatomy Lesson of Doctor Nicolaes Tulp* (1632) and *The Anatomy Lesson of Doctor Joan Deyman* (1658). In the twentieth century, Thomas Eakins (1844–1916) continued this practice in works like *The Gross Clinic* (1875) and *The Agnew Clinic* (1889).[12]

In fact, the Western figurative tradition is neither staid nor secure, and the record of its mercurial rising and falling is well documented. Since the account of artists who painted and sculpted the figure from the mid-nineteenth century onward is decidedly nonlinear, to locate the significance of the human figure squarely within the postwar period, it will be useful to examine five thematic arenas of concern: the radical reappraisal of social and sexual manners, the angst of existential being in the modern world, a critique of popular consumer culture, the politics of difference and, finally, the brokenness of the modern body.

## MODERNISM'S BODY

Much of Kiki Smith's (b. 1954) artistic output has been given to depict bodily forms, especially their transient beauty and provisional nature.[13] In this regard,

---

[12]See Yale professor of surgery and medical historian Sherman B. Nuland, "The Anatomy: Matters of the Heart and Other Matters," in *Leonardo da Vinci* (New York: Penguin, 2000), 141-66.

[13]Siri Engberg, Linda Nochlin and Marina Warner, *Kiki Smith: A Gathering, 1980–2005* (Minneapolis: Walker Art Museum, 2005), and Michael Kimmelman, "The Intuitionist," *New York Times Magazine*, November 5, 2006, 40-45.

her mid-career sculpture *Untitled* (1987–1990) is particularly arresting (fig. 2.2). The work consists of a dozen silvered water jars, measuring twenty and a

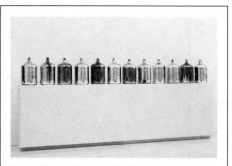

**2.2.** Kiki Smith, *Untitled: Silvered glass water bottles*, 1987–1990

half inches high and aligned single file on a waist-high white base. Etched into the glass of each of the twelve containers is the name of a bodily fluid that is presumably contained within, and the names appear as follows: diarrhea, blood, semen, vomit, tears, pus, urine, saliva, sweat, mucus, milk and oil. Not unlike some medieval scientific endeavor, Smith's work reduces the body to its constituent fluids. Her seemingly clinical treatment of these extractions and distillations reminds those who view the work that the human body is a vessel, the container of one's being. On one hand, Smith has tidied up the gross mess of our embodiment, and her alignment of silvered jars and their etched labels brandishes a kind of modernist elegance. On the other, her mere listing of these twelve bodily fluids elicits from most a visceral reaction of disgust or repulsion. However one understands the meaning of Smith's provocative work, it exists in a universe far removed from a workshop in ancient Greece where, say, a gifted stone carver must labor for many months to render an ideally proportioned Venus. Nonetheless, for both Smith and the unnamed Greek

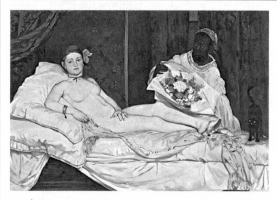

**2.3.** Édouard Manet, *Olympia*, 1863

artisan, the body remains a worthy subject, not least because the being of every man, woman and child abides in a body. Aesthetically speaking, it might

be reasoned that Smith's lineup of silvered jars is the logical outcome of a century or more of the figurative tradition preceding it.

In his book *The Painting of Modern Life*, art historian T. J. Clark proposes that the first truly modern nude was Édouard Manet's (1832–1883) *Olympia* (1863) (fig. 2.3), a painting often compared to Titian's *Venus of Urbino* (1538).[14] *Olympia* was exhibited in 1856 in the Paris Salon, where it hung beneath another of Manet's paintings, *Jesus Mocked by the Soldiers* (1865) (fig. 2.4). While both works explore the stigmatized social standing of their subjects, Manet was painting in a secular city and for a secular age. Therefore, it was *Olympia* that incited popular derision and critical contempt and not *Jesus Mocked by Soldiers*.

The widespread and negative reaction to *Olympia* was decidedly not to the model's nudity, since paintings and sculptures of the nude female figure were commonplace in nineteenth-century Paris. Rather, it was Manet's bold juxtaposition of Olympia's likely occupation as a courtesan and her corresponding "uncleanness" over against the symbols of affluence and sensuality that adorned her— pearl earrings and bracelet, a black ribbon about her neck, an orchid in her hair and the oriental shawl beneath—that fomented the

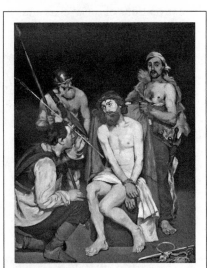

**2.4.** Édouard Manet, *Jesus Mocked by the Soldiers*, 1865

outrage. In a forthright manner, Manet's work showcased the realities of prostitution in Paris and the interchange of class, money and sex that sustained it. Moreover, Manet had not only painted a prostitute; he had depicted a woman who brazenly refused the gaze of those (male clients) who would possess her. "Manet's [model] is bold and looks directly, almost confrontationally, at the viewer. Thus looking out at those who are looking at her, she defies the age-old objectification of undressed women. And with her candid unidealized

---

[14]T. J. Clark, *The Painting of Modern Life: Paris in the Art of Manet and His Followers* (Princeton, NJ: Princeton University Press, 1984).

appearance, she is a frankly 'naked' woman defying a tradition of prettified academic 'nudes.'"[15]

To be sure, Manet's depiction of Olympia's defiant sexual persona is unhinged or liberated from the constraints of older Victorian and puritanical manners. But more than this, Manet alerts his viewers to the ambiguous social standing of the courtesan. Meanwhile, the black woman, who presumably bears flowers from the courtesan's client and whose figure occupies a place of importance in the visual structure of the painting, introduces race to the discourse. Manet's pictorial strategy confirms that whether clothed or unclothed, bodies situated within the picture plane can be used to question the conventions of social class and challenge prevailing sexual mores.

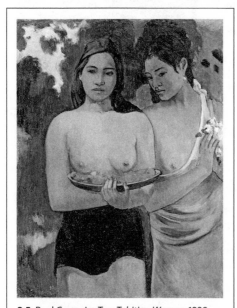

**2.5.** Paul Gauguin, *Two Tahitian Women*, 1899

Like Manet, Gustave Klimt (1862–1918) also embraced avant-garde sensibilities and endured hostile reviews from more traditional critics in late nineteenth-century Vienna. But if Manet had managed to explore the social meaning of his courtesan's world, Klimt was simply enamored of the erotic allure and mystery of the women that he painted. Meanwhile, both Manet and Klimt would have known of Paul Gauguin (1848–1903) and his sojourn to Tahiti, where, having abandoned his wife, children and friends, he would spend the final thirteen years of his life. During his stay in Tahiti, the artist frequently painted the female nude, and his work continued to explore quasi-Christian themes (see fig. 2.5). Gauguin was on a quest to find paradise, an Eden apart from the business and infighting of the art world. But, in the end, this effort left him disconsolate.

---

[15]Nancy Frazier, *The Penguin Concise Dictionary of Art History* (New York: Penguin, 2000), 416.

As demonstrated by their depictions of the female nude, artists such as Manet, Klimt and Gauguin were relocating the central interest of painting away from the verisimilitude and idealism that had guided it for nearly five centuries.[16] If the study of the figure once found its primary focus in recounting the stories of nobles, courtiers, prostitutes, revolutionaries, peasants and deities, then from the mid-nineteenth century onward, new social, political and existential understandings of the human form were being cultivated. From this point forward, a common feature of the modern era would be the transformation of what had formerly been *private manners* to *public spectacle*. Critically and aesthetically, these kinds of paintings—which relied on a high degree of realistic rendering—anticipated a time when verisimilitude would yield to more plastic, abstract concerns. In 1960, ninety-seven years after Manet had completed *Olympia*, critic Clement Greenberg anointed *Olympia* the first truly modernist work and celebrated the "flatness" of its paint.[17]

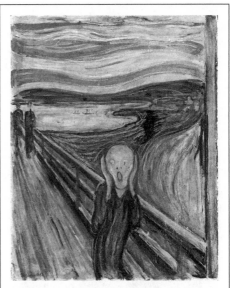

**2.6.** Edvard Munch, *The Scream*, 1893

If the coming secular age and its promise of personal and social emancipation seemed intoxicating, this optimism was offset by the horrors of modernity. Like some bewildering Pandora's box, modern life ushered in the regimens of widespread industrialization, political repression and injustice, the surveillance and brutality of new totalitarian regimes, and, eventually, the unfulfilled promise of consumer capitalism. Despite the seemingly miraculous advances of science and the ever-expanding frontiers of human freedom, the demise of

---

[16]In this regard the photography of Eadweard James Muybridge (1830–1904) was transformative. Muybridge had devised a means via time-lapse photography to record the movement of human and animal figures. Beyond this, the photographer's ability to "capture" likeness would demystify the painter's skill at rendering likeness.

[17]Ian Chilvers, *A Dictionary of Twentieth-Century Art* (Oxford: Oxford University Press, 1999), 403.

one's body could not be reversed; death could not be circumvented. It was this modern milieu that sponsored Edvard Munch's terror-filled painting *The Scream* (1893) (fig. 2.6), and it was in this same period that Vincent van Gogh produced his garish yet stunning self-portraits. In 1953, sixty years after Munch had painted *The Scream*, Irish artist Francis Bacon exhibited his *Screaming Pope*, a work based substantially on the *Portrait of Pope Innocent X* painted by Spanish artist Diego Velázquez in 1650. Modern artists could not abate the terror of the modern world, and for painters like Bacon the institutional church was complicit in this.

Meanwhile, in the twentieth century the cubism of Picasso's *Les Demoiselles d'Avignon* (1907), the deconstruction of Marcel Duchamp's *Nude Descending a Staircase (No. 2)* (1912) (fig. 2.7), the aimless wanderings and alienation of Alberto

**2.7.** Marcel Duchamp, *Nude Descending a Staircase (No. 2)*, 1912

Giacometti's solitary sculpted figures and the abstract expressionist canvases of Willem de Kooning's *Woman* series charted yet another course for the figure. The severe treatment of these figures, again mostly female nudes, challenged the long-standing assumptions of the figurative tradition: it seemed to these artists that the classic beauty of ideal human forms had been exhausted. Present in their work was an existential anxiety that carried forward the philosophical and literary ruminations of European intellectuals such as Albert Camus, Franz Kafka, Friedrich Nietzsche and Jean-Paul Sartre. The violence of two world wars, the dismissal of tradition, the ascent of modern psychology and the death of God placed artists and intellectuals alike on the edge of a philosophical precipice. For them, art making was a means to respond to the yawning abyss that opened before them.

By mid-century and especially on the American scene, art turned to explore the weighty business of being a fully modern, social and secular self. With the advent of photography and at the apex of modernism's aesthetic sway, the realism, verisimilitude and iconography of the past was thought to be horribly out of fashion.[18] High modernism was bent on capturing pure form, form unencumbered by the burden of realism and representation. And so, at least for a season, the relative honor or dishonor of the unclothed body would be regarded as a mostly parochial interest. Nevertheless, the figure would remain a perennially important subject, for, as critic Arthur Danto reminds us, "The body is the emblem of our common humanity."[19] And as the earlier reference to Kiki Smith's silvered jars suggests, this work was often highly provocative, intended to shock the viewer.

## THE SEXED BODY

In 1953 Hugh Hefner founded *Playboy*, the "men's entertainment magazine." Hefner's genius was his ability to exploit and then monetize the precarious tension that exists between nice-girl nudity and its raunchy cousin, pornography. Despised by some and admired by others, Hefner embraced the proposition "sex sells" full on. As early as the 1960s, pop artists such as Mel Ramos (b. 1935) and Tom Wesselmann (b. 1931) played fast and loose with the slippery connection between these kinds of sexually provocative images and their usefulness in gaining market share. Consider the odd dissonance of one Ramos painting, *Hippopotamus* (1967), in which a curvaceous, blonde female nude awkwardly straddles an enormous, fleshy hippopotamus, or Wesselmann's *Great American Nude* series (c. 1961), where campy erotic caricatures of female nudes are surrounded by generic suburban props such as televisions and other household objects. Was the purpose of these works by Ramos and Wesselmann to expose the superficiality of the pinup mythology or simply to exploit it? The answer to this question remains ambiguous. But viewing these works, now decades later, one may be impressed by the pop movement's ability to mimic and thus critique the emerging social norms of its day.

---

[18]While the curriculum of many contemporary art schools undergirded this conviction, a substantial number of traditional academies did not, and today an increasing number of these academies have redoubled their efforts to recover classical ideas.

[19]Arthur C. Danto, *The Body/Body Problem: Selected Essays* (Berkeley: University of California Press, 2001), 198.

Was it this same disposition that prompted Jeff Koons (b. 1955) to have his studio meticulously craft *Made in Heaven* (1989–1991), a series of paintings and sculptures featuring larger-than-life images of the artist with his (now former) wife, Cicciolina (a well-known Italian porn star), in various stages of sexual intercourse? Did Koons create this body of work to seize an art market opportunity? Did he intend to shock his viewing public? Or was this creative venture simply a record of the artist's narcissism? In the end, the artist would gain considerable critical attention, not least because individual and museum patrons were willing to pay high prices to add a "Koons" to their collection.

My purpose in citing Heffner, Ramos, Wesselmann and Koons is not to celebrate their achievements but instead to point out that beneath the gloss of consumer images and the cultural sophistication of contemporary art, the sinister undertow of sexual exploitation is an ever-present reality. Regrettably, the very freedom that secures space for an artist to produce and exhibit serious work without fear of censure also creates space for a multibillion-dollar porn industry where, under the imprimatur of artistic expression, nearly every instance of critical, cultural and moral resistance is silenced. Once limited to adult movie selections on hotel televisions and the printed page of newsstand tabloids, the ubiquity of internet porn is now considered normative, a cultural given.

The central theme of pornography is male domination over women, other men and even children. As such, it perverts the goodness of human sexuality; worse still, it perpetuates unspeakable evil, enabling as it does the *few* to amass extraordinary fortunes by materially exploiting the addictions of the *many*. The dignity of these victims is of no concern to those who profit from them, nor is the degradation of the bodies involved. Ironically and tragically, since neither intimacy nor beauty is here present, sex itself is demeaned. Pornography's objectification of men, women and children and its chronic sadness are so repugnant that more liberal-minded artists and aesthetes should join with conservatives to condemn it. In the presence of this powerful economic engine—its unequaled capacity to generate and then monetize desire—an undergraduate studying the figure or an artist painting or sculpting a nude in her studio hardly bears mention.

Near the conclusion of Kenneth Clark's discussion of the nude (cited earlier in this chapter), he compares the work of Henri Matisse to that of Pablo Picasso and then offers this cautionary note: "To scrutinize a naked girl as if she were a loaf of bread or a piece of rustic pottery is surely to exclude one of

the human emotions of which a work of art is composed; and, as a matter of history, the Victorian moralists who alleged that painting the nude usually ended in fornication were not far from the mark. In some ways nature can always triumph over art."[20] Like their Victorian forebears, most moral conservatives and, not inconsequently, feminists consider the inevitability of Clark's scenario repugnant. If moral conservatives remain troubled by the provocative and unending connection between nudity and sexual immorality, feminists rightly protest the objectification of women and their bodies.

In the postwar period, the pursuit of physical beauty could be unrelenting. Reasonable concern for hygiene, fitness and attractiveness often gave way to irrational longings for perfection and, ultimately, immortality. Together, fashion and consumer culture generated ideal images of the male and female beauty managed by the whim and wishes of the market. Countless weight-loss regimens, how-to sex manuals, fitness programs and anti-aging remedies confirmed an American fixation with the body that was tantamount to worship. And this desire for bodily perfection was met by an industry of extreme remedies (surgical, cosmetic, pharmacological and prosthetic) that promised to perfect male and female bodies. With these came a corresponding rise in personal pathologies (eating disorders, drug abuse, self-mutilation and even suicide).[21] In the end, the desperate quest for perfection was shaped less by received classical categories of the sort examined earlier in this chapter and more by the demand of fashion. Beneath what could appear to be virtuous pursuits, darker social, sexual, political and economic functions prevailed. What emerged was a highly conflicted understanding of the self with particular regard to the limits and hazards of embodiment, wherein the fact of mortality was both embraced and denied. When bodily perfection cannot be realized, narcissism devolves to tragic forms of self-loathing. Hence the pathos and irony of the bumper sticker that reads "Start a revolution . . . stop hating your body."[22]

---

[20]Clark, *The Nude*, 366.

[21]According to some estimates, beauty is a "$160 billion-a-year global industry, encompassing make-up, skin and hair care, fragrances, cosmetic surgery, health clubs and diet pills. Americans spend more each year on beauty than they do on education. Such spending is not mere vanity. Being pretty—or just not ugly—confers enormous genetic and social advantages. Attractive people (both men and women) are judged to be more intelligent and better in bed; they earn more, and they are more likely to marry." "The Beauty Business: Pots of Promise," *Economist*, May 24, 2003, 69.

[22]The changing norms regarding ideal body types and customs of dress and undress belong to the extensive history of manners and social customs. See Stuart Ewen, *All Consuming Images: The Politics of Style in Consumer Culture* (New York: Basic Books, 1988).

While the physical beauty of a man or a woman is surely fleeting and the standards used to establish this are superficial at best, popular conceptions of physical beauty remain linked to sexual identity and performance. The history of sexual desire and the corresponding mores and manners assigned to rein it in are vast. In this regard the sexual revolution of the 1960s radically reset the table. Long-standing conventional commitments such as fidelity and fecundity gave way to the promise of heightened and spontaneous erotic sexual encounters to be enjoyed by new emancipated selves.[23] A host of emerging realities including free love, feminism and the pill would challenge and, for many, overturn traditional conceptions of marriage. Accompanying the rise of sexual options and preferences was an alarming increase in sexually transmitted disease, interpersonal alienation, sex trafficking and personal brokenness. As general prewar cultural agreements about the meaning of marriage and family dissolved, the decades of lawmaking that followed would secure a new paradigm. The youth culture longed for personal and expressive freedom, and within a decade or so sexual performance and experience would be severed from marital virtues of fidelity and commitment.

Both aesthetics and art making figured importantly in this conversation. As modernism's formal and formalist regard for the body passed from fashion,

**2.8.** Barbara Kruger, *Untitled (Your Body Is a Battleground)*, 1989

new debates regarding the body's social and political meaning came to occupy the stage. As Barbara Kruger's photomontage *Untitled (Your Body Is a Battleground)* (1989) confirms, by the end of the twentieth century the body itself had become a site of struggle (fig. 2.8). Did legislative, judicial and ecclesial leaders hold the right to determine the meaning of one's ethnicity or the morality of one's

---

[23]In modern thought it was the psychoanalytical work of Sigmund Freud that examined the complex linkage between sexual longing and one's being or identity and, importantly, laid the foundation for this revolution.

sexual practice or identity? As if to challenge all conventional thoughts on this matter, in the 1980s and 1990s numerous artists produced work that featured sexually explicit content: the performances of Karen Finley (b. 1956) and the homoerotic photographs of Robert Mapplethorpe (1946–1989) come easily to mind. The purpose of these works varied, of course, from wry aesthetic commentary and social protest to the bizarre sexual fixations and fetishes of individual artists. But whatever their purpose, Finley's and Mapplethorpe's works were intended to startle the viewer and, in doing so, to transgress conventional mores and manners with the hope of maximizing personal freedom and moral license.[24]

While works by Krueger, Mapplethorpe and Finley hardly invented the politics of the body, they championed a new ideological framework that came to be known as critical theory. The focus of this rising intellectual revolution, which received widespread endorsement from the humanities curricula of America's leading universities, was ethnic and gender politics. The support that critical theory gained from innumerable artists eager to support a cluster of ideologically divisive issues—including women's rights; gay, bisexual, lesbian and transgender preferences; the dignity of the physically impaired; and ethnic diversity—was nothing less than viral.[25] Thus, in the closing decades of the twentieth century a revolution centered on personal rights ensued. From education to commerce and politics to entertainment, no part of the American social or economic fabric was untouched by this agenda.

This review of the figurative tradition in the modern era—its abstraction, exploitation and politicization—points to a complex and summative reality: the brokenness of our corporeal being.[26] If cubism anticipated this, it

---

[24]Lawrence Rinder, *Whitney Biennial 2002: 2002 Biennial Exhibition* (New York: Whitney Museum, 2002).

[25]Judy Chicago and Edward Lucie-Smith, "Body as Battleground," in *Women and Art: Contested Territory* (New York: Watson-Guptill, 1999).

[26]A surprising range of art history and criticism takes up the theme of the body's brokenness. See James Elkin, *Pictures of the Body: Pain and Metamorphosis* (Stanford, CA: Stanford University Press, 1999); Michal Fehrer with Romona Naddaff and Nadia Tazi, eds., *Fragments for a History of the Human Body*, parts 1, 2 and 3 (New York: Zone, 1989); Linda Nochlin, *The Body in Pieces: The Fragment as a Metaphor of Modernity* (New York: Thames & Hudson, 1994); Nigel Spivey, "This Is My Body," in *Enduring Creation: Art, Pain, and Fortitude* (Berkeley: University of California Press, 2001), 100-111; and Alexa Wright, "Partial Bodies: Reestablishing Boundaries, Medical and Virtual," in *Digital Desires: Language, Identity and New Technologies*, ed. Cutting Edge, the Women's Research Group (London: I. B. Tauris, 1999).

is the sculptures of German-born Hans Bellmer (1902–1975) that established the fragmented body as a modern category.[27] Bellmer's odd-looking photographs and sculptural assemblages appear to be fashioned from female limbs, torsos, breasts and buttocks. And while these constructions surely find their origin in the surreal erotic fantasies of the artist, in the end they resurface as a Frankensteinian nightmare.

At the close of the century, art critic Roberta Smith wrote, "These are the days of underwear as outerwear, X-rated fashion photography, devolving standards of modesty and privacy, and relentless image bombardment. These are the days of ubiquitous naked bodies, and sexual references in contemporary art."[28] The sexed body of modernism was in fact a broken body.

## BROKEN BODIES

Unexpectedly, in the 1960s and on the heels of the pop art movement, drawing, painting and sculpting the figure enjoyed a vigorous revival. In the movement known as new figuration, the body was once again a primary subject for painters, photographers and sculptors such as Frank Auerbach, Eric Fischl, Lucian Freud, Robert Graham, David Hockney, Sally Mann, Robert Mapplethorpe, Philip Pearlstein, David Salle and Kiki Smith.[29] Generally speaking, the task of these artists was to document the body in the context of modern life. As painter Lucian Freud (the grandson of Sigmund Freud) explains it, "For me, painting people naked, regardless of whether they are lovers, children, or friends, is never an erotic situation. The sitter and I are involved in making a painting, not love. These are things that people who are not painters fail to understand."[30] Describing Freud's paintings, one writer wondered: "Isn't the potential of paint

---

[27]See Therese Lichtenstein, *Behind Closed Doors: The Art of Hans Bellmer* (Berkeley: University of California Press, 2001), and Sue Taylor, *Hans Bellmer: The Anatomy of Anxiety* (Cambridge, MA: MIT Press, 2000).

[28]Roberta Smith, "Glossy Portrait of the Artist as a Young Woman," *New York Times*, July 5, 2000, B1, B5.

[29]James F. Cooper argues that figurative realism has been alive and well since the 1960s. In support of this he highlights an exhibition hosted at the Pennsylvania Academy of the Fine Arts under the theme "Contemporary Realism Since 1960." Cooper's claim is that modernist critics dismissed the importance of these traditional works, favoring instead the more caricatured paintings of "new realists" such as Philip Pearlstein, Jack Beal, Chuck Close, Larry Rivers and Alex Katz. Cooper, "Realism: The Path to Beauty," *American Arts Quarterly*, Spring 2002, 3-7.

[30]Richardson, "Lucian Freud," 334. See also Martin Gayford, *Man with a Blue Scarf: On Sitting for a Portrait by Lucian Freud* (New York: Thames & Hudson, 2010).

to become flesh and not merely simulate it what all [of his] works celebrate?"[31] Similarly, figurative painter Philip Pearlstein comments, "The act of re-creating the visual experience of the models in front of me is absolutely absorbing, leaving no room for extraneous thoughts, sexual or otherwise."[32]

One realist painter, Melissa Weinman, depicts Christian martyrs in contemporary settings as a means to explore what she terms "unredeemed pain."[33] This idea animates one of her most arresting paintings, *St. Agatha's Grief* (1999), in which two "Agathas" stand back to back in full-length profile. The garment of the figure on the right is bloodied, and her chest is flattened, indicating that her breasts have been severed from her torso. It is a gritty image that invites the viewer to wonder whether Weinman is depicting Christian faithfulness or the ravages of cancer. Likely both. Writes one reviewer: "These icons are just like us; they are us; their blood is wet; their feet hurt; their hearts break. Let your mind reach over time, she seems to goad us, and see them as they were, as they are, not as relics but as human beings suffering the same woes as us."[34]

As noted, the history of the body and its treatment during the modern and postmodern period is neither linear nor tidy. Alongside the new figuration, another submovement known as body art emerged in the 1960s and 1970s.[35] It included everything from self-mutilation to masturbation to sadomasochism. Disturbing, sometimes gruesome, performances by artists such as Marina Abramović (b. 1946), Vito Acconci (b. 1940) and Chris Burden (b. 1946) raised the profile of this enterprise.

For our purposes, at least one of these events warrants further comment. In 1974 Chris Burden completed a performance piece titled *Trans-Fixed*, in which the artist had himself "crucified" atop the hood of a Volkswagen Beetle. With nails piercing each hand, he sought to reenact the central icon of Christendom. Responses to Burden's performance ranged from initial disgust and bewilderment to more considered explorations of the social and theological meaning of his body and, by analogy, the broken human body. It can be argued

---

[31]Richardson, "Lucian Freud," 334.

[32]Michael Kimmelman, *The Accidental Masterpiece: On the Art of Life and Vice Versa* (New York: Penguin, 2006), 171-72.

[33]Melissa Weinman, "Taking Responsibility: Preserving Sacred Space" (*Image* conference, Seattle Pacific University, 2000).

[34]Randall Kenan, "The Weirdness of Modern Faith; or, Quantum Christianity in the Images of Melissa Weinman," *Image* 30 (Spring 2001): 33.

[35]Chilvers, *Dictionary of Twentieth-Century Art*, 80-83.

that Burden's work was not different in substance from Munch's *The Scream* (1893), painted more than eighty years earlier, since both works explored the "angst of being" that had become part and parcel of modern life.

Burden was hardly alone in calling on the central and classic Christian theme of crucifixion to advance his interests. In 1992 Benetton, the Italian fashion house known for its enigmatic and sometimes disturbing print advertisements, published the image of an AIDS patient whose anguished face and onlooking bedside friends bore a striking resemblance to Andrea Mantegna's *The Dead Christ* (c. 1500) (plate 2). In the Benetton ad, AIDS activist David Kirby lies in a hospital bed at death's edge surrounded by his grieving family. In featuring this advertisement, Benetton and its designer Oliviero Toscani *appear* to demonstrate their solidarity with the gay community. Comments Toscani, "I called the picture of David Kirby and his family 'La Pieta' because it is a Pieta which is real." He continues, "The Michelangelo's *Pieta* during the Renaissance might be fake, Jesus Christ may never have existed. But we know this death happened. This is the real thing."[36]

Much in the spirit of the sexual politics and critical theory noted at the close of the previous section, Benetton, with the publication of its AIDS ad, consciously entered what was, even in the 1990s, risky social and political territory. One wonders, had Benetton's marketers appropriated the grim reality of the AIDS pandemic to establish the appearance of being a socially progressive brand and, therefore, to expand its market in the youth culture? Or, conversely, was Benetton responding to the AIDS crisis with genuine humanitarian concern well before it became fashionable to do so? Having launched its marketing strategy in uncharted waters, the questions surrounding Benetton's sincerity remain.[37] However one assesses the situation, in the Benetton advertisement art, life, disease and death embrace uneasily at the forefront of fashion.

---

[36]Duncan Macleod, "Benetton Pieta in AIDS campaign," Inspiration Room, April 7, 2007, http://theinspirationroom.com/daily/2007/benetton-pieta-in-aids-campaign.

[37]These kinds of moves were granted substantial intellectual force by the work of the French philosopher Michel Foucault (1926–1984), a brilliant yet unconventional thinker who examined a number of themes including the nature of political power and repression and the meaning of sexual mores and manners. Sadly, Foucault, a keen champion for the left in its quest for sexual liberation, died of AIDS. For a summary of his aesthetic theory, see Allan Megill, *Prophets of Extremity: Nietzsche, Heidegger, Foucault, Derrida* (Berkeley: University of California Press, 1985), 183-256.

## TENTS AND TEMPLES

Like all saints and sinners, we exist as *carnal* beings—a term derived from the Latin root *carnis*, meaning "flesh" and belonging to a family of words such as *carnivore, carnage* and, notably, *incarnation*. The base connotation of these terms and their respective allusions to sexuality, appetite and slaughter have caused some in every age to disparage our embodiment. The fact of our mortality is unsettling. And across the centuries, the abiding inclination to denigrate our bodies sponsored at least two notable heresies: Docetism, the claim that Jesus did not have a real body, and Gnosticism, the conviction that genuine spiritual knowledge exists in a realm apart from our embodiment in this dull, material world.[38] In both instances, material being is thought to be antagonistic to spiritual enlightenment. While Western Christian thought generally discarded these views, it often favored the Platonic dualism of body and soul.

As underscored throughout this chapter, evidence of the body's temporality and glory is shot clear through the Western figurative tradition. For Christians seeking to make sense of this tradition, it follows that a biblical understanding of the self must regard physical being as an essential component of true spirituality.[39] A robust theology of the body is needed. With this goal before us, two biblical images—the tent and the temple—provide useful categories for further reflection.

In his second letter to the believers at Corinth, Paul (himself a tentmaker) describes the body as an earthly *tent*, a temporary residence given to us during our journey on earth. Many Christians, especially amid physical suffering, have readily agreed with the apostle that "while we are at home in the body

---

[38]"Gnosis means knowledge, and the Gnostics acquired this in a number of ways. The first and most fundamental form of knowledge is good news, and concerns the divine nature of one's own essence: the soul appears as a divine spark of light. The second is bad news and concerns the 'terror of the situation': the spark of light is subject to the influence of external dark forces, in the exile of matter. Imprisoned within the coarse dungeon of the body, it is betrayed by the external senses; the demonic stars sully and bewitch the divine essence of one's nature in order to prevent a return to the divine home. . . . In Gnosis, *pleroma*, the spiritual plentitude of the divine world of light stands immediately opposite *kenoma*, the material void of the earthly world of phenomena." Alexander Roob, *The Hermetic Museum: Alchemy and Mysticism* (Köln: Taschen, 2001), 18. For a much lengthier discussion of Gnosticism and its impact on the church, see Philip J. Lee, *Against the Protestant Gnostics* (New York: Oxford University Press, 1987).

[39]F. LeRon Shults, "Relationality and the Doctrine of Human Nature," in *Reforming Theological Anthropology: After the Philosophical Turn to Relationality* (Grand Rapids: Eerdmans, 2003), 163-88.

we are away from the Lord" (2 Cor 5:6).[40] Meanwhile, in his first letter to this same community and as a corrective to their sexual misconduct, Paul reminds them that their bodies are temples of the Holy Spirit (1 Cor 6:19) and charges to them to "glorify God" (1 Cor 6:20) through their bodies. Here the body is not a tent vulnerable to the effects of sin and death but rather a temple suited to host nothing less than the indwelling of God's Holy Spirit.

Whether Paul's reference is to the Jewish temple in Jerusalem or temples generally, he selects a sacred structure to serve as a metaphor for the body. This choice will remind Bible readers of Jesus' heated exchange with the moneychangers, wherein he compared his body to the temple in Jerusalem (Jn 2:13-22). While the limits and vulnerabilities of our embodiment do present a myriad of challenges, the Bible is unequivocal in its insistence that the body is a physical site suited to host the dynamic relationship between the divine Spirit and our human spirit. To understand this more fully, the sections that follow consider four facets of our embodiment—its beauty, agency, sexuality and mortality—and their subsequent bearing on our spiritual formation.

**Beauty.** The second chapter of Genesis reports, "The LORD God formed the man from the dust of the ground, and breathed into his nostrils the breath of life; and the man became a living being" (Gen 2:7). Then, observing the man's aloneness, God created other living things (Gen 2:19), but supremely it was his creation of the woman (Gen 2:22) that supplied the man with a true "partner" (Gen 2:20). According to the divine design, and set apart from other creatures, humankind—male and female together—bears the *imago Dei*, the image of God (Gen 1:26).[41] That is, while

---

[40]Paul suffered unusual physical distress for his faith and could, in good conscience, claim, "I bear on my body the marks of Jesus" (Gal 6:17 NIV).

[41]For an excellent historical survey of the theological understanding of the *imago Dei*, see F. LeRon Shults, "Relationality and the Doctrine of *Imago Dei*," in *Reforming Theological Anthropology*, 217-43. Shults observes that theologians such as Augustine, Aquinas, Luther and Calvin understood "image" as having largely to do with one's intellectual and moral capacity. Later Protestant theologians, such as Reinhold Niebuhr and Paul Tillich, tended to explore the more existential application of this idea. For the visual artist it is the "imagistic" force of this idea as well as the radical embodiment of the Messiah—the one whom we could "behold"—that captures one's imagination.

Across the centuries, scholars have debated the significance of the distinction between the terms *image* and *likeness*. For instance, Diadochus of Photice believed that "all men are made in God's image; but to be in his likeness is granted only to those who through great love have brought their own freedom into subjection to God." Irenaeus thought that "when the Word of God was made flesh, he confirmed both image and likeness. For on the one hand he truly showed the image by

the whole of creation abounds in aesthetic delight (Gen 1:31), the human form is a body of particular beauty.

From Genesis onward, two events—conception and birth—mark the beginning of human life. Caught up in this wonder, the psalmist writes, "I was being made in secret / intricately woven" (Ps 139:15), a declaration drafted long after Adam and Eve had fallen from grace.[42] Apparently even bodies born in sin (conceived after the fall) are beautiful. The Christian view of corporeality, then, is that our bodies are beautiful simply because our physical being is a means given to us wherein we show forth God's image. And it follows that the history of art simply confirms the fluid nature of aesthetics with regard to human beauty in every epoch and across all cultures. In this regard and with varying measure, we understand that particular standards for beauty—the proportion of one's physique, the color of one's eyes, the tone of one's skin and the luster of one's hair— are socially constructed.

*Agency.* The human body is more than an aesthetic object, a delight to the eye. It possesses impressive agency. With seeming ease, children—who display their own kind of radiant beauty—train their limbs to jump, pull, push and twist. This is the early evidence of their potential to flourish. As these young bodies gain form, skill and strength, they might someday fell a tree and fashion it into a cabinet, run a swift footrace, deftly finger an instrument, endure the hardship of military battle or wait patiently in a receiving line. Indeed, it is in and through these remarkable abilities and capacities that we

---

becoming what his image was. On the other hand he firmly established the likeness by the co-assimilation of man to the invisible Father through the visible Word." Commenting on the biblical phrase "Let us make man in our image, after our likeness," Gregory of Nyssa wrote, "We possess the one by creation, we acquire the other by free will." Andrew Louth, ed., *Genesis 1–11*, Ancient Christian Commentary on Scripture (Downers Grove, IL: InterVarsity Press, 2001), 29-37.

[42]There has been considerable debate surrounding whether or not men and women continue to bear this divine image after the fall. Calvin believed that "as the image of God constitutes the entire excellence of human nature, as it shone in Adam before his fall, but was afterwards vitiated and almost destroyed, nothing remaining but a ruin, confused, mutilated, and tainted with impurity, so it is now partly seen in the elect, in so far as they are regenerated by the Spirit. Its full lustre, however, will be displayed in heaven." John Calvin, *Institutes of the Christian Religion*, trans. Henry Beveridge (Grand Rapids: Eerdmans, 1995), 165. But this view seems to be a minority opinion. Most theologians agree that "image bearing" is basic to our humanity and distinguishes us from other animals. This is borne out in biblical passages such as Genesis 5:1-3 and 9:6-7, which occur after the fall. The church generally seems to agree that, to the extent one is reconciled to God and experiencing ongoing redemption, this "image" shines ever more brightly (or grows to become "likeness") in the man or woman who bears it.

act in the world. In turn, these acts are the threshold to human culture making. But more than this, these actions, rightly conceived, confirm that the *imago Dei* lies latent within us.

*Sexuality.* Both beauty and agency find particular expression in human sexuality. To be sure, our present age is obsessed with sexual performance and identity, but this fixation is hardly original, nor is it uniquely modern. Rather, the impulse to procreate and the desire associated with it are normative for *Homo sapiens* across the whole of human culture. Moreover, there is a fittingness to God's design of our sexuality. For instance, the sight of an unclothed or partially clothed body is intended to stimulate sexual desire, but not in every case. That is, while unclothed or partially clothed bodies might be sexually provocative, there are notable and often lovely exceptions to this rule: the body of a newborn child; the physique of a dancer, athlete or laborer at work; the wise beauty of an elderly man or woman, especially their face and hands, to mention a few. With this distinction as background, we return to the matters of dress and undress and sexuality that are present in the biblical narrative.

While many assume that Adam and Eve's rebellion against God was fundamentally sexual in nature, having to do with their nakedness, this notion is mistaken. Prior to their rebellion, Genesis reports that "the man and his wife were both naked, and were not ashamed" (Gen 2:25).[43] We also learn something about God's intentions for marriage: "A man leaves his father and mother and clings to his wife, and they become one flesh" (Gen 2:24). This core understanding of nakedness, marriage and heterosexual physical union has been the tradition of the church for centuries and remains widely accepted by most Christians, especially those within evangelical circles. It is only in the aftermath of Adam and Eve's disobedience that shame enters the narrative: "Then the eyes of both were opened, and they knew that they were naked; and they sewed fig leaves together and made loincloths for themselves" (Gen 3:7).

There is not, I think, a more haunting image of this epochal fall from grace than Masaccio's *Expulsion from the Garden of Eden* (c. 1424) (fig. 2.9). This fresco in the Brancacci Chapel in Florence depicts Adam with his face buried

---

[43]John Berger argues that the Adam and Eve story is the earliest reference to "nudity" and that in this story "nakedness was created in the mind of the beholder." Berger, *Ways of Seeing*, 47-48.

in his hands and Eve, who searches for a way to cover her exposed body. Surely the shame of this consumes the entirety of their beings—body, mind and soul. Following their banishment from Eden and in their postlapsarian condition, the man and woman's physical nakedness became a visceral symbol of their spiritual exposure, the tangible evidence of their desire to hide from God (Gen 3:8). Only then, apart from God's blessing and beneath the curse, is the problematic nature of their new sexual relationship revealed. For the woman, pain will now be associated with childbirth. For both, the fidelity that they once enjoyed will be displaced by a new relational dynamic: the man will dominate the women, and she will become his subordinate (Gen 3:16).

If, however, Genesis 3 calls on human nakedness to illustrate spiritual and psychological alienation, this sits in sharp relief to the affirmation that Adam and Eve were created to be ones who bore God's image, this prior to their rush to put on the fig leaves that they had stitched together or to wear the garments that God made for them from the skin of animals (Gen 3:21).

**2.9.** Masaccio, *Expulsion from the Garden of Eden*, c. 1424–1427

While the unclothed body maintains a place of importance in the biblical narrative, its moral meaning remains inconclusive. But here Kenneth Clark's distinction between nudity and nakedness (noted earlier in this chapter) provides a useful way forward. If we follow Clark's line of reasoning, we might say that the pathos of Adam and Eve's descent into disobedience, fear and shame as observed in Masaccio's painting represents their *nakedness*. Meanwhile, the mutual delight and sensuality of the unclothed lovers described in Song of Solomon finds expression in their *nudity*:

> How graceful are your feet in sandals,
>    O queenly maiden!
> Your rounded thighs are like jewels,
>    the work of a master hand.
> Your navel is a rounded bowl
>    that never lacks mixed wine.
> Your belly is a heap of wheat,
>    encircled with lilies.
> Your two breasts are like two fawns,
>    twins of a gazelle.
> Your neck is like an ivory tower. (Song 7:1-4)

By design, this Hebrew poem summons images of unclothed bodies. And whether readers understand this biblical text to express a young groom's passion for his bride or to serve as a metaphor for Christ's love of his church, its eros is unmistakable. As we know, many pagan ancients engaged in practices such as temple prostitution, believing that there was a palpable connection between human sexuality and the fertility of their crops and cattle. They imagined a dynamic, albeit blurred, connection between eros and transcendence.

Could it be that human *nakedness* is an apt image of humanity separated from God by its willful disobedience, even as instances of human *nudity* provides us with images of redemption and renewal? The larger point is this: the biblical narrative frequently employs themes of nakedness, nudity and human sexuality to serve as parables of spiritual union and knowing. In this regard, Israel's disobedience caused her to be described as the idolatrous whore of Babylon (Rev 17), even as the church is celebrated as the chaste virgin presented to Christ (2 Cor 11:2; Rev 21:9).

*Mortality.* Time passes. In due course, childish bodies bear the anxious confusion of puberty until, almost without notice, a blossoming occurs wherein awkwardness yields to the discovery of physical powers and comeliness (or lack thereof) in life and love. Those who have entered the second half of their lives recognize full well that new physical realities have settled in. Their bodies, now marked by the cares and hazards of the world, begin to expire. The wizened faces and uncertain steps of our elders confirm what lies ahead: we are made from dust, and to dust we shall return. Once only an abstraction, the psalmist's words gain gravity:

As for mortals, their days are like grass;
they flourish like a flower of the field;
for the wind passes over it, and it is gone,
and its place knows it no more.

George Steiner is right to insist that we must not gloss the finality of physical death:

> In death the intractable constancy of the other, of that on which we have no pur-
> chase, is given its most evident concentration. It is the facticity of death, a facticity
> wholly resistant to reason, to metaphor, to revelatory representation, which makes
> us "guest workers," *frontaliers*, in the boarding-houses of life.... However inspired,
> no poem, no painting, no musical piece—though music comes closest—can
> make us at home with death, let alone "weep it from its purpose."[44]

And in this matter the artist's vision—say, the prematurely aged face of Walker
Evans's *Allie Mae Burroughs* (1936) or Jacques-Louis David's *Death of Marat*
(1793)—and the biblical record are allied. Even a simple child's prayer cap-
tures the fact of our finitude:

Now I lay me down to sleep,
I pray the Lord my soul to keep.
If I should die before I wake,
I pray the Lord my soul to take.

This child's prayer reminds us that our present, unredeemed bodies are the
temporary residence of our being, but that our soul or essence will live on in
a resurrected body (1 Cor 15:35-48). From cradle to grave, it is within flesh and
blood that we "live and move and have our being" (Acts 17:28).

In a deep Christian understanding of things, however, death and bro-
kenness are somehow joined to redemption. Returning to the opening
chapters of Genesis, the central fact of the drama is that Adam and Eve chose
to eat fruit from the forbidden tree. Their agency opened the door to mortality.
Their earlier innocence but a memory, they fled God's presence even as he cast
them from his garden. And as we have already noted, God extended a small
mercy to these exiles and "made garments of skins for the man and for his wife,
and clothed them" (Gen 3:21). Throughout our lives the preservation of our
bodies remains a central concern, and this is magnified with the passing of

---

[44]George Steiner, *Real Presences* (Chicago: University of Chicago Press, 1991), 140-41.

life's seasons. The prospect of death might be the most frightful aspect of our being, but in the end and empowered by the promise of resurrection bodies, Christians are those who stare death down.

*Spiritual formation.* While the reality of physical death leaves us wounded and often afraid, considerably more can be said about the spiritual dimensions of our embodiment, and the remainder of this section is given to consider them. Thus far, the vital connection between body and spirit is self-evident. That is, if those who follow Christ seek to become like him, then their spiritual formation must contend with and be guided by the material reality of their bodies. But as Dallas Willard points out: "It is precisely this appropriate recognition of the body and of its implications for theology that is missing in currently dominant views of Christian salvation or deliverance. The human body is the focal point of human existence. Jesus had one. We have one. Without the body in its proper place, the pieces of the puzzle of new life in Christ do not realistically fit together."[45]

Willard's observation has not seemed so obvious to many New Testament readers, who have been quick to point out that our "flesh" is a problem. For instance, in his letter to the churches in Galatia, Paul identifies the works of the flesh as "fornication, impurity, licentiousness, idolatry, sorcery, enmities, strife, jealously, anger, quarrels, dissension, factions, envy, drunkenness, carousing, and things like these." Not a pretty list, and the apostle goes on to insist that "those who do such things will not inherit the kingdom of God" (Gal 5:19-21). Our sinful attitudes and behaviors pose a grave spiritual hazard, and because of this Paul presses on to say, "Those who belong to Christ Jesus have crucified the flesh with its passions and desires" (Gal 5:24). If these warnings about the flesh are not foreboding enough, during his dark night in Gethsemane, Jesus spoke these words to his weary disciples, "The spirit indeed is willing, but the flesh is weak" (Mt 26:41). Our flesh is at odds, at enmity with God.

Regrettably, decades of sermonizing and popularizing have skewed our understanding of "the world," "the flesh" and "the devil." By stripping biblical terms like these of their metaphorical meaning, one can wrongly equate the world with God's created order, flesh with our actual physical bodies and the

---

[45]Dallas Willard, *The Spirit of the Disciplines: Understanding How God Changes Lives* (San Francisco: Harper & Row, 1988), 29-30.

devil with some comic caricature. Indeed, this triad of resistance should be of considerable concern to all who seek after God. But the reference to flesh in these disparate accounts does not center on the physical body, and when we mistakenly advance such an alignment, we both degrade God's intention for our physical being and curtail the work of the Spirit.

Such a degrading of the body was neither Paul's nor Jesus' intent, for both employed the term *flesh* as a figure of speech to illustrate two frontiers of human struggle. As we will observe in chapter three, the first of these has to do with unrighteous or unrestrained passions that stand opposed to the real presence and work of God's Spirit. Second, and confirming what we have already observed, the body in which our spirit resides is finite and temporary. That is, our mortal bodies are subject to the same "bondage to decay" (Rom 8:21) such that "the whole of creation has been groaning in labor pains until now" (Rom 8:22).

Properly understood, the meaning of "flesh" in the New Testament does not entirely reverse our inclination to disparage our bodies. In Jesus' day, for instance, it was commonly believed that a man born blind or bearing some other physical infirmity was encountering, in his body, God's judgment for his sin or the sins of his parents. But Jesus was quick to challenge this assumption, saying, "Neither this man nor his parents sinned; he was born blind so that God's works might be revealed in him" (Jn 9:3).

In fact, corporeality is not the enemy of one's spirit but rather the stage on which moral goodness and evil are both acted out and acted on. That is, God acts on our bodies, and we, in our bodies, serve and worship him. Regarding the former, consider this: when a woman "who had been suffering from hemorrhages for twelve years" touched the hem of Jesus' garment, her bleeding ceased (Mk 5:25-29). When Jesus ordered Lazarus, by then dead four days, to "come out," Lazarus arose and exited the tomb, grave clothes and all (Jn 11:43-44). Miracles, God's supernatural intervention in the natural world, confirm that the membrane that separates the material from the spiritual is more permeable than generally imagined and that the spiritual is ultimately more real than the material.[46] God, by

---

[46]There is an interesting visual parallel to this. Video and installation artist Bill Viola writes, "One of the most striking things about medieval religious art is that the landscape (for us the *materia prima*; the physical, hard, 'real' stuff of the world) appears as an insignificant element, a backdrop

his Spirit, provides physical healing, safety, rest and empowerment.

God, then, acts on and through our bodies, and in the same manner we respond to him. Christians have long understood the importance of subduing or denying bodily demands. To that end they have practiced spiritual disciplines such as fasting, prayer, meditation and solitude as means to open themselves fully to God's Spirit. The truism "cleanliness is next to godliness" might seem quaint or even puritanical to some, but this allusion to personal hygiene finds a connection not only to the idea of ceremonial cleanliness but also with regard to personal transformation and identity. Whether it is found in the code of the Nazarites in ancient Israel (Num 6:1-21), particular behaviors mandated by the Levitical law, the rite of baptism or the metaphor that is resident in the gospel hymn "Are You Washed in the Blood," a cleansed body is the tangible reminder that those who fear God seek purity of heart. While the various practices we have considered might invite disciples to refrain from particular comforts and indulgences for a season, the purpose of this restraint is not to punish the body but rather to eliminate passing distractions and discipline the will.

Adjacent to the concern for purity is the spiritual significance of physical posture. The position of one's body in relation to God has been used to express everything from celebration (choreographed or spontaneous dance) to penitence (kneeling or falling prostrate for prayer) and from praise (hands held high) to grief (a defeated body crying out in despair). In all of these acts we note that the physical body is *not* assigned a volitional capacity or will. Rather, it is the mind and heart that generate moral decisions and then summon one's body into action. Attending to our corporeality in this manner becomes a means for God's sons and daughters to *consecrate* themselves. Here the mundane or even profaned body is made holy. This is not unlike the host and its transformation into the body of Christ within more sacramental Christian traditions. The higher goal is "that the life of Jesus may be made visible in our mortal flesh" (2 Cor 4:11).

To summarize, genuine Christian spirituality embraces the unity and coherence of our entire being and, as such, the body's manifold functions, including pain and

---

subordinate to the religious vision or epiphany. Space is a radiant gold and is substantially less real than the spiritual reality (scene or events) depicted. From our point of view, the inner and outer worlds have reversed their roles." Viola, "Video Black—The Mortality of the Image," in *Theories and Documents of Contemporary Art: A Sourcebook of Artists' Writing*, ed. Peter Selz and Kristine Stiles (Berkeley: University of California Press, 1996), 446.

pleasure. Reflecting the spirit of Jesus' teaching, "If any want to become my followers, let them deny themselves and take up their cross and follow me" (Mk 8:34), is Jerome's sentiment *nudus nudum Christum sequi* ("followed naked the naked Christ").[47] While the marketplace trains us to despise our bodies (in the guise of loving them), and though evangelical theologians have overlooked them (with eternity in view), the body is best regarded as a sacred vessel. These bodies—the ones we have loved and despised, protected and volunteered, the ones that have borne so many celebrations and sorrows—contain our conscious being. It is within these bodies that we are known and through these bodies that we come to know. The same bodies that are given in love are taken from us in death. No wonder artists have wrestled so mightily to come to terms with the human form, this habitation of our spirit that is universally shared by all living human beings.

## A Sacred Vessel

Across the spectrum of Christian belief, it is agreed that men and women bear the image of God. But this understanding is but a prelude to the simple yet monumental fact that God, who is unseen, was pleased to release his fullness in the body of Christ. That is, the Father chose the medium of human flesh as his preferred means to reveal his presence. As we have already observed, this embodiment of being began with the first Adam in Eden. But it finds its fulfillment in the second Adam, Jesus Christ (1 Cor 15:48-49). Those struggling to make sense of this quickly find themselves exploring territory that is alternately strange and strangely wonderful.[48] In reference to the incarnation, Flannery O'Connor writes:

> This is an unlimited God and one who has revealed himself specifically. It is one who became man and rose from the dead. It is one who confounds the senses and sensibilities, one known early on as a stumbling block. There is no way to gloss over this specification or to make it more acceptable to modern thought. This God is the object of ultimate concern and he has a name.[49]

---

[47]"This became the slogan of late classical and medieval ascetics who, identifying with the spiritual commitment of the martyrs of the early church, called themselves 'daily martyrs.' Stripping themselves of possessions, family, and familiar environment, they entered full-time training in the Christian life." Miles, *Carnal Knowing*, xi-xii.

[48]Danto, "The Body/Body Problem," in *Body/Body Problem*, 184-205.

[49]Flannery O'Connor, *Mystery and Manners: Occasional Prose*, ed. Sally Fitzgerald and Robert Fitzgerald (New York: Noonday, 1997), 161.

Apart from Jesus' corporeality in time and space, the gospel is not the gospel. That is, while many prefer to romanticize, allegorize and rationalize the humanity of Jesus, the "gospel truth" is that he possessed those bodily functions that are common to all of us—perspiration, urination and defecation (to identify those we regard as most ignoble, a fact that helps us to further grasp the meaning of Kiki Smith's silvered jars considered earlier in this chapter). In other words, Jesus entered fully and "naturally" into the world, and there is no sacrilege involved in depicting the infant Jesus with a penis, feeding at Mary's breast, passing through puberty, knowing hunger and thirst, experiencing physical exhaustion and bearing the agony of death.[50]

> Our embodied condition has played a very central role in the artistic tradition, mainly because visual artists in the West had the task of representing the mystery on which Christianity, as the defining Western religion, is based—the mystery, namely of incarnation, under which God, as supreme act of love and forgiveness, resolves to be born in human flesh as a human baby, destined to undergo an ordeal of suffering of which only flesh is capable, in order to erase an original stigma of sin.[51]

Nor is it a problem to theorize that the adult Jesus experienced sexual longing (though no text records this). More than this, to the extent that he did encounter sexual temptation, he neither yielded to it nor was corrupted by it (Heb 4:15). Simone Weil puts it like this: "Christ experienced all human misery, except sin. But he experienced everything which makes man capable of sin."[52] In a verse added in 1978 by Mark E. Hunt to Charles Wesley's original hymn "Come, Thou Long-Expected Jesus" (1744), Hunt reminds us that Jesus came "to earth to taste our sadness." The vulnerability of our humanity is known to God, but, as Hunt insists, in Christ, God goes on to meet what we lack by becoming our "Redeemer, Shepherd, Friend."

> Come to earth to taste our sadness,
>   he whose glories knew no end;

---

[50]In 1983 art historian Leo Steinberg published "The Sexuality of Christ in Renaissance Art and in Modern Oblivion," *October* 25 (Summer 1983). With no hint of sacrilege, the essay explored the literal and metaphorical meaning of Jesus' gender as depicted in Renaissance art and beyond.
[51]Arthur C. Danto, *What Art Is* (New Haven, CT: Yale University Press, 2013), 80.
[52]Simone Weil, *Gravity and Grace*, intro. Gustave Thibor, trans. Emma Crawford and Mario von der Ruhr (London: Routledge, 2004), 23.

by his life he brings us gladness,
our Redeemer, Shepherd, Friend.
Leaving riches without number,
born within a cattle stall;
this the everlasting wonder,
Christ was born the Lord of all.[53]

In becoming the servant to humankind, Jesus knew the water of his mother's womb and the blood of the cross. The stress of Gethsemane and the disfigurement of his Roman execution confirm that he came to suffer. Indeed, both the internal organs and external members of his body absorbed the physical, mental and spiritual demands of human sin. Anticipating the moment and meaning of his death, Jesus issued this challenge to his disciples: "Unless you eat the flesh of the Son of Man and drink his blood, you have no life in you" (Jn 6:53). As painter Bruce Herman explains it, "The brokenness of the Messiah, the Suffering Servant of Isaiah 53, is the central mystery of cosmic and salvation history. God's body broken for us is the source of hope and healing in a lost world. It is our communion, the only genuine possibility of meaning and belonging."[54]

He was wounded for our transgressions,
Crushed for our iniquities;
Upon him was the punishment that made us whole
And by his bruises we are healed. (Is 53:5)

This season of Christ's suffering has passed, of course, so that humanity is invited now to live inside the victory of Easter. God's demonstration of triumph in the resurrection—wherein physical death is conquered—is the symbol of a new promise, and on the day of our own resurrection, we too shall receive imperishable bodies (1 Cor 15:35-57). According to Paul, "We are expecting a Savior, the Lord Jesus Christ. He will transform the body of our humiliation so that it may be conformed to the body of his glory" (Phil 3:20-21). Our "adoption" leads to the eventual "redemption of our bodies" (Rom 8:23).

---

[53]Mark Hunt, "Come, Thou Long-Expected Jesus," vs. 3, (1978), www.digitalsongsandhymns.com/songs/5856.

[54]From an email exchange with artist Bruce Herman.

Even as we await the day when our lowly bodies will one day be perfected (Phil 3:21), we might also observe that the postresurrection, glorified and eternal body of Jesus bore the scars of his crucifixion. What does the record of these wounds suggest to us about our own resurrection? Will our new bodies also bear some perfected version of our scars, laugh lines and furrowed brows? We cannot know, but these considerations surely add intrigue to the artist's exploration of the human form. Of this we can be certain: our present bodies manifest the *imago Dei*, and the incarnation confirms that this image is more than the emanation of our persona or the cultivation of our inner spiritual life. The eternity of our soul is secured in the truth of God and his kingdom, and the resurrection of our bodies will be the final demonstration of his power.

To conclude this chapter we return again to the promise of the figurative tradition. As we have noted, the bodies of contemporary men and women are burdened by the false messages they receive from the visual culture that surrounds them. The worlds of fashion, marketing and design advance a *myth* about our corporeality that must be deconstructed. In turn, this myth must be re-formed by the *reality* that is revealed in everything from ancient biblical stories, poetry and letters to the contemporary paintings of artists such as Melissa Weinman and Lucian Freud. Indeed, drawing, painting and sculpting the figure is often a consecrating act that empowers artist and viewer alike, as it increases their regard for the uniqueness, significance and dignity of all persons. Moreover, we are presented with the plain fact that the reality of our embodied existence also requires redemption. As painter Catherine Prescott proposes: "Our fears, our sorrows, our loves, our longings, are the inescapable reality of our daily, visible lives and if we can bring these things to the canvas in the current atmosphere of free-for-all appropriation of images, style, technique and identity, then we can perhaps present a solid alternative to the fractured world all around us."[55]

Contrary to the profusion of digitally manipulated images that appear within the cinematic frame, on the pages of print journals and on the screens of our now-ubiquitous handheld devices, the consideration of real bodies is a study of common humanity. It is, therefore, not only an

---

[55]Catherine Prescott, "Where Have All the Realists Gone? Recent Trends in Representational Painting" (paper presented at the 1999 Biennial CIVA conference).

aesthetic endeavor but also a moral act. Regarding his work, figurative painter Edward Knippers comments: "I am trying to engage viewers in such a way that they have to contend with their own physicality in response to the work—come to grips with who they are as physical beings. Without that reality, the spiritual aspects of life will tend toward fantasy. In any practical day to day sense, we cannot have the spirit without the body. That is the nature of human existence."[56] Catherine Prescott urges, "If ever there were a challenge for those of us who are Christian representational painters, perhaps especially of the figure, the presentation of our humanness and our creaturely nobility in the face of a creation 'that groaneth and travaileth,' is it."[57]

No wonder the ordinary act of viewing another's face is among the most poignant in human experience.[58] Indeed, the eyes do seem to be a window into the soul, and this invitation to know an other is what imbues the figure, the portrait and the self-portrait with such power.[59] Our embodied hope is this: the splendor of creation, the surprise of the incarnation and the wonder of Christ's resurrection all boldly endorse the spiritual merits of the physical world. God created material reality, he chose to inhabit the same in the body of Jesus and, at the end of time, he will create yet another material heaven and earth.

Finally, whether Christians at work in the visual arts should or should not direct particular energy to draw, paint, sculpt, photograph or film the nude human figure is not for this writer to determine. But of this we can be certain:

---

[56]Edward Knippers as quoted in James Romaine, *Objects of Grace: Conversations on Creativity and Faith* (Baltimore: Square Halo, 2002), 80.

[57]Prescott, "Where Have All the Realists Gone?"

[58]"There are layers of memory, deposits and interweavings of narratives and more fragmentary images, and often the focus for memory is a face. A face is a distillation of time and memory. . . . We talk of gazing deeply into the face of another. There is a concept of depth that does not separate it from the face. There are faces in the memory, in the heart. In mutual joy or grief it is as if the whole self in its heights or depths strains to appear in the face and accompanying words and behaviour, and 'superficiality' would be a ridiculous description. It seems that face to face behaviour can embody depth or shallowness." David F. Ford, *Self and Salvation: Being Transformed* (Cambridge: Cambridge University Press, 1999), 18-21.

[59]Bill Viola writes, "There is a natural human propensity to want to stare into the eye of another or, by extension of oneself, a desire to see seeing itself, as if the straining to see inside the little black center of the eye will reveal not only the secrets of the other, but of the totality of human vision. After all, the pupil is the boundary, and veil, to both internal and external vision." Viola, "Video Black," 449.

in the broad scope of our lives with each other and with God, we embrace the reality that we are, in this season, embodied spirits. And to the extent that visual art and Christian theology are poised to address this foundational reality, both will be able speak to us in our day.

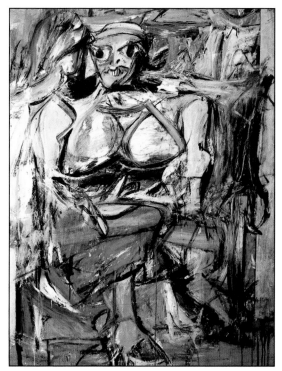

WILLEM **DE KOONING**

*Woman II* – 1952                    PLATE 1

ANDREA **MANTEGNA**

*The Dead Christ* – c. 1500                    PLATE 2

THOMAS **INGMIRE**

*The Ten Commandments,* from *The Saint John's Bible*                    PLATE 3

SOL **LeWITT**

*Objectivity* – 1962

PLATE 4

RICHARD **SERRA**
*Charlie Brown* – 2000

PLATE 5

# 3

# Secular Sirens

*In the beginning, there was no word. There was touch and there was smell and there were pheromone receptors. There was sensitivity to light; the beginnings of hearing and sight.*

JACQUELYN MCBAIN, ARTIST STATEMENT

*The senses don't just make sense of life in bold or subtle acts of clarity, they tear reality apart into vibrant morsels and reassemble them into a meaningful pattern.*

DIANE ACKERMAN, A NATURAL HISTORY OF THE SENSES

*Appetite or desire, not DNA, is the deepest principle of life.*

LEON KASS, THE HUNGRY SOUL

In weaving the tale of Odysseus and his ancient voyage to Ithaca, Homer tells his readers that the goddess Circe cautioned the hero to keep his distance from the Sirens, "those creatures who spellbind any man alive." It was believed that if a ship's crew heard the Sirens' beguiling melody, they would lose all reason and wreck their vessel on the rocky shoal. Often with a word of warning comes the means to escape: "Soften some beeswax and stop your shipmates ears so none can hear, none of the crew," insisted Circe, "but if *you* are bent on hearing, have them tie you hand and foot in the swift ship, erect at the mast-block, lashed by ropes to the mast so you can hear the Sirens'

**3.1.** Hans Holbein the Younger, *An Allegory of Passion*, c. 1532–1536

song to your heart's content."[1] The Sirens' song and its allure illustrates a worry that permeates the moral, social and religious conscience of the West: if sensate experience ignites one's passion, then one will be tempted to abandon all reason.

Painted centuries later, a similar tension appears in Hans Holbein the Younger's *An Allegory of Passion* (c. 1530) (fig. 3.1). Holbein depicts a rider atop a galloping, unbridled white horse. The horseman's red cape flaps in the breeze behind him, and to avoid being thrown violently to the ground, he clings to the steed's mane. An accompanying text, painted by the artist and located in the bottom center of the painting, reads *e cosi desio me mena* ("and so desire carries me along"). Similarly, consider Jean-Baptiste Regnault's painting *Socrates Tearing Alcibiades from the Embrace of Sensuality* (1785) (fig. 3.2). In literature Alcibiades, a political figure who appears in several Socratic dialogues, is a pleasure seeker whose indiscretions led to the betrayal of his fellow soldiers and, subsequently, the downfall of Athens. Having alerted readers and viewers to the dangerous entanglements of sensual pleasure, Homer, Holbein and Regnault go on to insist that the pull of these enticements is so strong that only acts of intervention can deliver us from their power.

Building on the broader theme of embodiment developed in the previous chapter, we turn now to examine the tension between moral restraint and sensate engagement or, more classically, between *asceticism* and *aesthetics*. There are two compelling reasons to pursue this tension. First, it is surely the case that Homer, Holbein and Regnault's worries about sensual pleasure comport with reality. Who can deny the powerful desire that is stirred up by our senses and its

---

[1]Homer, *The Odyssey*, trans. Robert Fagles, intro. Bernard Knox (London: Penguin, 1996), 272-73. See William Kentridge and Rosalind C. Morris, *That Which Is Not Drawn: Conversations* (Calcutta: Seagull, 2014), 17-19.

corresponding hold on every facet of life? Second and pertinent to our consideration of the relationship between art and religion, secular and religious leaders in postwar America perpetuated a dichotomous understanding regarding the relationship of piety to pleasure and used this as a means to organize their respective agendas. In this ar-

**3.2.** Jean-Baptiste Regnault, *Socrates Tearing Alcibiades from the Embrace of Sensuality*, 1785

rangement, particular forms of asceticism enabled evangelicals to isolate their devotion to Christ from the stain of worldliness. Meanwhile and entirely apart from the piety of religious regulation, artists embraced an aesthetic enterprise that permitted them to drink deep of the world and its pleasures. Hence, there emerged a binary pair wherein evangelicals regarded particular evidences of piety to be the central feature of Christian discipleship as contrasted with the secular art world, where radical expressive freedom formed the basis of creative exploration.

To clarify the thematic weave of this chapter, consider these familiar lines from a chorus sung by children across the land during their Sunday school classes:

O be careful little eyes what you see.
O be careful little eyes what you see.
There's a Father up above,
And He's looking down in love,
So, be careful little eyes what you see.

Those familiar with this chorus know that it contains four additional verses—each an iteration of its first—so that in the remaining stanzas the phrase "eyes what you see" is replaced by "ears what you hear," "hands what you do," "feet where you go" and, finally, "mouth what you say."

At one level, this chorus is sage advice to persons of every age. After all, who has not regretted *seeing* what should not be seen, *hearing* what should not be heard, *touching* what should not be touched, *going* where one should not go or *speaking* what should not be said? In this cautionary counsel we

hear wisdom's voice, for, indeed, managing one's passions is daily and demanding work. Ever since learning of Adam and Eve and their taste of Eden's forbidden fruit, many Christians have imagined that the pursuit of pleasure can only be the enemy of piety.[2]

But this simple scheme should also give us pause, for its practicality offer no guidance with regard to the corresponding pleasures of sight, sound, touch, exploration and speech. How, in particular, shall we evaluate our encounters with visual art and, more broadly, visual cultural? For religious believers, the matter grows yet more complicated. What shall we make of the implicit theological claims contained in the words of this chorus: Father / up above / looking down / in love / so be careful. Christian believers will be comforted by the thought that they have a loving Father who watches over them from above. But are their sensate practices truly subject to regular divine surveillance? For twentieth-century evangelicals, the moral watchword was "be careful." And while they sought to live upright lives, the moral code that they advanced often defaulted to a graceless legalism.

Having introduced the challenge posed to us by our senses and then citing a children's chorus to illustrate the dilemma, let me quickly affirm that the biblical narrative accredits substantial virtue to our sensate being. We will consider this claim at length in the closing section of this chapter. Before doing so, however, it will be important to summarize the disposition of postwar evangelicals regarding their moral management of our five senses.

## AN EVANGELICAL TAXONOMY OF THE SENSES

Through the ages, Christians have recognized their primal attraction to what Augustine termed "the temptation of the flesh."[3] If a person's base behavior leads him to spiritual calamity, then he must forsake it. To accomplish this, Christians advanced a variety of strategies to "mortify the flesh." For instance, Catholic orders took vows of chastity, poverty and simplicity as means to avoid worldly distractions that might prevent them from leading lives devoted

---

[2]"The brain is blind, deaf, dumb, unfeeling. The body is a transducer (from Latin, *transducere*, to lead across, transfer), a device that converts energy of one sort to energy of another sort, and this is its genius. Our bodies take on mechanical energy and convert it to electrical energy." Diane Ackerman, *A Natural History of the Senses* (New York: Vintage, 1990), 307.

[3]Augustine, *The Confessions*, trans. Maria Boulding, O.S.B. (New York: Vintage, 1998), 230.

to service and prayer.[4] Also seeking to be faithful disciples of Christ, postwar American evangelicals adopted similar disciplines and prohibitions that were the natural outworking of their Puritan and Pietist roots. Whether Catholic or Protestant, this effort seems consonant with Jesus' insistence that the path to God and his kingdom is a narrow way, one that forsakes the pleasures of this world. This view was surely the sentiment of the psalmist who wrote:

> Keep your servant also from willful sins;
>> may they not rule over me.
> Then I will be blameless,
>> innocent of great transgression. (Ps 19:13 NIV)

Desiring personal holiness and eternal reward, postwar evangelicals exercised caution and restraint with respect to their cultural participation. And nowhere is this more evident than in their management of the senses. In this regard, Christ's example seemed the most compelling. If, like Christ, believers would willingly bear the burdens of this life as those who had been crucified with him, then in the life to come they would receive a great crown of glory. In the pages that follow, I offer a brief taxonomy of the senses as viewed through an evangelical lens.

First, let's consider the olfactory sense—our capacity to smell. Although the Bible makes abundant reference to fragrant offerings and sweet aromas, evangelicals seldom associated the olfactory sense with any serious moral problems. Contemporary women may find the fragrant soaps, lotions and candles at Bath and Body Works appealing, and the marketers of perfumes such as Obsession, Forbidden and Tabu may hope to incite sexual rendezvous; even so, on the whole postwar evangelicals would have agreed with Augustine: "I am not much troubled by sensuality in regard to pleasant smells: if they are absent I do not seek them, if present, I do not reject them, and I am prepared to do without them at all times."[5]

Second and closely related to smell is our capacity to taste. The potential hazard of taste is its direct connection to our appetite for food and drink. As Leon Kass puts it, "The danger and the glory of living forms is writ large in

---

[4]See Carmen Acevedo Butcher, *A Life of St. Benedict: Man of Blessing* (Brewster, MA: Paraclete, 2006).
[5]Augustine, *Confessions*, 228.

the fact of eating."[6] To eat is to live, and the manner in which we do this is freighted with personal, social and religious meaning.[7] Taste may invite the selfish or undisciplined consumption of food that can in turn lead to a wide range of maladies and diseases including obesity.[8] Still, although gluttony is listed as one of the seven deadly sins or vices, few sermons have ever been preached from an evangelical pulpit on overeating and related eating disorders.[9] And, of course, drawing attention to someone's corpulence would always be considered impolite.[10]

By contrast, evangelical attitudes regarding drink, or alcohol, were an altogether different matter. Without exception the Bible regards drunkenness as a sin. In the early decades of the twentieth century this conviction motivated fundamentalists to take up the cause of Prohibition, and the tales of baseball-star-cum-itinerant-evangelist Billy Sunday (1862–1935) preaching against the evils of alcohol are legend. Prohibition was rescinded in 1933, and yet throughout the postwar period thousands of local churches and Christian organizations continued to regard abstinence from alcohol as a precondition for membership. In this same spirit, most of today's conservative Christian colleges require students to sign a morality statement confirming that, among other abstentions, they will not consume alcohol. While these kinds of elective pledges might ring hollow for some, given the staggering abuse of alcohol by today's undergraduates, it is hard to see the downside of the policy.

But where appetite for food and drink is concerned, a more filled-out biblical view cannot be limited to prohibitions. This account must include the frequent mention of celebratory feasts where friends gather in table fellowship to partake of rich food and drink. And in this regard, Bible readers will recall that Jesus' first public miracle in Cana was to produce fine wine at the end of

---

[6]Leon Kass, *The Hungry Soul: Eating and the Perfecting of Our Nature* (Chicago: University of Chicago Press, 1999), 55.

[7]See the section "Sanctified Eating: A Memorial of Creation," in ibid., 191-225.

[8]In the art world, paintings, prints and drawings of food and drink and banquets and feasts are common fare. See Carolyn Korsmeyer, "The Meaning of Taste and the Taste of Meaning," in *Arguing About Art: Contemporary Philosophical Debates*, 2nd ed., ed. Alex Neil and Aaron Ridley (London: Routledge, 2002), 28-49.

[9]Augustine found his own appetite for food problematic, writing, "It is no uncleanness in food that I fear, but the uncleanness of greed." Augustine, *Confessions*, 227.

[10]"Religious folk smoke less, abuse drugs less and contract fewer sexually transmitted diseases, but according to Kenneth Ferraro, a Purdue sociologist, they weigh more." Michael Singer, "Fat of the Land," *New York Times Magazine*, March 3, 2001, 22.

the marriage feast. Suffice to say, instances of God's people gathered in community around feasts appear again and again in Scripture, the supreme example of this surely being "the marriage supper of the Lamb" (Rev 19:9).[11] Imagining this great marriage feast, theologian David F. Ford offers an intriguing image: "To envisage the ultimate feasting is to imagine an endless overflow of communication between those who love and enjoy each other. It embraces body language, facial expressions, the ways we eat, drink, toast, dance and sing; and accompanying every course, encounter and artistic performance are conversations taken up into celebration."[12]

Third, in assessing the potential hazards for the five senses, our auditory sense, hearing, has been highly controversial for evangelicals. It is the auditory sense that invites one's mind and body to enter into everything from the tender phrasing of "Amazing Grace" to Mick Jagger's complaint that he "can't get no satisfaction." For postwar evangelicals it was secular music—especially the beat of modern jazz, rhythm and blues, rock and roll, disco, and heavy metal—and its impact on the spiritual development of their young people that was most grievous.[13] Some argued that the sonic waves generated by these musical genres stimulated sexual desire and that dance, which introduced touch, further sexualized these encounters. And in a sort of sensual crescendo, the addition of moving images and the provocative staging and choreography of MTV in the 1980s and 1990s replaced the more subtle sexual innuendo of earlier forms with narratives of steamy desire and conquest.

Along the way, evangelicals mustered one of two responses to the seeming irresistible hold of contemporary music on their youth. Beginning in the 1970s, some launched a no-holds-barred campaign against popular music from the pulpit. In that decade and the ones to follow, it was not uncommon to have a

---

[11]Based on a story by Isak Dinesen, Gabriel Axel's film *Babette's Feast* (1987) is the cinematic enactment of such a meal. It features the preparation and service of an extravagant dinner, and as the story unfolds, the gathering becomes a holy feast and its food and drink, a sacrament. See also Robert Farrar Capon, *The Supper of the Lamb: A Culinary Reflection* (New York: Modern Library, 2002).

[12]David F. Ford, *Self and Salvation: Being Transformed* (Cambridge: Cambridge University Press, 1999), 271.

[13]I thank my editor, David McNutt, for pointing out that evangelicals are not alone in this worry. John Calvin, who generally held the singing of worship songs in high regard, warned that "songs composed merely to tickle and delight the ear are unbecoming the majesty of the Church, and cannot but be most displeasing to God." John Calvin, *Institutes of the Christian Religion*, trans. Henry Beveridge (Grand Rapids: Eerdmans, 1995), 182.

youth pastor challenge his teens to burn their secular record albums or, later on, to destroy their compact discs as a means to defeat the power of "worldliness"— a strategy not unlike Savonarola's fifteenth-century Bonfire of the Vanities mentioned earlier. Other evangelicals chose a more practical measure: they adopted the centuries-old habit of "baptizing" or sacralizing secular musical forms, assigning new lyrics to existing secular or pagan melodies.

While the debate surrounding music and its proper function in worship is long-standing, generally speaking most Protestants and even Catholics would find themselves in agreement with Martin Luther, who believed that "next to the Word of God, music deserves the highest praise. The gift of language combined with gift of song was given to man that he should proclaim the Word of God through music."[14] And here it is worth noting that many of the sixteenth-century Protestant churches that cleansed their sanctuaries of religious paintings and sculptures were among the first both to sponsor composers such as Johann Sebastian Bach (1685–1750) to write stunning hymns for the church and to install impressive pipe organs in their sanctuaries on which to perform them.[15]

In revisiting evangelical strategies designed to manage the impact of secular music on its members, it can be observed that an unintended shift occurred. Nearing the end of the twentieth century, the Reformational emphasis on biblical preaching and teaching was supplanted by a palpable hunger for spiritual experience. Increasing numbers of evangelicals abandoned traditional hymnody and replaced the organs and acoustic pianos that once accompanied

---

[14]Martin Luther as quoted by Charles R. Swindoll, foreword to *The Hymnal for Worship and Celebration* (Waco, TX: Word Music, 1986). Moreover, many philosophers and aestheticians have claimed that, of all the arts, music holds the greatest possibility for transcendence and is the most sublime. See also George Steiner, *Real Presences* (Chicago: University of Chicago Press, 1991), 18-21.

Augustine, however, is more circumspect in writing, "Without pretending to give a definitive opinion I am more inclined to approve the custom of singing in church, to the end that through the pleasures of the ear a weaker mind may rise up to loving devotion. Nonetheless when in my own case it happens that the singing has a more powerful effect on me than the sense of what is sung, I confess my sin and my need of repentance, and then I would rather not hear any singer." Augustine, *Confessions*, 23.

[15]The Reformation "brought a new kind of art into prominence, a kind of music based on the participation of the congregation, as in the work of Heinrich Schutz and Johann Sebastian Bach, for example. This new style revitalized the language of music through text, thereby continuing in a quite new way the great unbroken tradition of Christian music that had begun with the chorale, which was itself the unity of Latin hymns and Gregorian melody bequeathed by Pope Gregory the Great." Hans-Georg Gadamer, *The Relevance of the Beautiful and other Essays*, ed. Robert Bernasconi (Cambridge: Cambridge University Press, 1987), 4.

them with microphone stands, electronic instruments, monitors and drum kits. To the extent that sacralized contemporary music could supply these longed-for experiences, the critical center of evangelical life for many was relocated from biblical pedagogy to the multibillion-dollar business of contemporary Christian music, where cognitive expressions of Christian belief were displaced by more sensually engaging contemporary musical genres.

Amid the rising din and spectacle of today's ubiquitous audiovisual world, one can easily forget that most of the sonic world exists elsewhere. This other world includes everything from whispered words, to the hum of machines on a factory floor, to wind blowing through a stand of poplars, to a cheering crowd at athletic events, to the sound of a house as it settles in the night. For more contemplative followers of Christ and as much as any familiar hymn, "The Sound of Silence" would remain spiritually evocative.

Next we consider a fourth sense, our capacity to see. For most, vision is our primary orientation to the world. Of the five senses, sight may be the most volatile since it directs our attention to those things and experiences that we long for but do not possess.[16] During childhood it may have been the sight of a stuffed bear or ice cream cone belonging to another that triggered our envy. But beginning with adolescence and continuing on through adulthood, the scope of our desire expands exponentially; we learned to long for objects, places, experiences and relationships not our own. As we gaze on those things that we desire, they become symbols, icons and idols that consume our thoughts and redirect our actions. Some postmodern thinkers convincingly argue that this powerful relationship between *vision* and *possession*—the central nervous system that regulates our vast network of political, financial and social economies—is best understood as a "gaze."[17] No wonder the last

---

[16]"As I have pointed out, general sense-experience is called lust of the eyes, because when the other senses explore an object in an effort to collect knowledge, they claim for themselves, by a certain analogy, the office of seeing, in which the eyes unquestionably hold primacy." Augustine, *Confessions*, 233.

[17]The "gaze" is often used to describe the social dynamics between men and women as well as the manner in which the affluent and powerful dominate the poor and subservient. As Margaret Olin explains it, "To say [that] we treat woman's body as an object is also to say something about the way we treat objects in the twentieth century: as commodities, as objects of possession." Describing these attachments as "fetishes," Olin goes on to explain that "once made into commodities fetishes are 'mystified,' that is, their status as commodities is covered over by rhetoric that treats them as quasi-religious objects." Margaret Olin, "Gaze," in *Critical Terms for Art History*, 2nd ed., ed. Robert S. Nelson and Richard Shiff (Chicago: University of Chicago Press, 2003), 323.

of the Ten Commandments offers such clear instruction: "Neither shall you covet your neighbor's wife. Neither shall you desire your neighbor's house, or field, or male or female slave, or ox, or donkey, or anything that belongs to your neighbor" (Deut 5:21).

Postwar evangelicals would have been quick to point out that our capacity see enables us to delight in the things of God, to have compassion on others and to engage in fruitful labor. Conversely, it was common for conservative Protestant congregations to discourage or even prohibit their members from attending the cinema. The rationale for this prohibition was as follows: since movies showcased the vanity, immorality and worldly ways of Hollywood, followers of Christ should keep themselves from it.

Of the five senses, the one we have yet to review is touch, our tactile capacity. Evangelical worries about touch centered mostly on sex. It was reasoned that if sight led one to the "lust of the flesh," then physical touch might lead to sexual passion, which would be the evidence of moral compromise and, eventually, personal ruin. Regarding touch, the Bible surely does rehearse the treachery of sexual immorality, but it also addresses the immorality of violence inflicted on innocents by a vicious hand. In this regard, no story is more central to the gospel message than the loving embrace of the Father who welcomes the prodigal home. Similar stories are Mary's washing of Jesus' feet with her hair and tears or the invitation from Jesus to Thomas to touch the Master's wounded hands and side. No extended description is more filled with eros than the Song of Solomon or more pathos than the Christ's passion. Meanwhile, it is generally held that common pleasures like petting one's dog, plunging headlong into a pool of water or slipping into a warm sweater on a brisk autumn morning pose no moral temptation or hazard.

Finally and complicating matters further still, there is no sharper critic of one's sensate being run amok than Jesus, for whom at least sight and touch presented a kind of treachery:

> But I say to you that everyone who looks at a woman with lust has already committed adultery with her in his heart. If your right eye causes you to sin, tear it out and throw it away; it is better for you to lose one of your members than for your whole body to be thrown into hell. And if your right hand causes you to sin, cut it off and throw it away; it is better for you to lose one of your members than for your whole body to go into hell. (Mt 5:28-30)

On the heels of a passage condemning adultery and situated inside a larger discourse in Matthew's Gospel—known to us as the Sermon on the Mount—the words of Jesus are arresting, to say the least. One suspects that most who gathered to listen to the teacher's words were either stunned or angered by them. For if maintaining the letter of Jewish law was already a daunting proposition, it must have seemed to Jesus' followers that he was calling them to a new and impossible standard: righteousness at any cost.

Recognizing Jesus' use of hyperbole in this teaching, we might ask, did he really expect his listeners to cease looking and touching? Only context can provide a suitable answer. If, for instance, touch tempts one to become an adulterer, then the answer is surely yes. At the same time, Jesus' actions reported in John 9:1-12 will confirm that a correct answer could also be no. Seeing a blind man, Jesus stooped to gather dirt in his hand, mixed it with his own saliva, spread the mud on the man's eyes and then commanded him to go and wash it off in the pool of Siloam. Immediately the man, who had been blind from birth, recovered his sight. All of the four Gospels abound with such stories: Jesus had compassion for those who could not see, hear or walk, and he routinely relied on his own sight and touch to heal them. It is the sensate-based practices of Jesus himself that form the foundation of every ministry of compassion ever to be sponsored by the church.

To summarize this section we may rightly conclude that smell, taste, hearing, touch and sight are essential features of our embodiment. Whether we warm our hands before a fire, taste the tang of sweet cherries or take in a lively performance of Beethoven's *Eroica*, the nerve-endings or surface-sensors that cover our bodies are vital components of our material being. In the event that any of these capacities cease to function, we are—in some degree—disabled or handicapped.

In this brief taxonomy I am surely not intending to suggest that there was or ever has been a uniform conservative Protestant estimation of the senses. But what can be claimed is that Protestant evangelicals found the corresponding pleasures and hazards of sensate engagement a source of considerable moral anxiety, especially in light of their desire to realize deeper levels of sanctification. And it followed that as these evangelicals sought to cultivate a morally careful life, it at least tempered their ability to enjoy God and his good creation. If the high point of this pursuit was marked by the deeper joy

of knowing God, it was often sullied by the keen awareness of personal failings and shortcomings and, consequently, overwrought by unnecessary guilt and shame.[18] In the next section we will consider a provocative secular counterpoint to such worries.

## AN ALLEGORY OF PASSION

Set in the late 1920s, *Sirens* recounts the fictional tale of Norman Lindsay, an artist-bohemian who resides on a secluded country estate in the Blue Mountains of southeastern Australia with an entourage of beautiful women—a wife, two models, a housemaid and two young daughters.[19] In the opening frames of the film, two cassock-attired clergy enter the Art Gallery of New South Wales and walk briskly through its corridors until they reach an artwork created by Lindsay. The etching is draped in dark cloth. The older man, the bishop of Sydney, uncloaks the piece to reveal a crucifixion scene in which the male Christ figure has been replaced by a nude Venus. As anticipated, the clerics regard the content of the artist's print blasphemous and its presence in the exhibit an affront to the church.

To remediate the problem, the bishop dispatches Anthony Campion, his young priest, and Campion's priggish yet attractive wife, Estella, to persuade Lindsay to remove his work from the exhibit. Having arrived in Australia only recently, the inexperienced Englishman sets out to visit the offending artist, who, it turns out, resides in Campion's newly assigned parish. At the end of a long and wearisome journey, the couple is warmly welcomed by Lindsay, who invites them to stay in his guest house.

In short order Campion grows intrigued by the appointments of Lindsay's gracious home and its surrounds. Dinner debates over rich food and drink seem to impassion Anthony, and when he happens on the artist posing and painting his nude models, the young priest finds himself an unexpected voyeur. But as the days pass, the anticipated schism between Campion's religious convictions and his host's obvious disdain for Christianity deepens. Beneath this burden the cleric's convictions about his own faith seem to falter. Nonetheless, in his commitment to persuade Lindsay to remove his offensive

---

[18]In certain respects popular evangelical speaker and writer John Piper sought to address this in his book *Desiring God: Meditations of a Christian Hedonist* (Portland: Multnomah Press, 1986).

[19]*Sirens*, John Duigan, director, Miramax Films, April 28, 1994.

print from the museum—especially before the show travels to England, Anthony's home country—Campion is undeterred.

Meanwhile Estella, Campion's wife, embarks on a different personal journey. Initially, her modest dress and obligatory sexual relations with her husband cause her to appear withdrawn and absent of passion. But like her husband, she too is intrigued by the sensual abandon of Lindsay's people and place. As the narrative unfolds, Estella warms to Lindsay's women, and then— in an episode reminiscent of an open-air water baptism—her defenses fall entirely away. Estella, now in a dreamlike state and dressed in a shimmering white gown, yields to the caress of the other women, and the film's viewers are given cause to believe that she is experiencing a kind of sensual-sexual rebirth. A bit too obviously, a large and dark water snake—the serpent in paradise— slithers from scene to scene.

*Sirens* narrates the conversion of two seekers—Campion and his wife—as they fall steadily beneath Lindsay's spell. At the film's conclusion, the couple departs from the region by train even as the film flashes back to a scene wherein five unclothed women stand atop a rocky hill—five Sybils heralding the Neopagan conquest of a dull and archaic Christian universe. Sensuality and the lurking serpent have prevailed over the rigid doctrine and manners of the church.

What shall we make of director John Duigan's fascination with the long-standing tension between staid religious orthodoxy and bohemian sensual abandon? Most viewers will be quick to understand that the film's setting—its lush landscape, charming spaces, sensuous women and attendant luxuries—is the stuff of movies. Nonetheless, in sketching an image of contemporary paradise set within a larger celebration of sensual gratification, Duigan is right to emphasize that art making is a sense-centered encounter.

Sculptor and designer Maya Lin asserts, "I think with my hands."[20] As her comment suggests, the art of making triggers a rapid sequence of sensate connections—the eye to the brain, the brain to the hand, the hand to the eye. Apart from sight, one cannot comprehend the brilliance of cobalt blue. Apart from sensing the drag of a loaded brush against the grain of paper, one cannot lay down a watercolor wash. And apart from the scent of, say, turpentine,

---

[20]Maya Lin, *Maya Lin Boundaries* (New York: Simon & Schuster, 2000), 3.09.

linseed oil, wax, machined steel, sawdust or acrylic polymers, the materials that we manage might leave us uninspired.

But if *Sirens* seeks to persuade its viewers that Lindsay and his women are "naturally" attending to their desires, it also hopes to convince us that Christians are sexually and aesthetically repressed. At the same time, Duigan's easy embrace of sensual license over against the abrupt dismissal of Christian piety is far too formulaic. That is, as Duigan invites his viewers to embrace a new Eden, he seems unwilling to scrutinize the charms of such a world with the same rigor that he levels at Christianity. One may dismiss these glosses as part and parcel of popular cinema. Had he desired, Duigan might have directed his viewers to a different conclusion. For instance, the opening scene of *Sirens* reveals Lindsay's intrigue with biblical themes, albeit their inversion. Why did Duigan choose to turn his artist away from Christianity rather than toward it? Why did Campion—we presume he is theologically trained—not lead the conversation to more transcendent matters?

What *Sirens* does portray is the abiding conflict that appears to exist between Christian *asceticism* (the denial of one's senses for some greater spiritual good)[21] and a secular, or in this instance pagan, *aestheticism* (the stimulation of one's senses through the arts).[22] Duigan invites his viewers to consider the latter, not the former, as a path to salvation. Perhaps this is what John Berger envisioned when Janos Lavin, a Hungarian artist in Berger's novel *A Painter of Our Time*, declares: "There comes a time in every work when suddenly the form of it takes over. Then I can do no wrong. I am Adam in paradise. And the whole of life seems to have conspired to help me. It can last five minutes. Just occasionally, like today, for a whole afternoon."[23]

---

[21]Generally speaking, Christian asceticism is the discipline of separating oneself from the pleasures and distractions of the world as a means to experience God's presence more directly and serve him more faithfully. Ascetic or spiritual disciplines include such things as times of extended prayer, fasting from food and drink, prolonged periods of silence, personal retreat to a monastery and spiritual pilgrimage. In some instances these practices take extreme form to include the rending of one's clothes, putting on "sackcloth and ashes," and even self-flagellation.

[22]In reference to aesthetic movements like the pre-Raphaelites, the Bloomsbury Group and the "pseudo-Rosicrucian cult" around Madame Blavatsky, George Steiner writes: "Aestheticism entailed a flight from the *vulgus profannum* of industrial and mass-consumption society. These diverse 'cells' shared the belief, often Nietzschean in origin, that renovation could only come from an initially occult revelation and discipleship." George Steiner, *Lessons of the Masters* (Cambridge, MA: Harvard University Press, 2005), 122.

[23]John Berger, *A Painter of Our Time* (1958; New York: Pantheon, 1989), 137.

Thus far we have examined evangelical worries about the capacity of our senses to enflame desire. Following that, we evaluated director John Duigan's counterproposal that we yield to the same. As such, it may seem that we are faced with a simple choice: *self-management* or *self-indulgence*. And while the implicit hedonism of the latter option is surely seductive, prudence invites us to consider the wisdom of the former: restraint.

However one navigates the liminal space between freedom and moral obligation, no one—not even the most pious spiritual seeker—can entirely dismiss her or his capacity to touch, taste, smell, hear and see. These abilities affect everything from our acquisition of knowledge to the management of daily life and from making art to Christian discipleship. We call on them to harvest the raw data that forms the bulwark of scientific observation, to keep our bodies from great physical harm and to distinguish fanciful imaginings from concrete reality.

The senses are basic to our being. And it follows that we employ phrases such as "coming to our senses" or "making sense" or "being sensible" to confirm that we are *reasonably* located in actual space and time. Cast in this light and contrary to the worries expressed thus far, our sensate being need not be either a path to wild abandon or an invitation to moral mishap. Rather we are, all of us, caught up in what appears to be an impossible paradox: on one hand, we *must trust* our senses to gain true knowledge of the world; on the other, we *dare not trust* ourselves to yield to their power.

## THE SENSATE LIFE

In his book *Which "Aesthetics" Do You Mean?* Leonard Koren writes, "Virtually everything we know about the world, except that which is genetically encoded, comes to us through our senses and is then intellectually processed in one way or another."[24] Similarly, Diane Ackerman theorizes, "There is no way to understand the world without first detecting it through the radar-net of our senses."[25] Artist Jacquelyn McBain presses the matter still further: "In the beginning, there was no word. There was touch and there was smell and there were pheromone receptors. There was sensitivity to light; the beginnings of hearing and sight."[26]

---

[24]Leonard Koren, *Which "Aesthetics" Do You Mean? Ten Definitions* (Point Reyes, CA: Imperfect Publishing, 2010), 53.

[25]Diane Ackerman, *Natural History*, xv.

[26]Jacquelyn McBain, from the artist's statement in her limited edition of prints, *Experiments Useful for the Cure of Men's Minds*.

Persuasive as Koren's, Ackerman's and McBain's claims might be, from the ancient Greeks onward the acquisition of "higher" knowledge in the West has been mostly regarded as a cognitive endeavor. This confidence in the pre-eminence of mind is subtly confirmed by the manner in which we rank our perceptual faculties within the vertical hierarchy of our bodies: reason or intellect being associated with the head and then, in descending order, feeling and belief attributed to the heart, and sensate encounters and animal passions paired with the bowel or gut (viscera). In this schema and with the "head" in first position, fully formed adults are preeminently thinking persons whose minds have gained mastery over the more base and profligate aspects of their being. Hence the familiar saying "mind over matter." In more educated and philosophical circles, intellection is elevated to a place of nobility and far above the taint of more ignoble urges and promptings. "I think, therefore I am," insists René Descartes.

This admittedly elegant arrangement wherein sensate data is mined and managed by a rational self advances its cause through proofs and propositions, measurement and assessment, strategies and tactics. Moreover, social and economic histories confirm that ordered worlds can be remarkably efficient and productive, engendering a strong sense of security, confidence and well-being for the individuals whom they serve. This rational self is most at home in branches of science, technology and business where logical patterns of organization are reinforced, and this self frequently calls into service sub-disciplines within philosophy, sociology, architecture and design that are practiced in social management and control.

When these disciplines and subdisciplines are ungoverned by law or unchecked by conscience, however, their considerable power is often harnessed to advance the self-interests of a few. And run amok, these practices and their agents have formed the operational center of every modern totalitarian state.[27] Consequently, these systems of power and those who control them must always be subject to criticism. Wendell Berry observes:

> In my region and within my memory . . . human life has become less creaturely and more engineered, less familiar and more remote from local places, resources, pleasures, and associations. Our knowledge, in short, has become

---

[27]See Czeslaw Milosz, *The Captive Mind* (1953; Vintage: New York, 1981), 64-69. In this work Milosz describes the deadening of aesthetic sensibilities and dullness of daily routine under the grip of Stalinism.

increasingly statistical. . . . This is the sort of knowledge we now call "data" or "facts" or "information." By means of such knowledge a category assumes dominion over its parts or members. . . . Virtually all of us, in order to participate and survive in their system, have had to agree to their substitution of *statistical knowledge* for *personal knowledge.*[28]

In support of Berry's complaint, it must be observed that the rational self is inclined to discredit and even disallow critical dimensions of life that are essential to human flourishing; *aesthetic* and *religious* experiences are most endangered. A line from Robert Browning's nineteenth-century poem "A Grammarian's Funeral" estimates the cost of preferring the rational self over other ways of being: "The man decided not to live but to know." Commenting on the same, George Steiner observes the critical distance that exists between knowledge (philosophy) and experience.[29] To grasp this difference, compare the following pair of actions: *studying* the description of a tantalizing entrée on the menu of a fine restaurant and actually *partaking* of the meal. The former might be an enticing prelude to the latter, but taking in the culinary delight (preferably with friends) is surely the greater good. And here a larger pattern holds, for, whether it is community, sex, manual labor, worship or travel, there is a critical difference between ideation and experience. Comprehending this distinction keeps us all from wondering off into unreality.

*Experience.* To enlarge our thinking about the nature of aesthetic and religious experience, consider a painting by Claude Monet (1840–1926) and a passage from the prophet Ezekiel. The expansive surface of Monet's *Water Lilies*—on view in New York's Museum of Modern Art (MoMA)—stretches nearly forty-two feet wide and stands seven feet tall. This triptych bears the weight of thickly scumbled impasto paint. One could, as many scholars have, engage this trio of panels in formal terms, taking care to document the work's provenance, assess its plastic qualities and flesh out the artist's biography.[30]

---

[28]Wendell Berry, *It All Turns on Affection: The Jefferson Lecture and Other Essays* (Berkeley: Counterpoint, 2012), 23-24 (italics mine). In this regard, Michael Polanyi is often credited with challenging the assumption that science alone is the source of objective truth. See *Personal Knowledge: Towards a Post-Critical Philosophy* (Chicago: University of Chicago Press, 1962), 16-17.

[29]Robert Browning, "A Grammarian's Funeral," as cited by George Steiner, *Lessons of the Masters: The Charles Eliot Norton Lectures 2001–2002* (Cambridge, MA: Harvard University Press, 2003), 70.

[30]The general viewing public might or might not find this sort of thing either interesting or useful, but it is what curators and historians give themselves to and, in constructing a history of art, it is essential.

Almost without fail, this kind of research yields interesting material. Concerning *Water Lilies*, for instance, we learn that the artist labored over this painting and the larger oeuvre to which it belongs from 1914 to 1926; he did so from the vantage point of his studio, which was situated at the edge of his celebrated water-garden at Giverny, some forty miles from Paris; later in life his eyesight grew weak; and, remarkably, this impressive painting was largely forgotten in Monet's studio until it was discovered and then purchased by MoMA in 1959.

While most are likely to find this data intriguing, my description of Monet's painting lacks what I regard to be its most salient element: the mention of a viewer's actual *encounter* with the work. Certainly formal considerations are *important* to the critical reception of any work of art, but the *essential* act is to witness it. For only in witnessing Monet's *Water Lilies* can one hope to recover something of the artist's encounter with his beloved lily pond at Giverny.

The experience of viewing a painting bears striking resemblance to the act of reading a text. More than two and half millennia before Monet commenced to paint, Ezekiel recorded a strange vision that he received from God by the river Chebar. I *saw*, he says, "a strong wind [coming] out of the north: a great cloud with brightness around it and fire flashing forth continually, and in the middle of the fire, something like gleaming amber" (Ezek 1:4). The passage goes on to describe four exotic and winged human-like beings, four wheels within wheels covered in eyes, a dome overhead, a throne attended by creatures that resembled lions and a visage seated on the throne who appeared to be a man. Ezekiel tells us, "This was the appearance of the likeness of the glory of the LORD. When I saw it, I fell on my face" (Ezek 1:28).

Similar to the formal considerations that may be directed to any work of visual art, a large and critical enterprise is dedicated to the interpretation of biblical texts. And it follows that if the primary experience we seek from a work such as *Water Lilies* is to stand before it, then with regard to Ezekiel's text we place ourselves beneath it. Of course it is not possible for us to witness Ezekiel's vision firsthand; even the prophet encountered his vision but once. But like Monet's painting, Ezekiel's account enables those who read it to see what the prophet saw. How did this vision alter the prophet's comprehension of God? Having read Ezekiel, should we dare to hope for or even desire a similar lucid and ecstatic encounter?

I have cited Monet's painting and Ezekiel's text for two reasons. First, each illustrates a way in which viewing or reading might shape our aesthetic or religious being. Second, each demonstrates the limits of the rational self. Indeed and contrary to its boast, the rational self is ill-equipped to process the overload of sensate data it receives from these kinds of encounters. Consider, for instance, Czeslaw Milosz's description of a man as he strolls a busy street:

> In the cities, the eye meets colorful store displays, the diversity of human types. Looking at passers-by, one can guess from their faces the story of their lives. The movement of the imagination when a man is walking through a crowd has an erotic tinge; his emotions are very close to physiological sensations. He rejoices in dresses, in the flash of lights; while, for instance, Parisian markets with their heaps of vegetables and flowers, fish of every shape and hue, fruits, sides of meat dripping every shade of red offers delights, he need not go seeking them in Dutch or Impressionist painting. He hears snatches of arias, the throbbing of motors mixed with the warble of birds, called greetings, laughter. His nose is assailed by changing odors: coffee, gasoline, oranges, ozone, roasting nuts, perfumes.[31]

Whether actual or imagined, Milosz's description remains fixed in the mind's eye of the one who beheld it. Moreover, the kind of sense-sifting and winnowing that it records is less the evidence of intellectual restlessness or indecision and more the confirmation of our unceasing need to make meaning.

It is sensate experience and not mere rational reflection that gives rise to life's most poignant moments. A story grips our soul, a spiritual encounter probes our deepest being, a musical performance plays on at the far horizon of our memory, the image of a face returns to us again and again, and because of this our lives are forever changed. English philosopher and geometer Keith Critchlow puts it like this: "The human mind takes apart with its analytical habits of reasoning but the human heart puts things together because it loves them."[32] That is, we sort through ideas, memories, signs, sensations and symbols, hoping—believing—that they will cohere into some greater whole and that this new knowledge will teach us how to live. All the while we recognize that the rationalization of experience is and can only be reductive.

---

[31]Milosz, *Captive Mind*, 65.
[32]Cited in Berry, *It All Turns on Affection*, 36.

Thus far we have noted that sensory data are fundamental to both the aspirations of the rational self and the experiences of aesthetic life and that, in fact, the rational cannot meaningfully exist apart from the experiential. Nonetheless, the debate in the West surrounding the relationship of cognition to more sensate ways of being has sponsored entire schools of thought in philosophy, art and religion.

**Binaries and their limitations.** The juxtaposition of the rational self to sensate being naturally returns us to the tension between Enlightenment and romantic habits of mind that we noted in chapter one as well as to the supposed contrast between asceticism and aestheticism that was highlighted earlier in this chapter. Ancient philosophers imagined another related polarity between the Apollonian and the Dionysian self—the former being rational, ordered and self-disciplined and the latter, sensual, spontaneous and given to emotion. Joining these pairs is the familiar wager concerning objective knowledge, or truth, and its counterpoint, subjectivity. Desiring to find a pattern in all of this, a "back of the envelope" approach might suggest the following pairs:

|                |              |
| -------------- | ------------ |
| Rationality    | Sensuality   |
| Asceticism     | Aestheticism |
| Enlightenment  | Romanticism  |
| Apollonian     | Dionysian    |
| Objectivity    | Subjectivity |

On first appearance this scheme offers a simple means to navigate what is surely complicated territory and then goes on to establish some observable affinities. For instance, where the rational self is concerned, there is a comfortable affiliation between the Enlightenment mind, an Apollonian persona and ascetic practices that favor reasoned decision making, deferred gratification and objective claims. Meanwhile, the sensate self easily advances a romantic vision, assumes a Dionysian persona and substantially resembles a version of the modernist aesthetic that prefers expressive forms marked by immediacy, directness and spontaneity, some of which are called on to manifest the unconscious or entertain the absurd.

In large part the language used to describe art and religion during America's postwar period conforms to this columnar alignment. Regarding

modernism, late nineteenth- and early twentieth-century schools and movements set the stage by coining terms like *abstract expressionism, art brut, Dada, fauvism* (wild beasts), *impressionism, surrealism* and so on that prized experience and celebrated subjectivity. Like the Beats and the politics and psychedelia of the counterculture that followed, the American modernist enterprise generally bears a strong Dionysian cast.

Meanwhile, consider the language conservative Protestants adopted to describe their regular behaviors and beliefs: discipline, sacrifice, piety, obedience and faithfulness. These habits of heart were paired with ideational commitments to a range of particular doctrines and moral absolutes that were surely Apollonian in character.[33]

Could it be that we have happened on a tidy summation wherein modernism might be classed as Dionysian and evangelicalism, Apollonian? Might it be that when this picture is fully colored in, we can locate religion—especially the various fundamentalisms—in the left column of our diagram and assign art—especially modernism—to the right? In fact, a careful review casts doubt on this arrangement.

Consider, for instance, the American minimalist movement that followed abstract expressionism. It is well known that devotees such as Donald Judd (1928–1994) were deeply indebted to forms found in Shaker furniture and architecture. As evidenced by his reliance on plainness, repetition, austere materials and monochromatic color,

**3.3.** Donald Judd, *Untitled*, Douglas fir plywood, 1976

Judd's minimalist aesthetic resembles the ascetic practices of Shaker Anabaptists (see fig. 3.3). As such, a good deal of minimalist work bears an easy resemblance to the appointments of a monastic enclosure, the silence of an empty chapel or even the rhythmic pattern of the daily offices. Within modernism, this same aesthetic disposition was fully present in the German Bauhaus, mid-century

---

[33]Other terms such as *joy, peace, grace, mercy* and *love* figured prominently in the rhetoric of these religious communities, but these distinctives were mostly not the hallmarks observed by the watching world.

American formalism, and the International Style in architecture. It continues in the contemporary work of painters like Sol LeWitt and Brice Marden. While, as already suggested, the larger modernist movement was primarily given to a more Dionysian way of being, clearly the noteworthy practitioners that I have mentioned embraced an Apollonian sensibility.

The reality of postwar conservative Protestant religion evidences similar anomalies. For instance, if fundamentalists and evangelicals were essentially Apollonian in habit of mind, the religion of their charismatic and Pentecostal sisters—whose doctrine and piety, save for the person and work of the Holy Spirit, was broadly and mutually aligned—was unabashedly Dionysian, less concerning beliefs and more in regard to style. Charismatic theological conservatives, including a great many African American congregations, promoted a wide range of practices centered primarily on spiritual experience—healing, glossolalia, dreams and visions, the casting out of demons and evil spirits, words of knowledge, and signs of supernatural power. In other words, the reality of Pentecostal and charismatic life was weighted more toward experience and less toward doctrine and apologetics, though these latter concerns remained important.

Given their scope, neither minimalism nor the charismatic movement can be regarded as mere aberrations or anomalies within the larger movements to which they belong. To account for them, therefore, our model needs to be more fluid. That is, as we seek to gain an accurate picture of American life and culture during the postwar period, we cannot claim either that modernists wholly embraced sensate experience or that conservative Protestants rejected it. The binary pairs and polarities we have outlined might be useful in charting differences of mind and disposition, but even the very architecture of this proposal demonstrates a clear preference for the rational self. By design, schematic charts are different in character from life lived; at best they are dinner menus and not the meal.

Meanwhile and with considerable confidence, we must insist that sensate experience and perception has been and will remain an animating force for artists and religious practitioners alike. Those who claim (or imagine) that they are able to perceive ideas in some pure and abstract form apart from their embodiment are simply misguided. For in making this claim they fail to remember that sensate experience precedes all intellection. It can be no other way. Indeed, the gravitas that we assign to art and religion is due substantially

to its ability to embody form and belief in ritual and routine, its capacity to cherish abstract dimensions "as lofty as the heavens," all the while grounding these in the materiality of daily life. And it is the business of aesthetics to plumb their depths.

**Aesthetics.** Leonard Koren reminds us that aesthetics "is less than three hundred years old. Etymologically it derives from a Greek work for perceptual or sensory knowledge, *aisthesis*."[34] "German philosopher Hegel defined art as 'the sensuous presentation of ideas.' It is, he indicated, in the business of conveying concepts, just like ordinary language, except that it engages us through both our senses *and* our reason, and is uniquely effective for its dual modes of address."[35] In concert with Koren's and Hegel's insistence that our senses enable us to acquire genuine knowledge, philosopher Arthur Danto takes the matter a step further by defining works of art as "embodied meaning."[36] This mode of thought comports nicely with the claim of artist Ellsworth Kelly, who, in describing his unframed relief paintings, announced, "What I've made is real—underline the word real."[37] While the nuances of particular aesthetic theories can be configured variously, most visual art seems to contain at least three elements: a core concept or idea, a physical form, and the sensate experience of both making objects and encountering them.[38] The discipline of aesthetics, therefore, provides a means to fruitfully consider the dynamic intersection of cognitive and sensate and material ways of being, a place that sponsors the poignant meeting of idea and experience in the material world. Diane Ackerman explains this as well as anyone:

> We look to artists to feel for us, to suffer and rejoice, to describe the heights of
> their passionate response to life so that we can enjoy them from a safe distance.
> . . . We look to artists to stop time for us, to break the cycle of birth and death
> and temporarily put an end to life's processes. It is too much of a whelm for any
> one person to face up to without going into sensory overload. Artists, on the

---

[34]Koren, *Which "Aesthetics,"* 15.

[35]Alain de Botton, *Religion for Atheists: A Non-believer's Guide to the Uses of Religion* (New York: Pantheon, 2012), 215-16.

[36]Arthur C. Danto, *What Art Is* (New Haven, CT: Yale University Press, 2013), 37.

[37]Ellsworth Kelly as quoted by Carol Vogel, "True to His Abstraction," Arts and Leisure, *New York Times,* January 22, 2012, 23.

[38]Conceptualists might take exception to this general outline since their ideas might not require any physical form or material making, but we can regard them as a special case and at the margin of art's larger history.

other hand, court that intensity. We ask artists to fill our lives with a cavalcade of fresh sights and insights, the way life was for us when we were children and everything was new.[39]

In the West, however, there is a long and commanding history of ideas that runs counter to this more integrated manner of thinking. Since the scope of this terrain lies beyond my training, philosopher Charles Taylor and his landmark study, *Sources of the Self*, will guide our thinking.[40] If Western dualism between mind and body begins with Plato (less so, Aristotle), it comes of age in the writings of Descartes. Taylor points out that the penchant of Cartesian thought was to distance ourselves from the embodied world, to regard our senses and passions as unenlightened, tawdry and plebeian. Built on the observations made earlier in this chapter, the shift from the primacy of one's senses to reason as the basis of self-formation effectively advances the Greek ideal of a rational and ordered world from which emerges a conception of higher and lower orders of being. The fully realized self is the precursor to new conceptions of everything from civic order to ideal beauty, as we observed in the previous chapter.

As Taylor points out, the move from sensate passions to rationality as the basis for being was just the first half of the story. There was also a move inward. That is, the move to the inner life as expressing the true nature of reality that would become the basis of the radical individualism that now forms the common understanding of our popular consumer culture and the disembodied spirit that remains part and parcel of American Protestantism. Put differently, the move upward toward intellection and inward toward the self is a striking affirmation of the Gnosticism that tempted second-century Christians.

Though unorthodox, Diane Ackerman's thinking on this matter is instructive. According to her, our routine juxtaposition of the cognitive to the sensate is entirely mistaken. That is, Ackerman believes these functions exist in a fluid and dynamic relationship to each other. "The *mind*," she writes, "doesn't really dwell in the brain but travels the whole body on caravans of hormone and enzyme, busily making sense of the compound wonders we

---

[39]Ackerman, *Natural History*, 277-78.
[40]Charles Taylor, "Descartes's Disengaged Reason," in *Sources of the Self: The Making of Modern Identity* (Cambridge: Cambridge University Press, 1989), 143-58.

catalogue as touch, taste, smell, hearing, vision."[41] Luci Shaw's poem "The Simple Dark" suggests a similar unity. Writes Shaw, "My whole body an ear, a nose, my whole being an eye."[42] For Christians like Shaw, there is a resonance between the integrated conception of the self that she advances and the ancient Hebrew worldview that showcases a unity of heart, mind, body and soul. Embracing this more filled-out understanding of the self, theologian David Ford wonders: "Are there also possibilities of transformed sensing which see with 'the eyes of the heart,' hear with 'the inner ear,' smell 'the odour of holiness,' savour 'the sweetness of the Lord' or feel 'the touch of the Spirit'? Are these only metaphors? Or is there something in the rich traditions about 'the spiritual senses' within and beyond Christianity?"[43]

While sorting out these preferences with respect to habits of mind is valuable work, our greater need is to construct a unified understanding of the self. In this regard, simple binaries will inevitably betray us since they lack any real capacity to account for wonder, doubt, mystery and suffering—the deeper matters that ground our being and also beguile us. Our senses are a vital and arresting means to muse, learn and know, but as we have observed throughout this chapter, many believe that a life given to the senses represents weakness. In the section to follow, we will consider the ways that unfortunate stereotypes concerning gender and age and have been mobilized to confirm this.

## BORN OF WEAKNESS

It is the nature of the rational self—the head—to overcome, to dominate, to rule. In the West this domain has been traditionally demarcated as male and adult, thereby assigning more diminutive aspects of being—matters of the heart and unrestrained passions—to women and children. In postwar America, gender bias occupied an important place in the sociology of the evangelical church as well as the secular art world. Regarding the latter, historian Francis Pohl states the matter forthrightly: "In the world of art, as elsewhere, women were perceived of as nature, both literally and figuratively. Women were seen as more 'natural' because of their supposed inability to engage in sophisticated intellectual activity. They represented the body, the

---

[41]Ackerman, *Natural History*, xix.
[42]Luci Shaw, "The Simple Dark," *What the Light Was Like* (Seattle: WordFarm, 2006), 20.
[43]Ford, *Self and Salvation*, 267.

world of the senses and the earth, while men represented the mind, the world of art and science and industry."[44]

The arrangement that Pohl suggests—in which women are bound to their nature and naturalness—is an assumption that prevails in the John Duigan film we considered earlier. If, as Western philosophy has argued, our higher nature is to *think*, then the well-formed rational self is imagined to be masculine and adult. In this arrangement the male mind strides, so to speak, with confidence toward objectivity. The unfortunate corollary to this view is that women and children are relegated to the domain of feeling and associated to nonrational functions such as passion, whimsy and hysteria. Again, a listing of binary pairs might help to sort out these simple, yet pernicious, assumptions:

| Higher Nature | Lower Nature |
|---------------|--------------|
| Thinking | Feeling |
| Objective | Subjective |
| Adult | Child |
| Male | Female |

In Western culture, at least, the qualities listed in the left-hand column of this oppositional arrangement have been granted dominance, such that lives given to feeling, emotion, intuition and pleasure must be regarded as subdominant. To maintain this ordering of passion, traditional understandings of masculinity have mostly aligned to the left-hand column, and the "weaker" inclinations of women and children have mostly aligned to the right. To further establish this pattern of dominance and subdominance, "soft" categories like naiveté, subjectivity, sentimentality and (surprisingly) promiscuity have been attributed to women and children.

First let's consider the state of naiveté or childishness. When a young boy explores the face of a grandparent with his hands, makes noise to discover language or experiments with movement to understand space, it is understood that these behaviors are his primary means to gain knowledge of the world.

---

[44]Frances K. Pohl, *Framing America: A Social History of American Art* (New York: Thames & Hudson, 2002), 171.

Consequently, these actions are lauded.[45] But in the modern world this cause-and-effect relationship is understood to be temporary. Childhood and the season of adolescence that follows is a transitional zone from which an adult self is to emerge. Adulthood calls for "more responsible action," wherein sensuality and subjectivity no longer hold sway over the rational self. That is, a fully formed adult is one who has abandoned adolescent practices by regularly exercising his mind over matter so that in his mature state he has undergone a Cartesian coming of age wherein his immaturity and naiveté have been redirected. In the developed world that follows, the work of the successful man no longer requires him to use his back or his hands. Here more base sensate encounters are displaced by cognitive being, hence the traditional workplace ascent from "blue collar" labor to the "white collar" professions.[46]

Second is the matter of subjectivity. If the realism of objectivity belongs to the rational self, then all else must be consigned to the domain of subjectivity, a territory that not only appears antithetical to certainty but also can be perceived as the dark entrance to theaters of doubt. Generally speaking, the arts are engulfed in subjectivity. Consider the following examples. To one, the luminous red field of a Mark Rothko painting appears to be empty, meaningless space. To another, this same work is the deep exploration of unconscious being. One connoisseur might delight in the finery of Japanese porcelain, even as another finds it wholly unremarkable. One admirer might find a monumental sculpture by Mark di Suvero fashioned from steel I-beams and painted blaze orange to be a bold, life-giving civic gesture. A critic of the same might regard it as an urban eyesore. Since there is no obvious objective means to account for this wide variety of likes and dislikes, we regard the variances that result as matters of personal taste or acquired social convention.

Again, if the adult male persona exudes confidence, rationality and certainty, then the disposition of women and children represents indecision, subjectivity and doubt, as the latter group moves move from impression to impression, never gaining mastery of the whole. Many find this soft or indeterminate territory troubling since it suggests that taste (and by extension

---

[45]This kind of sensorial engagement with the world and its subsequent linkage to notions of childish innocence and spirituality is both a central tenet of romanticism and a quality present in a good deal of outsider art.

[46]See Matthew B. Crawford, *Shop Class as Soulcraft: An Inquiry into the Value of Work* (New York: Penguin, 2009), for a highly readable personal reflection on this classist frame of mind.

truth) is a relative matter and that, beheld in this zone, it lacks the needed mettle to accomplish real good in the world.

A third worry has to do with sentimentality. Sentimentality signals a return to childish ways, but unlike the bliss of childish ignorance, when this state is willful or elected, when feelings are either untethered from formal training or some agreed-upon rational framework, it is believed that these lack substance, gravitas. For some religious believers, sentimental notions invite saccharine and even maudlin images of Mary and Jesus in religious gift shops.[47] Their secular counterpart delights in collecting Precious Moments and all manner of mass-produced tchotchkes. Together they find solace in the screensaver kitsch of market-savvy Thomas Kinkade's Media Arts Group, Inc. In these kinds of situations, the objects in question might hold substantial personal meaning to those who possess them, and yet in the larger cultural context they are cliché and trite. But these kinds of objects are easy to criticize. Sports paraphernalia, designer labels and material pop culture are simply more refined iterations of the same.

A fourth and final concern is that the sensate self is vulnerable to the ways of pleasure, especially sexual pleasure. In this regard, the woman is thought to be a disordering presence, a Siren. From Eve to Delilah and from Bathsheba to Salomé, the woman is not only a beauty; she is also a temptress. Meanwhile, it is generally understood that the man who pursues these encounters is the aggressor. But things are not as they appear, for in pursuit of this pleasure he finds himself yielding to an irrational force: the woman in whom he encounters subjectivity and sensuality—this is beyond his control.

Simple physiology confirms that real difference between male and female *Homo sapiens* does exist. But beyond this, the degree to which similarity and difference between males and females is genetically coded or socially acquired remains a matter of considerable research and speculation. Nonetheless, while the topic of difference is both interesting and important, with regard to this study it is secondary. Our interest here is simply to observe the ways in which age and gender stereotypes have been used as a means to dismiss the authority of art and religion.

In fact, postwar conservative Protestants and secular modernists cultivated institutional machismo as a means to establish their dominance. If evangelicals

---

[47]Betty Spackman, *A Profound Weakness: Christians and Kitsch* (Carlisle, UK: Piquant, 2005).

aligned themselves with professional athletes, military heroes and handsome preachers, modernists adopted a frontier aesthetic, tackled monumental projects and assumed a barroom swagger. These inclinations may be more the evidence of America's postwar cultural norms than any doctrinal or aesthetic convictions. But whatever its source or sources, from the 1950s onward both movements sought to cultivate a masculine identity, which in turn generated considerable internal strife.

American modernism often evidences a hard-edged, gritty realism. The movement was urban and not pastoral, more prosaic than poetic, dystopic and not utopian. If America's popular culture celebrated the heroism of what would come to be known as the "greatest generation," modernists traded in existential doubt and explored the anxiety of the unconscious that had been spawned by the violence, mechanization and bloodshed of the new world that was emerging. The work of painters such as Franz Kline and Jackson Pollock and the sculptures of Mark di Suvero and David Smith bears the marks of this kind of machismo—they are bold, direct, raw and immediate.

Also present, but consigned more to the background, was the movement's penchant to explain subconscious states, dreams and primitive mark-making and to make assertions about the primarily subjective nature of aesthetic experience. In one sense, the art world went on to celebrate visionaries and naives and their automatic drawing, brute experiences, sensuality and sexuality. But in another, the demonstration of a kind of romantic weakness in the visual arts has often been regarded as a feminine enterprise, and through much of the modern period, the men who ventured into these endeavors were thought to be feminized or effeminate. If gay identity and sexual practice had previously been present mostly in the background, in the closing decades of the twentieth century it was entirely "outed" in the art world.[48]

---

[48]Unexpectedly, perhaps, modernism pursued a very different direction. Its aesthetic agenda was thought to be overtly masculine (macho) in character. "The gendering of the beautiful as a quality associated with allegedly feminine characteristics came to a head within modernist discourse. Decorousness and grace bowed before virility and authenticity. Raphael was out and Rothko was in. Virile modernists, with the masculine distrust of ostensibly feminine qualities—enveloping, illusory, space, grace, and harmony—searched for a masculine sublime exemplified by Barnett Newman's *Vir Heroicus Sublimis*." Ivan Gaskell, "Beauty," in *Critical Terms for Art History*, ed. Robert S. Nelson and Richard Shiff, 2nd ed. (Chicago: University of Chicago Press, 2003), 272.

While these claims invite all manner of political posturing and social critique, pursuing them in this study will not help us to estimate what is actually at stake. A remarkable irony underlies all of this: most artists in the annals of art history are male, and most architecture in the West is masculine in form.

Meanwhile, postwar evangelicals maintained their own convictions about the roles of men and women. Consider, for instance, the nature of Christian discipleship. Having managed his petulance and subdued his passions, the young believer was to move from "drinking milk" to "eating meat." In time he would gain the very mind of Christ (1 Cor 2:16; Eph 2:3).[49] There is much to commend this account. But in their haste to define Christian maturity, low-church Protestants generally bypassed a role for the senses, save for music. And to the extent that they sought spiritual experience, these were lodged less in the material world and more in the momentary warming of hearts and the training of minds toward God. In other words, evangelical spirituality remained largely gnostic, and this proclivity was reflected in its programs of discipleship and leadership.

If the "upward" move from sensate being to an adult cognitive self seemed like a sure route to Christian maturity, then it was also the prelude to Christian leadership. With few exceptions, Catholics and evangelicals regarded leadership in the church as an exclusively masculine domain. The man of God was to preach the Word of God. Other church duties such as service, hospitality and teaching children were delegated to women. And in Protestant circles, this view gained substantial momentum from turn-of-the-century movements such as "muscular Christianity," which was designed to reverse the feminization of

---

[49]"The religious quest is understood as a commitment to higher things, with a corresponding contempt for the lower. Anthropologically, this has often pitted the soul (more or less associated with reason) against the passions and the body; it has been responsible for the doubtful association of Christianity with the notion of immortality of a disembodied soul. And certain conclusions have followed for the ideal of human maturity often encountered in historical Christianity. This conception is the source of a Christian ethics of repression, directed (like the pagan ethics of the Hellenistic world) chiefly against sexuality as the most imperious of the bodily passions; of Christian distrust of spontaneity, a quality especially associated with childhood; and of the notion of a mature Christian—this might be called the Christian ideal of manhood—as a person who has so successfully cultivated his own bad conscience, his guilt for his persistent attraction to lower things, that he can only come to terms with his existence by a deliberate and rigorous program of self-discipline and self-denial in the interest of saving his soul." William Bouwsma, *A Usable Past: Essays in European Cultural History* (Berkeley: University of California Press, 1990), 399.

faith.[50] In the light of these arrangements, it is no surprise that aesthetic concerns seldom appeared among the "core values" of most evangelical ministries during the postwar period. If the character of art was essentially subjective and feminine, then its purpose must be limited to mere embellishment and decoration. During the postwar period, rare would be the man who ever served on a church decorating committee.

Could it be that these Christians had forgotten Jesus' teaching "Blessed are the meek, for they will inherit the earth" (Mt 5:5), or Paul's reminder to the Corinthian church that "God chose what is foolish in the world to shame the wise; God chose what is weak in the world to shame the strong" (1 Cor 1:27)? Art and life are born of such weakness. And great art and great lives must be continuously open to consider the possibility that weakness is the truth, the truth that lies beyond or beneath the so-called facts that we substitute for truth. This is because truth is engaged and given to empathy. Perhaps we have underrepresented the virtue of childlikeness. Perhaps we have forgotten that childlike faith is lauded in the New Testament.

Whether it is Odysseus's intrigue with the Sirens, the fictional John Lindsay's attempt to create a new Eden, Jesus' teaching regarding the law, or Platonic and Cartesian habits of mind, in the West there has been an imposing and collective nervousness about the capacity of our senses to generate desire even as they jettison reason. As we have seen in this section, one strategy for managing the senses has been to align them with weakness, to regard them as essentially childlike or feminine. In the postwar period, both the evangelical church and the secular art world embraced this bias, albeit in dramatically different ways.

But failing to extol the virtue of our senses might be likened to an urban planner who cannot see a place of brilliance, beauty and hope beyond the failed systems of her city. Meanwhile, the true promise of her blighted habitat can be realized only when its architectural achievements, natural assets, economic

---

[50]"Muscular Christianity," first advanced in nineteenth-century Britain, gained its greatest following in the United States from 1880 to 1920. Fearing that Christianity was being feminized and, therefore, sentimentalized, church leaders observed the need to restore "healthy" and "husky" manliness to the church pews. To accomplish this they undertook a widespread effort to promote physical training and competitive sports among young men, and the YMCA was often the primary vehicle to accomplish this. Though neo-orthodox and liberal Protestant leaders later belittled these convictions, conservatives kept them in play, as evidenced in the Promise Keepers movement (founded in 1990). See Clifford Putney, *Muscular Christianity: Manhood and Sports in Protestant America, 1880–1920* (Cambridge, MA: Harvard University Press, 2001).

potential and civic pride are attended to. So it is with our senses; every effort
to recover their virtue will be futile until we can see beyond the ways in which
they have been apprenticed to debauchery.

In most Christian contexts the way of the cross rests at the heart of disci-
pleship, and it follows that every effort must be made to pilot the ship of the
self away from any ruinous shore. But in resisting the kinds of desires that are
summoned by our senses, Christians must not forgo their opportunity to
enjoy God's good world. In fact, it is God's intention that psalmic joy—a joy
that draws its vitality from unending encounters with the goodness of God
and the fecund splendor of his created cosmos—coexist with sacrifice. A deep
and rich spiritual life will be lived only when aesthetic delight and ascetic
discipline walk hand in hand.[51]

## PLEASURE REDEEMED

Luke 7:36-50 recounts the story of a woman who anointed Jesus' feet with
expensive perfume. Each time I read it, I am reminded of her overwhelming
need and audacious course of action. In what must have seemed like mad hys-
teria to all of those who watched, she rushed to Jesus to prevail on his mercy.

The incident that Luke describes occurs in the household of Simon, where
Jesus, an invited guest, reclines at the Pharisee's table. Though not an eye-
witness to the event, Luke reports that the woman, who had entered the room
uninvited, "brought an alabaster jar of ointment. She stood behind him
[Jesus] at his feet, weeping, and began to bathe his feet with her tears and dry
them with her hair. Then she continued kissing his feet and anointing them
with the ointment" (Lk 7:37-38). By any social or religious standard, the
woman's impulse to let down her hair in public and then use it to cleanse Jesus'
feet—all the while kissing them—was an outrage. She was, according to Luke,
"a woman in the city, who was a sinner" (Lk 7:37). No doubt, the sweet scent
of the spilled perfume permeated the room, and her provocative actions might
have aroused the sexual passions and/or social protests of the men present.

---

[51]Thomas Merton explains it as follows: "Our five senses are dulled by inordinate pleasure. Penance
makes them keen, gives them back their vitality, and more. Penance clears the eye of conscience
and reason. It helps us to think clearly, judge sanely. It strengthens the action of our will. And
penance also tunes us the quality of emotion; it is the lack of self-denial and self-discipline that
explains the mediocrity of so much devotional art, so much pious writing, so much sentimental
prayer, so many religious lives." Merton, *Thoughts in Solitude* (Canada: HarperCollins, 1956), 14.

For most moderns, it will be impossible to estimate the woman's social, psychological and physical vulnerability. Her gender and her supposed profession suggest that she was unwelcome and even unsafe in the Pharisee's house. In fact, Hebrew law might have permitted these men to rise up and stone her, but they did not. The woman's desperate need to be in the presence of Jesus, to receive his forgiveness for her sins and, subsequently, to worship him enabled her to overcome any shame or fear that might have kept her from interrupting Simon's meal.

Audacious though it was, the most remarkable aspect of this story is not the woman's behavior. Rather it is Jesus' acceptance of her advance—even in the face of Simon's protestation. Turning to the woman (facing her), Jesus rebuked Simon, saying, "Do you see this woman? I entered your house; you gave me no water for my feet, but she has bathed my feet with her tears and dried them with her hair. You gave me no kiss, but from the time I came in she has not stopped kissing my feet. You did not anoint my head with oil, but she has anointed my feet with ointment." Not only had Simon refused to receive the woman; he had failed to properly welcome Jesus. Speaking to Simon, but all the while looking at the woman, Jesus continues, "Therefore, I tell you, her sins, which are many, have been forgiven; hence she has shown great love" (Lk 7:44-47). The woman had placed herself beneath the mercy of the only one who could save her and the one who—unbeknown to Simon, the other men and the woman—would one day redeem the whole of creation.

I am grateful that Luke includes this outrageous encounter in his Gospel, but this Gentile writer was not alone in recording this event, or at least an event that resembles it. Mark and John offer similar accounts. On first reading Mark 14:3-9, it might appear to be an abbreviated version of Luke 7. In Mark's telling, however, the woman pours the ointment on Jesus' head, not on his feet, and the interruption in Simon's home occurs just days before Jesus' crucifixion, whereas Luke sets it in an earlier period amid Jesus' active ministry. Simon is mentioned in both accounts, but Luke identifies him as a Pharisee while Mark reports only that he is a leper. Regarding Mark's mention of leprosy, it is worth noting that Simon, the host, might have been considered ceremonially unclean. Meanwhile, Mark's telling includes no mention of the woman's sinfulness.

If the chronologies supplied by Mark and Luke are somewhat reliable, it is not beyond the pale to imagine two separate accounts that feature a man

named Simon (presumably a common name). But perhaps there was just one Simon—both a Pharisee and a leper—and the other conflicting details such as the perfume poured on Jesus' feet in Luke and emptied onto his head in Mark can be harmonized.

Meanwhile, John 12:1-8 provides yet another account of a woman who anoints Jesus with perfume. In John's Gospel this event occurs after Jesus raised Lazarus from the dead and before his final journey to Jerusalem. In certain respects this telling parallels the stories found in Luke and Mark, except for this: here the woman is known to us. She is Mary, the sister of Martha and Lazarus, and a close friend of Jesus. She too empties a "pound of costly perfume made of pure nard" (its value equal to a common laborer's annual earnings) onto Jesus' feet, but not his head. As in the Lucan account, she loosens her hair to wipe Jesus' feet, but unlike in Mark's telling, we have no reason to suspect that Mary is a "sinful woman" or that she has any cause to repent.

In all three accounts, male onlookers are offended by the woman's importunity. In Luke, Simon objects, pointing out that she is a "sinful woman." Jesus rebukes him. In Mark, several self-righteous men protest that the perfume she has spilled might have been sold and its proceeds used to feed the poor. Jesus rebukes them, saying, "You always have the poor with you, and you can show kindness to them whenever you wish; but you will not always have me" (Mk 14:7). In John there is but one detractor, Judas, who is not mentioned either in Mark or Luke. He too protests the waste but then goes on to betray Jesus for thirty pieces of silver. The men—the keepers of decorum, the rule makers and maintainers—are self-righteous and inhospitable. Failing to understand Jesus, each man or group of men betrays him.

The three events we have considered feature a highly sensual moment in which a woman humbles herself before Jesus and anoints him with expensive perfume. The sensuality of what transpires should not suggest that the woman's actions are unmitigated by rational constraint. She is entirely clear-headed about her need, as well as the one who can meet it. In fact, it is only the woman (the one anointing Jesus) and Jesus (the one being anointed) who seem to grasp the gravity of what is occurring. Indeed, each of these sensual anointings either acknowledges the Jewish practice of placing oil on one's head to bestow blessing or imitates the preparation of a deceased body for burial. Jesus confirms this, saying, "She has done what she could; she has anointed my body

beforehand for its burial" (Mk 14:8). This same sentiment is echoed in John 12:7. These sensual acts are entirely sacramental in character.

The Gospels, then, contain one, two or even three separate events that celebrate the sensual, even sensuous, exchange between Jesus and a woman who seeks to worship him.[52] They are spiritual transactions of the deepest sort that are marked by mess, passion and adoration. They are raw, direct and expressionistic, not unlike some kinds of performance art. They stun those who read them. While these women possess no social or cultural power, each has placed herself in the presence of the one who has all power.

The bearing of these three Gospel narratives on the concerns explored in this chapter is powerful and direct. In his telling, each writer highlights the primacy of sensual being as it is manifested in the materiality of the world. In connection to the discussion of our embodiment in chapter two, we are ones who bear God's image and as such are made to exist in life-giving relationship to the created order, our human community and our Creator. This cannot be achieved by the renewing of our minds alone. Rather, it requires the redemption of the whole person, including every sensory receptor that makes its home in our bodies.

Having made this claim, however, once again we come face-to-face with the truth about ourselves: a great gap exists between our human nature and our human potential. We are conflicted beings. We have sinned and will continue to sin, and in this regard it is tempting to blame our senses for these troubles. But according to Jesus the breeding ground for sin lies not in tasting unclean food served up by unwashed hands. Rather, "out of the heart come evil intentions, murder, adultery, fornication, theft, false witness, slander" (Mt 15:19). In line with this thinking, Thomas Aquinas reasons, "For parts of the body don't start action but are merely slaves of the soul's desires, whereas our inner ability to desire is not a slave but a free man in relation to reason, acting as well as being acted on."[53] The pleasure that we derive from our senses is God's good gift to us. As such, we have been created to participate in life to the

---

[52]To help sort this out, William Safire draws a distinction between the terms *sensual* and *sensuous*. "You get a *sensual* kick out of watching an R-rated movie," he says, and "a *sensuous* kick out of listening to music or sniffing the cookies in grandma's oven." Safire, "On Language," *New York Times Magazine*, April 23, 2000, 42. In seeming agreement, Diane Ackerman employs two similar terms, *sensualist* and *sensuist*. Ackerman, *Natural History*, xvii.

[53]Thomas Aquinas, *Summa Theologiae: A Concise Translation*, ed. Timothy McDermott (Notre Dame, IN: Ave Maria Press), 255.

full. To that end, millions of Christians regularly enjoy food, sex, music and art all in a spirit of great thanksgiving. It follows that our propensity to sin is not as the inevitable outcome of our sensate being or any pleasure that it might supply but rather the bad fruit of our misplaced longings.

This chapter underscores the conviction that our passions must be bounded so that we do not harm ourselves, devastate others or spoil the creation—an obligation no different from the one we have to manage whatever wealth, privilege and power we might possess. Stewardship, artisanship and citizenship are all rooted in the same convictions. If love is the best reason to live a bold, generous and audacious life, then love also calls us to practice restraint.

Some years ago it was my good fortune to hear Oscar Hijuelos read the following excerpt from his novel *Mr. Ives' Christmas*. As the story opens, Ives recalls entering Saint Patrick's Cathedral and becoming "lost in a kind of euphoric longing."

> Each time he entered a sanctuary, Ives himself nearly wept, especially at Christmas, when the image of one particular church on Seventh Avenue in Brooklyn, whose choir was very good and the worshipers were devout, came back to him, its interior smelling mightily of evergreen boughs, candle wax, and pots of red and white blossoms set against the columns. Dignified Irishmen, with greatly slicked heads of hair, dockworkers for the most part, turned up in ties and jackets, their wives and children by their sides. And there were bootleggers and policemen and carpenters and street sweepers in attendance as well. And a blind man whom Ives sometimes helped down the marble stairs; a few Negroes, as they were called in those days, all, Ives was convinced, believing in the majesty of the child. The old Italian ladies, their heads wrapped in black scarves and their violet lips kissing their scapular medals, and crucifixes and rosaries, kneeling, nearly weeping before the altar and the statues of Christ and His mother; and at Christmas, the beginning of *His* story, sweetly invoked by the rustic and somehow ancient-looking crèche.
>
> The fact was that Ives, uncertain of many things, could at that time of year sit rather effortlessly within the incense-and-wax-candle-scented confines of a church like Saint Patrick's thinking about the images, ever present and timeless, that seemed to speak especially to him. Not about the cheery wreaths, the boughs of pine branches, the decorative ivy and flowers set out here and there, but rather about the Christ child, whose meaning evoked for

him a feeling for "the beginning of things," a feeling that time and all its suf-
ferings had fallen away.[54]

Deeply Catholic in character, Hijuelos's wonderful prose describes an instance
where Ives indulges the sights, smells, sounds and textures of Christmas and
is led to worship Jesus. The moment is both immanent and transcendent.

While each of our perceptual capacities enables us to participate in the
splendor and mystery of God's world, the most exalted function of the senses
might be realized in worship. To underscore this point, consider the highly
sensate experience of Israel's tabernacle worship—*smell* in the incense and the
offering, *sound* in the trumpet blast and the priest's blessing, *sight* in the
symbols and space, *touch* in the animal sacrifices carried in, *taste* in consuming
the offering itself. For Israelites wandering in the wilderness, this spectacle
would have been unequaled in pageantry.

At their best, sensate encounters are a wellspring of spiritual communion. It
was surely this conviction that led the poet to pen, "Taste and see that the LORD
is good" (Ps 34:8).[55] And here the psalmist simply anticipates John's later claims
regarding the incarnation: "We declare to you what was from the beginning,
what we have *heard*, what we have *seen* with our eyes, what we have *looked* at and
*touched* with our hands, concerning the word of life—the life was revealed, as
we have seen it and testify to it" (1 John 1:1-2). It turns out that the very hearing,
seeing, looking and touching that is the precondition of all art making is also the
bedrock of Christian experience and belief. For as one evangelical hymn con-
firms, in Christ it is possible to celebrate the redemption of all things:

> Bane and blessing, pain and pleasure,
> by the cross are sanctified;
> peace is there that knows no measure,
> joys that through all time abide.[56]

While art might summon our senses to their highest order, our sensate ca-
pacities enable us to love what God loves—his world, his creatures and his
people.

---

[54]Oscar Hijuelos, *Mr. Ives' Christmas* (New York: HarperCollins, 1995), 3-4.
[55]I have in mind writings such as Annie Dillard's *Pilgrim at Tinker Creek*, the poetry of Gerard
Manley Hopkins, the poetry and essays of Wendell Berry, and the creation psalms.
[56]John Bowring (1792–1872), "In the Cross of Christ I Glory."

# 4

# Be Careful Little Eyes What You See

*You cannot see my face; for no one shall see me and live.*

EXODUS 33:20

*When shall I come and behold the face of God?*

PSALM 42:2

*Every picture tells a story, don't it.*

ROD STEWART, *EVERY PICTURE TELLS A STORY*

*We can forgive a man for making a useful thing as long as he does not admire it. The only excuse for making a useless thing is that he admires it intensely. All art is quite useless.*

OSCAR WILDE, *THE PICTURE OF DORIAN GRAY*

On March 12, 2001, obeying the orders of their commanders, Taliban fighters commenced destroying two fifteen-hundred-year-old statues of the Buddha. This pair of landmarks—one towering an imposing 175 feet and the other 120 feet—had been carved deep in the stone cliffs of a remote region near Bamiyan, Afghanistan (figs. 4.1 and 4.2). At one time, some portion of each statue had been gilded, and ample evidence indicates that they were also decorated with lapis or ocher. The outcry against the desecration of these religious and cultural icons was international in scope. Still, the government

of Afghanistan ignored the vehement protest of archaeologists, heads of state and religious leaders and made no effort to curtail or even forestall the horrific iconoclast actions of the Taliban. Even the economic threat of global trade sanctions could not prevent the soldiers from calling down a daily barrage of artillery fire and, finally, using dynamite to utterly destroy the monuments.[1] Islamic fundamentalists like the Taliban are monotheists. They regard Allah as the only true god, and it follows that they do not tolerate the mention of other gods and abhor any image or idol that seeks to represent him.

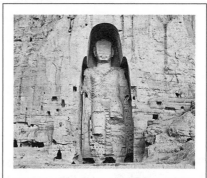

**4.1.** The Buddha, Bamiyan, Afghanistan, c. 500

The repudiation of representational images is the iconoclast's central concern, and the production and adoration of such images has been the occasion for bitter disputes in all three Abrahamic faiths. It has naturally followed that the faith traditions that embrace an iconoclast position are generally those most wary of visual art and especially the rhetorical force of representational images.

Whether one is a thoroughgoing *iconoclast* or a sympathetic

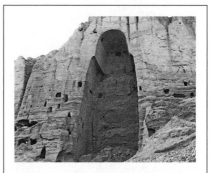

**4.2.** The Buddha after Taliban desecration

*iconophile*, the aims of this chapter are twofold.[2] First, it revisits the besetting and perpetual swirl of controversy regarding the place and meaning of religious images—especially representations of God within the Judeo-Christian tradition. With this first objective before us, it makes sense to revisit Israel's creation and adoration of the golden calf and then to examine the contrasting account of God's command to erect a bronze serpent. Following this, we will

---

[1]See Matthew Powers, "Picking up the Pieces in Afghanistan," *Atlantic*, March 2005, 71.

[2]In some religious communities, *iconodoule*, meaning "servant of the icon," is preferred over the term *iconophile*.

review a trio of church controversies, including the debate surrounding the use of icons in Byzantium, the banishment of religious art and artifacts during the Protestant Reformation and the reinstatement of the same during the Catholic Counter-Reformation. Having assessed these events and debates, we will press ahead to our second aim: an exploration of how images and icons have functioned within conservative Protestantism, with particular attention to the yawning gap that lies between the stated beliefs of postwar American evangelicals and their practice of public and private worship.[3]

## CALVES AND SERPENTS

The account of Israel's golden calf stands as "Exhibit A" in the argument against the construction and adoration of images. In reading Exodus 31 and 32, it is not entirely clear why Aaron, Moses' elder brother, yielded to Israel's demand to fashion this idol. But the text suggests that Moses' forty-day retreat to Mount Sinai had caused the prophet's followers to doubt his actual return. Fearing that the promise of Canaan could not be realized apart from his presence, Israel's leaders, it seems, appropriated the religious practices of their Canaanite neighbors.[4]

In the earlier chapters of Exodus we learn that, prior to their flight from the land of Egypt, God had instructed the people of Israel to plunder the wealth of their oppressors. In due course this material bounty would be used to construct the tabernacle (Ex 12:35-36). But, impatient with Yahweh, the

---

[3]First published in 1973, a frequently quoted evangelical argument against the role of the visual arts in Christian worship is the fourth chapter of J. I. Packer, *Knowing God* (Downers Grove, IL: Inter-Varsity Press, 1993). His understanding of the second commandment centers on a quote from Charles Hodge: "Idolatry consists not only in the worship of false gods, but also in the worship of the true God by images." Packer concludes, "This means that we are not to make use of visual or pictorial representations of the triune God, or of any person of the Trinity, for the purposes of Christian worship. The commandment . . . tells us that statues and pictures of the One whom we worship are not to be used as an aid to worshipping him" (40). But Packer's claim is hardly the central concern of either the first commandment, "you shall have no other gods before me," or the second, "you shall not to make for yourself an idol" (Ex 20:3-4). Rather, both commandments stand against *false worship*, either the worship of *false gods* or the reliance on *false modes*. Since Packer's argument reasonably represents the more iconoclastic side of Protestant evangelicalism, we shall return to it throughout this chapter and again in chapter seven.

[4]"This idol is sometimes thought to be the Egyptian Apis-bull of Memphis or Mnevis bull of Heliopolis." A more likely possibility is that the image was linked to the "Egyptian Horus-worship and bull- or calf-cult." The bull was a symbol of power and fertility. "In nearby Canaan, however, the bull or calf was the animal of Baal or Hadad, god(s) of storm, fertility and strength." J. D. Douglas, ed., *The Illustrated Bible Dictionary: Part I* (Leicester, UK: Inter-Varsity Press, 1998), 225-26.

Jews contributed their gold to the cause of casting and erecting the calf-god. In fact, God had already provided the Jews with several ritual means to encounter his presence, but Israel chose to forsake them. Indeed, the scandalous decision to fashion the golden calf demonstrates Israel's failure to remember the powerful displays of God's providence that they had already witnessed: his visitation of ten plagues on Egypt, his miraculous parting of the Red Sea and the manifestation of his presence in the cloud by day and the pillar of fire by night, to mention a few.[5]

Israel's embrace of the Canaanite idol violated both the spirit and letter of two divine commands. First, God's people had been charged to utterly destroy all idols originating from any of the pagan cultures that surrounded them:

> The images of their gods you shall burn with fire. Do not covet the silver or the gold that is on them and take it for yourself, because you could be ensnared by it; for it is abhorrent to the LORD your God. Do not bring any abhorrent thing into your house, or you will be set apart for destruction like it. You must utterly detest and abhor it, for it is set apart for destruction. (Deut 7:25-26)

Here we must confirm the awkward fact that God's command to Israel recorded in Deuteronomy is not different, in principle, from the actions taken by the Taliban troops in Bamiyan, Afghanistan, who employed explosives as their means to "burn with fire" the ancient carvings of the Buddha.[6]

The second command given to Israel regarding idols is a corollary of the first: God forbade them from fashioning and then worshiping any idols of their own: "You shall not make for yourself an idol, whether in the form of anything that is in heaven above, or that is on the earth beneath, or that is in the water under the earth. You shall not bow down to them or worship them; for I the LORD your God am a jealous God" (Ex 20:4-5). Regrettably, the practice of calf-worship had remarkable longevity in the religious life of Israel. Seven centuries later and in his effort to rival the significance of the temple in Jerusalem,

---

[5]The reality of God's presence and power during the exodus poses a direct challenge to Packer's claim that "God did not show them a visible symbol of himself, but spoke to them; therefore they are not now to seek visible symbols of God, but simply to obey his Word." Packer, *Knowing God*, 49. The mighty acts of God in the wilderness were first and foremost visual and material in nature.

[6]"As many people have remarked, 99 percent of those who were scandalized by the Taliban gesture of vandalism descended from ancestors who had smashed to pieces the most precious icons of some other people—or, indeed, they had themselves participated in some deed of deconstruction." Bruno Latour and Peter Weibel, ed., *Iconoclash: Beyond the Image Wars in Science, Religion, and Art* (Cambridge, MA: MIT Press, 2002), 19.

Jeroboam, Israel's godless ruler during the divided kingdom, erected two more calves, one in Bethel and one in Dan.[7] Condemning this practice, the prophet Hosea protests:

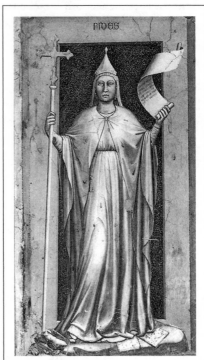

> And now they keep on sinning
>   and make a cast image for
>     themselves,
> idols of silver made according to
>   their understanding,
>   all of them the work of artisans.
> "Sacrifice to these," they say.
>   People are kissing calves!
> Therefore they shall be like the
>   morning mist
>   or like the dew that goes
>     early away,
> like the chaff that swirls from the
>   threshing floor
>   or like smoke from a window.
>       (Hos 13:2-3)

**4.3.** Giotto, *Faith*, c. 1304

Obeisance to an idol invites those who worship it to imagine that the idol's material substance is somehow magical or that it can serve as a medium to the supernatural.[8] As a visual commentary concerning the nature of idolatry, consider Giotto's (1266–1337) fresco painting *Faith and Infidelity*, one of seven pairs that depict the vices and virtues and are a central feature of the considerably larger narrative program of the Scrovegni Chapel in Padua, Italy.[9] The female figure in Giotto's left-hand panel upholds the Word of God in one hand even as she supports a

---

[7]"They rejected all the commandments of the LORD their god and made for themselves cast images of two calves; they made a sacred pole, worshiped all the host of heaven, and served Baal" (2 Kings 17:16). See also 1 Kings 12:28-33 and 2 Chronicles 13:8.

[8]This notion stands opposed to the biblical affirmation that God cannot be contained within or controlled by the things we make. "The God who made the world and everything in it, he who is Lord of heaven and earth, does not live in shrines made by human hands, nor is he served by human hands, as though he needed anything. . . . Since we are God's offspring, we ought not to think that the deity is like gold, or silver, or stone, an image formed by the art and imagination of mortals" (Acts 17:24-25, 29).

[9]I thank art historian Wayne Roosa for directing my attention to this work by Giotto.

cross in the other (fig. 4.3). Her faith is wholly dependent on God's written and living Word. Meanwhile, the male figure in the right-hand panel supports the statue of an idol—presumably representative of pagan deities—in the palm of his upturned hand (fig. 4.4). The idol is inconveniently tethered to him. If he fails to uphold it, the idol will fall to hang like a millstone about his neck, thereby betraying him. Giotto's image, which is not without humor, nicely illustrates the sentiments of the prophet Isaiah, whose words expose the foolish mind of any artisan who elects to craft an idol:

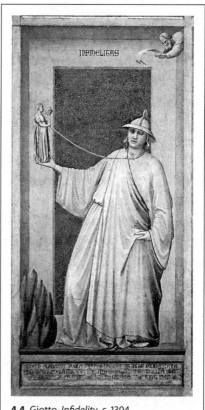

**4.4.** Giotto, *Infidelity*, c. 1304

> The carpenter stretches a line, marks it out with a stylus, fashions it with planes, and marks it with a compass; he makes it in human form, with human beauty, to be set up in a shrine. He cuts down cedars or chooses a holm tree or an oak and lets it grow strong among the trees of the forest. . . . Half of it he burns in the fire; over this half he roasts meat, eats it and is satisfied. He also warms himself and says, "Ah, I am warm, I can feel the fire!" The rest of it he makes into a god, his idol, bows down to it and worships it; he prays to it and says, "Save me, for you are my god!" (Is 44:13-14, 16-17)

It might seem that Isaiah's reasoning supplies iron-clad support for the iconoclast position, but the larger Sinai story reveals three divine mandates that counter this conclusion: the planning and construction of the tabernacle and the ark of the covenant, including the use of symbols and images; God's Spirit-filled call to Bezalel and Oholiab, artisans who possess the extraordinary set of skills needed to lead the effort; and the production and erection of the bronze

serpent as an icon of healing. While each of these mandates merits lengthier discussion, for our purpose a closer look at the serpent narrative will suffice.

As noted, Israel's forty-year sojourn in the wilderness was marked by impatience. Following a military victory over the Canaanites and en route to the Red Sea, they complained, "Why have you brought us up out of Egypt to die in the wilderness?" In response, "the LORD sent poisonous serpents among the people, and they bit the people, so that many Israelites died" (Num 21:5-6). Realizing their desperate plight, the people repented and begged Moses to intercede to God for their deliverance. In response, "the LORD said to Moses, 'Make a poisonous serpent, and set it on a pole; and everyone who is bitten shall look at it and live'" (Num 21:8).

Given God's judgment on Israel for erecting the calf, coupled with Satan's earlier personification as a serpent (Gen 3:4, 13)—not to mention the snakes' predatory nature in the Numbers account and their general status as an "unclean" creatures according to Levitical law—God's command to fashion the likeness of a reptile and then to lift it up on a pole appears counterintuitive, if not absurd. Nonetheless, this bronze casting became a means of God's mercy so that, as promised, all who gazed on it would be rescued (saved). During Israel's exodus and beyond, this image became a tangible symbol of redemption, so much so that according to Jesus it foreshadowed his atoning work: "Just as Moses lifted up the serpent in the wilderness, so must the Son of Man be lifted up, that whoever believes in him may have eternal life" (Jn 3:14-15).[10]

In fact, the Bible makes frequent and positive reference to the use of visual symbols. Early in Israel's formation, for instance, the patriarchs were instructed to build altars; upon Israel's long-awaited entry into the Promised Land, God commanded Joshua to assemble two twelve-stone "memorials"—one in the middle of the Jordan and the other on its western shore—to serve as a signs (Josh 4:1-24); a pair of golden cherubim and

---

[10]King Hezekiah, who "did what was right in the sight of the LORD," "removed the high places, broke down the pillars, and cut down the sacred pole. He broke in pieces the bronze serpent that Moses had made, for until those days the people of Israel had made offerings to it; it was called Nehushtan" (2 Kings 18:3-4). In the New Testament Paul refers to this destruction of the serpents (1 Cor 10:9). See also David Freedberg, *The Power of Images: Studies in the History and Theory of Response* (Chicago: University of Chicago Press, 1989).

other elaborate ornaments and utensils were created for the tabernacle (Ex 25:17-40); symbols of God's presence were contained within the ark of the covenant (Ex 25:10-16); and Solomon replaced the portable tabernacle with a permanent temple that included the design and creation of numerous sacred vessels (2 Chron 2:1–4:22).[11] Not least, Jesus imbued common bread and table wine with profound spiritual significance. The Bible supplies incontrovertible evidence that images and symbols that exist in service to God might be rightly held in high esteem.

But these positive biblical examples notwithstanding, the allure of refined materials and skillfully crafted objects enhanced by the artist's vision and persona have tempted many to be more impressed by the passing work of human hands than the power and splendor of God's presence.[12] According to philosopher Nicholas Wolterstorff, here "works of art become surrogate gods, taking the place of God the Creator; aesthetic contemplation takes the place of religious adoration; and the artist becomes one who, in agony of creation, brings forth objects in absorbed contemplation of which we experience what is of ultimate significance in human life."[13]

### THREE CONTROVERSIES

Having contrasted one account of Israel's abuse of an image in worship with a second that highlights an acceptable, God-assigned use, intriguing questions arise. For instance, if an artist is both unable and forbidden to create an actual *likeness* of God, is she permitted to create a *symbol* or an *image* that represents God? If such symbols or images are permitted, what is their place or function

---

[11]See Wayne Roosa, "A Meditation on the Joint and Its Holy Ornaments," in *Imagination and Interpretation: Christian Perspectives*, ed. Hans Boersma (Vancouver: Regent College Publishing, 2005), 152-54.

[12]The heart of the pagan challenge, of course, has less to do with the *medium* of representation (such as word, image and ritual) by which deities are depicted and more to do with its *message* (the identity of these deities and what they represent). See Herbert N. Schneidau, *Sacred Discontent: The Bible and Western Tradition* (Berkeley: University of California Press, 1977).

For Christians, Augustine offers this apt assessment: "How many things craftsmen have made, things without number, employing their manifold skill and ingenuity on apparel, footwear, pottery and artifacts of every conceivable kind, on pictures too, and various images; and how far they have in these matters exceeded what is reasonably necessary or useful, or serves some pious purpose! All of them increase the temptations to which our eyes are subject." Augustine, *The Confessions*, trans. Maria Boulding, O.S.B. (New York: Vintage, 1998), 232.

[13]Nicholas Wolterstorff, *Art in Action: Toward a Christian Aesthetic* (Grand Rapids: Eerdmans, 1980), 50.

in personal or corporate worship? In the history of the church, this pair of questions represents the substance of three precedent-setting debates.

*The Second Council of Nicaea.* In years that followed the conversion of Roman emperor Constantine (c. 274–325) to Christianity in 312, the center of the empire was relocated from Rome to Byzantium, which the ruler renamed Constantinople. It is said that Eusebius (c. 260–339), the bishop of Caesarea, would not allow the emperor an image of Christ. Nonetheless and in service to the church, artists of the day produced a great many liturgical objects and crucifixes of rare beauty, and this practice continued for several hundred years.[14]

Young Leo III (680–741), however, a brilliant military tactician and the seventh emperor of Byzantium, was a hard-bitten iconoclast. As John Julius Norwich explains, it might have been the influence of Islam on Leo's family that created this disposition. In any case, "for some time the cult of icons had been growing steadily more uncontrolled, to the point where holy images were openly worshiped in their own right and occasionally even served as godparents at baptisms."[15] Nine years into his rule, Leo destroyed "the most prominent icon in the whole city," a large golden image of Christ placed high atop the Chalke Gate, the principal entrance to the imperial palace.[16] The popular reaction was immediate: a group of outraged women killed the commander of the demolition party on the spot. Matters continued to escalate:

> In 730 he [Leo III] finally issued his one and only edict against the images. All, he commanded, were to be destroyed forthwith. Those who disobeyed would be arrested and punished. In the East, the blow fell most heavily on the monasteries, many of which possessed superb collections of ancient icons— together with vast quantities of holy relics, now similarly condemned. Hundreds of monks fled secretly to Greece and Italy taking with them such smaller treasures as could be concealed beneath their robes.[17]

---

[14]Samuel Laeuchli, *Religion and Art in Conflict* (Philadelphia: Fortress, 1980), 79.

[15]John Julius Norwich, *A Short History of Byzantium* (New York: Vintage, 1999), 112.

[16]Some scholars contest the historicity of this account.

[17]Norwich, *Short History*, 112. Revisiting this history, Martin Chemnitz wrote, "He himself at Constantinople collected all statues from the churches, and burned them in the midst of the city, scraped off the pictures, and whitewashed the walls. Those who spoke against this he either beheaded, or mutilated in some other part of their body. He burned a teacher together with his pupils, having shut them up in a house." Chemnitz, *Examination of the Council of Trent,* trans. Fred Kramer (St. Louis: Concordia, 1986), 4:108.

Leo died in 742 and was succeeded by his son, Constantine V, who, like his father, hated icon worshipers and continued the cruel persecutions. "His most celebrated victim was Stephen, Abbot of the monastery of St. Auxentius. Accused of every kind of vice, he was stoned to death in the street, but he was only one of several thousand intractable monks and nuns who suffered ridicule, mutilation or death in defence of the icons."[18]

On the occasion of Constantine V's death, his eldest son, Leo IV, assumed the throne, but he died at the early age of thirty-one, leaving the rule of Byzantium to his wife, Irene. She was "a fervent supporter of images, who constantly strove against iconoclasm and all that it stood for." With her son, Irene invited Pope Hadrian I to attend what would become the seventh ecumenical council, the Second Council of Nicaea (787), at which a great reversal occurred: "Iconoclasm was condemned as heresy" but with the proviso that icons were "to be objects of veneration rather than adoration."[19] It was agreed: signs, symbols and icons could again be permitted as a means to prepare the worshiper to embrace and adore God's true icon, Jesus Christ.[20]

More than six hundred years later and at the height of the Italian Renaissance, it must have seemed that the place of religious icons and images was wholly secure. But while artists continued to produce extraordinary Christian art, they and their scholarly counterparts also demonstrated a renewed appreciation for pagan myths and ancient philosophies.[21] Increasingly, they celebrated the human spirit rather than the divine. Powered by economic abundance, the compromised ambition of powerful Renaissance patrons and church leaders was often exposed.

*The Protestant Reformation.* In 1517 Martin Luther (1483–1546) inaugurated a sea change in the religious, social, economic and political life of Europe. In nailing his *Ninety-Five Theses* to the door of Castle Church in Wittenberg, the German cleric effectively launched the Protestant Reformation. Challenging the divine right of the pope and the cardinal doctrines and practices of the church in Rome, Luther held the conviction that, in matters of faith, *sola*

---

[18]Norwich, *Short History*, 114.

[19]Ibid., 116.

[20]See John of Damascus, *On the Divine Images: Three Apologies Against Those Who Attack the Divine Images*, trans. David Anderson (Crestwood, NY: St. Vladimir's Seminary Press, 2000).

[21]See Malcolm Bull, *The Mirror of the Gods: How Renaissance Artists Rediscovered the Pagan God* (Oxford: Oxford University Press, 2005).

*scriptura* (Scripture alone) and not the traditions of the church and its clerics should be the absolute source of all spiritual authority.

Once again, the visual arts were implicated and in two respects. First, art represented the considerable wealth and holdings of the church, a symbol of its oft-abused privilege. But more than this, the production of devotional images—especially efforts to produce likenesses of God—seemed to defy the biblical injunction against adding or subtracting a single word from Holy Scripture (Rev 22:18-19).[22] That is, fashioning images of God was additive since its visual and material nature would, of necessity, communicate something of God's true nature. The greater offense is that the mystery and beauty of God would now be represented by artists and artisans who were re-fashioning the God-created material world that was already bearing witness to his power and glory (Rom 1:20, 23). And so, like the iconoclasts who preceded them, Protestant reformers such as Zwingli and Calvin regarded the creaturely use of material forms to represent God's ineffable nature a blasphemy.

As early as 1524, Swiss reformer Ulrich Zwingli (1484–1531) had paintings and sculptures systematically removed from Protestant churches in Zurich. And as historian Lee Wandel explains it, although the actual destruction of Christian icons and the whitewash of sanctuary walls in major European cities such as Zurich, Strasbourg and Basel were executed by relatively small bands of activists, it was the sermons being preached in the churches that incited the reactionary zeal of its parishioners.[23]

While the writings of French reformer John Calvin (1509–1564) often celebrate the beauty of God's creation and demonstrate confidence in the place of beauty and the value of the arts, he too deeply opposed the presence of

---

[22]Though overstated, here Packer heads in the right direction: "The heart of the objection to pictures and images is that they inevitably conceal most, if not all, of the truth about the personal nature and character of the divine Being whom they represent." Packer, *Knowing God*, 46.

[23]"In the sixteenth century, in dozens of towns and villages, otherwise ordinary people—parish clergy, bakers, carpenters, gardeners, most employed and most of them citizens—broke into local churches and smashed or burned thousands of long-beloved, familiar, treasured objects: altars, altar retables, crucifixes, carved and painted triptychs and diptychs, panel paintings, architectural and free-standing sculptures, chalices, patens, candlesticks, and oil lamps." Lee Palmer Wandel, *Voracious Idols and Violent Hands: Iconoclasm in Reformation Zurich, Strasbourg, and Basel* (Cambridge: Cambridge University Press, 1994), 3-4. Also see Carl C. Christensen, "Reformation and Art," in *Reformation Europe: A Guide for Research*, ed. Steven Ozment (St. Louis: Center for Reformation Research, 1982), 250, and Carlos M. N. Eire, *War Against the Idols: The Reformation of Worship from Erasmus to Calvin* (Cambridge: Cambridge University Press, 1998).

images and symbols in the church. According to Calvin, "Paul declares, that by the true preaching of the gospel Christ is portrayed and in a manner crucified before our eyes.... From this one doctrine the people would learn more than from a thousand crosses of wood and stone."[24] In concert with other reformers, Calvin believed that when someone placed his life before the measure of God's Word, his idolatrous nature—the temptation to worship inert and visible things rather than the living and invisible God—would be made plain. The reformer would certainly have agreed with Lutheran theologian and reformer Martin Chemnitz, who wrote, "The best, surest, and most useful image of God and of Christ is the one which the understanding of our minds forms and conceives from the Word of God."[25] In this regard, extrabiblical ideas were especially objectionable so that highly popular religious images such as the pietà were regarded not only as fiction but, worse still, as heresy. It followed that artists who fashioned these kinds of work or the patrons who sponsored them could only be regarded as enemies of the gospel.

*The Council of Trent.* The charges of these upstart Protestant clerics and scholars, coupled with the violent actions of their followers, could hardly be ignored by the Roman Church. In a defensive posture, the Council of Trent (1545–1563) preserved the view that sacred images were legitimate provided they met certain criteria:

> The holy synod enjoins that images of Christ, of the Virgin Bearer of God, and of other saints are to be had and retained particularly in the churches, and that due honor and veneration be shown them; not as though they were believed that any divinity or power resided in them, on account of which they are to be worshipped, or that anything should be requested of them, or that trust should be placed in images, as was formerly done by the heathen, who placed their hope in idols, but because the honor which is shown them is bestowed on the prototypes they represent, so that through the images which we kiss, and before which we uncover our head and bow down, we may adore Christ, and venerate the saints whose similitude the images bear, as has been defined by the decrees of councils, especially the Second Nicene Synod, against the opponents of images.[26]

---

[24]To this Calvin adds, "As for crosses of gold and silver, it may be true that the avaricious give their eyes and minds to them more eagerly than to any heavenly instructor." John Calvin, *Institutes of the Christian Religion*, trans. Henry Beveridge (Grand Rapids: Eerdmans, 1995), 96.

[25]Chemnitz, *Council of Trent*, 80.

[26]Ibid., 53.

These affirmations of the Catholic Reformation protected the interests of late sixteenth-century Italian artists who sought to create religious images, particularly works depicting the Godhead and Mary. In addition to renewing the church's general support for Christian art, the council was careful to protect church interests. More practically, this meant that the form and content of the artists' labors would be closely monitored to ensure that their works conformed to established church doctrines and enhanced the devotion of the laity.

In sympathy with the events that led to the Catholic reform, Ignatius Loyola (1491–1556), founder of the Jesuits, created a spiritual exercise that utilized both word and image. Exercise forty-seven states, "When the contemplation or meditation is on something visible, for example, when we contemplate Christ our Lord, the representation will consist in seeing in imagination the material place where the object is that we wish to contemplate."[27] Modern secular people might regard the ascetic constraints of Ignatius's *Spiritual Exercises* extreme or obscure, but they were not regarded as such by the renowned sculptor Gian Lorenzo Bernini (1598–1680), who, "following the counsel of Ignatius, withdrew once a year into the solitude of a monastery to devote himself to spiritual exercises."[28] Similarly, the Spanish painter El Greco (1541–1614) gave himself to these same disciplines.

In the aftermath of Trent, these devotional practices demonstrate that the ongoing presence of sacred themes in the art of the day amounted, for some at least, to something considerably more substantially than the resolution of a formal problem or the completion of a public commission. Of this we can be certain: both the Catholic reformers and their Protestant antagonists understood the capacity of religious images to codify theological understanding and secure the affection of worshipers. For this reason the ratification of Trent held profound aesthetic and ecclesiastical implications.[29] In this regard art historian A. W. A. Boschloo compares the painter's vocation to that of a preacher:

---

[27]Ignatius Loyola, *The Spiritual Exercises of St. Ignatius*, trans. Louis J. Puhl, S.J. (Chicago: Loyola University Press, 1951), 25.

[28]Arnold Hauser, *The Social History of Art*, vol. 2, *Renaissance, Mannerism, Baroque* (New York: Vintage, 1957), 185.

[29]Hauser asserts that "the mature baroque triumphs over the more refined and exclusive style of mannerism, as the ecclesiastical propaganda of the Counter Reformation spreads and Catholicism again becomes a people's religion." Ibid., 104. See also Frederic C. Church, *The Italian Reformers 1534–1564* (New York: Columbia University Press, 1932), 34.

The painter is a preacher differing from the "true" preacher only to the extent that he addresses the people with image and not with words. Like the artist, the preacher is advised to adhere literally to the biblical text and not employ complicated imagery, but to penetrate his audience's heart with simple unembellished terms. Useless eloquence and rhetorical fireworks are reprehensible; they testify only to the speaker's vanity, while it is really the spiritual welfare of the faithful he should have at heart.[30]

**Modern divergence.** A mere half-century after the ratification of Trent, boatloads of colonists crossed the Atlantic to establish communities in America. These Puritans, Quakers and other low-church or free-church Pietists sought a simple word-based, congregational approach to worship. They were iconoclast in every respect.[31] And while later groups such as the Shakers and eventually the Amish upheld similar views, the aesthetic disposition of America's religious founders indelibly marked the nation's attitude toward the visual arts.[32]

Having noted the iconoclasm of the Protestant Reformation and the centrality of this mindset to the early colonizers of America, it seems important to remember that the iconoclastic impulse is not unique to Christianity or, for that matter, even to religion. A diverse range of social, political and aesthetic revolutions and reforms, often secular in nature, have called for the annihilation of images. During the French Revolution (1789–1791), for instance, angry mobs smashed stained-glass windows and Gothic sculptures. As we observed in chapter three, claiming aesthetic affiliation with Shaker sensibilities, 1960s minimalists were no less radical. In pursuit of referent-free objects, they directed their creative attention to inert material and pure form, hoping to resist the tug of either spiritual transcendence or political engagement. Similarly, as American forces invaded Iraq in 2003, statues and images of brutal dictator Saddam Hussein were gleefully toppled and defaced—this only two years after Taliban soldiers had destroyed the Buddhas in Bamiyan (fig. 4.5).

Despite America's iconoclastic Protestant roots, contemporary Americans are essentially iconophiles and radically so; that is, they rely on the visual to

---

[30]A. W. A. Boschloo, *Annibale Carracci in Bologna: Visible Reality in Art After the Council of Trent,* trans. R. R. Symonds (Maarsen: Gary Schwartz, 1974), 153.

[31]See William A. Dyrness, "The Visual Arts in America," in *Visual Faith: Art, Theology, and Worship in Dialogue* (Grand Rapids: Baker Academic, 2001), 58-67.

[32]The colonizing efforts by predominantly Catholic countries such as Spain and France yielded entirely different results.

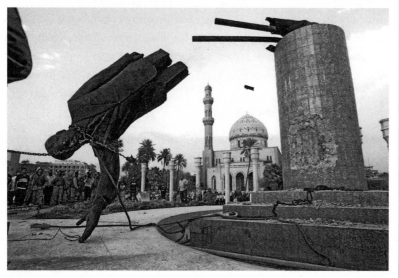

**4.5.** US troops topple a statue of Saddam Hussein in Baghdad, Iraq

represent their passions, preferences and beliefs. Nowhere is this more evident than in the popular appropriations of the term *icon*. For nearly two millennia this word was a referent to objects or images representing God. But in recent decades *icon* has been assigned new duties; today the term signifies the adulation of popular personalities, the focus of consumer desire and the graphical interface that appears on millions of computer screens.[33] The dramatic secularization of this term is now so thorough that even the most committed Protestant iconoclast might be inclined to appreciate Pope John Paul II's conviction that

> the rediscovery of the Christian icon will . . . help in raising the awareness of the urgency of reacting against the depersonalizing and at times degrading effects of the many images that condition our lives in advertisements and the media, for it is an image that turns towards us the look of Another invisible one and gives us access to the reality of the eschatological world.[34]

---

[33]Consider William Safire's wry commentary: "The meaning of icon has evolved to 'revered symbol.' . . . Now, in this time of symbol-fascination, icon is being worked harder by people who have tired of using metaphor as a voguish substitute for paradigm, model, archetype, standard, or beau ideal. . . . I get the unmistakable message that the word's meaning is now 'cherished symbol' extended far beyond religion." Safire, "I Like Icon," *New York Times Magazine*, February 4, 1990.

[34]John Paul II, *Duodecimum Saeculum* (Veneration of Holy Images), December 4, 1987, sec. 11.

## EVANGELICAL ICONS

Not a few evangelical readers who have followed my account thus far of the icon and its alter ego, the idol, might imagine that this business is not much their concern. But they are mistaken. To illustrate the point I will again reference my own Protestant upbringing. In the church of my youth, a picture of Jesus occupied the central place on the front wall of our main Sunday school room. It featured a lighted door at nightfall, and before it stood Jesus patiently knocking. Painted by a woman in our congregation, it was a persuasive rendering—a copy— of Warner Sallman's *Christ at Heart's Door* (1942) (fig. 4.6), which itself owes a substantial debt to William Holman Hunt's *Light of the World* (1851–1856). Considerable care had been taken to mount the woman's work in a gold frame and to illuminate it from above. Apart from the stained-glass window at the front of our sanctuary (another image of Jesus), this picture was the only "original" work of art in the church.

**4.6.** Warner Sallman, *Christ at Heart's Door,* 1942

Decades later I viewed Sallman's *Christ at Heart's Door* in an exhibition of his work on display at the University of Chicago.[35] Sallman (1892–1968) "lived his life in Chicago, where he was trained as a commercial artist at the School of the Art Institute."[36] Without a doubt, the artist's most popular work is his *Head of Christ* (1940), and this painting in its original state was also on

[35]This exhibition of Sallman's paintings, on loan from Anderson College, a small Christian liberal arts college in Anderson, Indiana, and Warner Press, was displayed at the University of Chicago's Divinity School. In conjunction with the show, Jason Knapp and David Morgan hosted a day-long scholarly symposium on March 4, 1994.

[36]David Morgan, *Icons of American Protestantism: The Art of Warner Sallman* (New Haven, CT: Yale University Press, 1996), 6.

view (fig. 4.7). In Protestant America, Sallman's *Head of Christ*—a blue-eyed and Nordic-looking Jesus—occupied a place of honor in countless churches and Christian homes. Some calculate that this painting has been reproduced more than 500 million times. Moreover, having completely penetrated the nation's postwar mentality, for many the painting functioned as nothing less than an authorized portrait of the Savior.[37]

**4.7.** Warner Sallman, *Head of Christ*, 1940

In theory the Protestant Reformation should have steeled fundamentalists and evangelicals against the production and distribution of such images. But even as they looked askance at Catholic devotion to, say, the Stations of the Cross or the Eastern Orthodox veneration of icons, largely because of the power of Christian publishing they embraced Sallman's work—as well as a host of images inspired by the Bible—without reservation.[38] Suffice it to say, if the King James Bible was considered to be the translation that best represented God's Word as he intended it to be read, then Sallman's painting was thought to be a reliable depiction of God's Son.

In fact, the postwar evangelical appetite for such images was voracious. In 1966, for instance, Kenneth Taylor produced his *Good News for Modern Man*, a widely released, reader-friendly paraphrase of the Bible filled with simple line drawings used to illustrate a variety of scenes and stories. Published by the American Bible Society, an estimated 225 million copies are in circulation. The illustrations for this bible were created by Annie Vallotton (1915–2013). In her

---

[37]Ibid. In fact, the picture's authority has far less to do with Sallman's artistry (there is reason to believe that he freely "appropriated" this image from Léon Augustin Lhermitte's *Friend of the Humble* [1892]) and more with the marketing savvy of Kriebel & Bates, Inc., the publisher who owned its copyright.

[38]David Morgan points out that nineteenth- and twentieth-century Protestant practices held devotional images in high esteem. Morgan, *Protestants and Pictures: Religion, Visual Culture, and the Age of American Mass Production* (New York: Oxford University Press, 1999).

effort to supply these drawings with a "modern look and feel," Vallotton did not assign a particular character to the figures or their faces. To twenty-first-century viewers, Jesus, John the Baptist and her other depictions might have the look and feel of alien invaders. But beyond Vallotton's illustrations for *Good News for Modern Man*, consider this: each year millions of Christians enthusiastically send and receive Christmas cards that, without qualification, depict the Holy Family at rest before the Bethlehem manger with the Christ child and choirs of angelic beings singing "Glory to God in the highest."

Meanwhile, illustrated Bibles and Christmas cards pale in comparison to the more recent and extraordinary confidence evangelicals have conferred on cinematic representations of Jesus. Consider Campus Crusade's *Jesus* film. Translated into 1,420 languages, this film has been screened around the globe with a viewership estimated to be in the billions.[39] The astonishing distribution of the *Jesus* film is regarded by some as a primary contribution to world evangelization and, not without irony, the film has been viewed in thousands of evangelical churches that are otherwise as "cleansed" of icons, paintings and sculptures as any in Calvin's Geneva. Supporters of this project defend its pedagogical value, its usefulness both in teaching the faithful and in communicating the story of Jesus to the unchurched.[40] But perhaps the greatest irony is this: though unwilling to display a crucifix on their sanctuary walls, in 2004 conservative Protestants bused record numbers of their congregants to local theaters to view Mel Gibson's *The Passion of the Christ*, a graphic and decidedly Catholic enactment of Jesus' suffering and death.

These wildly popular receptions should not lead one to conclude that in postwar America the iconoclastic spirit that was once so foundational to the establishment of American fundamentalism and evangelicalism has substantially vanished. But generally speaking, "imaging" Jesus became an accepted practice—accepted, that is, unless these images were either not to their liking or at odds with their interpretation of the biblical account. If they failed either of

---

[39]"The Official Ministry Statistics of The JESUS Film Project," The Jesus Film Project, March 4, 2016, www.jesusfilm.org/film-and-media/statistics/statistics.

[40]According to Joseph Leo Koerner, the precedent for these attitudes toward images can be found with Luther, who "tolerated and then finally even espoused church art if it served to instruct." Koerner continues, "Didacticism required that the image become less rather than more: Less visually seductive, less emotionally charged, less semantically rich. Deemed useless save as school pictures, images were built to signal the fact of their impotence." Koerner, *The Reformation of the Image* (Chicago: University of Chicago Press, 2004), 28.

these tests, they would meet harsh evangelical resistance staged on one of two fronts: edgy or controversial films such as Monty Python's *Life of Brian* (1979), Martin Scorsese's *The Last Temptation of Christ* (1988) and Denys Arcand's *Jesus of Montreal* (1989) would be either boycotted or ignored. Meanwhile, in conservative evangelical settings, a deep mistrust of icon veneration remained.

Thus far we have considered the relative merits and demerits of religious images in Christian life and worship and observed that, contrary to their theological and historical roots, twentieth-century conservative Protestants were in fact rabid consumers of Jesus images. But a deeper and more penetrating matter remains, and it has to do with the increasing use of images in evangelical spiritual formation.

## OBJECTS OF DEVOTION

In some evangelical circles and especially in the 1980s and 1990s, it was not unusual for Henri Nouwen's thoughts regarding Jesus, the simple life and compassion for the needy to turn up in a Sunday sermon or a small group discussion. But from time to time even Nouwen's Protestant enthusiasts could find the priest's Catholicism disconcerting. Such is his meditation on an image of Jesus fashioned by world-renowned Orthodox icon writer Andrei Rublev (c. 1360–1430).[41] In Nouwen's essay *The Road to Daybreak*, the priest explains how, after pondering Rublev's icon for several exasperating days, he was led to a direct encounter with Jesus:

> As I look into your eyes, they frighten me because they pierce like flames of fire my innermost being, but they console me as well, because these flames are purifying and healing. Your eyes are so severe yet so loving, so unmasking yet so protecting, so penetrating yet so caressing, so profound yet so intimate, so distant yet so inviting.[42]

What shall we make of Nouwen's epiphany? Did God's Spirit use the tiny strokes of the icon writer's brush to generate a connection between the priest's physical vision and his heart, mind and spirit—a mystical encounter unbounded by words? Or did Rublev's image simply function as a talisman, bringing forward what Nouwen already knew of Jesus from his many readings of the Gospels?

---

[41]For more on the life and work of Andrei Rublev, view Andrei Tarkovsky, *Andrei Rublev* (1966).
[42]Henri J. M. Nouwen, *The Road to Daybreak: A Spiritual Journey* (New York: Doubleday, 1990), 56.

While evangelicals have considered Nouwen's encounter a mostly Catholic or Orthodox event, their own devotional practices could bear remarkable similarities.[43] Richard Foster, a devout Quaker, writes, "Sometimes it is good to close the eyes in order to remove distractions and center attention on the living Christ. At other times it is helpful to ponder a picture of the Lord or look out at the lovely trees and plants for this purpose."[44] Older evangelicals will recall the familiar refrain of Helen H. Lemmel's hymn "Turn Your Eyes upon Jesus." Written in 1922, it remained popular for many decades, including later interpretations and performances by Amy Grant and Michael W. Smith.

Typically, evangelicals have embraced and continue to embrace two primary devotional practices: Bible reading and prayer. In fact, visual imagination is critical to both. On hearing the Gospel account of, for example, Jesus calming the storm on the Sea of Galilee, a person might imagine Galilee's choppy water and gusty winds as well as that next moment when Jesus commands the storm to be still. In her mind's eye, she might see the sky brighten and serenity return to the water's surface and calm come across the faces of the troubled disciples. While reading or listening to the story, a mental picture of the scene takes form. Similar phenomena transpire during prayer. When a person closes his eyes to pray, it is not unusual for a set of images to appear. Here the disciple can employ his imagination to recall stories and events; use a natural object such as a stone, a feather or a shell to contemplate God's divine design; light a Christ candle; place a cross or crucifix in his hand; or even imagine the face of Jesus.

The larger point is this: the history of American evangelicalism and its relationship to material culture confirms that *visualization* has been central to its piety. Argues Foster, "We simply must become convinced of the importance of thinking and experiencing in images. It came so spontaneously to us as children, but for years now we have been trained to disregard the imagination, even to fear it."[45] What Foster and others like him propose is a devotional bridge that connects the visible to the invisible—one not unlike Jacob's waking vision of angels ascending and descending in the night (Gen 28:10-17).

---

[43]In fact, American Protestantism abounds in popular religious images, and though they rarely occupy a central place in public worship, they are devotionally significant. See Morgan, *Protestants and Pictures.*

[44]Richard J. Foster, *Celebration of Discipline: The Path to Spiritual Growth* (San Francisco: Harper & Row, 1978), 21-22.

[45]Ibid., 23.

Father Sebastião Rodrigues, the protagonist in Shusaku Endo's novel *Silence*, describes his encounter with the face of Christ as follows:

> As for me, perhaps I am so fascinated by his face because the Scriptures make no mention of it. Precisely because it is not mentioned, all its details are left to my imagination. From childhood I have clasped that face to my breast just like the person who romantically idealizes the countenance of one he loves. While I was still a student, studying in the seminary, if ever I had a sleepless night, his beautiful face would rise up in my heart.[46]

While it is not clear how exactly God's Spirit guides such transactions, it is surely the case that modern-day Bible readers and prayer practitioners reflexively consult a vast archive of movie clips, personal experiences, artist renderings and subconscious archetypes to complete these acts.[47]

Meanwhile, to those who find Foster's line of reasoning either awkward or suspect, the sentiment of the children's Sunday school chorus we considered earlier might seem apt:

> O be careful little eyes what you see,
> O be careful little eyes what you see,
> For the father up above is looking down in love,
> So be careful little eyes what you see.

Within the church, at least, the kinds of practices considered in this chapter continue to stir substantial disagreement. Some believe that any preoccupation with physical spaces, objects and images belonging to the material world should be set to the side so that one may approach God unhindered. Others, meanwhile, regard these same encounters as central to their devotional life. So, while the evangelical rank and file may fear that Nouwen's interaction with the Rublev icon crossed into unacceptable territory, many of their most cherished practices bear a striking resemblance to his account.[48]

---

[46]Shusaku Endo, *Silence*, trans. William Johnston (1967; London: Peter Owen, 1976), 79. See also Makoto Fujimura, *Silence and Beauty: Hidden Faith Born of Suffering* (Downers Grove, IL: InterVarsity Press, 2016).

[47]For instance, if the actor Charlton Heston parting the Red Sea in Cecil B. DeMille's *The Ten Commandments* is the first image of Moses to register on one's mind, then each subsequent image of Moses (literal or imagined) can only be, in some way, a revision of the first.

[48]Here literary critic Northrop Frye is helpful: "The poetic imagination constructs a cosmos of its own, a cosmos to be studied not simply as a map but as a world of powerful conflicting forces. This imaginative cosmos is neither the objective environment studied by natural science nor a subjec-

## SEEING THE UNSEEN

Given the problematic nature of representing the divine, one might conclude that picturing God is best left to God. Indeed, the hiddenness of God's face is a recurring biblical theme. Prior to meeting with Yahweh on Mount Sinai, for instance, God warned Moses, "You cannot see my face; for no one shall see me and live" (Ex 33:20). And surely this is the Old Testament understanding of things: in powerful deeds and actions, God shows his *hand* but never his *face*.

A central figure in this ongoing controversy is theologian J. I. Packer and, in particular, the fourth chapter of his widely read book *Knowing God*. Commenting on the second commandment, he writes, "Just as it forbids us to manufacture molten images of God, so it forbids us to dream up mental images of him. Imagining God in our heads can be just as real a breach . . . as imagining him by the work of our hands." As already noted, the *actual* practice of many evangelicals ignores Packer's claim. But more than this, one is left to wonder how this theologian or any other disciple of Christ is able to comprehend God incarnate, God with us, apart from calling on his or her imagination. Perhaps Packer has been satisfied to conceive of God as a hyperrational being or, alternatively, encounter him inside various emotions. In either case, most of us—especially artists—function differently and must object to Packer's claim that "all manmade images of God, whether molten or mental, are really borrowings from the stock-in-trade of a sinful and ungodly world, and are bound therefore to be out of accord with God's own holy Word."[49] In effect, Packer has dismissed nearly the whole of Christian art. Dorothy Sayers's conviction on this matter runs entirely counter to Packer's: "To forbid the making of pictures about God would be to forbid thinking about God at all, for man is so made that he has no way to think except in pictures."[50]

It might seem that this line of reasoning from the Old Testament continues on into the New, where John's Gospel states, "No one has ever seen God" (Jn 1:18).

---

tive inner space to be studied by psychology. It is an intermediate world in which the images of higher and lower, the categories of beauty and ugliness, the feeling of love and hatred, the associations of sense experience, can be expressed only by metaphor and yet cannot be either dismissed or reduced to projections of something else." Northrop Frye, *Words with Power: Being a Second Study of "The Bible and Literature"* (San Diego: Harcourt, Brace, Jovanovich, 1990), xxii.

[49]Packer, *Knowing God*, 47. It is a wrong-headed presupposition. Clearly, his claim that all images of God find their source in a "sinful and ungodly world" has no empirical, philosophical or theological basis.

[50]Dorothy Sayers, *The Mind of the Maker* (1941; San Francisco: HarperCollins, 1987), 22.

But then, with the stroke of his stylus, the Gospel writer declares that God has been seen! John explains, "It is God the only Son, who is close to the Father's heart, who has made him known" ( Jn 1:18). In these same verses John reminds us that the mission of John the Baptist is to "testify to the light" ( Jn 1:8). Indeed, "the true light, which enlightens everyone, was coming into the world" ( Jn 1:9). Reading on we learn that when Jesus first appeared to this wilderness prophet, John declared, "I myself have *seen* and have testified that this is the Son of God" ( Jn 1:34). On the next day the Baptizer saw Jesus pass by again and announced to all within earshot, "*Look*, here is the Lamb of God" ( Jn 1:36). And on the following day, the Evangelist reports, Philip encouraged the skeptical Nathanael to "come and *see*" ( Jn 1:46).[51] And so John's narrative continues on, the disciples

**4.8.** Caravaggio, *Conversion on the Way to Damascus*, c. 1601

*seeing* Jesus and Jesus, God's Son, being *seen*. These early disciples were beginning to understand that in Christ the Father was showing his face.

Later on and having already ascended to the Father, Jesus appeared to Saul as he and his companions made their way along the road to Damascus (Acts 9:1-9). Saul, a learned Jew and a rabid persecutor of early Christians, was entirely transformed in heart and mind by his encounter with Christ. So much so that in later letters he would boldly assert that in Christ "all the fullness of God was pleased to dwell" (Col 1:19). Saint Paul's conversion has been the subject of many paintings, most famously, perhaps, by Caravaggio (c. 1601) (fig. 4.8).[52]

---

[51]The humanity of Jesus is central to the Orthodox understanding of the image. Leonid Ouspensky, "The Meaning and Content of the Icon," in *Eastern Orthodox Theology: A Contemporary Reader*, 2nd ed., ed. Daniel B. Clendenin (Grand Rapids: Baker Academic, 2003), 33-63.

[52]Caravaggio painted an earlier version approximately one year before.

The author of Hebrews writes, "He [the Son] is the reflection of God's glory and the exact imprint of God's very being" (Heb 1:3). Whether one is an iconoclast or iconophile, the meaning of the incarnation is certain: the unseen God is *seen* through the veil of Christ's flesh. This simple fact has redirected the whole of human history.

When we embrace this cardinal Christian doctrine and it radical impact, a kind of oddness settles in. For while the face of Christ is surely the central image of the Christian faith, there is no firsthand visual or even verbal record of Jesus' actual appearance save, perhaps, for two lines from one messianic Hebrew poem written several hundred years before his birth: "His eyes are darker than wine, / and his teeth whiter than milk" (Gen 49:12).[53] As early as the first century, however, symbols representing Christ made frequent appearance:

> Jesus Christ was portrayed on the walls of the catacombs as a fish, a vine or a lamb. Fish were historically linked with the miracle of the loaves and fishes, and with the apostolic vocation to become "fishers of men." The letters of the Greek word for fish, *ichthus*, stand for "Jesus Christ, Son of God, Saviour," and the sign therefore became a logo for the faith, carved on gravestones and on walls. The vine was for Jesus a symbol of his union between himself and his people, and a memorial of his passion.[54]

These symbols notwithstanding, there appear to be no likenesses of Jesus—not a single one—generated by artists who worked during his lifetime. How shall we account for this absence? Certainly, the Roman artists of Jesus' day sculpted marvelous busts and figures of emperors, philosophers, military commanders and deities. Perhaps the Jewish observance of the first and second commandments forbade Gentile images of Christ. Or perhaps Jesus' lowly origin—a poor Jew from Palestine—isolated him from artistic scrutiny. However one accounts for this initial absence, two millennia later we possess innumerable images of Jesus, and all of these are *inventions* conjured in the mind of an artist and rendered by an artist's hand.

---

[53]"The most obvious problem for a theology of the face of Jesus Christ is its apparent vagueness. Nobody can see this face. We do not even have artistic or photographic evidence of it. So people might imagine any sort of face and project whatever they like on to it." David F. Ford, *Self and Salvation: Being Transformed* (Cambridge: Cambridge University Press, 1999), 171. See also Hans Belting, *Likeness and Presence: A History of the Image Before the Era of Art*, trans. Edmund Jephcott (Chicago: University of Chicago Press, 1994). Despite the often feminized depictions of Jesus in devotional art, Revelation 1:12-17 suggests that in his resurrected and glorified state Jesus possesses a terrible beauty.

[54]Helen de Borchgrave, *A Journey into Christian Art* (Minneapolis: Fortress, 2000), 11.

During the postwar period, the far-flung examination of Christian images and icons that we have considered in this chapter led to two straightforward conclusions. First, relatively few Protestant evangelicals were actually iconoclasts. To the contrary, their Christmas cards, the paintings and posters that adorned their walls, and their general viewing habits betrayed their deeper desire to possess images of Christ. Some, of course, continued to resist the use of religious images and icons, but it may be that this reluctance had more to do with their unfamiliarity with or backlash against other Christian traditions than with some carefully reasoned biblical or theological position.

Second, by the close of the twentieth century, significant numbers of evangelicals turned to embrace liturgical, iconic, sacramental and ecclesial forms and practices that lay well outside their own tradition. And not coincidentally, some evangelical churches in America became more open to visual art and more supportive of their members who sensed a call to create it. Meanwhile, to the extent that conservative Protestants embraced the iconoclasm of their sixteenth-century forebears, many serious visual artists concluded that they needed to worship elsewhere.

To make sense of the presence and meaning of images and icons within the church, this chapter has highlighted the contest between iconoclasts and iconophiles. But there is a second side to this coin: Protestantism's preference for texts rather than images, and especially its unique regard for the Bible. This contest, which pits the *verbal* against the *visual*, is the central subject of the chapter that follows.

# A People of the Book and the Image

*Reading begins with the eyes.*

ALBERTO MANGUEL, *A HISTORY OF READING*

*In our beginning, in an entirely rational, concrete sense, lies the word or more exactly, the sentence.*

GEORGE STEINER, *REAL PRESENCES*

*What God has made boldly manifest we should not shyly conceal.*

FREDERICA MATHEWES-GREEN, *THE OPEN DOOR*

Steven Spielberg's 1997 film *Amistad* recounts the cruel capture of Sierra Leone natives by Spanish slavers and their horrific passage to the United States onboard a Portuguese slave ship. The treatment of the Africans is unconscionable. One scene depicts sick and dying slaves being thrown overboard, while another portrays the brutality inflicted on the men and women who remain chained two-by-two in the cargo hold below. In 1839 and while shuttling between Cuban ports, the slaves overtook their captors, leaving the ship, the *Amistad*, to float adrift on the open sea for two months. Finally, its "cargo" of slaves was seized by the United States Coast Guard off the coast of Long Island and towed to port in New London, Connecticut. Once ashore and having survived the harrowing ordeal, the Africans were charged with mutiny and then placed in a New Haven jail to await trial in the Hartford Circuit Court. After a series of decisions and appeals, their case found its way

to the US Supreme Court, where on March 9, 1841, this precedent-setting legal battle came to an end and the surviving slaves were granted freedom.

Midway through the lengthy courtroom proceedings, film producer Spielberg inserts an intriguing scene. Bible in hand, Joseph Cinque, a young Mende man and the slave group's apparent leader, is shown enthusiastically recounting the story of Jesus' life, death and resurrection to his fellow Africans. Cinque possesses a keen mind. This is confirmed in a later scene where he reasons, via translation, with his defense attorney, former US president John Quincy Adams, but his ability to speak or read English is rudimentary at best. Cinque's limited literacy, however, does not quell his zeal to proclaim the gospel to his friends. And so, while the words contained in the Bible that has been given to him are of no use, he relies instead on the handsome engravings that are contained in the pages.[1] Image by image, the young man bears witness to his newfound faith.[2]

Whether Spielberg's account of Cinque's biblical storytelling is fact or fiction, it nicely illustrates the central question this chapter addresses: is it *word* or *image*, the *verbal* or the *visual* that is best suited to communicate the Christian story? In Christian history both modes have occupied a place of honor. Nonetheless, proponents of the word have often been antagonistic to the rhetorical force of images and, as outlined in the previous chapter, on some occasions this opposition led to the destruction of Christian art and icons. Yet more extreme, those who created or protected such images were sometimes maimed and even murdered. Meanwhile, champions of the image have sometimes accused their detractors of being bibliolaters, those given to worship of the Book rather than the God who inspired it. Indeed, advocates and critics on both sides have uttered absurd accusations and even committed violent acts against each other. Later in this chapter I will argue that this supposed dichotomy between word and image has sown the seed of unnecessary discord within the church and that under careful scrutiny this schism falters.

---

[1] Period accounts report that seminarians attending Yale Divinity School were teaching Cinque and his friends to read and write English.

[2] Mel Gibson's *The Passion of the Christ* presents a contemporary parallel wherein the film features provocative images of Christ and his suffering even as the Latin and Aramaic words spoken by the actors—the verbal—occupy a secondary role as they are spelled out in English subtitles across the bottom of the screen.

Postwar fundamentalists and evangelicals were first and foremost a "people of the Book." For these conservatives, the centrality of God's Word was a primary concern. They believed that all of life should be placed under its authority, and to meet this objective they expended considerable human and financial capital to establish and sustain Bible churches, Bible schools, Bible conferences, Bible camps, Bible colleges and Bible societies. And with the challenge of the Great Commission before them, they made impressive efforts to translate the Bible into the vernacular language of every tribe and tongue around the globe.[3] While much of their effort was directed to Bible teaching and preaching, substantial energy was also directed to shore up their defenses against the higher-critical methods of liberal Protestantism, the supposed apostasy of the Roman Catholic Church, the ever-present threat of cults and the rising secular tide of popular culture.[4]

This defense—often a campaign for biblical inerrancy—was advanced by academic theologians and popular preachers alike and was rooted, primarily, in the power of reason.[5] That is, if late nineteenth- and early twentieth-century modernist methods of biblical interpretation and higher criticism threatened to dismantle sacrosanct beliefs about creation, salvation and eschatology, then conservatives enlisted rational claims and counterclaims to "fight fire with fire."[6] However one assesses these gains and losses, in American centers of learning and culture the reactionary posture of conservative Protestants caused them to be regarded as anti-intellectual, anti-culture and anti-elite.[7]

---

[3]Mark A. Noll, *Between Faith and Criticism: Evangelicals, Scholarship, and the Bible in America* (New York: Harper & Row, 1987).

[4]The postwar effort to uphold or defend the Bible generated a wide swath of literature including everything from simple tracts to theological tomes. Less well known are more serious books and articles written to demonstrate the authenticity and, therefore, authority of the Bible. Early examples are J. I. Packer, *Fundamentalism and the Word of God: Some Evangelical Principles* (Grand Rapids: Eerdmans, 1958); F. F. Bruce, *The New Testament Documents: Are They Reliable?* (Chicago: Inter-Varsity Press, 1960); Clark H. Pinnock, *Biblical Revelation: The Foundation of Christian Theology* (Chicago: Moody, 1971); and Carl F. H. Henry's six-volume magnum opus, *God, Revelation and Authority*, 2nd ed. (Wheaton, IL: Crossway, 1999).

[5]Surely the most popular postwar iteration of this strategy was Josh McDowell's defense of Christ's bodily resurrection. See Josh McDowell, *Evidence That Demands a Verdict* (San Bernardino, CA: Here's Life, 1979).

[6]George Marsden, *Fundamentalism and American Culture: The Shaping of Twentieth-Century Evangelicalism, 1870–1925* (New York: Oxford University Press, 1982).

[7]See Mark A. Noll, *The Scandal of the Evangelical Mind* (Grand Rapids: Eerdmans, 1994).

## THE PRECINCTS OF WORD AND IMAGE

For children who came of age in the postwar evangelical church, ideas about God and life were shaped substantially by Sunday school, Vacation Bible School and other programs like them. Gospel choruses were foundational to their instruction, and the familiar lines of one such chorus—its tune sounding a bit like the "fight song" for a junior varsity team—went like this:

The B-I-B-L-E,
Yes, that's the book for me.
I stand alone on the Word of God,
The B-I-B-L-E.

Even before entering grade school, my classmates and I had sung these words dozens of times, and our young and trusting minds had no reason to doubt what they affirmed. Adult believers might have been more circumspect. What, for instance, did it mean to "stand alone on the Word of God"? If one grants elevated status to the Bible's verbal authority, how should one regard the many words, images, ideas and experiences that receive no mention in its pages?

These kinds of queries generally did not trouble children participating in Christian education programs. But more subtly, the literal claim of this chorus might have seemed confusing in other respects. Here is why: as noted in the previous chapter, the "Bible church" orientation of these congregations was essentially iconoclastic. Yet almost without exception the curricular materials that were part and parcel of preschool and elementary religious education were, much like public school textbooks, generously illustrated with *pictures*. Clearly Christian publishers of the day had authorized the use of images—depictions of Old Testament characters, Mary, Jesus and his disciples to instruct children. On some occasions, representations of God the Father and the Holy Spirit also made appearance.[8] These images were, of course, the fruit of an artist's or illustrator's imagination and often drawn with substantial reference to the earlier history of Christian art.

On entering middle school, however, the content of evangelical religious training began to shift. Confirmation class (more conservative congregations termed it "pastor's instruction class") became the pedagogical pathway to

---

[8]David Morgan and Sally M. Promey, *Exhibiting the Visual Culture of America's Religions* (Valparaiso, IN: Brauer Museum of Art, 2000), 12-13.

adult participation in the church. At the end of this two-year term of study, there loomed for most a Sunday morning exam. Standing before the entire congregation, members of the confirmation class were expected to answer pre-assigned doctrinal questions and also recite selected Bible passages from memory. The prize for completing this ordeal was often a leather-bound, gilded-edge Bible, embossed with the confirmand's name. Notably, these Bibles no longer contained pictures.

There is no evidence, so far as I can tell, that introducing adolescents to basic Christian doctrine, more rigorous Bible reading and Bible memory work did them any harm. Likely it accomplished a fair bit of good. But in this sequence of events something had transpired: the images that guided the spiritual formation of young minds through their preschool and elementary years were retired.[9] Indeed, the Bibles given to new confirmands were a subtle signification that they had graduated from the *visual* world and its supposed subjectivity to a faith founded on something more solid: these young followers of Christ would now "stand alone" on the Word of God.[10]

This leads to a broader observation: in the Bible church tradition, scant attention was paid to sacred images and icons, and, generally speaking, Christian art had no standing. Meanwhile, at the height of the Cold War, math and science ruled supreme, and art history offerings (even elective) were not included in most public school curricula. Apart from selected graphs, maps and charts, it was understood that written and spoken word was the source of true knowledge.

In the end, the education that children and youth received in the evangelical church, coupled with the curriculum of the public schools that they

---

[9]For a user-friendly introduction to the rich world of Christian symbols, see Alva William Steffler, *Symbols of the Christian Faith* (Grand Rapids: Eerdmans, 2002). For a more comprehensive survey of symbols, see Harold Bayley, *The Lost Language of Symbolism: An Inquiry into the Origins of Certain Letters, Names, Fairy-Tales, Folklore and Mythologies*, 2nd ed. (London and Tonbridge: Ernest Bonn, 1968).

[10]While the Gutenberg Bible (1465) contained no pictures or illustrations, it did feature page headings and elaborate embellishments that were lettered and colored by hand. See Christopher de Hamel, "The Gutenberg Bible," in *The Book: A History of the Bible* (London: Phaidon, 2001), 190-215. Related to this theme, William Dyrness notes that well into the sixteenth century, the practice of commissioning artists to illustrate Bibles and other sacred books was commonplace. For instance, King Henry's Coverdale Bible (1535) was lavishly illustrated by Hans Holbein. Dyrness goes on to point out that "in 1580 all biblical images were banned in Geneva, even in print books; in England a clear reaction to imagery takes hold after that date." William A. Dyrness, *Reformed Theology and Visual Culture: The Protestant Imagination from Calvin to Edwards* (Cambridge: Cambridge University Press, 2004), 98-99, 103.

attended, communicated that the greater goal was to acquire a kind of "objective knowledge." If postwar evangelicals were mostly ambivalent about Christian art, in this regard American public education was a coconspirator. The tragedy of this arrangement is that it pressed artists of faith to align their aesthetic interests with art academies, university art departments, art museums and journals that lay beyond the mission and program of the church. More tragic still, churchgoers were cut off from vital epochs and experiences of Christian belief. Suffice it to say, in today's hypervisual environment the conditions that I have described might seem hard to fathom.

The previous chapter outlined ways in which Protestants differ from their Catholic and Orthodox counterparts with respect to the use of images, especially in worship. Theologian Donald Bloesch describes the pattern like this: "The emphasis on hearing over sight is much more conspicuous in the churches of the Reformation, particularly those in the Puritan tradition, than in either Roman Catholicism or Eastern Orthodoxy."[11] But the account of iconoclasts and iconophiles that we considered in that chapter only partially explains why evangelicals were so wary of religious icons and images. To fill out the picture, it will be important to gain a broader understanding of the status of the Bible within conservative Protestantism.

**Sola scriptura.** Alongside Jews and Muslims, Christians are a "people of the Book."[12] Flying the sixteenth-century reformers' banner of *sola scriptura* (Scripture alone), postwar evangelicals held to the conviction that the Bible is God's accurate, unique and authoritative revelation—a view consonant with Jesus' estimation of the Old Testament as well as the convictions of New Testament writers and early church fathers. Many, especially fundamentalists

---

[11]Bloesch continues, "The evangelical distrust of image is less evident in Eastern Orthodoxy. . . . In this tradition religious symbols are believed to be invested with sacramental power and thereby become bearers of the Transcendent." Donald Bloesch, *A Theology of Word and Spirit: Authority and Method in Theology* (Downers Grove, IL: InterVarsity Press, 1992), 101.

[12]"It appears that the familiar phrase 'people of the book' may have been coined by Muhammad, the Prophet of Islam. In the Quran the term is used self-consciously to distinguish a religious culture in which revelation is handed down orally (Islam) and the two religions in which it is both handed down and authoritatively transmitted in writing (Judaism and Christianity)." Though "people of the book" might have been initially intended as derisive, devout Jews and, more recently, conservative Protestants have come to regard it as a badge of honor. For Jews and Christians, reading, hearing and heeding the Word of God is central to theological, spiritual and ecclesial formation. Bible-believing Christians who attend Bible churches and send their offspring to Bible colleges might be rightly regarded as a people of the book. David Lyle Jeffrey, *People of the Book: Christian Identity and Literary Culture* (Grand Rapids: Eerdmans, 1996), xi.

and most evangelicals, went further to insist on biblical inerrancy. The Bible's self-report is that God's Spirit inspired faithful men to record God's words and that this same Spirit emboldened prophets and preachers to proclaim it. In his letter to the Ephesians, Paul describes God's revelation as "the word of truth, the gospel of your salvation" (Eph 1:13). And in a later letter the seasoned apostle reminds Timothy that the sacred Hebrew writings that this young pastor had learned during childhood are "able to instruct [him] for salvation through faith in Christ Jesus. All scripture is inspired by God and is useful for teaching, for reproof, for correction, and for training in righteousness, so that everyone who belongs to God may be proficient, equipped for every good work" (2 Tim 3:15-17).

Given the primacy of the Word of God in both creation and redemption, conservative Protestants had good cause to affirm champions of the Bible as heroes of the faith. From the anonymous monks (green martyrs) who holed up in remote Irish cottages to copy pages of the Bible by hand to public figures such as John Wycliffe (martyred posthumously), who translated the Latin Vulgate into English, and from missionaries smuggling the Bible into "closed countries" to linguists translating the New Testament into obscure tribal tongues, these men and women were legend in the church.

It is at this point that complications for visual art in the church arise. As already suggested, *sola scriptura*'s most ardent advocates have often been those most troubled by the ascendancy of images and symbols within the church.[13] In their view, emphasizing the visual is a treacherous business since it stands to diminish the authority of the Bible, grant credibility to non-Protestant spiritual practices and loose the raw force of popular culture on unsuspecting believers.[14]

---

[13]"To Protestants, this triumph of the verbal over the visual is a proper reformation of the image. *Sola scriptura* was a rallying cry in a territorial war between rival communicative media. On one side stood the word, that which (to its partisans) was apostolic and is now, once more, 'special dispensation' of truth. On the other side stood the image, instrument and emblem of the Roman Church's deceit." Joseph Leo Koerner, *The Reformation of the Image* (Chicago: University of Chicago Press, 2004), 46.

[14]This is certainly J. I. Packer's worry: "[God] has spoken through his prophets and apostles, and he has spoken in word and deeds of his own Son. Through this revelation, which is made available to us in holy Scripture, we may form a true notion of God; without it we never can. Thus it appears that the positive force of the second commandment is that it compels us to take our thoughts of God from his holy Word, and from no other source whatsoever." J. I. Packer, *Knowing God* (Downers Grove, IL: InterVarsity Press, 1993), 49.

**Biblia Pauperum.** If *sola scriptura* (one of the five "solas") was a distin-
guishing feature of the Protestant Reformation, it might be argued that in
earlier centuries and especially during the Middle Ages *Biblia Pauperum* (the
Bible of the poor) was its alter ego.[15] During this period, artists produced
collections of portable prints as a means to communicate the biblical story.
Hans-Georg Gadamer explains the phenomenon: "One of the crucial factors
in the justification of art in the West was *Biblia Pauperum*, a pictorial narration
of the Bible designed for the poor, who could not read or knew no Latin and
because of this were unable to receive the Christian message with complete
understanding."[16] In concert with Gadamer, Michelle Brown explains that
these miniatures illustrated

> the parallels between the Old and New Testaments. Scenes from the life of
> Christ are accompanied by Old Testament scenes and figures of the prophets.
> Although few have survived, such books are known to have been very popular
> during the later Middle Ages, especially as a tool for religious instruction
> among poorer clergy and the members of lay society who, although often quite
> wealthy, were not especially learned.[17]

Likely, those who owned such books also heard the word read (though often
not in their native tongue) and preached, and for nonreaders these opportu-
nities would have occurred primarily in the church.

In considering the character and function of *Biblia Pauperum*, we return
full circle to Joseph Cinque's decision to use pictures as his means to boldly
communicate the gospel message. Eighth-century theologian John of Da-
mascus believed that "just as words edify the ear, so also the image stimulates
the eye. What the book is to the literate, the image is to the illiterate. Just as
words speak to the ear, so the image speaks to the sight; it brings us
understanding."[18] In a more contemporary voice, Orthodox writer Frederica
Mathewes-Green explains, "Icons could tell the story consistently and clearly,

---

[15]Gregory the Great, Epistle 13 to Serenus, Bishop of Massilia, in *Nicene and Post-Nicene Fathers*, Series
2, vol. 5, *Gregory of Nyssa: Dogmatic Treatises, Select Writings and Letters* (Grand Rapids: Eerdmans,
1893), 134-36.

[16]Hans-Georg Gadamer, *The Relevance of the Beautiful and other Essays*, ed. Robert Bernasconi
(Cambridge: Cambridge University Press, 1987), 4.

[17]Michelle P. Brown, *Understanding Illuminated Manuscripts: A Guide to Technical Terms* (Los An-
geles: Getty Publications, 1994), 21.

[18]John of Damascus, *On Divine Images: Three Apologies Against Those Who Attack the Divine Images*,
trans. David Anderson (Crestwood, NY: St. Vladimir's Seminary Press, 2000).

even where Bibles weren't available; in fact, an iconographer is sometimes said to 'write' rather than 'paint' an icon, since it is conveying Scripture by a different medium. As the faith spread across language and cultural barriers, portable icons were no doubt indispensable to missionaries."[19]

While the convictions of John of Damascus, Mathewes-Green and others like them might have seemed foreign to postwar American evangelicals, together they share at least one patch of common ground. That is, those evangelicals did and continue to believe that it is possible—indeed, desirable—for nonreading adults and young children to possess genuine "saving" faith. Hence the use of illustrated Sunday school materials. If this is true for children, then these same evangelicals must concede that the thousands upon thousands of nonreading medieval and Renaissance Christians who absorbed the iconographic programs displayed on the exterior façades and interior walls of their churches might have enjoyed a saving faith similar to their own. Quite simply, when these churchgoers attended weekly Mass or participated in daily prayer, religiously themed picture books, prints, painting, sculpture and architecture provided theological instruction and invited spiritual reflection.[20] Whether the message of religious images and narratives such as these was didactic or mysterious, the work created by artists and artisans became a home for wondering theological minds. And here we should add that for many Catholic and Orthodox Christians the iconic program of the sanctuary was and remains a foreshadowing or preview of heaven.

## THE MODERN CONTEST

The contest between word and image outlined thus far is hardly limited to the church and its interests. In his brief essay *This Is Not a Pipe*, Michel Foucault (1926–1984) advances the idea that "two systems" or ways of thinking "ruled Western painting from the fifteenth to the twentieth century."[21] The late French philosopher goes on to delineate a struggle that, he believes, lies between the *figure* (image) and the *discourse* (word). According to Foucault:

[19]Frederica Mathewes-Green, *The Open Door: Entering the Sanctuary of Icons and Prayer* (Brewster, MA: Paraclete Press, 2003), 30.

[20]For a straightforward and contemporary account of the way in which religious images can foster Christian belief, see Timothy Verdon, *Art, Faith, History: A Guide to Christian Florence*, trans. Timothy Verdon and Stephanie Johnson (Florence: Arch Diocese of Florence, 1999).

[21]Michel Foucault, *This Is Not a Pipe*, trans. and ed. James Harkness (Berkeley: University of California Press, 1982), 32.

The two systems can neither merge nor intersect. In one way or another, subordination is required. Either the text is ruled by the image (as in those paintings where a book, an inscription, a letter, or the name of a person are represented); or else the image is ruled by the text (as in books where a drawing completes, as it were merely taking a short cut, the message the words are charged to represent). True, the subordination remains stable only very rarely. What happens to the text of the book is that it becomes merely a commentary on the image, and the linear channel, through words, or its simultaneous forms; and what happens to the picture is that it is dominated by a text, all of whose signification it figuratively illustrates. . . . What is essential is that verbal signs and visual representations are never given at once. An order always hierarchizes them, running from the figure to discourse or from discourse to the figure.[22]

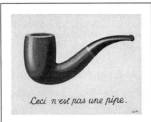

**5.1.** René Magritte, *The Treason of Images (This Is Not a Pipe)*, 1929

What stimulated Foucault's proposal? Apparently it is the competing claims contained within Réne Magritte's surrealist painting *The Treason of Images* (1929) (fig. 5.1). Magritte's enigmatic work features the realistic portrayal of a smoker's pipe, and the inscription beneath it reads: *Ceci n'est pas une pipe* (this is not a pipe). On one hand, the artist's rendering of the painting's *figure* insists "surely, this *is* a smoker's pipe." On the other, his matter-of-fact *discourse* makes the opposite claim, "this *is not* a pipe."[23] Those who elect to engage Magritte's visual riddle quickly discover that it cannot be solved. In *Ceci n'est pas une pipe*, at least, the contest between word and image results in a stalemate.

Like Foucault's other postmodern or poststructuralist writings, his close reading of Magritte's painting investigates the use and abuse of power.[24] Within his figure/discourse polarity, the philosopher, who demonstrated

---

[22]Ibid.

[23]Ibid., 30.

[24]In the 1980s and 1990s Foucault's work received considerable attention. His writings examine the origin and meaning of social realities such as insanity (*Madness and Civilization: A History of Insanity in an Age of Reason* [1961]); medical clinics (*The Birth of the Clinic: An Archaeology of Medical Perception* [1963]); penal institutions (*Discipline and Punish: The Birth of the Prison* [1975]) and sexual mores (*The History of Sexuality*, vol. 1, *An Introduction* [1976], vol. 2, *The Use of Pleasure* [1984], vol. 3, *The Care of the Self* [1984]).

great disdain for religious belief, observes a struggle for power that extends far beyond the domain of the church.

Taking a bird's-eye view of American religious practice, art critic Eleanor Heartney directs her attention to a similar schism that, she believes, lies between Protestants and Catholics—the former being *word-based* and the latter *image-based*. Writes Heartney:

> [A] lot of research that I've been doing has really been about differentiating between this sort of Catholic body-based imagery with a sensual, sexual kind of an aesthetic, versus what I see as this country's more dominant Protestant, Puritan-based approach. I see the latter as a more word-based, abstract-oriented, and more non-corporeal kind of an aesthetic. In fact one of the things I hypothesize is going on in the so-called culture war is that the aesthetic of Catholicism, which is a minority position in this country, is coming into conflict with the dominant Protestantism.[25]

Obviously, Heartney is eager to engage a wide swath of concerns; nonetheless, I believe that her core thesis is correct: if receptivity to the *image* is an essentially Catholic (or Orthodox) disposition, then single-minded devotion to the *word* is primarily Protestant. To the extent that this distinction reflects actual practice, it requires no imagination to understand why so many artists have felt estranged from evangelical congregations. Insists Heartney, "In a word-based culture, there's a tendency to not be able to see the complexity of an image like say *Piss Christ*, or the Chris Ofili *Holy Virgin Mary*. Instead they get reduced to glib verbal descriptions."[26] The Catholic roots of celebrated artists such as Salvador Dali, Chris Ofili, Andres Serrano, Kiki Smith and Andy Warhol add heft to Heartney's thesis.

In the twentieth century, American fundamentalists and evangelicals exhibited the very polarization that Foucault and Heartney observe. Rather than explore the possible fidelity of word to image or image to word, these

---

[25]Eleanor Heartney as quoted in Christian Eckhart and Harry Philbrick, *Faith: The Impact of Judeo-Christian Religion on Art at the Millennium* (Ridgefield, CT: Aldrich Museum of Contemporary Art, 2000), 62. Humanities scholar Camille Paglia offers a similar appraisal: "The primary problem of Protestantism is word-fixation: Scripture-study is at its heart. No fleshly mediator is needed between the soul and God; no images of saints, Mary, or God are permitted, though portraits of the Good Shepherd began to slip into some denominations within the last century. In highly ritualized Italian and Spanish Catholicism, by contrast, there is a constant, direct appeal to the senses." Camille Paglia, *Sex, Art and American Culture: Essays* (New York: Vintage, 1992), 29.

[26]Heartney as quoted in Eckhart and Philbrick, *Faith*, 62.

conservatives believed that the pair could not be suitably yoked. To the degree they elevated the authority of God's Word, in equal measure they felt obliged to diminish the visual arts.

To observe this pattern of evangelical thought in action, consider two possible readings of Genesis 1. In considering this text, evangelicals will be quick to observe that it is the Word of God that initiates his work of creation. Indeed, in this opening chapter of the Bible, "God said" is stated no less than ten times. And so it is surely correct to underscore the repeated instances of God's "saying," "naming" and "blessing" here and throughout the book of Genesis as evidence of God's verbal authority. Meanwhile, it is also the case that Genesis 1 features the visual and material dimension of God's work: he is one who "makes," "forms" and "sees." This second reading reminds us that the most *tangible* fruit of God's Word is God's creation, the visual and material world that is seen.

Theologian Raymond Brown writes, "The fact that the Word creates means that creation is an act of revelation. All creation bears the stamp of God's Word. . . . Since the Word is related to the Father and the Word creates, the Father may be said to create through the Word. Thus the material world has been created by God and is good."[27] As Paul's letter to the church in Rome makes plain, God's eternal and invisible nature is grounded in the visible, material world (Rom 1:20). But this is not the end of the matter. By virtue of creation and redemption, this same nature is present in the exalted image and office of the men and women who inhabit God's world. If the creation of the cosmos begins with God's command "let there be light" (Gen 1:3), then it concludes with God's twofold mandate to Adam and Eve to "be fruitful and multiply" and to "have dominion" (Gen 1:28). Put differently, humankind is charged by God to continue both the naming and the material making that he has begun.

To observe God's speaking and making in more proper balance we turn to what may be a surprising source. In 1561 and six years before he was martyred, Guido de Brès, a Protestant reformer from the Netherlands, authored the Belgic Confession. The substance of de Brès's confession is based on another penned by John Calvin just two years earlier. In the second of his thirty-seven articles, de Brès states, "We know [God] by two means: First, by the creation,

---

[27]Raymond E. Brown, *The Gospel According to John: I–XII*, Anchor Bible, vol. 29 (New York: Doubleday, 1966), 25-26.

preservation, and government of the universe, since that universe is before our eyes like a beautiful book. . . . Second, he makes himself known to us more openly by his holy and divine Word." De Brès advances what is sometimes termed "two book theology"—the first of the pair being the book of creation (the visual and material world) and the second, the book of revelation (the spoken and discursive word).[28] In essence de Brès simply embraces David's earlier conclusion:

> The heavens are telling the glory of God;
>> and the firmament proclaims his handiwork.
> Day to day pours forth speech,
>> and night to night declares knowledge. (Ps 19:1-2)

According to this psalm, the splendor of the skies speaks without uttering speech, and the passing events of each day make their declaration using no words. Still, "their voice goes out through all the earth, and their words to the ends of the world" (Ps 19:4).[29] Subsequent verses extol the virtue of God's speech acts, variously termed "law," "decrees," "precepts," "commandment" and "ordinances," and according to the psalmist these are more desirable than gold and sweeter than honey (Ps 19:7-11). Additionally, Isaiah reminds his readers that the witness of God's Word is more enduring than the witness of creation, since "the grass withers, the flower fades; but the word of our God will stand forever" (Is 40:8).

Naturally, we associate de Brès with the iconoclastic tradition, and it is reasonable to believe that God's creation is what most interested him and not the work of human hands. But his logic is instructive nonetheless, for while the visual and the verbal are distinct in form and function, both are windows through which men and women behold God's character and action. Consequently, it seems to be no great stretch to propose that *Biblia Pauperum* might be regarded as the positive counterpoint to *sola scriptura*. That is, rather than

---

[28]John Calvin expresses a similar view regarding our meditation on creation: "For, as we have elsewhere observed, though not the chief, it is in point of order, the first evidence of faith, to remember to which side soever we turn, that all which meets the eye is the work of God, and at the same time to meditate with pious care on the end which God had in view in creating it." John Calvin, *Institutes of the Christian Religion*, trans. Henry Beveridge (Grand Rapids: Eerdmans, 1995), 20.

[29]It is, therefore, entirely reasonable for University of Wisconsin wetlands scientist Calvin DeWitt to insist that "God publishes in the landscape." From a series of lectures given June 18–22, 2006, at an InterVarsity Christian Fellowship faculty retreat held at Cedar Campus, Cedarville, MI.

concede Foucault's cycle of unending subordination, a spirit of hospitality can be reasonably advanced wherein the visual and the verbal exist in a dynamic, dialogical relationship. Perhaps the interpenetrating functions of word and image are best likened to what some describe as our bicameral brain, wherein the left side is primarily given to literacy and logic and the right to image and abstraction.

To review, we have noted the following: within Christendom both the verbal and the visual have been employed to communicate the Christian story; in this regard, word and image have often been positioned as competitors, and the resulting standoff between the pair has generated a false dichotomy in both the art world and the church. To fully grasp the relationship of the visual to the verbal within conservative Protestantism, at least one more consideration bears mention: the *act* of reading. For while doctrinal statements shed considerable light on the Protestant regard for Holy Scripture, the Bible's practical authority is substantially determined by the manner in which it is read.

## READING—IT'S NOT WHAT IT USED TO BE

In postwar America the mention of God's Word might bring to mind a thick volume containing pages of numbered verses and chapters arranged in columns, all bound within a leather or cloth cover bearing the embossed words *Holy Bible*. God's Word was a particular kind of object. Evangelical theologians, of course, maintained a more nuanced understanding. But whether one was a regular parishioner or a scholar there was broad agreement that the Bible was a verbal medium. Consequently, it was easy to overlook the extent to which visual experience informed the character of God's Word and the manner in which it was comprehended by those who read it. Here it will be helpful to review the broader history of reading itself.

*Literacy.* The Old Testament confirms that some number of ancient Israelites were highly literate.[30] The same can be said of Jesus, his brother

---

[30]Although Israel regularly failed to maintain its fidelity to the law of God, from time to time the sheer force of the law shaped its corporate life. One such moment is recorded in Nehemiah, where we learn that, upon the completion of the rebuilding of Jerusalem's wall, Ezra and a group of Levite teachers spent an entire day reading and teaching the law to 42,310 Jews who had gathered. Nehemiah reports, "So they read from the book, from the law of God, with interpretation. They gave the sense, so that the people understood the reading. And Nehemiah, who was the governor, and Ezra the priest and scribe, and the Levites who taught the people said to all the people, 'This day is holy to the LORD your God; do not mourn or weep.' For all the people wept when they heard the words of the law" (Neh 8:8-9).

James and at least three of Jesus' disciples: Matthew, John and Peter. Still, it is surely the case that the literacy of most Jews in ancient Israel and most of Jesus' early followers was rudimentary at best. In the broad sweep of history, Jews and Christians have primarily been nonreaders belonging to cultures wherein stories and sayings were committed to memory and orally transmitted.[31] When Paul reminds the church in Rome that "faith comes from what is heard, and what is heard comes through the word of Christ" (Rom 10:17), the apostle's primary audience was likely nonreaders, who had much to gain from the teaching and preaching that occurred in the early church community.[32] That is, the various epistles that circulated among these believers—including those now belonging to the New Testament canon— were read *to* them and not *by* them.

Beginning with the early church and continuing on through the medieval period, the illiteracy of Christians was compounded by the scarcity of sacred texts. Prior to Gutenberg's invention of the movable type press and his printing of what is often referred to as the "42-line Bible" (1453–1455), only the wealthy and a small number of scholars owned parchments or books. As Robert Hughes explains:

> Most Europeans were totally illiterate and the skills of Gutenberg and Aldus only reached a tiny fraction of society—the fraction of the upper fraction that could both afford and read a small-edition, bound text. Before the Industrial Revolution mechanized the world's presses, the idea of mass literacy was only an idea, and not always a welcome one. That left two channels of information: the spoken word (which included everything from village-pump gossip to the high rhetoric of tribune and pulpit) and visual images—painting and sculpture. Hence the immense role played by didactic art, from mediaeval illuminations through the great fresco cycles of the sixteenth century to secular political icons

---

[31]"In the West through the Renaissance, the oration was the most taught of all verbal productions and remained implicitly the basic paradigm for all discourse, written as well as oral. Written material was subsidiary to hearing in ways which strike us today as bizarre. . . . Memorization was encouraged and facilitated also by the fact that in highly oral manuscript cultures, the verbalization that one encountered even in written texts often continued the oral mnemonic patterning that made for ready recall." Walter J. Ong, *Orality and Literacy: The Technology of the Word* (London: Methuen, 1982), 119. See also Alberto Manguel, "The Book of Memory," in *A History of Reading* (New York: Viking, 2006), 54-65.

[32]Ong points out that "in Christianity . . . the Bible is read aloud at liturgical services. For God is thought of always as 'speaking' to human beings, not as writing to them. The orality of the mindset in biblical texts, even in epistolary sections, is overwhelming." Ong, *Orality and Literacy*, 75.

like Jacques-Louis David's *Oath of the Horatii*, in determining not merely public taste but mass social and religious conviction as well.[33]

Affluent moderns with bookshelves filled from floor to ceiling might find it hard to imagine that "before printing, only the very largest libraries contained as many as six hundred books, and the total number of books in Europe was well under one hundred thousand. By 1500, after forty-five years of the printed book, the total has been calculated at nine million."[34] Prior to Gutenberg, the sight of a saint or scholar with a book in hand was uncommon, and this reality helps one to understand why Albrecht Dürer might have chosen to produce a woodcut such as *St. Jerome in His Study* (1514) (fig. 5.2).[35] Only in the past century or two have great numbers of individuals possessed copies of the Bible in their native tongue.

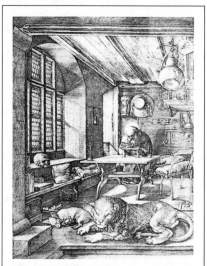

**5.2.** Albrecht Dürer, *St. Jerome in His Study*, 1514

As broad numbers of Europeans gained the ability to read and write, the West was transformed. In fact, the Protestant commitment to translate the Bible into vernacular languages and to teach believers how to read and write was an essential contribution to Europe's modernization.[36] Paralleling this rise, men and women learned to read silently to themselves. In due course they found that they could consult the

---

[33]Robert Hughes, *The Shock of the New* (New York: Knopf, 1981), 366-67.

[34]Paul Johnson, *The Renaissance: A Short History* (New York: Modern Library, 2000), 21.

[35]Jeffrey, *People of the Book*, 214-15. Prints and paintings depicting "bookish" scholars in their study are intriguing in their own right, for the appointments of these chambers often included natural curiosities, art objects and religious symbols. See Dora Thornton, *The Scholar in His Study: Ownership and Experience in Renaissance Italy* (New Haven, CT: Yale University Press, 1997).

[36]Here it should be noted that the arrival of the printing press was a great boon to the Protestant Reformation. "By one estimate more than three hundred thousand copies of Luther's works were printed between 1517 and 1520." Mitchell Stephens, *The Rise of the Image, the Fall of the Word* (Oxford: Oxford University Press, 1998), 20.

"Good Book" for private spiritual counsel entirely on their own.[37] This internalization of the self, which we noted previously, was a revolutionary act since, for many, it redirected the locus of spiritual life from public worship to the interior of one's mind and heart.

*The mind's eye.* The commitment of Martin Luther and other reformers to the primacy of Scripture and its subsequent translation into vernacular languages helps to explain why postwar evangelicals remained so eager to invite "seekers" to "simply read the Bible." But while many inquiring minds regard Bible reading as a clear path to entering God's presence, this way has not been so direct for others. Here is why: verbal understanding is critically linked to verbal perception. In other words, there is a fundamental connection between one's belief in the Bible's verbal authority and the manner in which one sees, a connection forged at the most basic level. "Western history was shaped for some three thousand years by the introduction of the phonetic alphabet, a medium that depends solely on the eye for comprehension. The alphabet is a construct of fragmented bits and parts which have no semantic meaning in themselves, and which must be strung together in a line, bead-like, and in a prescribed order."[38]

The ancient practice of arranging pictures into some coded system is the foundation of written language, and as John Updike points out, "The itch to make dark marks on white paper is shared by writers and artists. Before the advent of the typewriter and now the word processor, pen and ink were what one drew pictures and word-pictures with; James Joyce, who let others do his typing, said he liked to feel the words flow through his wrist." In the early stages of language development, continues Updike, the distinction "between picture and symbol is a fine one."[39] And so it seems reasonable to propose that while the acquisition of sight, speech and literacy occurs in a natural and

[37]Alberto Manguel proposes that silent reading did not begin until the ninth or tenth century—a practice that radically redirected learning and, eventually, social being itself. See Manguel, "Silent Readers," in *A History of Reading*, 50-51.

[38]See Quentin Fiore and Marshall McLuhan, *The Medium Is the Massage: An Inventory of Effects* (New York: Bantam, 1967), 44.

[39]John Updike, *Just Looking: Essays on Art* (New York: Knopf, 1989), 191. In fact, text itself is a multivalent category. For instance, meteorologists read the weather, doctors read x-rays and travelers on their way read road signs. Leon Battista Alberti, the fifteenth-century Renaissance artist and scholar, described "buildings as a text written in the languages of arithmetic, geometry, and ornament." As quoted in Bruce Boucher, "Mr. Humanismus," *New York Times Book Review*, December 3, 2000, 35.

predictable sequence, the predominance of one mode over against the others is relative to the manner in which each is deployed.[40]

*Learning from metaphors.* An experienced reader expects something more than the acquisition of bare information or ideas. She mines for meaning. She is able to enter *deeper* regions because, among other possibilities, words function as signs. That is, verbal language stimulates the visual imagination, which in turn marries abstract concepts to concrete objects and experiences. Poet Richard Jones puts it like this: "God—a mystery that cannot be expressed—has revealed himself in human words that we might share in his divine nature."[41] In anthropomorphic terms, we know God to be an "author" who uses his "finger" to inscribe his commands on the tablets of stone given to Moses atop Sinai (Ex 31:18), to scrawl a mysterious warning in the plaster of Belshazzar's palace wall (Dan 5:5), to write his truths on the human heart.

To build on this idea, consider the various figures employed by the Son of God to describe what we now term the doctrine of salvation. Here legal (justification), economic (redemption), familial (the return of the prodigal and the adopted child), perceptual (darkness to light) and agrarian (the lost sheep) images come easily to mind. Frederick Buechner points out that Jesus' teaching employed "the language of images and metaphor, which is finally the only language you can use if you want not just to elucidate the hidden thing but to make it come alive."[42] Pauline language is no less evocative. Consider, for example, the allusive power of this passage from 2 Corinthians: "For this slight and momentary affliction is preparing us for an eternal weight of glory beyond all measure, because we look not at what can be seen but at what cannot be seen; for what can be seen is temporary, but what cannot be seen is eternal" (2 Cor 4:17-18). And the living creatures, beasts, golden bowls, bloody battles and glorious light of John's Apocalypse are simply over the top.[43]

---

[40]Pointing to the primacy of speech, Millard Erickson observes, "Speaking is the next nearest approximation to this pure identity of meaning and sign. Here the speaker and the hearer are present with one another, both spatially and temporally. Writing, however, according to Plato's interpretation and the classic understanding is secondary to speaking." Millard J. Erickson, *Truth or Consequences: The Promise and Perils of Postmodernism* (Downers Grove, IL: InterVarsity Press, 2001), 116.

[41]Richard Jones, "The Last Book on the Shelf," *Image* 55 (Fall 2007): 94.

[42]Frederick Buechner, *Telling the Truth: The Gospel as Tragedy, Comedy, and Fairy Tale* (San Francisco: Harper & Row, 1977), 62.

[43]The Bible overflows with such signs. See Leland Ryken, James C. Wilhoit and Tremper Longman III, eds., *Dictionary of Biblical Imagery* (Downers Grove, IL: InterVarsity Press, 1998), and also Jeffrey, "Symbolism and the Reader," in *People of the Book*, 209-64.

For most evangelical Christians, the Bible's verbal witness is the bedrock on which the whole of Christian theology and ethics stand. Yet more needs to be said about this claim. First, the principle of *sola scriptura* is most fully realized when a Bible is placed in the hands of a reader. And second, apart from a deep and synthetic relationship to a variety of visual forms, these doctrines are seldom persuasive or practicable. In fact, Bible reading is most transformative when the availability and comprehensibility of the text, rational thought, imaginative associations, diverse literary genres, cultural context and believing actions genuinely meet.

This convergence of seeing, speaking and reading is played out annually in evangelical experience. Consider a typical Maundy Thursday or Good Friday sermon. Almost certainly the presiding pastor will read from one or more of the Gospels, taking great care to describe the physical, mental and spiritual agony of Christ's crucifixion. His goal is transparent: to encourage listeners to identify with their suffering Savior, thereby deepening their devotion to Jesus (2 Cor 4:8-12). But the minister's success is substantially dependent on his ability to "paint" a word picture in the mind's eye of his listeners. In such a moment visual imagination, speech and reading are conjoined. The same word-to-image transfer transpires when one reads any passage of narrative, poetic or apocalyptic literature.

For the visual artist, however, the Protestant emphasis on the preacher's persuasive rhetoric returns us directly to Cinque's dilemma: In what sense are images conjured by words—spoken or written—preferable to the more palpable images of suffering depicted in, say, Matthias Grünewald's *Crucifixion* (1515) (fig. 5.3) or a work on this same theme produced by some artist in the pastor's congregation? Clearly, reading— and by inference preaching—

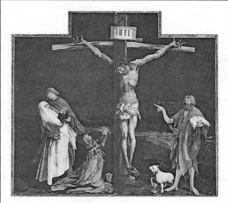

**5.3.** Matthias Grünewald, *Crucifixion*, panel from the Isenheim altarpiece, 1515

summons more than one's rote ability to identify alphanumeric characters, form characters into words and then arrange these words into a sentence.

Whether one's perceptual orientation leans toward *Biblia Pauperum* or *sola scriptura*, the larger matter of *communication* remains. Indeed, all satisfying interpersonal relations and civil societies, all private prayer and public worship, rest on the conviction that language in a variety of guises is a means to know and be known. The desire to possess and then propagate this kind of knowledge prompts artists of faith to seek common ground between the word-centered didacticism of evangelical Protestantism and the image-centered devotion of Orthodox and Catholic traditions.

## A BOOK FOR THE PEOPLE

In 2006 it was my good fortune to visit the newly renovated (and renamed) Morgan Library & Museum in New York City. The construction of J. P. Morgan's original library, built adjacent to his Madison Avenue home, was based on a design by architect Charles Filler McKim of the firm McKim, Mead & White commenced in 1902. In 1924 "Jack," Morgan's son, made the momentous decision to place the Morgan Library & Museum into public trust. To increase public access to the Morgan's three separate buildings, architect Renzo Piano was commissioned to design a new street entrance, central court, café and performance hall, all of which were completed in 2006. The vast holdings of this venerable institution include rare books and manuscripts, as well as medieval and Renaissance paintings and sculpture, all from Morgan's original collection.

On the particular day of my visit, the Morgan Stanley Gallery West featured an exhibit of manuscripts including a symphonic score drafted by Arnold Schönberg; an original cartoon from illustrator Saul Steinberg; an autographed, handwritten journal from Henry David Thoreau dated "Walden, 5 July 1845"; and the original lyrics of "Blow'n in the Wind" jotted by Bob Dylan on the letterhead of a Parisian hotel. While it was surely a pleasure to view these items firsthand, the Morgan's vast collection of illuminated Bibles, Psalters and Books of Hours and, not least, their three Gutenberg Bibles was more impressive still.[44]

Leaving the Morgan, I walked toward the west side of Manhattan. Within the hour I was on Broadway, a block or so from Lincoln Center, and inside

---

[44]It is believed that Gutenberg printed an edition of 180 Bibles on both paper and vellum. Today, fifty copies survive, and of these the Morgan Library & Museum owns three. Christopher De Hamel, *The Book: A History of the Bible*, 192.

the glass façade of the Museum of Biblical Art (MOBIA). Once inside, I climbed the stairs to the second floor, eager to view the current exhibit, titled *Gilded Legacies: The Saint John's Bible in Context*.[45] The work of calligrapher and illuminator Donald Jackson filled the gallery, and immediately I recognized the connection between this contemporary work and the ancient manuscripts on display at the Morgan. Jackson and his small team of calligraphers had painstakingly combined ancient materials and methods with contemporary technologies to produce what the exhibit brochure described as "the first commissioned Bible to be handwritten and illuminated since the invention of printing more than five hundred years ago."[46] The project was underwritten by St. John's Abby and University in Collegeville, Minnesota, and much of the work was completed by Jackson and his team in residence at a scriptorium in Wales. At the time, the estimated cost of the project was four million dollars, with an anticipated completion date of 2009. Since then, *The Saint John's Bible* has been completed and the Museum of Biblical Art has closed its doors (see plate 3).

Illumination is the practice of embellishing otherwise plain pages of text with precious metals such as gold and silver and rare pigments like vermilion and ultramarine. The illuminator's task is to surround the text with luminous, light-reflecting material and brilliant design, thereby instigating a subtle interplay between the Word of God and the brilliance of the artist's surface. Commenting on the gargantuan task of copying the entire Bible by hand, Jackson said, "It is the pinnacle of a person's life to be working with God's word. . . . There couldn't be a better, higher use for one's skills."[47] Simply stated, the purpose of *The Saint John's Bible*—Jackson's lifelong vision transposed onto 1,150 pages of vellum and animated by 160 illuminations—was both to breathe new life into an ancient tradition and to engage a new generation of readers.

If *illumination* highlights the text, then *illustration* builds out or interprets its meaning.[48] In 1995 artist Barry Moser began the arduous task of producing

[45]Bradford Winters, "Eat This Scroll: *The Saint John's Bible* and the Word Made Flesh," *Image* 53: 56-67.
[46]*Gilded Legacies: The Saint John's Bible in Context*, MOBIA Gallery Program, September 7– November 26, 2006.
[47]Jennifer Trafton, "Bible in Brush and Stroke," *Christianity Today*, September 2007, www.christianitytoday.com/ct/2007/september/28.58.html.
[48]See Christopher de Hamel, *A History of Illuminated Manuscripts* (London: Phaidon, 2005).

233 engravings for the Pennyroyal Caxton edition of the Holy Bible (fig. 5.4). Like Jackson's, Moser's work draws on a rich tradition, and here the engravings of German-born artist Gustave Doré (1832–1883) come to mind.

**5.4.** Barry Moser, engraving from The Pennyroyal Caxton Bible, 1995–1999

Doré, a prolific artist, spent much of his adult life in Paris and is best known for the illustrations he provided for the *English Bible* (1865) and Dante's *Divine Comedy*. In this same spirit, Moser invested the better part of four years to complete his full set of illustrations.

Preceding Jackson's and Moser's lifework, of course, is a rich history of important visual artists who employed their various and considerable skills to tell the biblical story. Here the work of artists such as Marc Chagall, Otto Dix, Dürer, Rembrandt and Sadao Watanabe comes easily to mind. Alongside hundreds of illuminators who worked in anonymity and are unknown to us, the labors of these artists are a central and enduring feature of the cultural legacy of the West. But all of these creative endeavors point to something greater than a desire for personal expression or the upholding of any particular tradition. These works and the artists who fashioned them manifest a bold desire to underscore the witness of Holy Scripture.

The larger point is this: neither Jackson nor Moser is interested in concealing or canceling the written text. Rather, like a Hebrew midrash, their imaginations and intellects, coupled with labors of eye and hand, are a means to simultaneously underscore the authority of the text and tease out its fresh meanings. Along with writer Jennifer Trafton, one wonders, "Could an illuminated Bible give visually sensitive Catholics and textually savvy Protestants a common place to meet?"[49] It seems to me that Trafton is correct, but before concluding this chapter it makes sense to venture toward some higher theological ground.

## THE WORD MADE FLESH

John 5 recounts the healing of a lame man near the pool of Beth-zatha in Jerusalem (Jn 5:2-9). Jesus performed the miracle on the Sabbath, and

---

[49]Trafton, "Bible in Brush and Stroke."

because of this the Jews sought to kill him. In their view he "was not only breaking the Sabbath, but was also calling God his own Father, thereby making himself equal to God" (Jn 5:18). Undeterred by their threats, Jesus continued his teaching. At the end of this brief yet agitated narrative, Jesus directs sharp words toward his accusers: "The works that the Father has given me to complete, the very works that I am doing, testify on my behalf that the Father has sent me. And the Father who sent me has himself testified on my behalf. You have never heard his *voice* or seen his *form*, and you do not have his word abiding in you, because you do not believe him whom he has sent" (Jn 5:36-38). According to Jesus, he is the literal manifestation of the Father's *voice* and *form*. But those opposed to him were neither willing nor able to comprehend his meaning. Jesus pressed them further, saying, "You search the scriptures because you think that in them you have eternal life; and it is they that testify on my behalf. Yet you refuse to come to me to have life" (Jn 5:39-40).

The entire force of Christian belief is directed toward the possibility that humankind can actually know God, and yet in this pursuit we frequently fail either to listen to God's voice or to look on God's form.[50]

"Keep listening, but do not comprehend;
keep looking, but do not understand."

Make the mind of this people dull,
and stop their ears,
and shut their eyes,

so that they may not look with their eyes,
and listen with their ears,

and comprehend with their minds,
and turn and be healed. (Is 6:9-10)

To reverse this course, men and women can be tempted to believe that they will find the spiritual life that they seek in Holy Scripture. But as noted throughout this chapter, while the written Word of God is a vital means to realize God's presence, it is nevertheless penultimate. According to Jesus, he himself is the one who possesses the spiritual life that we seek.

---

[50]See also Mt 13:14-15; Mk 4:2; Lk 8:10; Jn 12:39-41; Acts 28:26-27; Rom 11:8.

This understanding forms the heart of the prologue to John's Gospel: "In the beginning was the Word [*logos*], and the Word was with God, and the Word was God" (Jn 1:1). No thoughtful Greek or Jew would have missed the significance of John's proposition. If to a Greek reader *logos* was a great unifying philosophical principle, to a Jew *logos* was the personification of wisdom. Both understood the term or concept to be something altogether more than a written text. Building out his argument, John asserts, "All things came into being through him [the Word], and without him not one thing came into being" (Jn 1:3). But highlighting the Word's primary agency in creation is not the crescendo of John's argument. Rather, John's ultimate concern is to announce that the *logos* was assigned a particular form: "The word became flesh and lived among us, and we have seen his glory, the glory as of a father's only son, full of grace and truth" (Jn 1:14).[51] Jesus, the Son of the Father, is God's ultimate act of revelation. Certainly, Jesus is God's Book. But more than this, John implores his readers to understand that the corporeality of Christ, his flesh, is the shimmering illumination of God's presence. In God's Son the true Word of God and the true Icon of God fully and gloriously coexist. In Jesus of Nazareth the verbal and the visual are forever reconciled.

An exalted theological and aesthetic vision of the sort just described presupposes that both word and image communicate meaning and, therefore, both are worth pursuing. But as we shall see in the chapter that follows, many twentieth-century artists and philosophers came to doubt the very possibility of this kind of knowledge.

---

[51]The Nicene Creed explains it as follows: "He came down from heaven; he became incarnate by the Holy Spirit and the Virgin Mary, and he was made human."

# A Semblance of a Whole

*All things are wearisome;*
*more than one can express;*
*the eye is not satisfied with seeing,*
*or the ear filled with hearing.*

ECCLESIASTES 1:8

*Our language is, at best, a series of signs, indeed, generations of signs,*
*which seek to mediate the gap between mystery and our own consciousness.*

WAYNE ROOSA, THE ART OF SANDRA BOWDEN

*All philosophy is a "critique of language."*

LUDWIG WITTGENSTEIN, TRACTATUS

At the midpoint of his career, artist Sol LeWitt (1928–2007)—regarded by art historians as the father of minimalism and conceptualism—produced a painted wood construction titled *Objectivity* (plate 4). Like the rest of LeWitt's oeuvre, the visual organization of this wall-hung piece, measuring 50 × 50 × 9.75, inches is relatively simple. The work's rudimentary appearance should not be allowed to mute its message, however. Assembled in 1962, *Objectivity* signals the coming flood of postmodern thought—that disquieting constellation of philosophic probes and prods that sought to dismantle the foundation of modernity and especially conventional notions about language.

As observed earlier, during the postwar period America gained unprece-
dented international political and economic sway even as it entered pell-mell
into the Cold War. But just as the nation began to enjoy its global prominence,
unity at home faltered. In the 1960s, America's mostly white, conservative,
Protestant establishment faced unprecedented social and political unrest, and
within a short span of years the driving force of the youth movement—the
counterculture—ushered in a new consciousness that would refashion nearly
every aspect of national life, not least the arts and humanities curricula at
leading colleges and universities. But I am rushing ahead.

To create *Objectivity*, LeWitt employed three visual devices. The first of these
is the painting's spatial organization. Having divided the eleven letters of the
word *objectivity* into five groups—OB/JE/CT/IV/ITY—LeWitt placed each
pair or trio of letters within a square and then aligned all five squares along one
horizontal row. This pattern of grouping and aligning is repeated four more
times, producing a total of five parallel, horizontal rows. Second, LeWitt varied
the relative depth of each row in relation to the picture plane. The uppermost
line of squares sits in front of the plane; the row that lies immediately beneath
the first rests directly on this same plane; and rows three, four and five recede
in equal increments behind the plane. LeWitt's third device is color. By care-
fully modulating its application, the red and blue paint in the topmost row
displays the greatest intensity and contrast. In each subsequent row these same
hues grow increasingly dark so that if the viewer reads the painting from top to
bottom (as she would a standard Western text), the blue letters in the bottom-
most row become nearly impossible to distinguish from their red background.

Apart from the painting's formal properties, two phenomena can be observed.
First, the painterly treatment of the eleven letters that appear in LeWitt's work
effectively erases their typographic form, thereby reducing the word *objectivity*
to a conflagration of arbitrary marks. Second, the intersection of the painting's
five rows and five columns forms a visual grid containing twenty-five squares.
The grid is a common modernist motif, one that critic Rosalind Krauss believes
evokes "silence" or the "refusal of speech." Writes Krauss, "The absolute stasis of
the grid, its lack of hierarchy, of center, of inflection, emphasizes not only its
anti-referential character, but—more importantly—its hostility to narrative."[1]

---

[1]Rosalind E. Krauss, *The Originality of the Avant-Garde and Other Modernist Myths* (Cambridge,
MA: MIT Press, 1985), 158.

LeWitt's two maneuvers—erasing the typographic form of his letters and then confining them within a grid—successfully deconstruct "objectivity." One might argue that the artist's playful choices are mere abstractions and that my mention of them here is "much ado about nothing." In fact, the symbolic function of LeWitt's work is potent, since it aims to deconstruct objectivity and, in turn, the very foundation of Enlightenment thought.[2]

In the previous chapter, we considered the long-standing contest between the verbal and the visual wherein one mode of communication continually seeks to trump the other. This chapter examines the related and more alarming possibility that it is no longer possible for either word or image to guide us to genuine knowledge. Not only does this newer arrangement pose a direct challenge to text-based systems of belief such as Judaism and Christianity; it also questions every aspect of an image-centric, image-directed enterprise such as the visual arts.

## CRISIS

From illuminated medieval manuscripts to the names of fallen warriors etched in the black granite of Maya Lin's *Vietnam Memorial* (1982), typography, words and phrases make regular appearance in the visual arts. A striking early Renaissance example is on view in the Museum of San Marco in Florence, where, together, the four painted panels of Fra Giovanni Angelico's (c. 1395–1455) *Doors of the Silver Cabinet* (c. 1450) contain thirty-six rectangles, thirty-four of which depict various episodes in the life of Jesus (see fig. 6.1).[3] Each scene is bordered by two painted scrolls. The scrolls appearing above Angelico's images contain quotations from the Old Testament, while those painted beneath contain words from the New. In total, the work boasts sixty-eight biblical quotations.

---

[2]I am a fan of LeWitt's work and especially his three-floor 2008 installation at MASS MoCA in North Adams, Massachusetts. While LeWitt designed this work, he did not personally execute it. Rather, a team of sixty-five artists and students followed the artist's detailed instructions to create this monumental piece during a six-month period after the artist's death, a fact that only increases my interest in the importance of his early work *Objectivity*.

[3]This work was completed by Angelico's assistants, including Alesso Baldovinetti. The San Marco monastery also makes it possible for one to consider the word/image problem in social terms. The monks who resided at San Marco had direct access to two phenomena: the *paintings* of Fra Angelico in their individual cells and the impressive *library* of Niccolò Niccoli, a leading humanist, established with funds from the Medici family. The larger point is this: words and images of the most refined sort were present to these Dominicans and on a daily basis. Magnolia Scudieri, *San Marco: Complete Guide to the Museum and Church* (Florence: Scala, 1995), 8.

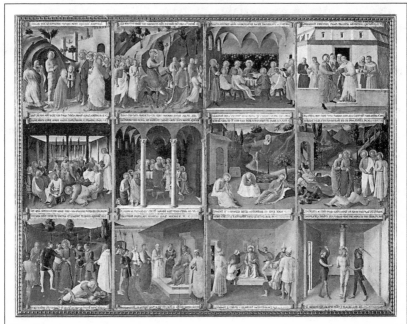

**6.1.** Fra Angelico, *Doors of the Silver Cabinet—Raising of Lazarus to Flagellation*, c. 1450

Like LeWitt, Angelico employs written text in his work. But as *Objectivity* demonstrates, LeWitt's theoretical interests are radically distinct from those of Angelico. Angelico's understanding of the world was shaped by his Dominican order, occasional brushes with the powerful Medici and the stimulation of fifteenth-century Florence. Like most Florentine artists of the day and the literate scholars and patrons whom he served, Angelico believed that words as well as the Word belonged to a metanarrative called Christendom. By contrast, LeWitt produced his work during the late modern period and at the center of the New York art scene. From Angelico to LeWitt, therefore, one witnesses an enormous gap: a fundamental shift regarding the purpose and meaning of language. Elena and Nicolas Calas describe this dramatic transition as follows: "The advertiser's oversize letters displaced the Flemish master's missal and the Dutch master's love letter; ecclesiastical symbols gave way to highway signs, calligraphy to childish scribblings, celestial maps to the computer's binary arithmetic."[4] Calas and Calas noted this paradigmatic shift in

---

[4]Elena Calas and Nicolas Calas, *Icons and Images of the Sixties* (New York: E. P. Dutton, 1971), 131.

1971. Given the ubiquity of today's digital information and the broad social and commercial enterprise that it supports, their observations—now more than fifty-five years past—seem more prescient than ever.

Twentieth-century moderns enlisted the term *crisis* to describe impending threats that could not be easily restrained or resolved. As noted in the previous chapter, the nature of the modern crisis has been well rehearsed: the extreme violence of two world wars, including the Nazi genocide of the Jews and the deployment of the atom bomb during the second; the dramatic modernization of social and economic life tempered by the failure of politicians and technocrats to create a more just and equitable world; and lingering doubt concerning the nature and meaning of being in a universe where transcendence has been dismissed.

Suffice it to say, in the second half of the twentieth century, conventional understandings about language were implicated in this crisis. To varying degrees, the leading intellectual lights of the late nineteenth and early twentieth century—Charles Darwin, Sigmund Freud, Karl Marx, Friedrich Nietzsche and their subsequent interpreters—recast the world in nontheistic terms, thereby releasing artists, intellectuals and other elites to pursue disciplines such as biology, psychology, economics and philosophy without reference to God. Said differently, these thought leaders exchanged enchanted or superstitious ideas about the world for secular notions about knowledge and progress, which in turn freed them from the grip of religion on their personal, cultural and institutional lives. This intellectual vanguard included many artists who, having discounted conventional pieties and practices, reveled in newfound aesthetic and ideological emancipation. While the world-shaping power of this ideological revolution (modernism) seemed filled with promise, it also fostered incalculable spiritual fatigue—an existential anomie—that secular schemes and freedoms were ill-equipped to address.

With this admittedly simple survey as backdrop, the import of LeWitt's *Objectivity* gains greater heft, for beneath the cool formalism of his work simmers the rising crisis of language.[5] Art critic Donald Kuspit writes,

---

[5]In seeking to define *language*, I am in agreement with Wayne Roosa, who writes, "By language, I mean every system for signifying human thought and meaning, whether verbal, plastic, aural, or gestural." Wayne Roosa, "A Meditation on the Joint and Its Holy Ornaments," in *Imagination and Interpretation: Christian Perspectives*, ed. Hans Boersma (Vancouver: Regent College Publishing, 2005), 131.

"Modernism assumes that language must necessarily die, that it can no longer be the ground of unity between speakers, but only, through its death the ground for a possible unity of self, for a radical or singular sense of the self."[6]

Postmodern philosophers generally regarded language as a cultural construction. They went on to reason that if language is an artifact of culture, a phenomenon tied to politics and peculiarities of the ones who create it, then its ability to describe can only be *imprecise* and its capacity to contain meaning *porous*. Consequently, modern men and women found themselves caught in an unending bait and switch wherein language claims degrees of certainty that it cannot defend (e.g., a promise might be made, but its obligation will remain opaque; a definition might be proposed, but its certainty will be subject to endless qualification). Well before the close of the twentieth century, some artists began to recognize the high-stakes nature of this argument. In fact, a cadre of philosophers in concert with a number of social scientists had introduced a dense fog of postmodern doubt that would envelop once more-certain horizons of belief. According to these philosophers and theorists, it was no longer sufficient for one simply to say what she meant or to mean what she said. But more than this, the deconstruction of language that was being proposed would continue on in infinite regress.

Many, of course, did and continue to maintain a large measure of confidence in language. But as already indicated, this kind of confidence faces a further challenge: a brave new mediated world in which vast quantities of textual, aural and visual information are being transmitted at breathtaking speed and aggregated in mind-numbing volume.[7] Some find promise in this deluge of data, believing that it will eradicate uncertainty. That is, if one is able

---

[6]Kuspit continues, "The singularity of form achieved through the subversion and death of language is emblematic of a radically individualized self. It is the form of the nonconformist self, the self that finds its unity in the dividedness of language, and that in a sense recovers its unity from the false, collective unity implied by historical, conformist language. In another sense, it recovers its authenticity from inauthentic language, using language against itself to break its hold on consciousness, and finally on being." Donald B. Kuspit, "The Unhappy Consciousness of Modernism," in *Zeitgeist in Babel: The Post-Modernist Controversy*, ed. Ingeborg Hoesterev (Bloomington: Indiana University Press, 1991), 61.

[7]See Neil Postman, *Amusing Ourselves to Death: Public Discourse in the Age of Show Business* (New York: Viking Penguin, 1985); Postman, *Technopoly: The Surrender of Culture to Technology* (New York: Vintage, 1993); and Mitchell Stephens, *The Rise of the Image, the Fall of the Word* (Oxford: Oxford University Press, 1998).

to plot these manifold points of information, then one can hope to accurately map the contours of reality.[8] But since the character of this raw data is indiscriminate and because it continues to multiply at an exponential rate, there is no evidence that its acquisition or management can lead to any increased knowledge about oneself, one's neighbor or God.

Meanwhile, popular culture—the vicarious thrill of sport and the pleasures of entertainment, food, drink and sex, coupled with the possession of high-tech toys, money and things—promises release. In fact, these delights require a mélange of digitally managed fonts, images, forms, colors, and apparently nothing—save a complete outage of electrical power—can quell their pulsating rush. On one hand, the stimulation of this media flood offers promising connection. But on the other it serves darker purposes designed to evade the questions that dog us, numbing our ability to sort fact from fiction and muting our capacity to distinguish the tawdry from the sublime. The larger point is this: together, twentieth-century philosophers, artists and designers radically reconfigured the nature, form and meaning of language.

While many persons and ideologies contributed to this new manner of thinking, two important and related twentieth-century endeavors merit special attention. The first of this pair is Lettrism, an early twentieth-century phenomenon that resided primarily in the politics and poetics of the visual arts. The second is the postwar theorizing known as deconstruction, which found its home primarily in philosophy and literature.

## Lettrism

During the postwar period, the authority of visual culture—the world consisting of pictures, signs, symbols and icons—ascended to regain the place of prominence it had previously enjoyed during premodern times. A collection of avant-garde movements such as Italian futurism (founded 1909), Russian constructivism (founded 1913), Swiss and German Dadaism (founded 1915) and the German Bauhaus (1919–1933) helped to resettle this new visual territory. Still, few cultural observers—save forward thinkers such as Walter Benjamin (1892–1940), Marshall McLuhan (1911–1980) and

---

[8]See Richard Saul Wurman, *Information Anxiety* (New York: Doubleday, 1989).

Jean Baudrillard (1927–2007)—seemed to anticipate the dramatic impact that this shift from word back to image would have on contemporary life.[9]

It is reasonable to propose that a primary impulse for the Lettrist movement was the late nineteenth-century French symbolist poet Stéphane Mallarmé (1842–1898) and in particular his experimental poem *Un coup de dés jamais n'abolira le hazard* (A throw of the dice will never abolish chance). As a young man Mallarmé appeared ill-suited to his large and otherwise respectable upper-middle-class French family. The writer was, by nature, a melancholic. From time to time he was given to visions of artistic grandeur, but these more romantic aspirations were tempered by his prevailing restlessness and extended periods of deep depression, during which he grew disconsolate.[10] In due course the writer came to be regarded as a true friend of a number of important modernist figures such as composer Claude Debussy, painters Émile Zola, Édouard Manet, Odilon Redon, Paul Gaugin, Paul Valéry and James Abott McNeil Whistler, and other aesthetes of his day.[11] In other words, as the ground for modernism was being established, Mallarmé figured importantly to the discourse that emerged.

*Un Coup de Dés*, a ten-page free-verse prose poem, was first published in the international arts magazine *Cosmopolis* in 1887 and not without controversy. To create the poem, Mallarmé experimented with "an alternate visual layout . . . constructing it around a single principal sentence or idea which would be printed line by line in capital letters, at differing heights of the page over several pages, around which other lines in smaller print would gravitate like cluster or constellations in such a way that the reader's own enthusiasm would hold the piece together."[12] In a subtle manner the poem bore the image of a seagoing vessel, and thematically, it sought to depict what Mallarmé imagined to be the critical stages of human history—from humankind's evolution from the sea to the return of the artist-seafarer to the same. Biographer Gordon Millan points that Mallarmé sought nothing less than to explore the

---

[9]See Walter Benjamin, "Works of Art in the Age of Mechanical Reproduction," in *Illuminations: Essays and Reflections* (New York: Schocken, 1969); Marshall McLuhan, *The Medium Is the Massage: An Inventory of Effects* (New York: Bantam, 1967); and Jean Baudrillard, *Simulations*, trans. Paul Foss, Paul Patton and Philip Beitchman (New York: Semiotext[e], 1983).

[10]Gordon Millan, *Mallarmé: A Throw of the Dice* (New York: Farrar, Straus and Giroux, 1994).

[11]Ibid., 323.

[12]Ibid., 310.

essential relationship between science and art, language and myth, ritual and religion. *Un Coup de Dés* was the writer's "first really serious attempt to produce the lasting literary monument to the post-Christian era which, many years earlier, he had announced to his friends."[13] Millan's reference here is to an excerpt from a personal manifesto Mallarmé had penned in April 1866. He was twenty-four at the time.

> Ah yes! I know, we are but mere forms of matter—but very sublime ones for having invented God and our souls. So sublime, my friend that I propose to offer myself the spectacle of matter, which, aware of what it is, nonetheless frenetically hurls itself up in the Dream which it knows does not exist, singing of the Soul and all the similar impressions of Divinity which have accumulated within us from the earliest ages and proclaiming, before the Nothingness which the Truth, these glorious lies. . . . I shall sing as a man without Hope.[14]

To the contemporary eye and in this digital age, where it is possible to download a vast number of fonts and arrange them in any manner and on any scale one may choose, the graphic design of Mallarmé's work can only seem unremarkable. But what is of interest to us in this chapter is Mallarmé's clear commitment to advance the post-Christian commitment to which he held so deeply. Indeed, his inventive literary form, coupled with his emerging worldview, anticipates both the post-Christian disposition that would sweep Europe in the twentieth century and the postmodern fascination with language, especially deconstruction, that would gain intellectual force near the century's end.

Though Mallarmé is not considered a major literary figure, in the modernist literary canon *Un Coup de Dés* is an important work, and the writer's revolutionary ideas did become part and parcel of the discourse that he shared within the circle of important modernist voices to which he belonged. For instance, it is reported that James Joyce kept a copy of *Un Coup de Dés* nearby as he wrote *Finnegan's Wake* (1939).[15] Mallarmé's imaginative work paved the way for a wide range of avant-garde projects including Guillaume Apollinaire's (1880–1918) *Ideogrammes*, the cubist compositions of Pablo Picasso (1881–1973) and George Braque (1882–1963), Kurt Schwitters's (1887–1948) *Merz*,

---

[13]Ibid.
[14]Ibid., 139.
[15]Ibid., 322.

and pieces by F. T. Marinetti (1876–1944), the founder of futurism.[16] Art critic Jori Finkel points out that "Marinetti, an Italian who also wrote in French, once boasted of using three or four colors and twenty fonts in a poem. He built his poems as collages, cuttings numbers and letters from newspapers as well as drawing some of the elements."[17] Apollinaire, one of the instigators of surrealism, wrote:

> O mouths, mankind is in search of a new form of speech
> With no grammar of any language will we be able to talk
> For these ancient languages are close to death
> It is really sheer habit and laziness
> That makes us continue to use them for poetry
> But they are like invalids who haven't the strength to say no
> People would soon get used to being dumb
> Mime is good enough for the cinema
> But we must decide to speak
> To move our tongues
> To splutter and stammer
> We want new sounds new sounds new sounds[18]

Much in the spirit of these avant-garde endeavors, the Romanian Isidore Isou, born Ioan-Isidor Goldstein (1925–2007), founded *Lettrisme*, or in its Anglicized form, Lettrism.[19] At the young age of sixteen Isou published a personal *Manifesto*, and near the close of World War II he moved to Paris, where he combined his study of poetry and the visual arts to explore the graphic nature of written texts. This season of experimentation led to the production of his Lettrist hypergraphics.

From Mallarmé's *Un Coup de Dés* to Apollinaire's insistence on the need for "new sounds new sounds new sounds," the various visual language experiments

---

[16]"Merz became the label for a process of transformation or creation ex nihilo: constructions, paintings, collages, plays, or poems." According to Schwitters, "Merz aims for freedom from anything that stands in the way of forming artistically. . . . An artist must have the right, for instance, to make a picture by putting together pieces of blotting paper. . . . I am interested in other artistic disciplines such as poetry. The elements of poetic arts are letters, syllables, words, phrases. From the reciprocal opening up of these elements, poetry is born." As quoted in Marc Dachy, *Dada: The Revolt of Art*, trans. Liz Nash (New York: Abrams, 2006), 46-47.

[17]Jori Finkel, "Oh, What a Futurist War," *New York Times*, August 27, 2006, 25.

[18]Guillaume Apollinaire, as cited by H. R. Rookmaker, *Modern Art and the Death of Culture* (Downers Grove, IL: InterVarsity Press, 1970), 122.

[19]Calas and Calas, *Icons and Images*, 131-48.

I have referenced might seem unremarkable in a contemporary setting where word coupled with image drives the whole of commerce and marketing. And by mid-century the voice of Lettrism would join its place in the larger modernist chorus. Anticipating this inclusion, a string of eccentric personalities and curious practices fill in the fascinating backstory, but among them it is Dada that best realizes Isou's original goal.

**Dada.** Birthed in Zurich by Jean Arp (1886–1996), Hans Richter (1888–1976) and poet Tristan Tzara (1896–1963), the movement was intent on toppling bourgeois taste and authority. Hell-bent to liberate the human spirit, these artist-activists labored to dismantle conventional ideas about the nature of language and, by extension, meaning itself. Passing familiarity with Dada might incline some viewers to regard its form and content as a kind of brazen nonsense. But when set against the horrible carnage and destruction of the First World War, the Dadaist campaign for radical social and political change is easier to comprehend. More than three decades after Dada's founding, Jean Arp commented: "We were looking for an elementary type of art that we thought would save mankind from the raging madness of those times. We aspired to a new order that could re-establish the balance between heaven and hell."[20]

Having begun in Zurich and Berlin, "Dada spread to Paris in 1920, and also extended to the 'free zones' of Barcelona, New York, Holland, and Tokyo, where Dada took off in sharply divergent directions, becoming an effervescent global network of free artists escaping from the control machine."[21] Then, stimulated in part by visits from Francis Picabia (1879–1953), the mad glee of Dada gained a foothold on the American scene, where artists such as émigré Marcel Duchamp (1887–1968) and Man Ray (1890–1976) experimented with new, more ignoble media such as photography, collage and found objects, which they enlisted to infuse new life into older forms such as painting, drawing and sculpture. The most iconic work of this period is surely Duchamp's *Fountain* (1917)—a white ceramic urinal he signed "R. Mutt"—which was exhibited at the Armory Show in New York in the aftermath of considerable protest.

In 1955 and much in line with Lettrist sensibilities, the practice of altering words and letters resurfaced in the literary world as concrete poetry. By the

[20]Dachy, *Dada*, 12.
[21]Ibid., 63.

1960s new anthologies, journals and exhibits sponsored by this fresh endeavor generated international attention.[22] But on the American scene and in the aftermath of Dada, Lettrism's most popular legacy is surely pop art. Artists such as Roy Lichtenstein (1923–1997), Robert Indiana (b. 1928), Bruce Nauman (b. 1941), Andy Warhol (1928–1987), Jasper Johns (b. 1930) and Ed Ruscha (b. 1937) found the word/image juxtapositions of contemporary advertising, product design and tabloid comic strips an unprecedented source of creative ideas that they rabidly repurposed to create new bodies of work.[23] In Bruce Nauman's *Life, Death, Love, Hate, Pleasure, Pain* (1983), for instance, the artist positions the six words (three binary pairs contained in the work's title) within a large neon circle, where, in some mechanically regulated sequence, the illuminated words flash on and then off (fig. 6.2). Tongue in cheek, Nauman's work serves to reduce life's weightiest existential concerns to storefront slogans. While some of these new visual formats were well suited to examine the philosophical contours of contemporary culture, others were a means to advance left-leaning social causes.

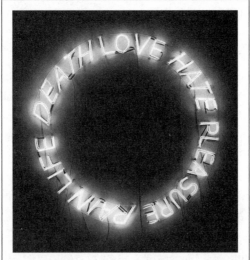

**6.2.** Bruce Nauman, *Life, Death, Love, Hate, Pleasure, Pain*, 1983

---

[22]Ian Chilvers, *A Dictionary of Twentieth-Century Art* (Oxford: Oxford University Press, 1999), 137.
[23]Other artists such as Cy Twombly, Shusaka Arakawa, Franz Kline and Willem de Kooning also explored the possible relationship between the verbal and the visual, including automatic drawing, the philosophy of signs (semiotics) and other expressive gestures.

***Discourse and dissent.*** Compared to the high profile of Dada and pop, Lettrism per se remained a minor cultural force. Still, the movement's enthusiasts applied their ideals to everything from communist posters and barricades to clothing, and these practices endured long enough to animate the rhetoric of the student protests in 1968. Just as Dadaists had labored to counter the violence of World War I, during the late 1960s university students in Europe and America campaigned to end America's failed war in Vietnam. Yet again the combined force of word and image was harnessed to achieve a particular political end. Present among these kinds of projects were protest prints like *Stop the Bombing* issued by Sister Corita Kent (1918–1986) during the Vietnam conflict (fig. 6.3).

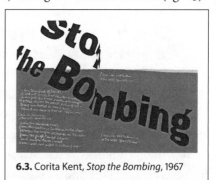

**6.3.** Corita Kent, *Stop the Bombing,* 1967

By the early 1980s the dynamism of the counterculture was mostly spent, America's religious right was gaining political clout, disenchantment swept the left, consumerism grew ubiquitous, and digitized new media repositioned communication, travel and business in a global context. Nonetheless, new artists such as Siah Armajani, Jean-Michel Basquait, Jenny Holzer, Barbara Kruger, Bruce Nauman and Tim Rollins ciphered fresh meanings from the rising tide of words and aphorisms. By the 1990s these artists, including the late Basquait, all enjoyed substantial critical attention.[24]

More than the others, Barbara Kruger's (b. 1945) streetwise social discourse carried the banner of Lettrist politics forward. Her work combined provocative black-and-white Photostat images with ironic or acerbic phrases spelled out in bold, sans serif type. The artist often added a brilliant hue of red to highlight selected borders, backgrounds and words contained in her compositions. Explains Kruger, "I work with pictures and words because they have the ability to determine who we are, what we want to be, and what we become."[25] The artist's feminist critique of male dominance—especially in reference to the objectification and commodification of the female

[24]James Romaine, "Making History," in *Tim Rollins and K.O.S.: A History*, ed. Ian Berry (Boston: MIT Press, 2009), 41-98.
[25]Jeanne Siegel, "Barbara Kruger: Pictures and Words," *Arts* 61, no. 10 (June 1987): 19.

body—packed a punch, and her allusions to rupture, discontinuity, exhaustion and suspicion invoked everything from semiotics to literary theory.

It will surprise no one, Kruger least of all, that some conservative Christians found her work off-putting. Consider, for example, *Untitled (God said it, I believe it and that settles it)* (1987). Here Kruger's intent is entirely transparent: by placing this popular religious truism inside the walls of an elite secular gallery or museum, she summoned the poetics and politics of contemporary art to deconstruct its message. Transferred from the narthex of a church or the bumper of a car to an art-world wall, this popular religious slogan appears unbearably naive. According to Rosalind Krauss the discursive zone in which Kruger operates is "paraliterary." It is "the space of debate, quotation, partisanship, betrayal, reconciliation; but it is not the space of unity, coherence, or resolution that we think of as constituting the work of literature. For both Barthes and Derrida have a deep enmity towards that notion of literary work. What is left is drama without the Play, voices without the Author, criticism without the Argument."[26]

Not all artists fascinated by the juxtaposition of word with image have been as overtly political as Kruger. Born in Iran, the American sculptor Siah Armajani (b. 1939) studied philosophy at Macalester College, where his early interests included existentialism and especially the work of twentieth-century German philosopher Martin Heidegger. On the completion of his undergraduate degree, however, the concrete nature of sculpture drew Armajani to the visual arts. His mature work features the construction of gardens and reading rooms where an assortment of benches, tables and lecterns inscribed with selected lines of poetry create a space for both private and public reading. While these projects often exude whimsy, their actual construction requires substantial cooperation between the artist and his tradesmen, poets and patrons. Armajani freely admits, "I often finish a work not out of satisfaction, but rather out of exhaustion."[27]

Like Armajani, Tim Rollins's (b. 1955) work is both literary, drawing on classic texts such as Mark Twain's *Huck Finn* and Ralph Elison's *The Invisible Man*, and visual, involving the application of paint and collaged cutouts to canvas or paper.[28] Working side by side with K.O.S. (Kids of Survival), an

---

[26]Krauss, *Originality of the Avant-Garde*, 292-93.

[27]Notes from Siah Armajani's May 25, 2006, lecture at the Madison Museum of Contemporary Art.

[28]For a critical assessment of Rollins's work, see Albert Pedulla, "Fulfilled in Your Seeing: The Life and Work of Tim Rollins and K.O.S.," *Image* 45: 22-34.

organization founded by Rollins, the artist and his projects serve the cause of justice and community.[29] This pair of values is embodied in everything from the artist's mentorship of the underserved children with whom he collaborates to the ambitious selection of social and political themes that surface in his work. Although it may appear that Rollins's theoretical excursions embrace the deconstructive direction of LeWitt's *Objectivity*, by building a bridge from canonical texts to volatile social situations he renews rather than obliterates the efficacy of language.[30]

***Appropriation.*** How shall we understand these projects by Kruger, Armajani and Rollins in the larger context of contemporary arts and its exploration of language? In 1991 the Walker Art Center commissioned a work by conceptual artist Lawrence Weiner (b. 1942) that provides a helpful frame of reference. Weiner's piece is composed of uppercase letters crafted from anodized aluminum and permanently affixed to center's east exterior wall. Those who walk or drive along Hennepin Avenue—a busy Minneapolis thoroughfare—can easily read the following:

BITS & PIECES
PUT TOGETHER
TO PRESENT A SEMBLANCE
OF A WHOLE

In our late- or postmodern situation, human knowledge is thought to be fragmentary, and in this context the pursuit of knowledge stimulates a bounty

---

[29]Rollins's exposure to the New York City public school system gave him great compassion for underprivileged students. "While teaching at I. S. 52, I was stunned at the discrepancy between my kids' artistic gifts and their abysmal reading abilities. They were totally excluded from the world of literature, while public schools paid thousands to so-called experts to tell us what our kids could not do. I was told that I was endangering the fragile self-esteem of my students by insisting that they read authors like Orwell, Kafka, Anne Frank, and Malcolm X. It was assumed that they could not read—or would not read, because of their background." Before long the artist began involving these children in his own art making, which led to the formation of K.O.S. David Deitcher, "Tim Rollins Talks to David Deitcher," *Artforum*, April 2003, 79.

[30]"The texts he works with could not be politically significant unless they were great in the first place as literature. . . . He is concerned with the transformative power of the best, and his respect for the canon is as profound as his admiration for the great art of the past. . . . Kids of Survival read Hawthorne, Orwell, Defoe, and Kafka, and they look at Goya, Grünewald, Leonardo, and Paolo Uccello. It is less as though he were rescuing adolescents from the ghetto than using them as a way of rescuing the great cultural tradition of the West—or they rescue one another." Arthur C. Danto, *Embodied Meanings: Critical Essays and Aesthetic Meditations* (New York: Farrar, Straus and Giroux, 1994), 70.

of "bottom up" operations. Consequently, a good deal of modern and post-modern art is fashioned from the "stuff" of culture—scavenged scraps, symbols and ideas reassembled into novel forms and appropriated to new causes. As Weiner's Walker installation suggests, the artist's task may be to gather up the "bits and pieces" of human understanding, culture and production and then arrange them into "a semblance of a whole." In a sense, the central feature of this effort highlights the artist's agency—his or her ability to edit, prefer, annotate, discard and rehabilitate the detritus of culture (both high and low).

Notably, in the postwar period, the very nature of these creative processes was mostly closed to transcendence. And so, while some artists may have aspired to witness the glimmer of a larger whole or even to glimpse a bit of the sacred, the abiding legacy of Lettrism tilted toward an opposite conclusion: the scaffolding of language was not sturdy enough to sustain the creation of culture, let alone to summon any enduring meaning from it. As if seated before several incomplete puzzles, artists were left to their own devices to sort through the "bits and pieces."

## DECONSTRUCTION

A dense philosophical discourse followed on the heels of Lettrism's poetic and political agenda, where the verbal and the visual existed in constant flux. To the fore of this critical phalanx was

> a group of avant-garde writers, critics, political thinkers, psychoanalytic theorists, radical semioticians and others that . . . gathered around the journal *Tel Quel* in the late 1960s and early 1970s. This collective, including Julia Kristeva, Philippe Sollers, Roland Barthes, and [Jacques] Derrida . . . was committed to a project which aimed to revolutionize the norms of "bourgeois" discourse through a practice of writing that transformed the very concepts of truth, reality and representation.[31]

To this circle one might rightly add leading intellectuals such as Harold Bloom, Noam Chomsky, Stanley Fish, Michel Foucault, Jacques Lacan and Richard Rorty. In the closing decades of the twentieth century, this was a

---

[31]Christopher Norris, introduction to *Positions*, by Jacques Derrida, 2nd ed., trans. and annotated Alan Bass (1972; repr., London: Continuum, 2002), xvii.

heralded bunch, and the broad intellectual terrain under their command was mostly painted with a postmodernism brush.[32] My abridged familiarity with literature, linguistics, psychology and philosophy will limit me from wading into this sophisticated terrain too deeply. The matter is further complicated by the reality that the voices we shall consider here, alongside the hundreds of others they represent, are hardly univocal. Invariably, postmodern discourse is diffused, multivalent and given to unending iterations. Nonetheless, it is possible to gain something like a ringside seat from which to witness this critical exchange, and that is my purpose in the pages that follow.

The broad scope of Derrida's reading and writing engages the work of Martin Heidegger and, to lesser degrees, Hegel, Husserl, Levinas, Nietzsche, Ricoeur and Wittgenstein.[33] Two of Derrida's seminal works are *Of Grammatology* (1967) and *Writing and Difference* (1967). His writing was first published in French, and with its translation into English during the 1980s, the philosopher's ideas, especially deconstruction, caught fire in American colleges and universities. Like *postmodernism*, the term *deconstruction* was bandied about for some time in everything from journalistic writing to evangelical preaching, but these popular treatments seldom mentioned Derrida or, less still, two of the philosopher's central concerns—his rejection of *logocentrism* and his embrace of *différance*.

For Derrida *logocentrism* is the conviction that some foundation or essence, a *logos*, underlies all of reality and that language is the sole point of access to this deeper truth or what some term a "presence." A critic of logocentrism, Derrida eagerly discredited the necessity of any overarching metaphysic or metanarrative, and the introduction of *différance* was his means to maneuver around or note endless exceptions to this possibility.[34] According to Millard Erickson, "The word *différance*, which Derrida created, contains two ideas

---

[32]Christopher Norris offers the following definition of postmodernism: "Postmodernism amounts—philosophically speaking—to a kind of generalized scepticism, a scepticism with regard to such typecast 'modernist' concepts as truth, reason and critique." Ibid., xii.

[33]"In Heidegger's greatest work, *Being and Time* (1927), the philosopher decides that human existence has no metaphysical grounds; it originates in the abyss of emptiness and culminates in the annihilation of death, a nothingness that man cannot know as fact or experience as emotion." John Patrick Diggins, *The Promise of Pragmatism: Modernism and the Crisis of Knowledge and Authority* (Chicago: University of Chicago Press, 1994), 410-11.

[34]"Derrida can be said to share the attitude of postmodern scepticism with regard to any metanarrative account that claims a privilege access to truth, or to the unfolding logic of historical events as revealed in the wisdom of theological insight." Norris, introduction to Derrida, *Positions*, xiv.

within it: differing and deferring. The differing is a matter of showing a series of 'traces,' of showing the difference between things. This is how reference works, such as dictionaries, function. We understand the sign by seeing, not so much what it is, but what it is not." Deferring points to "the endless play of signifiers, in which one gives way or defers to the next, that builds up the meaning of the sign."[35] It is from these bottom-up associations and interactions that one attempts to assemble a coherent view of the world. If meaning does exist—for Derrida, this possibility remained an open, yet troubling, pursuit—it can only be derived from the jostling of one sign against another.

In seeking to understand deconstruction, three themes merit further articulation: the meaning of *play*, the exercise of *power* and the arousal of *suspicion*.[36] As we shall see, there is a vital link between contemporary theorizing about language and the visual arts. In fact, historian Allan Megill points out that it was the "self-questioning" of leading twentieth-century artists and writers that prompted Derrida's line of reasoning.[37]

**Play.** When postmodern philosophers or language theorists refer to "play" or "language games," they usually intend one of three meanings: a child's naive yet tenacious examination of the world; the calculated moves and countermoves of something like a chess match; or the loose action of a worn or ill-fitted joint.[38] Generally speaking, the idea of language games originated with Austrian-born philosopher Ludwig Wittgenstein (1889–1951). Wittgenstein's grandfather, Hermann Wittgenstein, was a Jewish convert to Catholicism, and the philosopher's father, Karl Wittgenstein, was a prosperous industrialist who maintained the family's allegiance to the church. Karl loved the arts, especially music, and it was not uncommon for him to host Johannes Brahms or Gustav Mahler in their grand home. He and his wife had eight children, many of whom were exceptional musicians, and

---

[35]Millard J. Erickson, *Truth or Consequences: The Promise and Perils of Postmodernism* (Downers Grove, IL: InterVarsity Press, 2001), 118-19. In an interview with Henri Ronse, Derrida proposes four possible meanings or uses for *différance*: delay, differentiation, the products of difference and the unfolding of difference. Derrida, *Positions*, 3-14.

[36]See Donald B. Kuspit, "Conflicting Logics: Twentieth-Century Studies at the Crossroads," *Art Bulletin* 69, no. 1 (March 1987): 117-32; and Howard Risotti, *Postmodern Perspectives: Issues in Contemporary Art* (Englewood Cliffs, NJ: Prentice Hall, 1990).

[37]Allan Megill, *Prophets of Extremity: Nietzsche, Heidegger, Foucault, Derrida* (Berkeley: University of California Press, 1985), 302.

[38]I am grateful to Wayne Roosa for this image of the ill-fitting joint.

together they embraced the world of art, culture and ideas. Ludwig was the youngest. Tragically, several of his siblings were tortured souls, and no less than three of his brothers committed suicide later in life.

Beyond the stimulation of his immediate family, young Wittgenstein found Viennese life and culture a source of considerable intrigue. During his formative years, "the beginnings of twelve-tone music, 'modern' architecture, legal and logical positivism, nonrepresentational painting and psychoanalysis—not to mention the revival of interest in Schopenhauer and Kierkegaard—were all taking place simultaneously and were largely concentrated in Vienna."[39] In other words, there was considerable correspondence between Wittgenstein's personal development and the rise of modernism.

In 1911 Wittgenstein arrived at Cambridge University unannounced and began attending lectures by the renowned mathematician and philosopher Bertrand Russell. Before long, he set his Catholic upbringing to the side and embraced the atheism of his new mentor. Though only in his mid-twenties, Wittgenstein soon wearied of Cambridge, and a considerable inheritance from his father allowed him to retreat to a small town in Norway in 1913, where he continued his studies alone.

With the outbreak of the First World War in 1914, Ludwig joined the Austro-Hungarian Army, an experience that dramatically changed his outlook. By 1916 he was fighting on the Russian front, and the brutality of battle led the once-militant atheist to embrace Tolstoy's *The Gospel in Brief*. During this enlistment Wittgenstein penned a letter to his mentor, Russell, describing Tolstoy's work as "the book that saved my life." Before long the young philosopher came to be known by his fellow soldiers as "the man with the gospels."[40]

Eventually Wittgenstein completed his solitary labors, and in 1921 he published *Tractatus Logico-Philosophicus*. The first edition was written in German and featured a foreword by Russell.[41] To the average reader *Tractatus* appeared inscrutable, but to the few who could comprehend the book it was thought to be a work of genius. In 1929 and with some fanfare Wittgenstein was invited to return to Cambridge and assume a faculty position. However, he could not accept the post since he had never actually completed a Cambridge degree.

---

[39]Allan Janik and Stephen Toulmin, *Wittgenstein's Vienna* (New York: Touchstone, 1973), 19.
[40]Ibid., 201.
[41]See ibid., 167-201.

The more senior Russell resolved the matter, arguing that the publication of *Tractatus* was equivalent to a doctoral dissertation.

It bears mention that philosophy was not Wittgenstein's sole interest and that the visual arts were always close at hand. After the manner of architect Adolf Loos, he designed a modernist house for his sister Margaret and produced a fair bit of sculpture. He also maintained some loose affiliation with the famed Vienna Circle and traveled and lectured broadly. The Austrian intellectual stayed on at Cambridge for eighteen years, a period that witnessed everything from the rise of Russell's logical positivism to the avant-garde affairs of the Bloomsbury Group.

Outlining Wittgenstein's concerns, Millard Erickson writes, "Language, then, does not simply name objects. It may be put to several different uses, such as giving orders, framing conjectures, making up a story, play-acting, telling a joke, translating, praying, cursing, greeting."[42] According to Wittgenstein, "the meaning, which gives life to the sign, is not something existing separately from the sign, in something called the mind, but is actually the use made of the sign, which may vary in different activities, or language-games."[43]

Wittgenstein's ideas were given to constant revision, and later in life he came to doubt his earlier views and, with this, to distance himself from Russell. Increasingly, the manifold functions of language troubled him, and to the degree that its layers of complexity made it impossible to tease out any primary causality, he preferred the "rough ground" of ordinary language. That is, common language and philosophy (the language about language) are best comprehended in their patterns of normal use, and these observations led Wittgenstein to conclude that the "play of language" is the source of all meaning.[44] With his Christian faith now mostly in the background, logic and its limits left Wittgenstein disconsolate.

Building on this foundation, Derrida's deconstruction delights in challenging received philosophical and literary categories: "To risk meaning nothing is to start to play, and first to enter into the play of *différance* which prevents any word, any concept, any major enunciation from coming to summarize and to

---

[42]Erickson, *Truth or Consequences*, 103.

[43]Ibid., 104.

[44]It should be noted that it was not until the posthumous publication of his second major work, *Philosophical Investigations*, that Wittgenstein's change of mind gained wider circulation. Ludwig Wittgenstein, *Philosophical Investigations*, 2nd ed. (New York: Macmillan, 1967).

govern from the theological presence of a center the movement and textual spacing of differences."[45] Exegeting texts with taunts and teases, Derrida's purpose is to expose the limitations of language—its random or arbitrary character—and its subsequent unsuitability to bear meaning. Erickson contends, "If there were a centering in a point of fixed reference outside the play of signifiers, or what [Derrida] terms *logocentrism*, there would obviously be a limit to this play of signifiers. Without that, however, the play is endless."[46] Not unlike the illusion of infinity generated by two mirrors placed face-to-face in perfect parallel, if one follows Derrida's reasoning to its logical conclusion, one will find it impossible to determine any authentic beginning or end.

*Power.* As already noted, language is used to accomplish a variety of ends: assigning names, outlining procedures, telling stories, drafting laws and advancing ideologies. Consider the repeated instances of naming and renaming in the Bible. Umberto Eco observes, "Creation itself arose through an act of speech; it was only by giving things their names that God created them and gave them an ontological status."[47] When God assigns one a name or, for that matter, names his own name, the purpose of this action is to reveal something of the named being's core nature. Names and titles can be used to convey honor or affection; just as easily they can be deployed as weapons. For instance, one need only mention epithets such as "gay" or "fundamentalist," "black" or "white," "bohemian" or "philistine" to taste something of their bitter power.

Whether one is a political tyrant or a religious guru, a marketing executive or a lover, those most skilled in managing rhetoric are also those most inclined to deploy its force. A man or woman who is granted the authority to name a person, a place or a thing holds the power to *describe* and *prescribe*. The first of these actions declares how things are, while the second outlines how things should be. In this arrangement, *is* precipitates *ought*. As we know, observed social conditions influence public policy, analysis directs planning, assessment shapes curriculum and doctrine determines practice. Language, then, is routinely employed to protect categories (taxonomies) and to enforce protocols

---

[45]Derrida, *Positions*, 14.

[46]Erickson, *Truth or Consequences*, 119.

[47]Umberto Eco, *Serendipities: Language and Lunacy*, trans. William Weaver, Italian Academic Lectures (New York: Columbia University Press, 1998), 23. It was Wittgenstein's belief that that act of naming connects abstract theory to real-world events. See Janik and Toulmin, *Wittgenstein's Vienna*, 184.

(rules), and it is this power and its corresponding privilege that avant-garde artists and postmodern philosophers were determined to overturn.

As a means to challenge both the coherence of particular texts and the originality of those who produce them, Derrida as well as Roland Barthes, Michel Foucault and others devoted substantial energy to challenge time-honored categories such as "writer," "author" and "text."[48] Their rationale was straightforward: the mastery of language and the mastery of one's neighbor are coextensive. To undo this arrangement these intellectuals wielded a double-edged sword. In one direction, their blade sliced through the romantic notion of the genius—the conviction that a few anointed souls possess insight of such brilliance that they must be appointed cultural sages or priests. In the other direction, the sharpened steel of this agreement severed the belief that language can accurately account for reality. One is left to conclude that if the house of knowledge is erected from nothing more than linguistic cards, then this fragile complex of words, figures and ideas lacks any capacity to bear the existential or spiritual weight of our being.

*Suspicion.* Derrida's thinly veiled goal was to use his command of language to master all other intellectual work. But his repeated building up (his writing) and tearing down (his assault of other texts) of language becomes a vicious cycle, and the playground-like contest that ensues is laden with irony, for clearly the one who unseats the "genius" stands to gain the positional authority of the one whom he has managed to defeat. Such are the spoils of conquest, and no quarter is more mesmerized by its ability to cause words to do its bidding than the philosophers of language who draft expansive tomes that in effect dismiss or erase the very precedents they claim to prize. Meanwhile, Derrida was committed to a particular kind of justice, especially its relationship to legal theory and the significance of human action with respect to improving the conditions of those who are disempowered and

---

[48]Since "author" is the root of "authority," when one challenges traditional notions of authorship, one necessarily confronts hierarchies and structures that are, in the estimation of their critics, oppressive. One plausible response to authority might be to ignore it. Michel Foucault speculates that "behind all the questions, we would hear hardly anything but the stirring of indifference: What difference does it make who is speaking?" Michel Foucault, "What Is an Author," in *A Foucault Reader*, ed. Paul Rabinow (New York: Pantheon Books, 1984), 120. Also see Roland Barthes, "The Death of the Author," *Image—Music—Text*, ed. and trans. S. Heath (New York: Hill and Wang, 1977), 145-46. This essay first appeared in the 1967 issue of the literary journal *Aspen*, edited by minimalist artist Brian O'Doherty (aka Patrick Ireland).

marginalized. But to realize the revolution that he sought to foment, the authority of language needed to be toppled.

In this desire to realize a particular kind of liberty and justice, Derrida was hardly alone. Whenever and wherever language appears to authorize conservative social and political ends, contemporary artists and intellectuals can be counted on to sound the critical alarm. Clearly, the ambiguity and authority that surround language stimulated the mind of innumerable modern philosophers and the hand of more than a few contemporary artists. While the force of these actions and inventions that captured the intellectual and aesthetic imagination by the close of the twentieth century is considerable, ideas about deconstruction run mostly counter to a biblical worldview.[49]

## Confronting Babel

Exasperated by his tedious self-examination and flirting with despair, the writer of Ecclesiastes announces, "There is nothing new under the sun" (Eccles 1:9). Language and its many shortcomings might lead one to a similar conclusion. Indeed, the negative impact of words is well established. Genesis 3, for instance, presents Adam, Eve and the serpent as beings who use words to reason, to persuade and to deceive. James reminds his readers that "the tongue is a fire . . . and is itself set on fire by hell." He continues, "No one can tame the tongue. . . . With it we bless the Lord and Father, and with it we curse those who are made in the likeness of God. From the same mouth come blessing and cursing" (Jas 3:6-10).

But of the many biblical accounts that showcase the treachery of language, it is the hubris and confusion of Babel that most fascinates modern and postmodern philosophers.[50] As early as 1937 theologian Reinhold Niebuhr wrote, "Every civilization and every culture is . . . a Tower of Babel."[51] Reading the

---

[49]Crystal Downing makes the case that Christian intellectuals such as C. S. Lewis and Dorothy Sayers held views that might be regarded as sympathetic to those of Derrida. Crystal L. Downing, *How Postmodernism Serves My Faith: Questioning Truth in Language, Philosophy and Art* (Downers Grove, IL: InterVarsity Press, 2006), 138-39.

[50]Umberto Eco's *Serendipities* makes numerous references to this event, and on the jacket of this book, designer Linda Secundari chose to reproduce Pieter Brueghel, *The Tower of Babel* (1563). My subsequent reading of Downing, *How Postmodernism Serves My Faith*, adds force to this observation. She cites five authors who make reference to the Babel narrative, including Reinhold Niebuhr and Jacques Derrida (ibid., 161-62).

[51]Reinhold Niebuhr, *Beyond Tragedy: Essays on the Christian Interpretation of History* (New York: Scribners, 1937), as quoted in Downing, *Postmodernism*, 28.

Genesis narrative, one is reminded that Babel's people were eager to make a name for themselves—that is, to demonstrate their independence from God. To that end they gathered to build a great tower (most likely a Mesopotamian

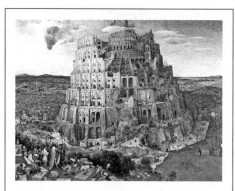

ziggurat) that could reach to heaven (see fig. 6.4). But God regarded their ambition an affront. To abate this effort, he confused their common language and "scattered them abroad over the face of all the earth" (Gen 11:4-9). Simply stated, Genesis 11 illustrates the potential force of a shared and coherent language and

**6.4.** Pieter Brueghel the Elder, *Tower of Babel*, 1563

the superior power of the one, in this instance God, who is authorized to deconstruct it. With this ancient story as deep background, we return to Derrida.

If Derrida's enthusiasts found his work elegant, erudite and liberating, it is also the case that secular and religious critics alike regarded it as bleak, bizarre and nihilistic.[52] According to his detractors, Derrida's deconstruction is concomitant to the abandonment of intellectual rigor, rational thought and even sanity. Charles Taylor observes:

> For Derrida, there is nothing but deconstruction, which swallows up the old hierarchical distinctions between philosophy and literature, and between men and women, but just as readily could swallow up equal/unequal, community/ discord, uncoerced/constrained dialogue, and the like. Nothing emerges from his flux worth affirming, and so what in fact comes to be celebrated is the deconstructing power itself, the prodigious power of subjectivity to undo all the potential allegiances which might bind it; pure untrammeled freedom.[53]

Reason is not deconstruction's only victim. Derrida's scheme is freighted with hostility toward metaphysics and especially spiritual transcendence.

---

[52]For an early conservative reaction see Allan Bloom, *The Closing of the American Mind: How Higher Education Has Failed Democracy and Impoverished the Souls of Today's Students* (New York: Simon and Schuster, 1987), 379.

[53]Charles Taylor, *Sources of the Self: The Making of Modern Identity* (Cambridge, MA: Harvard University Press, 1989), 489.

The "people of the Book" are right to suspect that a primary target for Derrida's critical missiles was biblical revelation.[54] Writes George Steiner, "This issue is, quite simply, that of the meaning of meaning, as it is re-insured by the postulate of the existence of God. 'In the beginning was the Word.' There was no such beginning, says deconstruction; only the play of sounds and markers amid the mutations of time."[55] In the end, Derrida's worldview may be likened to a winding mountain road where, all guard rails removed, one's descent becomes a ride of terror.[56]

What shall we make of these manifold doubts and challenges? In their rush to honestly delineate the limits of language, postmodern artists and intellectuals were too eager to deny the capacity of language to accurately describe reality. In fact, great numbers of men and women persist in reading novels and essays and listening to poets and preachers simply because the clarity and artfulness of such texts and voices makes sense and provides pleasure. Day in and day out we call on language—what else could we use?—to navigate our encounters with sculpture, painting, music and drama. Language enables us to celebrate life and to mourn death. In other words, we choose to believe that our propositions, poetry and prayers are meaning-filled. Furthermore, these pursuits yield the profound hope that language will lead us beyond these forms to meaning itself. And, remarkably, we belong to communities in which these words, though limited, serve us remarkably well. To test this claim, simply recall a recent conversation you have had with a friend or colleague that seemed especially meaningful. Understood within this frame, the vocation of the artist and the poet is to undertake the tremendous burden and pleasure of saying what seems unsayable.

---

[54]"Among other things, such theories of language and poetry as Bloom's and Derrida's strive to effect a misconstruction of the historical role of the Bible among Christian writers and readers. In this misconstruction, residual respect for the Bible's continual witness in the form of a metaphysical 'grand narrative' (the term is Lyotard's but the concept readily allies itself with Derrida's 'logocentrism'), or for its place as the perceived foundation of literary tradition in the once-Christian West, is to be erased. This erasure is to be effected by the tactics of subversion, by reading and writing which overthrows the 'precursor,' the previously respected text. Such programmatic 'overthrowing,' whether by 'perversity of the spirit' in a calculated 'misprision' or misreading of classic texts, as in Bloom, or by refusal of logic and normative lexical and grammatical conventions, as in Derrida, has become not merely a kind of fantasy or playful miscreance on the part of such theorists but, on their own attestation and that of many others, an attack on the central values embodied in the Christian biblical tradition as most have understood it." David Lyle Jeffrey, *People of the Book: Christian Identity and Literary Culture* (Grand Rapids: Eerdmans, 1996), xvii.

[55]George Steiner, *Real Presences* (Chicago: University of Chicago Press, 1991), 120.

[56]See Megill, "On the Meaning of Jacques Derrida," in *Prophets of Extremity*, 257-338.

Curiously, it is this very possibility of saying the unsayable that haunted Derrida; for there is good evidence that the "God question" dogged him, not unlike Wittgenstein.[57] John Caputo, a leading interpreter of Derrida, documents one occasion when, near the end of the philosopher's life, he publicly acknowledged the "possibility" of "the impossible" or an Other—one whom Derrida both sought to address in prayer but also regarded as beyond the ability of language to name.

Born in Algeria and to a Jewish family, Derrida held a Judaism that was hardly orthodox. Still, it is reasonable to suppose his familiarity with the story of Moses and, in particular, the prophet's dramatic encounter with the angel of the Lord who appeared to him in the flames of a bush that would not be consumed. The sight so intrigued Moses that he left his wilderness path to study the spectacle, and it was in that moment that God charged the prophet to deliver the people of Israel from the land of Egypt. Anticipating the resistance of his stubborn kinsmen, Moses wondered, "Who shall I say sent me?" Yahweh replied, "I AM WHO I AM" (see Ex 3:1-14).

Looking beyond the particularity of this account and to the whole of the Bible, one discerns a larger pattern: "What makes Christianity distinctive from other religions is the belief that since language cannot reach God, God reached down to us, taking the form of a servant who bore the sins of the world on his flesh."[58] To lead reasonable lives—to keep our wits—the esoteric and often grandiose ideas that we have considered in this chapter need to occupy real ground.

Must we concede that both words and images are inherently unreliable and even sinister? I think not. To the contrary, the malleability and flexibility of language actually enhances its ability to sift and sort the particularities of life. Deftly handled, language makes it possible to scale the height and plumb the depth of our daily routines. More than this, it allows us to approach the splendor of God's creation and peer into the mystery of God's being. Indeed, it might be that our struggle with language has less to do with the limitation of its various forms and more to do with the staggering brilliance of reality. And to the degree that language is used either to oppress or to deceive, the responsibility for this abuse rests squarely on the shoulders of its handlers.

---

[57]For Caputo's account of Derrida, see Downing, *Postmodernism*, 173-76.

[58]Ibid., 177. To this I add David Jeffrey's observation that "the perennial generation of words, *dor le dor*, is not a function of either the dearth or the plentitude of their meaning. It is a function rather of our getting it at best about half-right, because language, even without communicating the divine Word, is simultaneously both revelatory and distorting." Jeffrey, *People of the Book*, 16.

## ANNUNCIATION

The setting for Jan van Eyck's *Annunciation* (c. 1434–1436), on view at the National Gallery of Art in Washington, DC, is a tall, open chapel (fig. 6.5). The upper-story

windows in the painting's interior space are Romanesque, while those below are Gothic; all in all, this architecture and space is anything but a humble room in first-century Palestine. But true to the painting's fifteenth-century provenance, the work displays a visual and verbal arsenal that includes a depiction of Yahweh located in an upper-story, stained-glass window, from which he omnisciently oversees the moment; God's messenger, the elegantly robed angel Gabriel; written text wherein Gabriel addresses Mary, "Hail, thou who art full of grace," to which she responds, "Behold, the handmaiden of the Lord" (emerging from their mouths, these words appear upside down so that, presumably, they can be read by God, who views them from above); the Holy Spirit, who, taking the form of a dove, descends on beams of light; a text bearing the words of Isaiah that rests on a table before Mary; and a vase filled with six white lilies, a sign of the Virgin's purity.[59] In other words, van Eyck employs the medium of paint to lavishly illustrate a central and singular event in the unfolding of the salvation story.

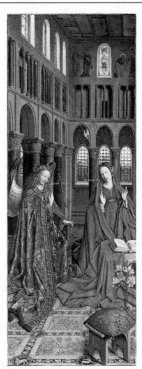

**6.5.** Jan van Eyck, *The Annunciation*, c. 1434–1436

In calling attention to van Eyck's *Annunciation*, it is hardly my purpose to propose that contemporary works of art must be biblically themed or even representational. Rather, I am impressed by the way that van Eyck models the fidelity of word to image and image to word. Throughout this chapter I have noted the numerous shortcomings and liabilities of language. By contrast, the numerous prints and paintings that depict the annunciation—God's

---

[59]"Mary is often depicted as the ideal reader of the ideal book, and the painters make it clear that this is to be understood by us as intrinsic to her being chosen as incarnational medium of the Logos himself." Jeffrey, *People of the Book*, 221.

announcement to Mary through Gabriel—offer fitting examples of word and image at work in tandem. And according to van Eyck's mind and hand, the shock of Gabriel's unlikely announcement is surrounded by holy play even as the central purpose of the painting is to display God's plan for the redemption of humankind.[60]

In the Christian understanding of things, one of the artist's central tasks is to quicken language, to grant verbal and visual ideas in material form, to employ every medium and metaphor to announce the presence of God in the world. Van Eyck's clever command of the verbal and the visual grants his viewer reasonable cause to be impressed by the durability, capacity and beauty of language—word and image alike—to meet its obligation. Indeed, for artists of faith, the ultimate goal of all speaking, writing and making is to restore the *fellowship* of thought and action, idea and meaning, and ultimately God and humankind.

Not coincidentally the reality of religious belief and the corresponding longing we have for meaning wends its way in and out of this story. When the breath of Christ's Spirit entered the believing community at Pentecost, Babel's precedent was reversed. On that day in Jerusalem, those who gathered were empowered by the Spirit of Christ to speak in tongues not their own and to understand the speech of foreigners (Acts 2:3-4). The promise of God's coming kingdom is that the intelligibility of language will be restored, not for language's sake, but rather in service to God, his creation and his people.

So there is no need for the "people of the Book," Bible-believing Christians, to place word in opposition to image. The fitting resolution to this tension is not *either/or* but *both/and*, all in service to God's purposes and greater glory. Yes, it is not difficult to see why Christians have found the modern and postmodern movements—from Dada to deconstruction—so disquieting. Indeed, these ideological perspectives pose a direct challenge to orthodox belief and practice. At the same time, Christians attuned to the cosmic nature of our being in the world should, of all persons, comprehend the deep struggle that lies beneath these expressions of modern and postmodern doubt. The promise of the gospel is that all things—not least word and image—hold together, cohere in Christ.

---

[60]William Bouwsma, *A Usable Past: Essays in European Cultural History* (Berkeley: University of California Press, 1990), 411-12.

# The Music of the Spheres

*Works of art can die as a result of being looked at by too many dull eyes, and even the radiance of holiness can, in a way, become blunted when it encounters nothing but hollow indifference.*

HANS URS VON BALTHASAR,
THE GLORY OF THE LORD: A THEOLOGICAL AESTHETICS

*Late have I loved you, Beauty so ancient and so new, late have I loved you!*

AUGUSTINE, CONFESSIONS

*And she looked and saw that which can't be expressed or explained or revealed, and her tears are gone . . .*

STEPHANIE SEEFELDT, ORION

The phrase "music of the spheres" first came to me as a child in the opening stanza of a beloved congregational hymn:

This is my Father's world,
And to my listening ears
All nature sings,
and round me rings
The music of the spheres.[1]

---

[1] Maltbie D. Babcock, *This Is My Father's World* (1901), vs. 1.

For reasons I could not then explain, the words and rolling melody of this anthem stirred something inside my soul. I now believe that this meeting of music and of mind was a summons to behold beauty. Maybe only innocent hearts hope for such encounters, and perhaps this is why Jesus regarded children as nearest to the kingdom of heaven. Writes William Bouwsma: "The child is not afraid to express wonder and astonishment. Thus the confident trust in life of a healthy child, so different from the wariness that develops with age, has often been taken in Christian thought as a natural prototype of faith; in this sense, the adult Christian life is something like a return to childhood."[2]

I am speculating, of course. What I do know, and with increasing certainty, is that I am as eager today as I was as a child to experience nature's sublime vitality to corral the chaos of the world into some pleasing order, to encounter God's transcendence and ineffability. Beauty matters.

## FINDING BEAUTY

My search to locate the source of the phrase "the music of the spheres" led me to the *Chambers Dictionary of Quotations*, where I found these words attributed to Aristotle, "There is geometry in the humming of the strings / There is music in the spacing of the spheres."[3] Another clue surfaced in the *Oxford Dictionary of Quotations*, where I happened on this insight from seventeenth-century writer and physician Sir Thomas Browne: "For there is a music wherever there is a harmony, order or proportion; and thus far we may maintain the music of the spheres; for those well ordered motions, and regular paces, though they give no sound unto the ear, yet to the understanding they

---

[2]William Bouwsma, *A Usable Past: Essays in European Cultural History* (Berkeley: University of California Press, 1990), 411.

[3]See Aristotle, *On the Heavens*, trans. W. K. C. Guthrie (Cambridge, MA: Harvard University Press, 1960). Popular wisdom credits Pythagoras (570–496 BC), the Greek mathematician, scientist and mystic, with establishing the relationship between mathematic ratios, patterns, cycles and beauty. According to Pythagoras, the objects, persons and buildings that are most attractive are those proportioned according to the *golden measure* or *ratio*.

Plato believed that the ordering of the heavens had its dynamic equivalent in the ordering of one's soul. "All audible musical sound is given for us for the sake of harmony, which has its motions akin to the orbits in our soul, and which, as anyone who makes intelligent use of the arts knows, is not to be used, as it is commonly thought, to give irrational pleasure, but as a heaven-sent ally in reducing to order and harmony any disharmony in the revolutions within us." Plato, *Timaeus and Critias*, trans. Desmond Lee (London: Penguin, 1977), 65.

strike a note most full of harmony."[4] Clearly, Browne regarded the pace and harmony of music a metaphor for visual space.

Building on Browne's meaning, contemporary Catholic theologian Robert Barron writes: "There is a correspondence between the ordered harmonies of nature and the Ordered Harmony who is God. Until the Enlightenment and the modern period that followed, mathematics and geometry were seen as sacred sciences, reflections of the divine mind, and not simply as tools for the mastery of nature."[5] No doubt those who designed and constructed Chartes, one of Europe's most magnificent medieval cathedrals, were moved by similar convictions:

> Everything in a Gothic cathedral is like a book full of meaning; cathedrals have been called "encyclopaedias of stone." The entire cathedral is an allegory for Heaven, since it is the House of God. All aspects of the cathedral at Chartres had allegorical meaning: the rose window referred to the orderly cosmos. The square, which illustrated moral perfection, was used to design portions of the façade, towers, bases of windows, walls of the interior; and even the stones themselves.[6]

From music to mathematics to theology to architecture, beauty has been a core feature of human culture.

In the West, our understanding of this virtue is rooted in Greek philosophy. Plato's *Symposium* invites the reader to listen in on Socrates, the wizened philosopher, as he recounts the words of his teacher, Diotima. According to Diotima, it is a particular instance of eros that sends him searching for beauty. Diotima likens this initial encounter with beauty to the first rung of a ladder. Beginning at the bottom, one ascends: "From the love of a person to love of two; from two to love of all physical beauty; from physical beauty to beauty in human behaviour; thence to beauty in subjects of study; from them he arrives finally at that branch of knowledge which studies nothing but ultimate beauty. Then at last he understands what true beauty is."[7]

---

[4]Sir Thomas Browne, *The Oxford Dictionary of Quotations*, 2nd ed. (Oxford: Oxford University Press, 1955), 86.

[5]Robert Barron, *Heaven in Stone and Glass: Experiencing the Spirituality of Gothic Cathedrals* (New York: Crossroad, 2000), 103.

[6]Cynthia Freeland, *But Is It Art? An Introduction to Art Theory* (Oxford: Oxford University Press, 2001), 41.

[7]Plato, *Symposium and Phaedrus*, trans. Tom Griffith (New York: Knopf, 2000), 67.

While Plato insists that beauty is first apprehended in the material, sensate world of eros, in its ideal form beauty is primarily a cognitive state wherein one aligns one's passions with the gods and in doing so gains immortality. Building on Plato and Aristotle, thirteenth-century theologian Thomas Aquinas writes, "Beauty consists in a certain clarity and due proportion, and both derive from mind as source of light and order."[8]

In our desire to understand the discourse that surrounds beauty, one sensible approach is to consult ancient philosophy, Christian theology and medieval architecture. With this foundation in place, a wide range of contemporary expressions are relevant. For instance, in his now-classic 1977 study *A Pattern Language*, Christopher Alexander points out that from the proportions of doorways and windows to the sensibilities of their moldings and materials, beauty graces the everyday.[9] In our contemporary world, beauty prompts the poet to write, the photographer to focus her lens and the gardener to lay plans for his perennials. And so whether one takes in the radiance of a Bellini painting, the patina of a Raku-fired pot, a meteor shower beneath an indigo sky or the subtle smile of a friend, most will acknowledge that one has beheld beauty.[10]

The opening direction and claims of this chapter might set a few readers on edge, however. In their view, popular notions of beauty sponsor Thomas Kinkade kitsch, fuel consumer desire, appear profligate in the glossy pages of *Vogue* and *Architectural Digest*, and rain down injustice on those who lack the requisite wealth, comeliness and cleverness to possess it.[11] Some hold that beauty lies mostly "in the eye of the beholder," that it is subject to its own subjectivity. Others regard beauty as a social construction—a cocktail of local customs, historical precedents, shifting social mores and aesthetic treatises— ill-suited to guide us to more lasting or transcendent realities. Acknowledging

---

[8]Thomas Aquinas, *Summa Theologiae: A Concise Translation*, ed. Timothy McDermott (Notre Dame, IN: Ave Maria Press), 451.

[9]Christopher Alexander, *A Pattern Language* (New York: Oxford University Press, 1977).

[10]Obviously, classical formulations such as symmetry, proportion, harmony and verisimilitude are all evidences of beauty. But beauty is the equal champion of asymmetry, disproportion, discord and abstraction. This is not to suggest that beauty is somehow bipolar or schizophrenic. Rather, beauty can be likened to both the serene centering and the wild decentering of a spinning top as it gains and then loses equilibrium. Put differently, there is a wildness to beauty that revels in the unfamiliar, exults in freedom and pursues pleasure with abandon. Beauty will not be tamed.

[11]Here I should add that beauty has a kind of *wildness*—a counterpoint, at least, to beauty's order— that is especially intriguing. But given the limits of this essay, that exploration must be deferred.

the same, art critic Peter Schjeldahl writes: "Much resistance to admitting the reality of beauty may be motivated by disappointment with beauty's failure to redeem the world. Experiences of beauty are sometimes attended by soaring hopes, such as that beauty must someday, or even immediately, heal humanity's wounds and rancours. It does no such thing, of course."[12]

In fact, beauty served and continues to serve a wide range of practical causes. Not a few of these are tasteless and even profane. Consequently, the challenge to rightly understand beauty is much like the struggle we considered in chapter two with respect to properly understanding our bodies and in chapter three with respect to rightly regarding our senses. That is, we have sufficient reason to exercise caution before rushing to embrace beauty.

Nonetheless, beauty remains the seed of remarkable human achievement—especially in the arts—and to many she is a welcome counterproposal to the chaos, injury and degradation of our world.[13] And as I will argue in the pages to follow, beauty is worth defending. Toward the end of this chapter we will survey beauty's biblical, theological and philosophical foundations, paying special attention to what the ancients termed the *transcendentals*. But before entering that territory, beauty's modern and postmodern detractors warrant serious attention.

## BEAUTY'S BLOODIED NOSE

In modernism's eagerness to demystify the world, no domain—least of all art and religion—lay safely beyond its reach. To understand what transpired, a 1939 Metro-Goldwyn-Mayer film, *The Wizard of Oz*, supplies an odd yet striking analogy. On entering the Wizard's great hall, Dorothy's dog, Toto, happens on the actual source of the city's terror: it turns out that the frightful spectacle before Dorothy and her shrinking companions is the mere pyrotechnics of a small old man concealed behind a large curtain. Believing that beauty's hegemony is derived from an admixture of dazzling technologies and romantic ideals, Toto's move nicely mimics, so to speak, modernism's quest to expose beauty's vacuity. In their effort to resist beauty's charm and discredit

---

[12]Peter Schjeldahl, "Notes on Beauty," in *Uncontrollable Beauty: Toward a New Aesthetics*, ed. Bill Beckley (New York: Allworth, 1998), 59.

[13]John Lane argues that beauty counters the negative effects of modernization and returns us to a more simple and, therefore, ecologically responsible way of life. See John Lane, *Timeless Beauty in the Arts and Everyday Life* (Foxhole, UK: Green Books, 2003).

her claims, modernist critics raised two primary objections. Then, in the closing decades of the twentieth century, the movement's postmodern offspring carried the project one step further and rose up to defend those they regarded as beauty's victims.

*Purity of form.* The first modernist objection resides in *philosophy*, and its origin may be traced to René Descartes (1596–1650) and the seventeenth-century rise of science.[14] Hoping to comprehend the world in more rational terms, the Enlightenment organized knowledge into constituent bodies or disciplines. In this arrangement, the pursuit of beauty can be likened to the capture of a biological specimen, say, a luna moth. When the insect is contained within a bell jar, its physical characteristics can be studied in great detail. But extracted from its regular habitat, the creature's pale-green luminescence is no longer "on the loose" or "in the world."

While the analogy I offer might be weighted unfairly (our sympathy being with the trapped luna moth), this does not alter the Enlightenment proclivity to catalog knowledge, and here Denis Diderot's creation of the *Encyclopédie* (c. 1750) is exemplar. In this same spirit and time, German philosopher Alexander Gottlieb Baumgarten (1714–1762) is generally credited with establishing *aesthetics* as a distinct discipline.[15] His goal, if you will, was to isolate beauty in something akin to the specimen jar already mentioned and then examine it with the rigor a scientist might reserve for biology or chemistry.[16] Approaching

---

[14]"Only with Descartes does philosophy become dependent on the scientific ideal of the rising natural sciences, thereby beginning its rift with theology. And only from this point onward do philosophers become eager to experiment with the question of what reason can accomplish without the aid of revelation and what the possibilities are for a pure nature without grace." Hans Urs von Balthasar, *The Glory of the Lord: A Theological Aesthetics,* vol. 1, *Seeing the Form,* trans. Erasmo Leiva-Merikakis, 2nd ed. (San Francisco: Ignatius, 1982), 72. See also Charles Taylor, "Descartes's Disengaged Reason," in *Sources of the Self: The Making of Modern Identity* (Cambridge, MA: Harvard University Press, 1989), 143-58.

[15]"The category of the aesthetic itself develops in the eighteenth century, along with a new understanding of natural and artistic beauty, which focused less on the nature of the object, and more on the quality of the experience evoked. The very term 'aesthetic' points us to a mode of experience." Taylor, *Sources of the Self,* 373.

[16]"The separation of aesthetics and rationality—or art and reason—soon became commonplace. To use the terms of Immanuel Kant, the preeminent figure of late-eighteenth-century aesthetics, both reason and art work with the sensory manifold, that array of unorganized particulars furnished to the mind by the experience of the senses. Rationality worked upon these phenomena for its own particular purposes, unifying them through the synthesizing powers of the understanding and organizing them for the purposes of scientific description and technological control." Roger Lundin, "The Beauty of Belief," in *The Beauty of God: Theology and the Arts,* ed. Daniel J. Trier, Mark Husbands and Roger Lundin (Downers Grove, IL: InterVarsity Press, 2007), 188.

knowledge in this manner was a boon to science, of course, as well as to some approaches to art history.[17] But for men and women eager to form a truly modern self, the isolation of beauty (and for that matter the pursuit of religious devotion) would cause it to grow increasingly arcane. As philosopher Alexander Nehemas suggests:

> The creation of an aesthetic domain and the elaboration of a doctrine of fine arts were meant to establish the epistemological authority of sensory perception and to secure the spiritual rights of beauty. To that end the eighteenth century placed the arts side by side with the sciences in a setting in which each was to become increasingly impervious, even incomprehensible, to the other.[18]

From German philosopher Arthur Schopenhauer (1788–1860) to British critic Clive Bell (1881–1964), many labored to understand the modern meaning of the visual arts. With respect to beauty, however, there is wide agreement that the work of Immanuel Kant (1724–1804) represents the single most important turn from the ancient Greeks to modern aesthetics. Like Baumgarten, Kant believed that art, in its purest form, should not be sullied by the constraint of external creeds, academic guilds or other rhetorical demands.

> In the *Critique of Judgment* Kant released art and the beautiful from linguistic control. He allowed one to think that the object and the pleasure that one takes in looking at it are exempt from conceptual determination. It soon emerges that this applies only to the kind of beauty the Kant calls free (*pulchritudo vaga*) rather than dependent (*pulchritudo adhaerens*). But even in this qualified form, Kant's release of beauty from conceptual control was a crucial development of an avant-garde in the nineteenth century: the independence of art from representation, social, political, religious, economic, and other imperatives had to be achieved and maintained.[19]

In formulating his modernist voice, influential New York critic Clement Greenberg (1909–1994) drew heavily on Kantian thought, especially the

---

[17]In this regard the important Swiss art historian Heinrich Wölfflin (1864–1945) comes to mind. His book *Principles of Art History: The Problem of the Development of Style in Later Art* (1932; Mineola, NY: Dover, 1950) shaped, for many generations of undergraduates, the study of art history in the twentieth century with its emphasis on five pairs of opposed or contrary precepts in the form and style of sixteenth- and seventeenth-century art.

[18]Alexander Nehemas, *Only a Promise of Happiness: The Place of Beauty in a World of Art* (Princeton, NJ: Princeton University Press, 2007), 190.

[19]Denis Donoghue, *Speaking of Beauty* (New Haven, CT: Yale University Press, 2003), 171.

philosopher's "sharp distinction between *art* and *handicraft*, or between what we might call the *fine* and the *useful* arts."[20] Viewed through a Greenbergian lens, Kant's aesthetic empowered the artist to concentrate on the nonobjective dimensions of art making, and it was Greenberg's unwavering commitment to the doctrine of disinterestedness—art's uselessness—that established the intellectual foundation of high modernism. Elaborating on the impact of Kantian thought in this regard, Cynthia Freeland writes: "The beautiful object appeals to our senses, but in a cool and detached way. A beautiful object's form and design are the key to the all-important feature of 'purposiveness without a purpose.' We respond to the object's rightness of design, which satisfies our imagination and intellect, even though we are not evaluating the object's purpose."[21] Kant proposes that "the best way to produce a free art is to remove it from constraint, and thus to change it from work into mere play."[22] Roger Lundin fills out the idea: "This power of choice is a sign of consciousness freely at labor, and it marks the distinctiveness of art. Here, at least, freedom is alive and vital, and the human mind and affections have their chance to make a mark, to leave the durable and indelible impression on an indifferent universe."[23]

For secular cultural elites, this rejection of art's utility, coupled with art's embrace of otherwise impractical, useless or extravagant interests, established modernism's bravura. Denis Donoghue posits, "By being disinterested, I clear a space for certain perceptions that would not survive in the marketplace. I cultivate a semblance of desire rather than yield to desire."[24] In this same spirit Greenberg sought to release art from all philosophical and ethical obligations, and for him the action painting of Jackson Pollock

---

[20]Lundin, "Beauty of Belief," 189.

[21]Freeland, *But Is It Art?*, 14. "Key to these models of aesthetic reasoning was the oversimplification of Kant's idea of 'disinterestedness,' which in Kant had accommodated (if awkwardly) the ambiguities and contradictions of positing judgments that are both 'universal' (at least within Kant's worldview) and particular to individual subjects. Stripped of the ambiguities and complexities of Kant's model, 'disinterestedness' in modernist art discourse was mobilized to ensure the possibility of an objective—disembodied, logical, 'correct'—evaluation of the aesthetic value and meaning of artworks." Amelia Jones, "Body," in *Critical Terms for Art History*, ed. Robert S. Nelson and Richard Shiff, 2nd ed. (Chicago: University of Chicago Press, 2003), 253.

[22]Immanuel Kant, *The Critique of Judgment*, trans. J. H. Bernard (Amherst, NY: Prometheus Books, 1969), 185.

[23]Lundin, "Beauty of Belief," 189.

[24]Donoghue, *Speaking of Beauty*, 79.

most approximated this ideal. As noted in chapter one, Pollock's moral recklessness and existential despair are widely known, and it seems to me there is at least an implied relationship between his *manner of making* and his *manner of being*. That is, I believe that it is possible to understand the force and power of action painting as the dark side of an aesthetic bargain— a kind of deal with a personal devil. To my mind, Pollock's works are at once elegant and foreboding.

As artists drank in Greenberg's vision, modernists came face-to-face with a genuine conundrum, for even as Greenberg's aesthetic promised emancipation from ancient stories and outmoded methods, painters and sculptors such as Willem de Kooning, Brice Marden, Barnett Newman and Mark Rothko seemed intent on nurturing their fascination with transcendence. To realize complete freedom—to come of age—modern art was resolute in its commitment to uncouple aesthetic pleasure (beauty) from any divine source or cause (God). To accomplish this, a subtle yet momentous shift occurred: talk about the beautiful was displaced by discourse about the sublime.

Some sleuthing through the *Oxford English Dictionary* (*OED*) reveals the seismic impact of this decision. According to the *OED*, the sublime is a thing or an experience "of such excellence, grandeur, or beauty as to inspire great admiration or awe."[25] In other words, the sublime bespeaks elevation, nobility and solemnity. But unlike traditional formulations of beauty, the modernist conception of the sublime bears no burden to uphold any philosophical ideal or to seek divine consolation. Rather, the sublime is self-satisfied, and to the extent that it finds expression in a work of art, the aesthetic train of modernism has arrived at its destination. According to Donoghue:

> In the sublime, the mind is beside itself; thinking defies its limits, forms stare into formlessness, and the aesthetic faculty shudders. It is best to think of these states of feeling as secular versions of religious experiences, peremptory intuitions of the holy, of mystical rapture, and of transcendence. The sublime transgresses grammar and syntax in collusion with the unsayable: it is that for which the undiscursive arts—music, painting, sculpture, dance—were invented, words having been shown to be inadequate.[26]

---

[25]Catherine Soanes and Angus Stevenson, eds., *Concise Oxford English Dictionary*, 11th ed. (Oxford: Oxford University Press, 2004), 1435-36.

[26]Donoghue, *Speaking of Beauty*, 74.

Thus far, this account is hardly complete. In fact, the concept of the sublime originated late in the eighteenth century and did not gain full stature until the emergence of nineteenth-century romanticism, where not only art and beauty functioned as signposts of the sacred but where spirituality itself was personified:

> Like other religions, the religion of art promised the individual not only the peace of harmonized feeling and understanding but also the bliss of spiritual ecstasies. For Wordsworth and Goethe, Beethoven and Berlioz, Turner and Delacroix, great art—including their own work—produced all the effects of religious fervor—enthusiasm, awe-struck admiration, raptures and devoutness. Great artists constituted the Communion of Saints.[27]

To summarize, while eighteenth- and nineteenth-century artists might have comfortably applied the term *beauty* to their work, in order to distance themselves from orthodox religious belief, avant-garde modernists preferred "the sublime" to "the beautiful" as means to discount the beautiful altogether.[28] Having demonstrated that the beautiful was no longer a serious enterprise, artists and aestheticians bequeathed it to the oppressive and outmoded work of religion.

*Triviality.* Modernism's second complaint against beauty is *sociological,* and it centers on the movement's palpable disdain for middle-class sensibilities. Consider this nineteenth-century caricature of the bourgeoisie:

> His condition deprives him of all great ideas and great passions. . . . The efficient administration of public affairs spares him the worries of material need and the anxieties of risk. And so he lives, dwarfed down to scale with the humdrum . . . empty of curiosity and desire, incapable of invention and enterprise, limited to a modest profit or income. He nurses his savings, seeks vapid entertainment, picks up discarded ideas and cheap furniture, and his whole ambition is to rise from Grand Rapids mahogany to department-store Swedish. His house is the reflection of his mind and his life in their incoherence, pettiness, and pretension.[29]

---

[27]Jacques Barzun, *Use and Abuse of Art,* A. W. Mellon Lectures in the Fine Arts, Bollingen Series 35 (Princeton, NJ: Princeton University Press, 1975), 27.

[28]"Each attribute or illustration of the beautiful became one member of an oppositional pair, and because it was almost always the diminutive member, it was also the dismissible member." Elaine Scarry, *On Beauty and Being Just* (Princeton, NJ: Princeton University Press, 1999), 84.

[29]As quoted by Barzun, *Use and Abuse of Art,* 60-61.

These sentiments, which belong to French historian Hippolyte Taine (1828–1893), are hardly kind. Plainly put, bourgeois taste refers to a kind of middle-class dullness wherein beauty is bound to the generation of trivial desires and the machinations of the market.[30] The avant-garde believed that bourgeois appetites for embellishment and decoration—baubles and bangles and bling—would, inevitably, co-opt true beauty. And to the extent that bourgeois taste supplanted art's more exalted aims, it was critical for the artist to wrest high art from the hands of the Philistines.[31] Said differently, avant-garde logic found the sentimentality and morality of the bourgeoisie unbearably naive, and with this view the aesthetic ignorance of the middle class seemed perfectly paired to its moral lassitude. As Herbert Muschamp points out, this suspicion is not groundless:

> Some artists and critics like to think of beauty as an incentive to reach toward the good and the true. I agree that art can be part of a philosophical system. But in the consumer society, beauty can also be a smokescreen—a tool for distracting our attention from the bad and the false, the less savory side of consumerism itself. What a car! What a body! What a cool computer! Who wants to think about the sweatshop, labor, acid rain, social disruption and disease that may be caused by the manufacture of these products? In this sense, beauty can be a veil, an invitation to overlook the ugly that we implicitly accept by buying into the system.[32]

---

[30]Though the term *bourgeois* has consistently been one of derision, the actual object of this criticism has varied widely. "Bourgeois means townsman. So the bourgeoisie starts to rise well before the twelfth century, when the great towns of Europe and their guilds were flourishing. It rises again in Italy in the fourteenth century to spur its prosperity and the fine arts of the Renaissance. And when we say Italy and bourgeois we are blurring some realities. There was no Italy—only towns. The bourgeois of Florence ruled by the bourgeois Medici were artisans and bankers; those of Genoa and Venice were merchants and sailors. So were the bourgeois who supported the confiscations of Henry VIII in England and backed up the piracy of Queen Elizabeth against Spain, in hopes of buying estates and ceasing to be bourgeois. . . . You perceive why I will not have the bourgeois on any terms. He is not a reliable historical character. He is shifty as to chronology, status, income, opinion, and activity. So much for the historical bourgeois." Barzun, *Use and Abuse of Art*, 59-60.

[31]Historian Peter Gay observes that "Nietzsche invented the devastating name *Bildungsphilister*— cultivated philistine—a formulation in which he took some pride. It designated what we have learned to call 'middlebrow,' unpoetic beings for whom thrift meant meanness; delicacy, prudishness; gentility, evasiveness; good taste, defensive aversion to depth and originality in the arts." Peter Gay, *The Bourgeois Experience: Victoria to Freud*, vol. 5, *Pleasure Wars* (New York: W. W. Norton, 1998), 34.

[32]Herbert Muschamp, "Captivated by a Happy, Scary New Day for Design," *New York Times*, October 15, 2000, 39.

Greenberg's 1939 essay "Avant-Garde and Kitsch" best articulates this disdain for popular sentimentality and kitsch. In it he demands that beauty be severed from any discourse about meaning since traditional formulations of beauty are incapable of making sense of modern life.[33]

Meanwhile, even as modernists abandoned the language of beauty, other disciplines were poised to appropriate it. Peter Schjeldahl notes, "Visual beauty has been escaping from visual art into movies, magazines, and other media, much as the poetic has escaped from contemporary poetry into popular songs and advertising."[34] Similarly, philosopher Elaine Scarry reports:

> Though the vocabulary of beauty has been banished or driven underground in the humanities for the last two decades, it has been openly in play in those fields that aspire to have "truth" as their object—math, physics, astrophysics, chemistry, biochemistry—where every day in laboratories and seminar rooms participants speak of problems that are "nice," theories that are "pretty," solutions that are "beautiful," approaches that are "elegant," "simple."[35]

And here we might add that in contemporary American life and culture, our appetites are keen to locate something more: spectacle and sensation. Whether it is a music concert or a sporting event, travel or shopping, sexual experimentation or contemporary worship, we pursue objects, ideas and experiences—access to a vast cultural substratum—that promise to satisfy our aesthetic longings. But even amid all these pleasures, I believe that it is beauty that we seek.

*Hegemony.* Having considered modernism's philosophical and sociological objections to beauty, we turn to a third, one that is *political* and substantially postmodern. In declaring a person, thing or experience beautiful, one has made a judgment. Consider the logical alternative: to declare that all things are beautiful is to insist that nothing is beautiful. In fact, assigning

---

[33]Clement Greenberg, *The Collected Essays and Criticism*, vol. 1, *Perceptions and Judgments, 1939–1944*, ed. John O'Brian (Chicago: University of Chicago Press, 1986), 5-22. "In art kitsch takes the form of the pretty, the sentimental and fashionable. It excludes all that is truly disturbing and harrowing. In morality kitsch takes the form of totalitarianism, the exclusion of all that is individual and distinctive." Richard Harries, *Art and the Beauty of God: A Christian Understanding* (London: Continuum, 1993), 58n. See also Betty Spackman, *A Profound Weakness: Christians and Kitsch* (Carlisle, UK: Piquant, 2005).

[34]Peter Schjeldahl, "Notes on Beauty," 57.

[35]Elaine Scarry, *On Beauty*, 52.

aesthetic value to a person, an object or an experience is neither democratic nor egalitarian. Rather, it is the exercise of personal or cultural authority.[36] To the extent that such judgments hold, varying degrees of authority follow.

Critics of this arrangement complain that when judgment and authority converge, objectification is inevitable. More than this, these actions enable the powerful to displace or disregard the powerless, especially subdominant groups such as the poor, the uneducated, the rural, women and ethnic minorities. Schjeldahl incisively comments, "Insensibility to beauty may be an index of misery. Or it may reflect wholehearted commitment to another value such as justice, whose claims seem more urgent."[37]

Here a brief digression regarding beauty's abuse seems important. The masculine persona of modernism, especially the mostly male membership of the New York School, is well established.[38] In the 1960s and 1970s, feminists exposed the injustice of this power imbalance by focusing on a social construct they termed the "male gaze."[39] According to this scheme, the male establishes his dominance by surveying the world to determine what is beautiful, objectifying what he desires and then striving to possess it.[40] Explaining the power of the gaze,

---

[36]Cynthia Freeland explains Kant's aesthetic as follows: "We label an object beautiful because it promotes an internal harmony or 'free play' of our mental faculties; we call something 'beautiful' when it elicits this pleasure. When you call a thing beautiful, you thereby assert that everyone ought to agree. Though the label is prompted by a subjective awareness or feeling of pleasure, it supposedly has objective application in the world." Freeland, *But Is It Art?*, 12.

[37]Peter Schjeldahl, "Notes on Beauty," 59.

[38]According to Wendy Steiner, the Enlightenment fascination with the sublime arose "from a disgust toward women and the bourgeoisie that had been building throughout the nineteenth century among increasingly disaffected artists and writers. During the very period, in fact, when the female subject was the predominant symbol of beauty in all the arts, and ideology was taking shape that would displace her entirely, and that ideology became the basis of the twentieth-century avant-garde." Wendy Steiner, *Venus in Exile: The Rejection of Beauty in 20th-Century Art* (New York: Free Press, 2001), 1. There is a real sense in which Kant cast the die for this paradigm when he aligned the female with the beautiful and the male with the sublime. See Immanuel Kant, *Observations on the Feeling of the Beautiful and Sublime*, trans. John T. Goldthwait (Berkeley: University of California Press, 2003), 76-77.

[39]"'Gaze' is a literary term for what could also be called 'looking' or 'watching.' Its connotation of a long, ardent look may bring to mind the intensity in which knowledge and pleasure mingle when I behold a work of art. While most discourse about gaze concerns pleasure and knowledge, however, it generally places both of these in service of issues of power, manipulation, and desire. There is usually something negative about the gaze as used in art theory. It is rather like the word 'stare' in everyday usage. . . . A typical strategy of art theory is to unmask gazing as something like staring, the publicly sanctioned actions of a peeping Tom." Margaret Olin, "Gaze," in *Critical Terms for Art History*, 2nd ed., ed. Robert S. Nelson and Richard Shiff (Chicago: University of Chicago Press, 2003), 319.

[40]"The gaze was . . . associated with power in early twentieth-century theory. German expressionism exploited this sense of power in images that stared out at the viewer menacingly. The charisma of the gaze came to a peak in Hitler, who prided himself on his hypnotic gaze. Jean-Paul Sartre's almost

Margaret Olin writes, "To acknowledge someone visually is to make that person a part of oneself, a possession, as though the person whose image is seen enters another's body through the window of the eyes and ceases to lead a separate life."[41]

In the end, the ego of modernism and the politics of feminism meet at cross purposes, and works such as Picasso's *Les Mademoiselles d'Avignon* (1907) and Willem de Kooning's *Woman I* (1952) embody the resulting schizophrenia. Beauty, of course, is most frequently associated with the feminine—literally in its fascination with the female face and form, and figuratively in its disposition and tone. But if the female form is the ready source of inspiration for Picasso and de Kooning's paintings, the figures that they render are abstracted, hideous creatures. Hence the contradiction, for while these modernists retained the female form as a referent to ideal beauty, the aesthetic judgment of movements such as cubism, Dada, abstract expressionism and pop deconstructed beauty's authority. If modern art hoped to realize its sublime potential, beauty's privilege—which, as we have already noted, is substantially grounded in the feminine—must be dethroned. Consequently, in the long-standing and intimate connection between beauty and the feminine, beauty functions both as the origin of woman's privilege and the source of her oppression.[42] For the woman who seeks release from male subjugation, an awkward choice presents itself: to free herself from this oppression she must disown or discredit herself. These are, of course, high-brow, theoretical considerations wherein men and women are being treated as types. For most contemporary men and women, the tide of popular culture flows entirely the other way.

The preceding trio of objections to beauty, then, are as follows: modernism's commitment to purity of form caused it to set aside traditional symbols and narratives in favor of the sublime; its distaste for bourgeois triviality and sentimentality led it to reject kitsch; and, finally, postmodern critics marshaled political resistance against those who deploy beauty either to ignite

paranoid treatment of 'le regard' (the look) in his treatise on existential philosophy, *Being and Nothingness*, portrayed the state of being watched as a threat to the self." Ibid., 324-25.

[41]Ibid., 327.

[42]"Consequently, we replaced feminine descriptives like *beauty, harmony*, and *generosity* with masculine terms like *strength, singularity*, and *autonomy*." Bill Beckley, "Introduction: Generosity and the Black Swan," in *Uncontrollable Beauty: Toward a New Aesthetics*, ed. Bill Beckley and David Shapiro (New York: Allworth, 1998), xv.

consumer desire or to oppress the powerless, especially women. As the twentieth century neared its close, the aquiline nose of beauty was a bloodied mess. And to the extent that beauty was regarded as the whore of marketing, mere decoration for idle minds or a means of social control, one was hard-pressed to withhold his or her voice from this chorus of dissent.

Meanwhile, a fourth concern lurks in the shadow of these philosophical, sociological and political objections: the modern artist's desire to live beyond the pale of any metanarrative, beauty being one. On the face of it, this resistance evidences the laudable embrace of *social justice* and *personal autonomy*. But as noted in chapter six, this rejection signals something weightier than the mere dismissal of an overarching story, be it Platonism, Christianity, romanticism, Marxism or some yet-to-be-named postmodern configuration. Rather, these fierce objections harbor the fundamental conviction that belief in God—especially the kind of God who sets the universe in motion, determines its future and has something to say about how a person conducts her daily life—is untenable. If God does not exist, then, just as modern and postmodern critics have reasoned, there is no need for beauty. But under these circumstances, what shall occupy beauty's place? It seems that one of two stand-ins is preferred: either the riddle of some self-referential aesthetic experience or the embrace of the popular 1990s injunction to practice "senseless acts of beauty."[43] In their own ways, both options possess a kind of heroic cachet, but to the religious mind both are empty categories that sponsor a dark and disturbing nihilism.

As I have underscored, there is ample reason to respect modern and postmodern objections to beauty since each one is grounded in a genuine concern. Nonetheless, I hold to a different view, or at least an expanded view. In fact, beauty in its dizzying array of manifestations is so basic to life that even its most strident critics cannot turn back my interest. Therefore, while my defense of beauty will seem too chivalrous or romantic or sentimental to some, to me any failure to do so would be an egregious error. Simply put, I wish to behold beauty.

## REVIVING BEAUTY

In 2003 PBS aired *art:21*, a series of eight hour-long programs that showcased thirty-seven of America's most celebrated contemporary artists. One segment

---

[43]Some attribute the phrase "practice random acts of kindness and senseless acts of beauty" to Anne Herbert, who reportedly wrote it on a placemat in Sausalito, California, in 1982.

featured sculptor Richard Serra (b. 1939) and opened with a scene from the
Guggenheim Museum in Bilbao, Spain.[44] Serra—a fit figure, dressed in black,
with chiseled features and a mostly shaved head—walked in and about several
of his monumental works. His left hand steadied a bound sketchbook, which
freed his right to execute simple yet bold line drawings with a marker on the
book's blank pages.

In the opening minutes of the documentary's news-like reportage, Serra's
manner might be likened to that of an architect or philosopher determined to
solve a formal problem. His commentary comes off cool, even terse. But then
the scene shifts from the Guggenheim to an unnamed site in San Francisco,
and with this relocation comes a change of mood or tone. An enthusiastic
crew of steelworkers, engineers and assistants sporting hard hats and rain gear
have assembled to install a new Serra piece, *Charlie Brown* (2000) (plate 5).
The sculpture, a towering figure, rises sixty feet into the air and is fashioned
from four sheets of Cor-Ten steel that were prefabricated offsite and then
trucked to the courtyard of Gap Inc. A crane operator booms these enormous
plates into place, and the drama of the scene unfolds. The artist and a few
other observers step back to admire the sculpture as it is bolted into place.
Musing on the moment, Serra admits that his project possesses a "kind of
wonder" and that "it has not reached closure." In a hushed tone, one assistant
volunteers that the work seems "omniscient." Indeed, as the camera deftly
pans the warm orange-brown tones of Serra's steel monolith, the sculpture
assumes a solemn aura and stillness, and almost imperceptibly, its materiality,
coupled with the feel of the day, coalesce into a moment of raw beauty. For
just a moment, even the viewers of the video gain a palpable sense of *Charlie
Brown* and its material presence.

There are plenty of reasons to imagine that a rugged minimalist like Serra
might not be much enthused about beauty and that works like *Charlie Brown*
exist as counterproposals to the consumer glitz of sprawling malls and bou-
tique galleries. But whatever position Serra holds to on such matters, this
short documentary confirms that the sculptor and his crew are drawn in by

---

[44]Some of Serra's public works—most notably his *Tilted Arc* (1981), a public sculpture installed
in the courtyard of the Federal Plaza in Manhattan—have been highly controversial. See Clara
Weyergraf-Serra and Martha Buskirk, eds., *The Destruction of Tilted Arc* (Cambridge, MA:
MIT Press, 1990).

beauty. Indeed, few persons, save the most diminished, can fathom a world devoid of it. Denis Donoghue writes:

> We continue to say without much hesitation that such-and-such and so-and-so are beautiful: tulips, roses, certain women, certain men, most children, a page of Chinese written characters, an African mask, a mathematical process, a piece of music, a view from Portofino, a certain sunset, a full moon, some animals (but not the rhinoceros), kingfishers, dragon flies, the air at Brighton, Alexander Kipnis's voice, the weather when noon's a purple glow.[45]

Like Donoghue, each of us might assemble a list of those things or moments that, in our estimation, embody beauty. If beauty is an enduring virtue, one that can be apprehended in some manner and with varying degrees of sophistication, then why is it that the subject of beauty rarely appears in evangelical sermons or systematic theologies? As noted throughout this study, nineteenth- and twentieth-century American evangelicals sought to keep popular culture at arm's length, and it might be that this worry about worldliness supplies a partial answer to the question that I am posing. Further scrutiny suggests that their long-standing wariness of "the things of this world" caused evangelicals to be ambivalent about beauty. When this ambivalence was married to a lingering gnosticism, the cautions of conservative Protestants, though not entirely misplaced, prevented them from perceiving any goodness in human culture.[46] Added to these worries about worldliness, more than a few Bible readers have surely noticed that beauty in its lavish and material sense is not voiced as a primary biblical concern. Still, even the most conservative pulpit would, from time to time, refer to Jesus' commentary on the lilies of the field (Mt 6:28-29) as well as the repeated mention of God's handiwork in creation.

*The Bible.* The core purpose of the Bible is to reveal God's character and actions to the men and women whom, paradoxically, he seeks as followers. As such, the Bible is not so much a book about beauty or truth or justice as it is a book about God. But to the extent that this trio of virtues forms an essential feature of God's character, one does learn a great deal about each in the Bible. Regarding the particular mention of beauty in the Old Testament, theologian

---

[45]Donoghue, *Speaking of Beauty*, 25.
[46]See Philip J. Lee, *Against the Protestant Gnostics* (New York: Oxford University Press, 1987).

William Dyrness observes, "Part of the modern problem is that the Hebrews had no special language for art and beauty, precisely because beauty was not something that occupied a separate part of their lives." Dyrness goes on to identify seven Hebrew word groups that serve as synonyms for beauty, terms denoting everything from delight to desire, fittingness to fairness and moral goodness to divine glory.[47]

Beauty generally assumes one of two divine forms in the Bible: it is *intrinsically* resident in God's being and *extrinsically* present in his creation. Regarding the second of this pair, the opening verse of Genesis establishes that "God created the heavens and the earth," a declaration that reverberates through the Psalms and the Prophets.

> To whom then will you compare me,
>     or who is my equal? says the Holy One.
> Lift up your eyes on high and see:
>     Who created these?
> He who brings out their host and numbers them,
>     calling them by name;
> because he is great in strength,
>     mighty in power,
>     not one is missing. (Is 40:25-26)

Indeed, the anthropomorphic language of the Old Testament likens God to an architect or engineer or artist. This mindset carries over to the New Testament, where is it confirmed that Jesus, the second person of the Trinity, was God's agent in creation. According to John's Gospel, "All things came into being through him, and without him not one thing came into being" (Jn 1:3). In this same spirit Paul writes to the church at Colossae, "In him [Jesus] all things were created, things visible and invisible, whether thrones or dominions or rulers or powers—all things have been created through him and for him." Paul continues, "He himself is before all things, and in him all things hold together" (Col 1:16-17). In concert with Isaiah, the whole of Scripture

---

[47]William A. Dyrness, *Visual Faith: Art, Theology, and Worship in Dialogue* (Grand Rapids: Baker Academic, 2001), 70-74. The NRSV cites beauty or beautiful 90 times, splendor 27 times, majestic or majesty 58 times, and glory or glorious 366 times. Notably, *The New Bible Dictionary* (Grand Rapids: Eerdmans, 1962), a standard evangelical reference, contains no articles on beauty, splendor or majesty. There is, however, one substantial article devoted to glory (472-73).

inquires, "Have you not known? Have you not heard? The LORD is the ever-lasting God, the Creator of the ends of the earth" (Is 40:28).

But God is more than a maker or a creator; he is beauty's source (Ps 27:4). The wisdom writer puts it like this: God "has made everything beautiful in its time" (Eccles 3:11 NIV). And since God's being (his nature and existence) always precedes his doing (his creative agency), each and every instance of the beauty that abounds in creation must be regarded as the natural fruit of God's being.[48] From the origin of light to the cycles of the seasons, and from the domains of earth, sea and sky to the living creatures—fish, birds, mammals, reptiles, insects and, supremely, men and women—that inhabit them, God's beauty infuses and entwines creation.

Having established that God's beauty is on display in creation, we must acknowledge three further realities: creation's *excess*, creation's *suffering* and creation's *redemption*. Regarding the first, one might argue that there is no practical need for iridescent sunsets to fill the evening sky, autumn leaves to assume their riot of warm hues, clouds to morph from shape to shape or snow-flakes to assume their unique crystalline structures. Moreover, there is no ob-vious case to be made for blueberries and raspberries and strawberries and huckleberries and blackberries and cranberries when, arguably, just one "all-purpose" berry might suffice. In other words, creation's aesthetic delight is superabundant and, as writer Annie Dillard observes, so also is creation's fe-cundity.[49] Yet more striking is this fact: most of creation's beauty exists in places where none but God can view it.

Any delight in creation's beauty must, however, be tempered by its suf-fering. As if in the pangs of birth, creation still groans under the burden of Adam's curse (Rom 8:19-23) so that neither its *original* beauty nor its *potential* beauty can be fully realized in this world. Theologian N. T. Wright puts it like this: "The kingdoms of this world are to become the kingdom of God, so the beauty of this world will be enfolded in the beauty of God—and not just the beauty of God himself, but the beauty which, because God is the creator par

---

[48]Addressing God and his nature, Augustine writes: "Nothing can happen to you in your unchange-able eternity, you who are truly the eternal creator of all minds. As you knew heaven and earth in the beginning, without the slightest modification in your knowledge, so too you made heaven and earth in the beginning without any distension in your activity." Augustine, *The Confessions*, trans. Maria Boulding, O.S.B. (New York: Vintage, 1998), 272.

[49]See Annie Dillard, *Pilgrim at Tinker Creek* (New York: Harper & Row, 1974), 159-81.

excellence, he will create when the present world is rescued, healed, restored, and completed."[50] For those who hold to a biblical worldview, the flourish of creation's excess and the tarnish of creation's suffering lead to something more compelling: an encounter with the Creator.[51] Redemption—the ongoing work of a gracious and loving God that is expressed in material reality but not bound to it—is also beautiful.

*The transcendentals.* Having surveyed what the Bible has to say about beauty, we turn now to ancient philosophy. In classical philosophy, truth, goodness and beauty can be likened to a three-legged stool wherein each leg is essential to the stool's overall stability. The Greeks termed this triad of virtues the transcendentals and believed that each one so interpenetrated the other two that when one delights, say, in beauty, one can rightly expect that goodness and truth will also be present.[52] While the idealism of Greek philosophy hardly mirrors the more earth-bound sensibilities of ancient Israel, it is no stretch to propose that the Hebrew mind had already imagined a similar scheme wherein this triunity of virtues revealed the fullness of God's being. Centuries later Hans Urs von Balthasar's (1905–1988) considerable reflection on the transcendentals led him to conclude:

> Our situation today shows that beauty demands for itself at least as much courage and decision as do truth and goodness, and she will not allow herself to be separated and banned from her two sisters without taking them along with herself in an act of mysterious vengeance. We can be sure that whoever sneers at her name as if she were the ornament of a bourgeois past—whether he admits it or not—can no longer pray and soon will no longer be able to love.[53]

---

[50]N. T. Wright, *Simply Christian: Why Christianity Makes Sense* (New York: HarperCollins, 2006), 47.

[51]Commenting on the word *good*, Richard Harries writes, "There is an integral connection between all that exists, its goodness and its beauty. . . . All that is, is fundamentally good; so all that is, radiates with divine splendour. This means that truly to discern the existence of anything, whether a flower or a grain of sand, is to see its finite existence rooted in the ground of being, God himself; it is to discern glimmerings of eternal light, flames or flashes of divine beauty." Richard Harries, *Art and the Beauty of God*, 36.

[52]Denis Donoghue, *Speaking of Beauty*, 63. The transcendentals assume "that everything which *is* in some measure or manner subject to denomination as true or false, good or evil, beautiful or ugly. But they have also been assigned to special spheres of being or subject matter—the true to thought and logic, the good to action and morals, the beautiful to enjoyment and aesthetics." Mortimer J. Adler, *The Great Ideas: A Synopticon of Great Books of the Western World* (Chicago: Encyclopaedia Britannica, 1952), 112. As further introduction, see Jaroslav Jan Pelikan, "The Good, the True, the Beautiful," in *Jesus Through the Centuries: His Place in the History of Culture* (New Haven, CT: Yale University Press, 1985), 1-8.

[53]Balthasar, *Glory of the Lord*, 1:18.

Like the Greeks, Balthasar believes that the transcendentals gain their full significance in dynamic relation.

**Christian thought.** In early Christian thought beauty's most famous proponent was St. Augustine (354–430). In his *Confessions* he volunteers, "I wrote some books entitled *The Beautiful and the Harmonious*, two or three books, I think—you know, O God, but it escapes me, for I no longer have them; they have somehow been lost."[54] In reading the *Confessions*, one learns that the young intellectual was beguiled by beauty. And similar to the tension surrounding the senses that we explored in chapter three, his struggle to rein in the power of his sensate being was lifelong. Apparently Augustine found the visual world especially tempting. Regarding "over-indulgence of the eyes" he writes:

> Beautiful things and varied shapes appeal to them, vivid and well-matched colors attract; but let not these captivate my soul. Rather let God ravish it; he made these things exceedingly good, to be sure, but he is my good, not they. Every day, all through the hours that I am awake, colors and shapes impinge upon me, and never is any respite from them allowed me, as it is from the sound of song, or sometimes from all sounds, when silence reigns.[55]

Augustine's struggle to eradicate all traces of sinful desire recalls the allure of Eden for Eve. In the third chapter of Genesis we read that "when the woman *saw* that the tree was good for food, and that it was a *delight to the eyes*, and that the tree was to be *desired* to make one wise, she took of its fruit and ate; and she also gave some to her husband, who was with her, and he ate" (Gen 3:6). Here it might seem that beauty is the serpent's accomplice. Eve fixes her eyes on the tree whose fruit she is forbidden to eat and, unable to resist its delight, she falters and eats.[56] In wrestling with the powerful stimuli of the visual world, Augustine reached a relatively simple conclusion: the beauty contained in earthly things is penultimate. True beauty is given to some greater purpose: it directs one to God, whose divine being is both beauty's source and summation.

Ten centuries after Augustine's reflections, beauty also occupied the mind of Thomas Aquinas (1225–1272), a celebrated Dominican scholar. Like

---

[54]Augustine, *Confessions*, 67.

[55]Ibid., 231.

[56]"When Adam and Eve are drawn to the beauty of the tree outside the moral context in which it was given, they take the first step toward making beauty an idol. They fail to appreciate that the beauty that draws them is part and parcel of the Word of God that instructs them—'the tree of knowledge of good and evil you shall not eat.'" Dyrness, *Visual Faith*, 76.

Augustine, Aquinas maintained substantial sympathy for the work of Plato and had mastered the writings of Aristotle. Regarding the influence of the latter, Thomas Cahill offers:

> For Thomas did not believe that we lived in the gloom of a cave, tied to a decaying mass of matter, and that everything we perceived was illusion or trickery. He believed we lived in our bodies, created good by a good God, and received true perceptions through the media of our five senses, which like clear windows enabled us to form generally accurate impressions of the world as it is.[57]

Indeed, Aquinas believed that the "contemplation of God's works belongs to the contemplative life" and that these sensate engagements, though secondary, could lead one to "the contemplation of God himself."[58] The view of French neo-Thomist Jacques Maritain (1882–1973) mirrors Aquinas's conviction: "God is beautiful. He is the most beautiful beings, because, as Denis the Areopagite and Saint Thomas explain, His beauty is without alteration or vicissitude, without increase or diminution; and because it is not as the beauty of things, all of which have a particularized beauty . . . He is beautiful through Himself and in Himself, beautiful absolutely." Maritain goes on to observe that God "is beautiful to the extreme . . . because in the perfectly simple unity of his nature there pre-exists in a super-excellent manner the fountain of all beauty."[59]

From the Protestant Reformation onward, however, Christians were of two minds regarding the relationship of beauty, art and belief. Like Augustine and Aquinas, John Calvin lauded beauty, especially as it could be observed in creation: "Being placed in this most beautiful theatre [creation], let us not decline to take a pious delight in the clear and manifest works of God."[60] Still, the reformer's iconoclasm left him deeply distrustful of the pictorial arts and, as noted in chapter four, he vehemently opposed the manufacture of divine images.

Like Calvin, Jonathan Edwards (1703–1758)—arguably the finest theological and philosophical mind in eighteenth-century Puritan America—was also suspicious of the visual imagination and especially the pictorial arts. "The imagination

---

[57]Thomas Cahill, *Mysteries of the Middle Ages: The Rise of Feminism, Science, and Art from the Cults of Catholic Europe* (New York: Doubleday, 2006), 209.

[58]Aquinas, *Summa Theologiae*, 452.

[59]Jacques Maritain, *Art and Scholasticism with Other Essays*, trans. J. F. Scanlan (New York: Charles Scribner's Sons, 1942), 30-32.

[60]John Calvin, *Institutes of the Christian Religion*, trans. Henry Beveridge (Grand Rapids: Eerdmans, 1995), 156.

or fancy seems to be that wherein are formed all those delusions of Satan, which those are carried away with who are under the influence of false religion and counterfeit graces and affections. Here is the devil's grand lurking place, the very nest of foul and delusive spirits."[61] Nonetheless, Edwards was taken by beauty and its theological scope, so much so that he regarded *beauty* rather than *power* or *sovereignty* as the first and most distinguishing feature of God's being. According to Edwards, beauty existed in two domains: in the *consent* that is fostered between beings and in the *harmony* or *proportion* that can be observed in things.[62]

It is no small challenge to meaningfully integrate theological propositions that describe God's ideal nature with the rightful appropriation of beauty as it fires the imagination and is manifest in human crafts, architecture and pictorial arts. But it is fair to point out that, excepting the work of Edwards and, two centuries later, neo-orthodox theologian Paul Tillich, beauty qua beauty had little bearing on the mind of Protestant America.

Meanwhile, leading Catholic and Orthodox theologians eagerly embrace beauty. Consider, for example, the capacious mind of the twentieth-century Catholic theologian Hans Urs von Balthasar and his magisterial *The Glory of the Lord: A Theological Aesthetic.* The primary focus of his life's work—seven volumes containing some five thousand pages—is the substance of God's being and glory, which he believed to be nothing less than beauty.[63] Similarly, one cannot miss the passion of Pope John Paul II (1920–2005) in his effort to underscore the centrality of beauty to the larger mission and witness of the church:

> The growing secularization of society shows that it is becoming largely estranged from spiritual values, from the mystery of our salvation in Jesus Christ, from the reality of the world to come. Our most authentic tradition, which we share with our Orthodox brethren, teaches us that the language of beauty placed at the service of faith is capable of reaching people's hearts and making them know from within the One whom we dare to represent in images, Jesus Christ, Son of God made man, "the same yesterday, today and forever" (Heb 13:8).[64]

---

[61]As quoted in Dyrness, *Visual Faith*, 59.

[62]Roland A. Delattre, *Beauty and Sensibility in the Thought of Jonathan Edwards: An Essay in Aesthetics and Theological Ethics* (New Haven, CT: Yale University Press, 1968). See also Robert Jenson, *America's Theologian: A Recommendation of Jonathan Edwards* (Oxford: Oxford University Press, 1992).

[63]Donoghue proposes that "if we took [Balthasar] as seriously as he deserves, we would have to change our lives." Denis Donoghue, *Speaking of Beauty*, 56.

[64]John Paul II, *Duodecimum Saeculum* (Veneration of Holy Images), December 4, 1987, sec. 12.

Sharing the late pope's conviction, Raniero Cantalamessa writes: "To say that God is the author of beauty not only means that he created all the beautiful things in the world but that he also created the very sense of beauty, putting a love for it and a capacity to recognize it in the hearts of human beings, which we call the aesthetic sense."[65] In agreement, David Bentley Hart, an Orthodox Christian, asserts that "beauty is a category indispensable to Christian thought; all that theology says of the triune life of God, the gratuity of creation, the incarnation of the Word, the salvation of the world makes room for— indeed depends upon—a thought, and a narrative, of the beautiful."[66]

With respect to beauty, the contrast between the Protestant mind and the Catholic or Orthodox mind is striking, and the reasons for this are several. And here at least one dimension of Catholic thought and worship bears added mention: the adoration of Mary. While devotion to Mary seems mostly strange to Protestants, Mary is the means by which the Catholic mind is able to showcase the more feminine aspects of the divine character, and to the extent that beauty is regarded as a feminine trait, the adoration of Mary creates more space for beauty. For good or for ill, the various depictions of Mary in the visual arts, such as the annunciation, the holy family, Madonna and child, and the pietà, often cause her to seem more like a sanctified Venus than God's humble handmaid.[67] And it is no secret that these kinds of descriptions are worrisome to evangelicals, some of whom might hesitate to call Mary "blessed" (Lk 1:45) in light of other Roman Catholic affirmations regarding Mary. Still, however Mary figures into one's theology, the larger point stands: Edwards, Balthasar, John Paul, Cantalamessa and Hart cannot imagine life and worship apart from beauty. Beauty is necessary. Beauty is essential.

*Evangelical forays.* Throughout this chapter my assertion has been that evangelicals have barely noticed beauty. Some will counter this claim by pointing to contemporary praise music where words like *beauty* and *beautiful* appear on the overhead screens or video monitors that now front many evangelical sanctuaries. Indeed, on any given Sunday, enthused worshipers can be

---

[65]Raniero Cantalamessa, *Contemplating the Trinity: The Path to the Abundant Christian Life*, trans. Marsha Daigle-Williamson (Ijamsville, MD: Word Among Us Press, 2007), 75.

[66]David Bentley Hart, *The Beauty of the Infinite: The Aesthetics of Christian Truth* (Grand Rapids: Eerdmans, 2003), 16.

[67]See Marina Warner, *Alone of All Her Sex: The Myth and the Cult of the Virgin Mary* (New York: Vintage, 1983).

heard to sing: "Lord, you are more precious than silver; . . . Lord, you are more beautiful than diamonds."[68] For these contemporary worshipers an entire constellation of regal superlatives such as splendor, majesty, wonder and glory are a kind of lingua franca.

This phenomenon invites two observations. First, the mention of beauty in song is not unique to contemporary evangelicalism. From the songs of Moses and his sister Miriam (Ex 15:1-21) to our present day, music has enlivened corporate worship. Notably, both Protestant reformer Martin Luther and twentieth-century theologian Karl Barth regarded the musical forms and verse of Christian hymnody sublime and, therefore, near to God's heart. And more senior church-goers will recall singing hymns such as *Beautiful Savior, For the Beauty of the Earth* and *My God, How Wonderful Thou Art.*

> How wonderful, how beautiful,
> The sight of Thee must be,
> Thine endless wisdom, boundless pow'r,
> And aweful purity.[69]

Second, it is generally the case that the mention of beauty in these hymns and choruses is directed either to God's moral goodness—the selfless giving of an all-powerful God—or his handiwork as displayed in creation. As such, they are not much concerned with the visual aesthetics of God's being, and Protestants remain especially nervous about any conversation having to do with Jesus' physical beauty.[70]

To summarize this cluster of observations regarding the relationship of American fundamentalism and evangelicalism to beauty, the analogy of the three-legged stool mentioned earlier might be useful. If this triunity of goodness, truth and beauty—the transcendentals—represents the virtuous life, then conservative Protestantism balances precariously on just two legs.

---

[68]Despite the often feminized depictions of Jesus in devotional art, Revelation 1:12-17 suggests that in his resurrected and glorified state Jesus possesses a "terrible beauty."

[69]Frederick W. Faber (1814–1863), *My God, How Wonderful Thou Art.*

[70]In contrast to the Bible's mention of, say, David or Esther's beauty, the Protestant inclination is to emphasize that Jesus, the suffering servant, "had no beauty or majesty to attract us to him, nothing in his appearance that we should desire him" (Is 53:2b). Similarly Paul's claim that "we proclaim Christ crucified, a stumbling block to Jews and foolishness to Gentiles" (1 Cor 1:23) seems to reinforce this. Alternatively, consider that the messianic groom is described as "the most handsome of men" (Ps 45:2). Some suppose that this latter reference was the basis of the words to the seventeenth-century German hymn *Fairest Lord Jesus.*

That is, evangelicals have mostly limited their understanding of goodness to the moral sphere, reduced their inquiries about truth to a set of propositions and gone on to wholly ignore beauty. And yet the unpublished cost of this decision is remarkably high, for when beauty is absent, goodness and truth grow anemic. Having considered the beauty of God's being, the manifestation of this beauty in creation, and centuries of reflection on the same, we turn finally to the question, how shall Christians regard beauty and the kind of knowledge that it sponsors?

## SIGNS OF GLORY

Imagine, if you can, weekly shopping without branding, sporting events without signage or automobiles with no attention to 3D design. Indeed, visual culture and its manifold logos, chromas and forms serve a wide range of instrumental purposes, and at least some of these uses should be subject to regular scrutiny. But it is also the case that, in this expanded domain, archetypes return us to a deep past, the material world bears traces of the divine and icons are signposts to the sacred.[71] But apart from beauty's animation, this vast visual world is nothing more than a bundle of lifeless signs.

Nearing the end of this chapter, we turn to two men, Augustine and C. S. Lewis, to aid us in recovering a more robust understanding of beauty. As previously noted, Augustine's *Confessions* enable the reader to observe his mind at work as he sorts out what it means to love God. "What," he inquires of God, "am I loving when I love you?"

> Not beauty of body nor transient grace, not this fair light which is now so friendly to my eyes, not melodious song in all of its lovely harmonies, the gracefulness of temporal rhythm, not the brightness of light (that friend of these eyes), nor the sweet fragrance of flowers or ointments or spices, not manna or honey, not limbs that draw me to carnal embrace: none of these do love when I love my God.

Augustine's point, of course, is that his love for God resides neither in the stimulation of his senses nor in the beauty of the material world. But then, just as Augustine readies us to accept the reasonableness of his proposal, he seems to entirely reverse his course:

---

[71]Balthasar, *Glory of the Lord*, 1:150-55.

And yet I do love a kind of light, a kind of voice, a certain fragrance, food and embrace for my inmost self, where something limited to no place shines into my mind, where something not snatched away by passing time sings for me, where something no breath blows away yields me to its scent, where there is savor undiminished by famished eating, and where I am clasped in a union from which no satiety can tear me away. This is what I love, when I love my God.[72]

What Augustine seems to realize is that his rich, sensate experience of the material world—these approximations of beauty—are a sign of God's greater beauty and, simultaneously, some modest fulfillment of this sign. Had C. S. Lewis been invited to name the nature of Augustine's quest, almost certainly he would have termed it "longing." In his essay "The Weight of Glory," Lewis seems to echo Augustine's conviction:

The books or the music in which we thought beauty was located will betray us if we trust to them; it was not *in* them, it only came *through* them and what came through them was longing. These things—the beauty, the memory of our own past—are good images of what we really desire; but if they are mistaken for the real thing itself, they turn into dumb idols, breaking the hearts of their worshippers. For they are not the thing itself; they are only the scent of a flower we have not found, the echo of a tune we have not heard, news from a country we have never yet visited.[73]

Says Lewis, "Our lifelong nostalgia, our longing to be reunited with something in the universe from which we now feel cut off, to be on the inside of some door which we have always seen from the outside, is no mere neurotic fancy, but the truest index of our real situation."[74] He continues:

Ah, but we want something so much more—something the books on aesthetics take little notice of. But the poets and mythologies know all about it. We do not want merely to *see* beauty, though, God knows, even that is bounty enough. We want something else which can hardly be put into words—to be united with the beauty we see, to pass into it, to receive it into ourselves, to bathe in it, to become part of it.[75]

---

[72]Augustine, *Confessions*, 202.
[73]C. S. Lewis, *The Weight of Glory and Other Addresses* (New York: HarperCollins, 2001), 30-31.
[74]Ibid., 42.
[75]Ibid.

In my view, Augustine's and Lewis's thoughts about beauty and longing are entirely correct. But I am equally certain that these men would be among the first to remind us that our creaturely penchant is to get all of this entirely wrong and in two respects. First, the visceral appeal of beauty—not to mention our similar eagerness to possess truth and to admire goodness—is so powerful that we are perennially tempted to transform these virtues into idols. As such, we fail to comprehend beauty's true purpose and then misdirect our worship to these the lesser things that we find to be lovely. In doing so, we grant penultimate things—appetites, experiences, understandings and skills—ultimate status. Second, a misguided understanding of piety of the sort we considered in chapter three can lead us to believe that our sensate engagement with the world is trivial or, worse, unrighteous.

By contrast, theologically centered hearts and minds can be satisfied with nothing less than true worship. Indeed, proper contemplation of the beautiful leads one to greater beholding both in this life and in the next. Alongside its partners, goodness and truth, beauty is a signpost of God's glory and, rightly perceived, this glory is so great that neither the brokenness of this world nor our false piety can block its rays from bursting forth.

Like the sun around which the planets of our small solar system orbit, the New Testament promise is that the full beauty of God's glory will one day occupy its appointed place at its appointed time. In that day every sphere of knowing and being will orbit in harmony around its *visible* center. Here I grant a final word to Monsignor Timothy Verdon: "At the last, beyond created beauty human beings will behold the beauty of the Creator, contemplating God in Christ Jesus. His alone is the beauty that saves the world."[76]

---

[76]Timothy Verdon, *Art and Prayer: The Beauty of Turning to God* (Brewster, MA: Paraclete Press, 2014), 298. See Gregory Wolfe, *Beauty Will Save the World: Recovering the Human in an Ideological Age* (Wilmington, DE: ISI, 2011), vi.

# An Aesthetic Pilgrimage

*Art has always been about meaning.*

NICHOLAS WOLTERSTORFF

*The Christian is the one whose imagination should fly beyond the stars.*

FRANCIS SCHAEFFER, *ART AND THE BIBLE*

*For now we see in a mirror, dimly, but then we will see face to face. Now I know only in part; then I will know fully, even as I have been fully known.*

1 CORINTHIANS 13:12

*See, I am making all things new.*

REVELATION 21:5

In an article written for *National Geographic*, Chip Walter describes his first experience viewing the chambers of the Cave of Chauvet-Pont-d'Arc, an important archaeological site discovered in 1994:

> Around 36,000 years ago, someone living in a time incomprehensibly different from ours walked from the original mouth of this cave to the chamber where we stand and, by flickering firelight, began to draw on its bare walls: profiles of cave lions, herds of rhinos and mammoths, a magnificent bison off to the right, and a chimeric creature—part bison, part woman—conjured from an enormous cone of overhanging rock. Other chambers harbor horses, ibex, and

aurochs; an owl shaped out of mud by a single finger on a rock wall; an immense bison formed from ocher-soaked handprints; and cave bears walking casually, as if in search of a spot for a long winter's nap. . . . In all, the artists depicted 442 animals over perhaps thousands of years, using nearly 400,000 square feet of cave surface as their canvas.[1]

Archaeologically speaking, the cave's spectacular drawings—some, Walter observes, "drawn with nothing more than a single and perfect continuous line"—are relative newcomers.[2] In other places, scientists have confirmed the discovery of beads, carved bone tools, and ocher and stone objects fashioned by the human hand and estimated to be one hundred thousand years old.

Ancient artifacts, including extraordinary drawings of the sort found in the Chauvet-Pont-d'Arc Cave, remind all who study them that it is the nature of human communities to generate a material culture. Made things, rendered images and built spaces record the imaginative acts and abiding values of the peoples who sponsor them. According to philosopher Nicholas Wolterstorff, "[We] know of no human society or sub-society which has managed to live without the arts—by which I mean, without music and poetry and role-playing and story-telling and pictorial representation and visual design and sculpture."[3]

When measured against art's shimmering tour de force throughout history, it is fair to insist that postwar conservative Protestants demonstrated little to no interest in the visual arts. They did, of course, publish educational materials, produce devotional objects and construct houses of worship, but the character of these popular arts was predictably didactic and utilitarian. Stained-glass windows being the notable exception, conservative Protestants did not display art in their church parlors, statuary was absent from their sanctuaries, and handsome liturgical objects and finery held no pride of place in the low-church worship experience. From early in the twentieth century onward, one expected the edifice and interior of, say, a Baptist or Assemblies of God church to look and feel substantially different from their Lutheran, Episcopalian or Catholic counterparts.

---

[1]Chip Walter, "The First Artists," *National Geographic*, January 2015, http://ngm.nationalgeo graphic.com/2015/01/first-artists/walter-text.
[2]Ibid.
[3]Nicholas Wolterstorff, "Evangelicalism and the Arts," *Christian Scholar's Review* 40, no. 1 (Fall 2010): 449.

If *aesthetics* was decidedly not a central concern for most postwar evangelical communities, *salvation* was: God saving men and women to himself and from the world. That is, evangelicals did not imagine that the aesthetic dimensions of their being—apart from music—had any bearing on their salvation. This commitment to a strong, demonstrable conversion was flanked on one side by steadfast allegiance to the authority of God's Word, the Bible. Matching it on the other was a resolute devotion to personal holiness, the ongoing sanctification of every believer. This trio of commitments—conversion, the Bible and personal piety—shaped conservative Protestant priorities, and by mid-century it also guided popular understandings of God, morality and community for millions of Americans, even nonbelievers.

Since most evangelicals considered the highbrow aesthetic commitments of the art world anathema, artists who longed for a place where art and faith could thrive in fruitful union found themselves in a precarious position. If their Christian belief inspired devotion to Christ and his body, artistic success assumed uncritical alignment with the ideology and practices of the secular art world. As their church communities preached separation from the world, in equal measure the creative pursuits of these artists were relegated to the margins of church life. In many respects this was a rational divide, for just as the aesthetic expressions of the art world were not easily comprehended by the church, moral frameworks wedded to divine revelation left aesthetes confused. And so it followed that where one community saw no virtue in visual aesthetics—including the possibility that aesthetics (beauty) could be a path to transcendent reality—the other doubted the possibility that the real presence of God could be revealed in a book, the Bible. Consequently, each community harbored deep skepticism concerning the core convictions and practices that animated the other.

Tertiary education contributed mightily to this divide. From the 1950s onward, BFA and MFA degree programs at secular academies, colleges and universities swelled in popularity, and student enrollment skyrocketed. Almost without exception, these courses of study embraced a modernist aesthetic that only widened the breach between art and religion.[4] In due course, art departments were also established at Christian colleges and universities.

---

[4]Howard Singerman, *Art Subjects: Making Artists in the American University* (Berkeley: University of California Press, 1999).

It followed that the faculty credentialed to offer instruction in these new programs were artists who had completed their MFA at secular institutions. While these newly minted professors could generally subscribe to the statement of faith and personal code of conduct of the institutions that employed them, it was their secular training that largely informed the philosophic and aesthetic commitments they brought to the classroom. Indeed, many of these art department faculty embodied the very tensions outlined in this book and, in due course, so also would their students.

Remarkably, during the postwar period almost no church-related Catholic or Protestant college or university art department encouraged students to make art for the church. And it remains the case that visual art directed to worship and liturgy is conspicuously absent from the curricula of these tertiary institutions. The reason for this is twofold. First, and as already noted, nearly all of the teaching faculty in these church-related college and university art programs completed their graduate training at secular institutions and had, therefore, no formal training in the liturgical arts. Second, the denominations that founded these institutions have been either disinterested in or opposed to finding a meaningful place for visual art in their worshiping communities. While a good many art departments at church-sponsored colleges and universities have flourished, the students who matriculate from these programs seldom bring their learning, skill and imagination back to the faith communities that have, at least in part, sponsored their education.

As we observed at the beginning of this book, from the mid-nineteenth century onward, artists of faith had been presented a false choice: an ultimatum insisting that art and religion could not reasonably coexist. Secular and even Christian art education reinforced this polarity, as did the social, critical and economic machinations of the art world. To manage this supposed conflict, artists in the Christian community found themselves opting for one of three perfunctory arrangements: they could remain in the conservative church and abandon their art, migrate to liberal Protestantism and enjoy a modicum of vocational support, or cast their lot with the art world, leaving their personal attachments to Christian belief behind. At the end of the day, each choice signaled a troubling loss of community. Conservative Christians attuned to the arts would need to find their way forward alone. Save for a few visionaries, most did not.

A primary objective of this study has been to understand why, in the second half of the twentieth century, American evangelicals and the modern art movement existed at such remove. During these decades this distance was the *given* condition. With the seven previous chapters of this book providing a rich context, this closing chapter aims to resurrect a measure of hope for those who believe they are called by God to be faithful artists. The thematic arc of this project requires nothing less.

## A GLIMMER OF LIGHT

In the 1970s a few visionaries in the evangelical community commenced on an aesthetic pilgrimage. The backdrop for this development was surely the rise of the American counterculture. As the 1960s youth movement grew, it challenged and then overturned traditional hierarchical structures—establishment practices—on every front. To the uninitiated, the spirit of freedom and creativity present in the Aquarian age was intoxicating. For while conservative Christians talked about the joy of knowing Christ, the innovative music and fashion of the counterculture, coupled with its radical politics and liberated social mores, enacted a more visceral exuberance—a festival of present delights rather than the deferred promise of an eternal home.

For a loosely configured yet dynamic fellowship of culturally attuned evangelical intellectuals, artists, pastors and ministry leaders, the broad-reaching force of this social revolution required a ready response. Some rose to meet it. To achieve this, these evangelicals would need to step away from the reactionary posture that had bound them for so long to embrace new strategies for church growth, preaching, scholarship and social engagement. Nuanced missional paradigms, ones intending to be biblically faithful yet culturally open, did emerge. And Christian perspectives on the visual arts benefited directly from these.

In his 1973 book *Art and the Bible*, Francis Schaeffer asserted: "While the lordship of Christ over the whole world would seem to include the arts, many Christians will respond by saying that the Bible has very little to say about the arts . . . but this is just what we *cannot* say if we read the Bible carefully."[5] According to Schaeffer, if one believed in the Bible, it followed that one must hold

---

[5]Francis Schaeffer, *Art and the Bible* (1973; Downers Grove, IL: InterVarsity Press, 2006), 14 (italics mine).

the arts in high regard. For artists in the evangelical church, Schaeffer's endorsement felt like a game changer. Indeed, not only had this popular Christian thinker granted Bible-believing Christians permission to accept the arts as a central feature of their story, but the apologist served notice to any in the church who might resist the idea. While the reach of Schaeffer's speaking and writing was limited primarily to the conservative Protestant community, for Christian artists a promising light had appeared on an otherwise dull horizon.

Across several decades, many have criticized Francis Schaeffer's "thin," generalist approach to weighty philosophical, theological and social issues. Few, however, dispute the broad encouragement that he and his wife, Edith, brought to a generation who longed for the day when the gospel of Jesus Christ would be regarded as culturally relevant. And no group in the Christian community benefited more from their efforts than artists.

In 1970, three years prior to Schaeffer's publication of *Art and the Bible*, his friend H. R. Rookmaaker published *Modern Art and the Death of Culture*.[6] The Dutchman was a learned art historian, and his regard for modernism was evident throughout the book. Still, for believers eager to find a Christian voice in the modernist milieu, Rookmaaker's critique offered little forward direction. Though insightful, it was not—as the book's title suggests—a hope-filled account.[7]

In 1978, however, Rookmaaker published *Art Needs No Justification*, a considerably smaller essay.[8] Like Schaeffer's *Art and the Bible*, this work affirmed the relevance and legitimacy of the arts to the evangelical community. Just two years later, philosopher Nicholas Wolterstorff published his book *Art in Action*, and that same year aesthetician Calvin Seerveld released *Rainbows for the Fallen World*.[9] Within a decade, a handful of Reformed thinkers had articulated the case for Christianity and the visual arts. While it should not be imagined that Rookmaaker, Schaeffer, Seerveld and Wolterstorff were

---

[6]H. R. Rookmaaker, *Modern Art and the Death of a Culture* (Downers Grove, IL: InterVarsity Press, 1970).

[7]Rookmaaker's conviction about death and culture was hardly misplaced. Poet Christian Wiman observes, "As belief in God waned among late-nineteenth- and early-twentieth-century artists, death became their ultimate concern." Wiman, *My Bright Abyss: Meditation of a Modern Believer* (New York: Farrar, Straus and Giroux, 2103), 50.

[8]H. R. Rookmaaker, *Art Needs No Justification* (Downers Grove, IL: InterVarsity Press, 1978).

[9]Nicholas Wolterstorff, *Art in Action* (Grand Rapids: Eerdmans, 1980); Calvin Seerveld, *Rainbows for the Fallen World* (Toronto: Tuppence Press, 1980).

evangelical spokespersons per se, their commitment to the authority of Scripture granted them an audience with other culturally attuned theological conservatives. In due course, their speaking and publishing, coupled with growing enthusiasm from younger followers, created new space for art.[10]

The basis for this new openness centered largely on a conviction espoused by Schaeffer and his protégés: if Christians hoped to reach a "lost world," then they needed to understand it firsthand. In other words, the context for Christian witness mattered profoundly. In practical terms, this revised understanding of evangelism caused increasing numbers of mission-minded evangelicals to view secular films, visit museums, listen to contemporary music and read modern literature and philosophy. Before long, evangelicals were sponsoring a wide variety of innovative endeavors that featured sophisticated cultural critiques and an ever-increasing sympathy for the arts. And here I would be remiss if I failed to note the founding of Christians in the Visual Arts (CIVA) by art professor Eugene Johnson at Bethel College in 1979. CIVA—for which I currently serve as executive director—occupied a place at the very center of the discourse I am describing.

If from the 1950s to the 1980s mainline Protestants and some Catholics had taken the lead in faith-based arts initiatives, evangelicals increasingly became core participants. By the close of the century, a common love of art and belief in the redemptive power of the gospel generated positive if not unexpected alliances. Across denominational boundaries, collegial friendships were formed, guilds and associations were established, and fresh aesthetic life was breathed into existing Christian institutions. An art and faith movement had been born, and not infrequently evangelicals provided leadership.

In the wake of all this promise, however, two or more decades would pass before a more filled-out Christian understanding of the artist's vocation would find expression.[11] In fact, Schaeffer, Rookmaaker, Wolterstorff, Seerveld and others had always been attuned to the social and spiritual realities of the artist's vocation. Nonetheless, most postwar evangelical leaders

---

[10]Daniel A. Siedell, "Art and the Practice of Evangelical Faith," *Christian Scholar's Review* 34, no. 1 (Fall 2004): 119-31.

[11]Christians did, however, continue to publish numerous books on related themes such as arts ministry, Christian art, and art and theology, and monographs featuring artists who were rising in popularity within the Christian community. See, for instance, Katie Kresser, "Art and Theology—a Review Essay," *Christian Scholar's Review* 43, no. 1 (Fall 2013).

were either unprepared or unwilling to embrace this new moment either for art or for artists who belonged to their congregations or organizations.

From the 1990s onward the tide began to turn as some evangelical leaders and institutions revisited their wavering commitment to the visual arts. A flurry of promising ventures followed. These belonged, more or less, to one of four categories: the formation of professional societies and publications, print and online; fresh arts-related initiatives at Christian liberal arts colleges and universities; related graduate-level study and research, with notable developments in theological education; and a wide range of congregational initiatives. With regard to the local church, mainstream evangelicals began to celebrate the artist's vocation, develop arts ministries, establish gallery spaces and exhibition programs, and introduce visual art into their preaching and teaching.

What grants this wide range of endeavors its authority, what lends gravitas to its cause, is the compelling breadth and quality of the artistic production that continues to occur. At the end of the day, the promise of the entire art and faith enterprise will be sustained only if artists in the community continue to make art of scope and substance.

Before pressing ahead, let's consider an important footnote to this social history. Two opportunities to redress the seeming impasse between visual art and Christian faith had been present to conservative Protestants all along. First, they might have consulted the marvelously rich yet largely forgotten history of Christian art. For at least fifteen centuries or more and prior to the Protestant Reformation, there existed a vital visual witness to Christian piety, worship and thought. Since this world of art and architecture is cherished by both secular and religious persons and respected by cultural elites, church leaders might have called on it as a means to meaningfully engage the art world.[12] But the iconoclasm of the Protestant tradition, nervousness about its alignment with a more Catholic past and the anti-intellectualism of its populist practitioners forestalled its ability to unpack these treasures. Second, conservative Protestants might have explored the art world's abiding intrigue with spirituality—a fascination that prevailed throughout the twentieth century despite the endemic bitterness

---

[12]Here Timothy Verdon's book *Art and Prayer* (Brewster, MA: Paraclete Press, 2014) offers a credible instance of this missed opportunity. But even this kind of scholarship—a work conceived from deep personal devotion to Christ—would have seemed entirely too Catholic for most postwar Protestants.

that so many modernists harbored toward organized religion.[13] In this regard Marcus Burke's caution is prescient:

> At the outset of the twenty-first century, it is a sort of dereliction of aesthetic duty for a believing artist, whether recently converted or long since brought to faith, to turn his or her back on the immense power that modern design has brought to art. Above all, the ability of modernist techniques to achieve visual and philosophical transformations and access human psychology must not and cannot be ignored by any artist seeking to express the life of faith.[14]

By the century's end, fresh winds did fill the sail of earlier developments, and for artists serious about Christian faith and art practice, it was time to enter or reenter the scene. But this new opportunity was limited and in two respects: their estimation of culture remained underdeveloped, and their understanding of the artist's vocation skewed or miscast. To these topics we now turn.

### THE CULTURE PROBLEM

In chapter one we noted H. Richard Niebuhr's publication of *Christ and Culture*, in which the theologian outlines the virtues and liabilities of five possible relationships between Christianity and culture, the first being a position he termed "Christ against culture." Those familiar with Niebuhr's work generally agree that his Christ-against-culture position best represents the operational paradigm of most American fundamentalists and evangelicals from the late nineteenth century through to the close of the twentieth. Admittedly, evangelical beliefs and practices during those decades were more complex than this—influenced as they were by denominational particularities, regional distinctives and the social standing of their adherents. And as previously mentioned, in the closing decades of the twentieth century, evangelicals grew more open to the possibility that a variety of faithful responses to culture might be possible. But none of these changes or modalities reverse Niebuhr's observation that the Christ-against-culture position is especially hostile to the arts.[15] In fact, it is impossible to meaningfully engage art and the artist's

---

[13]For the case in favor of modernism, see Daniel A. Siedell, *Who's Afraid of Modern Art? Essays on Modern Art and Theology in Conversation* (Eugene, OR: Cascade, 2015).

[14]Marcus Burke, "The Life of Faith and Contemporary Art," in *The Word as Art: Contemporary Renderings* (New York: American Bible Society, 2000), 52.

[15]Interestingly, Niebuhr refers to the work of Tertullian and Tolstoy to establish the point. H. Richard Niebuhr, *Christ and Culture* (1951; New York: Harper and Brothers, 1956), 54-55, 62-63.

vocation while sidestepping or disabusing the reality of human culture. For artists hoping to remain faithful to Christ, three commonly held misperceptions about culture must be overturned.

The first and perhaps fatal flaw of the anticulture position is its failure to comprehend the intractable bond that each of us has to the whole of humanity—our communities of origin and then each subsequent community to which we belong. Modern men and women may theorize about living "off the grid," but in reality planes and satellites continue to orbit planet Earth, the overflow of consumer waste routinely washes ashore and global digital networks pulse with data. To be human necessitates participation in the human community. That is, from financial management to education, from health care to commerce, each of us swims in a social pond. Common languages, customs and social policies, alongside less evident realities such as shared weights, measures and currencies, are essential to human flourishing. It follows that most men, women and children need an ordered civic life to thrive. No authentic discussion about culture can therefore occur when "others" who exist in that same culture are understood primarily as abstractions. According to Niebuhr, "Christ claims no man purely as a natural being, but always as one who has become human in a culture; who is not only in culture, but into whom culture has penetrated."[16]

A second deficiency of most anticulture schemes is the assumption that movements like the art world or the evangelical church are monolithic. During the postwar period, both entities were loose federations at best, and their respective visions and programs fluid and contingent. Put differently, these enterprises behaved more like a school of fish darting about in deep waters than, say, a Roman legion on a measured march, and internal conflict and dissent was standard fare.[17] In any case, the ever-shifting and sometimes fugitive character of these movements should forestall any impulse to universalize the beliefs and practices of one group and set these against the aesthetics and behaviors of the other. Faithful accounts will acknowledge a variety of actors whose manner and methods display divergent motives and ambitions. It is

---

[16]Ibid., 69.

[17]Regarding the transitory nature of groups and institutions, see Peter Senge et al., *The Dance of Change: The Challenges to Sustaining Momentum in Learning Organizations* (New York: Doubleday, 1999).

because of this that a bright line demarcating one community from the other is not easily drawn.

Third, twentieth-century evangelicals worried a great deal about membership—who belonged to their camp and who did not. The centerpiece of this concern was a fierce and long-standing debate regarding the nature of Christian conversion. If, they reasoned, eternal destiny is a matter of ultimate concern, then nothing is more important than the assurance of one's salvation—to know for certain who has and has not passed from darkness into light, from death unto life. These impassioned and often fine-tuned discussions remain a central feature of evangelical identity, and especially as a counter to "cheap grace" or a hedge against universalism.

Not so subtly, this ongoing to-and-fro concerning the identity of the "saved" and "unsaved" underscored the anticultural stance of the fundamentalists and evangelicals who advanced it. That is, accompanying this spirit of separation was an abiding yet little-noticed assumption concerning class. The populist nature of conservative Protestantism inclined it to regard cultural elites—the moneyed, famous, powerful and privileged—as those least able to humble themselves and to take up the cross of Christ. There is a definite sense in which this conviction is rightly aligned with Jesus' ministry and teaching, since Jesus boldly announced his Father's heart for the least among us: the lame and the blind, the orphan and the widow, the beggar and those possessed by evil spirits. According to Jesus, the disciple who chooses the low road that leads to salvation must eschew money, status and privilege.[18] Individual artists might or might not have belonged to this camp, but art-world elites—famous artists, collectors, museum patrons, curators and critics—surely did.

In this regard the rich young man is presented as the tragic exemplar (Mt 19:16-26; Mk 10:17-27; Lk 18:18-25). Though this affluent man longed to enter the kingdom of God, he could not heed Jesus' instruction to "go, sell all your possessions, and give the money to the poor, and you will have treasure in heaven; then come, follow me" (Mt 19:21). Fundamentalists and evangelicals reasoned that cultural elites, captivated by self-interest and pride, had chosen

---

[18]Here it would seem that Jesus' teaching nicely aligns with the perspective of some historians wherein the time-honored notion that history is primarily an account of powerful men and their deeds yields to a revised narrative that highlights the choices and abilities of common folk and their "unexceptional" lives as a more reliable account.

the wide road to their own destruction. At the same time, they imagined themselves accounted among Christ's most faithful disciples. In the face of spiritual pride, of course, no measure of weakness, poverty or powerlessness is a guarantor of spiritual fidelity.

Twentieth-century fundamentalists and their evangelical heirs sought to establish a bulwark against liberalism, secularism and the worldliness of popular culture. At its best, the Christ-against-culture position was and remains a corrective to moral relativism and soteriological sloppiness. And here Niebuhr's own estimation of the needed balance is instructive:

> The relation of the authority of Jesus Christ to the authority of culture is such that every Christian must often feel himself claimed by the Lord to reject the world and its kingdoms with their pluralism and temporalism, their makeshift compromises of many interests, their hypnotic obsession by the love of life and the fear of death. The movement of withdrawal and renunciation is a necessary element in every Christian life, even though it be followed by an equally necessary movement of responsible engagement in cultural tasks. Where this is lacking, Christian faith quickly degenerates into a utilitarian device for the attainment of personal prosperity of public peace; and some imagined idol called by its name take the place of Jesus Christ the Lord.[19]

By the close of the twentieth century, the explicit challenge of secularism—a world without God—gained remarkable acceptance, especially among cultural elites. With this the optimistic theism that had marked so much of American life and culture five decades earlier dissipated. American religious history confirms that the Christ-against-culture posture did not abate this advance, nor did it offer much guidance to Christian disciples attempting to live faithful lives before the rising specter of pluralism.

In the opening decade of the twenty-first century, the cultural posture of evangelicals continued to evolve, and a pair of books deepened the conversation: Andy Crouch's *Culture Making: Recovering Our Creative Calling* (2008) and, two years later, James Davison Hunter's *To Change the World: The Irony, Tragedy, and Possibility of Christianity in the Late Modern World* (2010). Crouch alerted his evangelical community to something that in retrospect should have been obvious: day in and day out, Christians make culture. Writes Crouch:

---

[19]Niebuhr, *Christ and Culture*, 68.

"We make sense of the world by making something of the world. The human quest for meaning is played out in human making: the finger-painting, omelet-stirring, chair-crafting, snow-swishing activities of culture. Meaning and making go together—culture, you could say, is the activity of making meaning."[20] According to Crouch, the making of culture is best understood as the natural fruit of daily thought and labor. In the opening pages of Hunter's book, the sociologist takes Crouch to task for his optimism concerning the power of grassroots efforts to effect longstanding change, but then goes on to advance his own thesis: only those with the requisite financial, social, intellectual and political capital—elites—have the capacity to inaugurate and then sustain deep cultural change.

I cite both positions here—Crouch's confidence in the significance of imaginative grassroots endeavors (bottom-up) and Hunter's endorsement of projects directed by and toward elites (top-down)—to highlight the evolution of evangelical thought and action with respect to culture. It takes little imagination, I think, to see that healthy communities who are eager to serve the commonweal will hope to discover genuine synergy between top-down and bottom-up operations. Whether one is inclined more toward Crouch or Hunter, both positions demonstrate the notable shift of some evangelicals away from reactionary separatism, on to apologetic engagement and eventually to culture making itself.

For younger, more progressive evangelicals who prefer cultural participation rather than separation, the older "culture war" has lost its force. And here we must acknowledge the substantially larger ideological conflict that engulfs these more particular iterations of evangelical community. That is, in this second decade of the twenty-first century, memories of Christian empire might persist, but the hegemony of Christendom no longer holds. Today Christian faith is but one of many options available to persons who choose or prefer to believe in God. And beyond these varieties of religious belief, the reigning ideological disposition of the West is now best described as post-Christian. Our emerging global context requires us to make peace with pluralism, to regard it as normative.[21] Still, no matter which cultural critique or

---

[20]Andy Crouch, *Culture Making: Recovering Our Creative Calling* (Downers Grove, IL: InterVarsity Press, 2008), 24. James Davison Hunter, *To Change the World: The Irony, Tragedy, and Possibility of Christianity in the Late Modern World* (New York: Oxford University Press, 2010).

[21]In a sense, this multiperspectivalism is the natural fruit of the postmodern thought that emerged some

worldview one holds to, for Christians at least, neither Jesus' *commission* to share the good news of the gospel with the world nor his *command* to love one's neighbor has been rescinded.

Thus far we have considered the shifting cultural stage set on which artists in the evangelical community were left to work out their calling during the postwar period. Now we press on to consider the nature of this call.

## CALLED BY GOD

A great deal has been written on the topic of Christian calling, and given its standing in the evangelical community, the topic remains a preeminent concern. Here is why. Beyond conversion to Christ, the most cherished position an evangelical man or woman can occupy is to be "called"—one who is able to discern and then pursue God's will for his or her life. I have no quarrel with this general understanding. Indeed, Scripture abounds with accounts of God's invitation to men, women and even children to assume divinely appointed roles and responsibilities in diverse settings and situations. In the Old Testament, God commanded Abraham, "Go from your country and kindred," and he "went" (Gen 12:1-4). In the New Testament, Jesus invites his disciples to follow him, and they do so, leaving family, friends, possessions and careers behind. Bible readers are given considerable cause to imagine that, large and small, these kinds of invitations are normative and that God, according to his grace, provides those who follow him with the gifts and abilities needed to complete such tasks.

In their postwar zeal to evangelize the world, most conservative pastors and teachers reasoned that Christians belonged to one of two camps: a select group called to full-time ministry or a more general group needed to send and support those who had been called. A two-tiered system emerged in which persons called to serve as pastors, leaders and evangelists operated in the upper story and those tasked with providing prayer, encouragement and financial support occupied the lower.[22] Across the centuries God's people have

---

thirty years ago. See Lesslie Newbigin, *The Gospel in a Pluralist Society* (Grand Rapids: Eerdmans, 1989).

[22]This prioritization is not without biblical precedent. "The gifts he gave were that some would be apostles, some prophets, some evangelists, some pastors and teachers, to equip the saints for the work of ministry, for building up the body of Christ, until all of us come to the unity of the faith and of the knowledge of the Son of God, to maturity, to the measure of the full stature of Christ" (Eph 4:11-13).

supplied material support for those they deemed to be "set apart" to his service. Early evidence of this practice is God's command that ancient Israel supply a tithe in order to support the Levites (Deut 18:1-8). Carried forward, this idea found radical expression in the early church, formed the operational heart of the premodern monastic movement that swept Europe and remained the foundation of missionary endeavors throughout the nineteenth and twentieth centuries. In the postwar period, impressive acts of generosity, sacrifice and service advanced the global evangelical mission, and it is reasonable to suggest that this demonstration of altruism and devotion represents one of the movement's finest hours.[23]

Acknowledging the strength of this position, there is ample reason to question the assumptions that undergird this two-tiered arrangement, not least because those occupying the upper story—persons who had themselves heeded a call to full-time ministry—were typically the ones commending the strategy. That is, pastors and other church leaders not only regarded this understanding of vocation as *the* biblical model; they occupied the podium from which it was announced. Because of this, the rich and expansive Reformational understanding that all believers are priests was often eclipsed or even forgotten.

If this two-tiered strategy effectively advanced particular expressions of the gospel message, too frequently it diminished the work of Christians who sensed no call from God to pursue "full-time" ministry. In its most flawed implementation, the calling of visual artists and countless other professionals was granted no standing, save in a supportive role. And more than bankers, or educators, or medical technicians, or ranchers, or auto mechanics, or military personnel, or homemakers, the usefulness of the artist's calling was questioned most frequently (church musicians being the exception).[24] How, after all, can making a painting measure up to the high calling of saving souls, healing the sick or feeding the hungry? Again and again, no ready or persuasive apologetic emerged.

---

[23]Here I cite the 1956 martyrdom of Jim Elliot and his four companions by the Auca Indians in Ecuador. See Elisabeth Elliot, *Shadow of the Almighty: The Life Adventure, Witness, Testament and Glory of Jim Elliot, One of the Five Martyrs of Ecuador* (London: Hodder & Stoughton, 1958). These kinds of sacrifices were striking in similarity to the ones that American troops made to prevail over Hitler's Germany. That is, impressive sacrifice for a cause greater than oneself was, for that season of American life, resident in the nation's character.

[24]This challenge to the legitimacy of the arts is hardly unique to conservative Christian circles. See John Carey, *What Good Are the Arts?* (New York: Oxford University Press, 2006).

Having served in full-time ministry for most of my adult life, but also being one with formal training in the visual arts and an ongoing studio practice, let me propose what I regard to be a more faithful approach to Christian calling. I term it "responsible agency." As persons made in God's image, we possess remarkable capacities. Our agency equips us to decide, act and create, to embrace opportunity and address need. But more fundamental than this, we have the ability to make moral, aesthetic, relational and spiritual decisions. This agency is basic to our being, so much so that the contours and capacities of our humanity cannot be understood apart from it.

The two creation stories featured in the opening chapters of Genesis establish the character of our agency. The first of the two is a kind of cosmic account that reviews the seven days of creation (Gen 1:1–2:3). The second finds its focus in the story of Adam and Eve (Gen 2:4-25). In these chapters, three primary realities about God's nature are revealed: God exists in trinitarian community, he has the ability to create *ex nihilo* and he delights in blessing what he has made. With this understanding as broad context, in Genesis 1:27 we then learn about the nature of humankind:

> So God created humankind in his image,
>> in the image of God he created them;
>> male and female he created them.

Together, male and female bear the *imago Dei*. In this regard the man and woman were charged to be fruitful and multiply (Gen 1:28a); granted dominion over the plants, fish, birds and mammals (Gen 1:28-30); placed in paradise to tend the garden (Gen 2:15); and tasked with naming the creatures (Gen 2:19-20). The evidence of their agency abounds. Adam and Eve are presented to us as imaginative, self-reflective and relational beings who have been invited by God to participate in what Dorothy Sayers describes as acts of "co-creation."[25]

Notably, God does not ask the man, Adam, to accomplish his work alone. Moreover, while Adam's powers are considerable—especially when compared

---

[25]"It is true that everybody is a 'maker' in the simplest meaning of the term. We spend our lives putting matter together in new patterns and so 'creating' forms which were not there before. This is so intimate and universal a function of nature that we scarcely ever think about it. In a sense, even this kind of creation is 'creation out of nothing.' Though we cannot create matter, we continually, by rearrangement, create new and unique entities." Dorothy Sayers, *Mind of the Maker* (1941; repr., San Francisco: HarperCollins, 1987), 28.

to the other creatures—his capacity is limited and in three respects: he is constrained to exercise his freedom within the boundaries of the paradise where God has placed him; unlike God, Adam cannot create *ex nihilo*; and not all good things are available to him. Notably, Adam is forbidden from eating fruit from the tree of the knowledge of good and evil (Gen 2:17).[26]

The unfolding story of the Bible visits the reality of human agency again and again. Early on, humankind's impressive capacity to design, invent, make and build is confirmed. In the millennia that follow, this agency appears in everything from engineering and scientific theorizing, to philosophic discourse and transformative education, to corporate leadership and entrepreneurial risk taking. When rightly conceived, these practices are regulated by moral and aesthetic judgment, exist in service to God's creation, including his creatures, and form the very foundation on which a full and meaning-filled life is constructed.

But we know that there is also a dark and disturbing side to this account. Scripture alerts us to the immense risk of granting fallible beings such potent agency. As the Babel account confirms, this agency is neither unbounded, nor is it (now in our postlapsarian condition) "naturally" poised to advance the good. To the contrary, creative agency can be employed to erect hubristic monuments (Gen 11:1-9), and throughout history our creative and imaginative capacity has been enlisted, again and again, to inflict unspeakable violence against other women and men, other creatures and creation itself. Not infrequently, art and architecture have been marshaled to advance reprehensible causes and conditions. But it is also the case that these same forms have been used redemptively to express deep, soul-searching lament.

To summarize, human agency is central to any understanding of Christian calling. Made in God's image, we are invited to join with him to accomplish God's work in the world. But if this *general* understanding is straightforward, it does not follow that identifying one's *particular* vocation is an easy task. Rather, the pursuit of meaningful work can be all-consuming and appear to be a fool's errand. This business is further complicated (but also blessed) by the reality that true vocation is worked out in a social context, a conflagration

---

[26]This third limitation—that any kind of obvious privilege or pleasure might be withheld from us—is an offense to the modern mind and its understanding that personal freedom should be understood primarily as access to privilege and entitlement.

of morals, muses and manners in which realities such as class, race and gender figure importantly. In other words, the pursuit of one's vocation necessarily intersects one's prevailing cultural narrative, the *Zeitgeist* one inhabits.

With evangelicals having proclaimed their desire to reach the world for Christ, the perennial temptation in postwar evangelical America was to frame Christian calling too narrowly, thereby ignoring or eclipsing critical expressions of human agency. Too often religious believers inclined toward the arts were expected to conform the complexity of their lives and callings to a theological framework that lacked imagination and an understanding of discipleship that preferred method over nuance. The legitimacy of the artist's agency, even its usefulness in the kingdom of God, was often questioned. We turn now to address the vocation of artist-actors themselves.

## THE ARTIST'S VOCATION

Art is an impressive and often beguiling demonstration of human agency writ large in the world, and more than a few minds have sought to describe the artist's task in relation to this. I believe that the artist's calling is fulfilled when at least one of four human needs is addressed or met: supplying fitting design, advancing meaningful critique, generating palpable beauty or exploring ineffable mystery. If this reasonably outlines the possible range of an artist's work, then it is not difficult to understand how the visual arts emerged.

Ancient man needed bowls and pots, fabric and clothing, tools and weapons, and furniture and shelter for sustenance and protection. Since the beginning of recorded history, *Homo sapiens* has been *Homo faber*, a worker, a maker of things. In preindustrial times, of course, these material goods were fashioned entirely by hand. In due course, familial and tribal structures would be organized around the acquisition and refinement of increasingly specialized making skills. Guilds and workshops were formed to cultivate mastery and increase productivity. Apprentices, usually younger family members, were mentored by elder generations, and those most gifted in making, embellishment and the ways of commerce rose in reputation and power.[27]

The earliest evidence of these kinds of activities in the biblical record appears in Genesis 4: "Adah bore Jabal; he was the ancestor of those who live

---

[27]For an engaging history of artisan guilds and their development, see Richard Sennett, *The Craftsman* (New Haven, CT: Yale University Press, 2008).

in tents and have livestock. His brother's name was Jubal; he was the ancestor of those who play the lyre and the pipe. Sillah bore Tubal-Cain, who made all kinds of bronze and iron tools" (Gen 4:20-22). In this ancient text, the arts are especially evident: musicians and metalsmiths existing on par with nomadic herdsmen. But material possessions were not humanity's only need. Humanity's social, intellectual and spiritual being required signs, images and icons (idols). It seems almost certain that Bezalel and Oholiab, the artist-artisans identified in Exodus, belonged to this kind of socioeconomic arrangement—Bezalel being the first person mentioned in the Bible to be filled by God's Spirit, and God being the one who guided the artist's mind and hand in designing and constructing the tabernacle (Ex 36:2).[28]

In its way, God's charge to Bezalel anticipates the later calling of the architects and artisans—workers in stone, metal, wood and masonry—who built Europe's celebrated cathedrals.[29] In this regard, a frieze located beneath the sculpture *Four Crowned Martyrs* on the exterior wall of the Oratory of St. Michael in Florence, Italy, is instructive (fig. 8.1).[30] Though now a church and museum, the Oratory was built in 1336 both to store grain and to serve as a center for commerce. In 1339 each of the city's professional guilds was invited to supply a statue of their respective patron saint to be placed in one of fourteen niches that now surround the building's exterior. The distinctly premodern tableau of this carved stone frieze highlights what

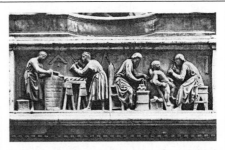

**8.1.** Carved stone relief, Oratory of St. Michael, Florence, 1339

would have been a typical relationship between artisans and artists: skilled masons and sculptors laboring side by side to complete a larger commission.

---

[28]Christian legend—not the biblical account—supposes that Luke the physician, who penned Luke–Acts, was himself an artist. Presumably Luke was a Gentile, and so he may have been more inclined than any Jew of his day to pursue such a task. Similarly, some believe that Nicodemus, the man who approached Jesus in the night and also who provided a lavish gift of spices to anoint Jesus at his burial, was a sculptor. But these possibilities are mostly hopeful suggestions and lack historical support.

[29]See Ross King, *Brunelleschi's Dome* (New York: Penguin, 2001).

[30]My thanks to John Skillen for introducing me to this work and its historical significance.

During the modern period, sites such as the Cave of Chauvet-Pont-d'Arc (mentioned at the beginning of this chapter) and the Oratory of St. Michael, and artisans like Tubal-Cain, Bezalel and Oholiab, remained archaeologically and historically interesting. But building on the brilliant accomplishments of Renaissance artists such as da Vinci, Michelangelo, Raphael and Caravaggio and then rising to a fever pitch during the romantic period, the artist was recast as a "genius." Increasingly, it was believed that the artist's powers of invention, skill and facility should be celebrated, admired. For some moderns the "true" artist was believed to be a cultural prophet or priest. Painters, poets, sculptors and musicians were exemplars of emancipated modern selves. With this a deep chasm between ideation and craft settled in. As the fame of the artist-genius increased, artisans would, more and more, be regarded as mere makers of mere things.[31] As William Deresiewicz explains it:

> All of this began to change in the late eighteenth and early nineteenth centuries, the period associated with Romanticism: the age of Rousseau, Goethe, Blake, and Beethoven, the age that taught itself to value not only individualism and originality but also rebellion and youth. Now it was desirable and even glamorous to break the rules and overthrow tradition—to reject society and blaze your own path. The age of revolution, it was also the age of secularization. As traditional belief became discredited, at least among the educated class, the arts emerged as the basis of a new creed, the place where people turned to put themselves in touch with higher truths.[32]

Having shed the burden of tradition and religion, the modern artist was no longer subservient to prescribed conventions or ruling institutions. Moreover, the advent of photography and its striking verisimilitude released artists from the burden of depicting people, places and events of note for posterity's sake.

---

[31]Glenn Adamson counters this view by arguing for the importance of craft, even in relation to modern art. "Modern art is staked on the principle of freedom, its potential transcendence of all limits, including (even especially) those of craft. Yet in the very marginality that results from craft's bounded character, craft finds its indispensability to the project of modern art. My central argument, when all is said and done, is that craft's inferiority may be the most productive thing about it." *Thinking Through Craft* (Oxford: Berg, 2007), 4.

[32]William Deresiewicz, "The Death of the Artist—and the Birth of the Creative Entrepreneur," *Atlantic*, www.theatlantic.com/magazine/archive/2015/01/the-death-of-the-artist-and-the-birth-of-the-creative-entrepreneur/383497/.

To illustrate the nature of this breathtaking transition, consider Claude Monet's serial depictions of the Rouen Cathedral (1891–1895) (fig. 8.2). As art historian Carla Rachman suggests:

> There was a long tradition of depicting the Gothic churches of northern France in a manner that emphasized their spiritual role, but Monet . . . was uninterested in entering the building. . . . The close-up viewpoint of most of the paintings treats the cathedral simply as an enthralling surface, faceted stone rising before our eyes like a man-made cliff eroded by the years.[33]

In other words, the theological or sacramental significance of this Parisian cathedral was *not* Monet's concern. Rather, fascinated by the quality of light as it played on the surface of the ornate structure, Monet appropriated the grand edifice to his aesthetic purposes. In the end, the thirty paintings in Monet's *Cathedral* series—over which he labored for several years—are most admired for their evocative, shimmering color, the plastic qualities of his paint.

For many centuries Europe's grand churches and cathedrals had been places of

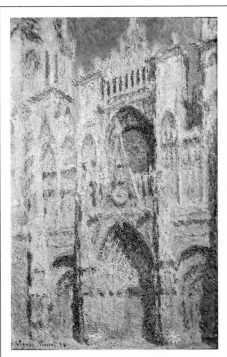

**8.2.** Claude Monet, *Rouen Cathedral*, 1894

rich spectacle and, more practically, centers of religious, social and economic power. As the modernist aesthetic gained influence, this extended season would end abruptly and, with it, the vitality of Christian art. Compelling exceptions—the paintings of Vincent van Gogh, the prints and paintings of Georges Rouault, the biblical art of Marc Chagall, to name a few—would continue. But on entering the twentieth century, the art world would mostly regard Christian

---

[33]Carla Rachman, *Monet* (London: Phaidon, 1997), 263.

art as anathema, declaring it to be (as it often was in popular forms and expressions) riddled with kitsch and compromised by sentimentality.

Though seldom compared or contrasted, concurrent with these mostly European developments in the art world, eighteenth-century American evangelicals were witnessing widespread revivals or "awakenings" stirred up by the "the spell-binding preacher George Whitefield, the indefatigable evangelist John Wesley, and the brilliant theologian Jonathan Edwards."[34] Late in the nineteenth century, popular evangelists such as Charles Finney, Dwight L. Moody, Billy Sunday and Rueben A. Torrey would gain impressive popularity, and their ministries were aided by theologians such as Augustus Strong, Charles Hodge and B. B. Warfield. These men, alongside a host of others, would shape the public character and evangelistic mission of conservative Protestantism for the rest of the century.

But the crisis of modernism had already begun in Europe, where, as noted, the artist's vocation was being dramatically reconfigured. From the mid-eighteenth century onward, the grand narrative of Christendom would be cast on the ash heap of history, and modern art tasked to find meaning and purpose apart from traditional religious belief. The restless spirit of modernism and its desire to usher in new political regimes, overturn social conventions and inaugurate utopian dreams had fully surfaced. It was, in a sense, a mad rush away from the past—from histories believed to curtail expressive freedom and toward a future yet to be invented.

Where art and faith are concerned, these historical developments lead naturally, I think, to six intriguing questions. First among them is this: What, after all, is the artist's work or calling? It seems unlikely that this substantially modern question much occupied the mind of premodern makers. But as the obligations of utility, religion and realism were sloughed off, the artist's task or calling was redirected to one of two primary functions: either *stimulating* personal expressive freedom, including at times the obligation to speak truth to power, or *simulating* transcendent encounters, supplying a suitable replacement for the efficacy of religious devotion and ritual. Consider the words of British painter Ben Nicholson (1894–1982): "Painting and religious experience are the same thing, and what we are all searching for is

---

[34]Mark A. Noll, *American Evangelical Christianity: An Introduction* (Oxford: Blackwell, 2001), 10.

the understanding and realization of infinity—an idea which is complete, with no beginning, no end, and therefore giving to all things for all times."[35]

Aided by the startling rise of consumer culture during the postwar period, art and design were allied to a third cause: the highly profitable yet contested prospect of gathering the spectacular tools needed to gain market share. In the aftermath of the Great Depression and the sacrifices of World War II, the behemoth of consumer culture swelled to meet material desires stimulated by rising affluence and increasingly liberal mores. The long season of destitution had passed.

Returning then to the prospect of the artist's calling, consider Frank Stella's (b. 1936) compelling reflection on the nature of painting, which he published in 1986:

> The ephemeral quality of painting reminds us that what is not there, what we cannot quite find, is what great paintings always promise. It does not surprise us, then, that at every moment when an artist has his eyes open, he worries that there is something present that he cannot quite see, something that is eluding him, something within his always limited field of vision, something in the dark spot that makes up his view of the back of his head. He keeps looking for this elusive something, out of habit as much as out of frustration. He searches even though he is quite certain that what he is looking for shadows him every moment he looks around. He hopes for what he cannot know, what he will never see, but the conviction remains that the shadow that follows but cannot be seen is simply the dull presence of his own mortality, the impending erasure of memory. Painters instinctively look to the mirror for reassurance, hoping to shake death, hoping to avoid the stare of persistent time, but the results are always disappointing. Still they keep checking.[36]

For Stella, there is a linkage between the "ephemeral quality of painting" and the "dull presence of our mortality." That is, the fugitive nature of the artist's work mirrors life's transience, "the impending erasure of memory." In one sense, negotiating this nature rests at the very heart of the artist's calling.

As well as any, Stella's own art showcased the pursuit of three primary, dynamically interconnected activities: the innovative manipulation of materials,

---

[35]Ben Nicholson quoted in Jeremy Lewison, *Ben Nicholson: The Years of Experiment 1919–39* (Cambridge: Kettle's Yard Gallery, 1983), 33.

[36]Frank Stella, *Working Space* (Cambridge, MA: Harvard University Press, 1986), 9.

the refinement of the artist's marks and the subsequent generation of meaning (see fig. 8.3). From Monet's impressionist daubs to Pollock's pours and drips to the patina on an Anselm Kiefer sculpture or the craftsmanship of a Martin Puryear installation, the natural sequence from *material making* to *making meaning* is a common modernist refrain. Borrowing on existentialist language,

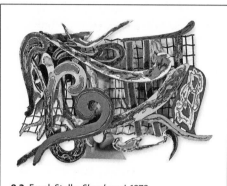

**8.3.** Frank Stella, *Shoubeegi*, 1978

these kinds of creative endeavors can be regarded as a kind of Tillichean quest to discover an "ultimate concern."[37]

At this point, some comment about the artist's persona seems fitting. Just as there is no acceptable way to describe the persona of all persons who are religiously inclined, neither is there one adequate means to characterize the artist's nature. Nonetheless, in the broad sweep of history, artists have borne a variety of guises—the bohemian, the scoundrel, the dandy, the trickster, the genius, the prophet, the narcissist, the hero and the shaman. Belittled by the ancient Greek philosopher Plato, but lauded by wealthy Italian patrons such as the Medici during the Renaissance, the artist, then, is heir to a checkered past. But no matter how one regards the standing of any particular artist, the modern reputation of artists is that they are the ones who rise up as a strident voice in the crowd, perform an unexpected gesture, pursue beauty, or hold out for greater wisdom and good that can only be realized by choosing the narrow way (Jesus) or heading down a road less traveled (Frost).

For believing persons, a second question follows: Does this description of the artist's calling hold up as a Christian calling? I believe that it does. After all, Stella's manner of thinking is aptly allied with biblical texts such as Job, Ecclesiastes and many of the psalms. I am not here attempting to describe Stella's "religion," since I know nothing of his personal convictions in this regard. My point is otherwise: from the brute and profane to the elegant and sublime,

---

[37]Paul Tillich, *Dynamics of Faith* (New York: Harper & Row, 1958), 1-4.

serious art either showcases or upholds our humanity.[38] Whether one is caught up in the cosmic breadth of the biblical story or some other compelling narrative, the ephemeral nature of our lives is central to their telling. And here we return full circle to Stella's insistence about the nature of painting. In pursuit of art or religion or both, we begin, as we must, by recognizing our finitude. In her recalibration of the world, the artist restores human proportion to the vast physical, intellectual and social space that each of us inhabits.

This leads to a third question, one frequently asked by art's detractors: Is art necessary? The ready answer to their query is this: art is only necessary if our being human is necessary. We have already established that art confirms our humanity, but here we go further to insist that art's existence is predicated on this humanity. And theologically speaking, we declare something more: art is manifest in the world because we are the *imago Dei*. It cannot be otherwise.

For Christian believers, then, a fourth question arises: Is it possible to make meaningful art in a post-Christian world? If a Christian worldview is now out of fashion, if this ancient intellectual framework has been displaced by secular ideologies, if God no longer establishes or animates reality, it can be argued that the table of the artist's task has been entirely reset. But here caution is invited. Although this perspective is widely lauded, it is but one perspective. Alternatively, consider Madeleine L'Engle's conviction concerning the interplay of art and faith: "To try to talk about art and about Christianity is for me one and the same thing, and it means attempting to share the meaning of my life, what gives it, for me, its tragedy and its glory."[39] L'Engle believed that art and Christianity lead to the same place: both aid us in our struggle to make sense of the "tragedy and glory" of life. In fact, we know more than we are able to express, and it is from this deep well of experience and being that the fullness of life emerges. To that end, the visual arts are a present help since aesthetic ideas are so often mediated to us as material forms. For artists of faith, then, the personal and interior aspects of knowing—everything from the sensate to the theological—can be negotiated, at least in part, in material terrain. For, like the gospel, art is incarnate.

---

[38]See the broad themes of Makoto Fujimura, *Refractions: A Journey of Faith, Art, and Culture* (Colorado Springs: NavPress, 2009), which were written in part as a response to the tragedies of 9/11.

[39]Madeleine L'Engle, *Walking on Water: Reflections on Faith and Art* (Wheaton, IL: Harold Shaw, 1972), 16.

Our fifth question and one of substantial interest to many is this: How shall we realize artistic success? My answer here is direct and oriented more toward performance than results. For Christians, it seems, the artist's true calling begins at the place where the desire for fame recedes and then slips entirely away. Rare is the contemporary artist who will earn his keep by selling art. Fewer still will exhibit in prestigious galleries or museums. For most, being an artist in America holds no promise of financial return or cultural prestige. Admittedly, this is not a promising report.

Still, and following on the topic of success, one observation seems to hold: the artists whom most of us deem to be successful share a common trait—they do the work. At some point they set romantic ideas about *being* an artist to the side and commenced *doing* the artist's work. Arriving at this place requires one to accept delayed gratification, the awkwardness that is sure to come from making bad art and the reality of negative cash flow. Pushing beyond distraction and discouragement, they accomplished something Herculean—they pushed beyond musing and imagining to establish regular studio practices, to take on habits of making. In the words of Karen Swallow Prior, these artists "clarified their telos."[40] Writes Madeleine L'Engle, "We must work every day, whether we feel like it or not, otherwise when it comes time to get out of the way and listen to the work, we will not be able to heed it.[41]

In the end, the contemporary artist is advised to shed vain imaginings about her "specialness" or "superiority" and direct her hands, heart and mind to the particular tasks she has been given or called to accomplish. Religious or not, the artist does so by faith, since she can have no confidence that what she has imagined and given herself to will take form.

Our sixth and final question is this: Having acknowledged that today's world is broadly post-Christian, should Christians abandon their time-honored beliefs? Not at all! Biblical precedent confirms that the relative standing of Christianity when compared to other religions and ideologies—its rank in the polls, so to speak—has no particular bearing on the truthfulness of the Bible nor the compelling nature of the gospel. In fact, ancient Israel was a persecuted minority that struggled to survive amid powerful pagan tribes

---

[40]Karen Swallow Prior, speaking at the conference "The Digitization of the Christian Imagination," Biola University, March 7, 2015.
[41]L'Engle, *Walking on Water*, 24.

and empires. Similarly, the early church emerged beneath the cruel hand of Roman rule and was surrounded by a multiplicity of philosophies and sects and a competing pantheon of gods and goddesses. Where truth and revelation are concerned, popular opinion can have no standing. The reigning empire of Christendom might be a fixture of the past, but for those who believe, the Christ-life remains as vital, potent and compelling as ever. The reason for our hope is fixed and constant.

### THE HOPE OF THE NEW

The God of the Bible is revealed to us as a covenant maker and covenant keeper, and orthodox Christian belief rests on the bedrock of God's faithfulness. This is the central message of the beloved hymn "Great Is Thy Faithfulness," penned by Thomas Chisholm in 1923:

> Great is Thy faithfulness, O God my Father,
> There is no shadow of turning with Thee;
> Thou changest not, Thy compassions they fail not;
> As Thou hast been, Thou forever wilt be.

A hallmark of evangelical Protestantism has been and continues to be its conviction that all true knowledge is rooted in the immutability of God's character, that his character is revealed in the Bible and that it is foundational to all faith and practice. These convictions form the basis of the creeds it confesses, its confidence in the efficacy of Christ's atonement for sin and its reason to hope for a heaven beyond this world. Throughout the twentieth century these biblical and theological convictions encountered unending and often vicious challenges, especially from cultural and intellectual elites. Understandably, the impulse of theological conservatives was to guard the gospel, keep the faith, hold their ground.

During these same decades, a radically different disposition was taking root in the secular world: modern art, philosophy and even theology set myth and superstition to the side to embrace what philosopher Charles Taylor terms a "disenchanted world." At the center of this new ideology was an increasingly independent and liberal self. Robert Hughes's description of modernism as the "shock of the new" is, therefore, an almost ideal summation of this movement, and to a substantial degree it continues to inform the unfolding

aesthetic of contemporary art. From the advent of modernism onward, the pursuit of the new—achieving something that has "not been done"—would indelibly mark the art world aesthetic. It was believed that innovation, invention and experimentation would eradicate the cliché, overcome sentimentality and deliver authenticity.

Here again, the oppositional dispositions present throughout this book surface. On one hand, we observe conservative Christians vouchsafing the past and cherishing the "old, old story." On the other, we note modernism's strident entrance into contemporary culture as an emancipating force. It might seem that if one community sought to obey God, then the other cast its lot with rebellion and revolution. It is remarkable, is it not, to observe the degree to which the impulse to conserve and its resistance to change so easily sponsors the kind of reactionary posture exhibited by the religious right. Alternatively, it seems that invention, which begs for rule breaking and the testing of limits, becomes fertile ground for the radical ways of the left. In noting these trends, my purpose is decidedly apolitical. I want to point out the degree to which the penchant either to conserve or to invent conforms so easily to the mental models we adopt. Spelled out, this simple binary appears as follows: Christianity is conservative and reactionary | Modern art is liberal and revolutionary. Let's explore the assets and deficits of each position a bit further.

The impulse to conserve is well justified. Most persons, religious or not, are inclined to preserve that which is good, true or beautiful. A conserving spirit (think of our museums and family archives) grounds us to reality and enables us to remain faithful to our story. In view of this, Christians in every age have been called to defend their faith, granting no quarter to heresy or false teaching. But in their pursuit of faithfulness, these same Christians have often succumbed to fear or entertained pride. That is, their foundational commitment to truth too often sponsored a spirit of moral and spiritual superiority and its overflow, judgment and haughtiness.

Our perennial fear of change—which seems to intensify over time—underestimates the dynamic nature of God's creative and redemptive work. And so it follows that stasis, the negative stance of the positive desire to conserve, can resist divine change and frustrate the work of the Holy Spirit. Here the continual temptation for evangelicals is to go directly to glory without

living for a season in this world. Marilynne Robinson cautions against this: "The great narrative, to which we as Christians are called to be faithful, begins at the beginning of things and ends at the end of things, and within the arc of it civilizations blossom and flourish, wither and perish."[42] In fact, change is normative and necessary, though not all change is good. For instance, when the systems in our body cease to function, death is near. Similarly, when spiritual life grows stagnant, when creative thought ceases and when institutional endeavors become gridlocked, the vitality of each is at risk. The cessation of change means certain death.

This understanding of change has direct bearing on the artist's calling. Critic Vicki Goldberg puts it like this: "Artists are engines of invention." Innovation is marrow in the creative bone, and at its best this kind of imaging enables us to meet the future. But the pursuit of innovation as an end— fomenting change simply to witness the thrill of disruption—can be foolhardy and even sinister. Novelty for novelty's sake runs the risk of being little more than an adolescent effort to relieve boredom or redress dystopia. Consequently, the penchant that some have to reflexively privilege "the new" raises important moral and spiritual questions, especially when, in the aftermath of this perennial change and the spectacle that accompanies it, we are not left enlightened, but rather numb or dumb.

Christians dedicated to the visual arts must recognize the need both to conserve and to innovate. And here we are well served by an insight from Dorothy L. Sayers: "The artist does not recognise that the phrases of the creeds purport to be observations of fact about the creative mind as such, including his own; while the theologian, limiting the application of the phrases to the divine Maker, neglects to inquire of the artist what light he can throw upon them from his own immediate apprehension of truth."[43] Ideally the "creeds" and the "creative mind" will coexist in splendid, life-affirming synergy.

For faithful artists, these impulses are best married, conjoined. This is because hope, Christian hope, is dynamic, not static. The Spirit of Christ has been loosed on the world and never tires from the work of transformation. The movement and labor of God's Spirit is fixed on healing, reformation, repair and

[42]Marilynne Robinson, *When I Was a Child I Read Books* (New York: Farrar, Straus and Giroux, 2012), 140.
[43]Dorothy L. Sayers, *The Mind of the Maker*, 30.

resurrection—infusing light into our dark souls, imparting theocentric order to the farthest reaches of the universe. In the Christian frame, then, it is not merely the new that we seek but rather the redemption of all things, including women and men, body and soul. We long for nothing less than a final reversal of our misfortune, fear and every cause of anxious being. Marilynne Robinson writes, "The meteoric passage of humankind through cosmic history has left a brilliant trail. Call it history, call it culture. We came from somewhere and we are tending somewhere, and the spectacle is glorious and portentous."[44] This new day comes to us as a fresh, dew-laden morning, and it is the radical nature of the gospel of Jesus Christ that prepares us to receive it.

If the Christian story is true, then there will be signs both hidden and seen scattered all about. In fact, the plans for a "new heaven" and a "new earth" have already been laid (Rev 21:1). A day is coming when the refiner's fire will sep-arate dross from pure gold. Sheep will be sorted from goats. The nations will be judged, but they will also be healed. The secrets formerly seen through the screens of sign, symbol and code will become hyperreal. At last, all that has been *unseen* will be *seen*. This is why the whole of creation and we ourselves groan as we await the redemption of all things at the end of chronological time (Rom 8:19-23). This longing anticipates that great day when all things will be made new. For God declares, "I am making all things new" (Rev 21:5).

I suppose that most who have read this book will be persons on a journey with God and toward God. Many might be artists. To make progress on our way—to see clearly—the substantial underbrush in this thicket we call life must be cleared away. Gaining clarity of vision, seeing rightly, is the first task of every true vocation and the particular task of every artist. The prospect of facing the future might alternately fill us with deep dread or eager anticipation, and no measure of planning or divining can equip us to face tomorrow's demand. Indeed, the heart of Christian religion is a decision to live by faith, to place oneself under the care of the only One who knows what the future holds.

---

[44]Robinson, *When I Was a Child I Read Books*, 201-2.

# Bibliography

Ackerman, Diane. *A Natural History of the Senses*. New York: Vintage, 1990.

Adamson, Glenn. *Thinking Through Craft*. Oxford: Berg, 2007.

Adler, Mortimer J. *The Great Ideas: A Synopticon of Great Books of the Western World*. Chicago: Encyclopaedia Britannica, 1952.

Alexander, Christopher. *A Pattern Language*. New York: Oxford University Press, 1977.

Appleyard, Bryan. "A Review of the Exhibition of Seeing Salvation: The Image of Christ at the London National Gallery." *Sunday Times of London*, February 13, 2000.

Aquinas, Thomas. *Summa Theologiae: A Concise Translation*. Edited by Timothy Mc-Dermott. Notre Dame, IN: Ave Maria Press, 1989.

Aristotle. *On the Heavens*. Translated by W. K. C. Guthrie. Cambridge, MA: Harvard University Press, 1960.

Augustine. *The Confessions*. Translated by Maria Boulding, O.S.B. New York: Vintage, 1998.

Balthasar, Hans Urs von. *The Glory of the Lord: A Theological Aesthetics*. Vol. 1, *Seeing the Form*. Translated by Erasmo Leiva-Merikakis. San Francisco: Ignatius Press, 1982.

Barron, Robert. *Heaven in Stone and Glass: Experiencing the Spirituality of Gothic Cathedrals*. New York: Crossroad, 2000.

Barthes, Roland. "The Death of the Author." In *Image—Music—Text*, 142-48. Edited and translated by S. Heath. New York: Hill and Wang, 1977.

Barzun, Jacques. *The Use and Abuses of Art*. The A. W. Mellon Lectures in the Fine Arts, Bollingen Series 35. Princeton, NJ: Princeton University Press, 1975.

Baudrillard, Jean. *Simulations*. Translated by Paul Foss, Paul Patton and Philip Beitchman. New York: Semiotext[e], 1983.

Bayley, Harold. *The Lost Language of Symbolism: An Inquiry into the Origins of Certain Letters, Names, Fairy-Tales, Folklore and Mythologies*. 2nd ed. London and Tonbridge: Ernest Bonn, 1968.

Beckley, Bill, and David Shapiro, eds. *Uncontrollable Beauty: Toward a New Aesthetics*. New York: Allworth, 1998.

Bell, Rob. *Love Wins: A Book About Heaven, Hell, and the Fate of Every Person Who Ever Lived*. New York: HarperOne, 2011.

Belting, Hans. *Likeness and Presence: A History of the Image Before the Era of Art.* Translated by Edmund Jephcott. Chicago: University of Chicago Press, 1994.

Benjamin, Walter. *Illuminations: Essays and Reflections.* New York: Schocken, 1969.

Berger, John. *A Painter of Our Time.* 1958. New York: Pantheon, 1989.

———. *Ways of Seeing.* London: Penguin, 1972.

Berry, Ian, ed. *Tim Rollins and K.O.S.: A History.* Boston: MIT Press, 2009.

Berry, Wendell. *It All Turns on Affection: The Jefferson Lecture and Other Essays.* Berkeley: Counterpoint, 2012.

Bishop, Janet, Cécile Debray and Rebecca Rabinow, eds. *The Steins Collect: Matisse, Picasso, and the Parisian Avant-Garde.* San Francisco: San Francisco Museum of Modern Art; New Haven, CT: Yale University Press, 2011.

Bloesch, Donald. *A Theology of Word and Spirit: Authority and Method in Theology.* Downers Grove, IL: InterVarsity Press, 1992.

Bloom, Allan. *The Closing of the American Mind: How Higher Education Has Failed Democracy and Impoverished the Souls of Today's Students.* New York: Simon & Schuster, 1987.

Boersma, Hans, ed. *Imagination and Interpretation: Christian Perspectives.* Vancouver: Regent College Publishing, 2005.

Boschloo, A. W. A. *Annibale Carracci in Bologna: Visible Reality in Art After the Council of Trent.* Translated by R. R. Symonds. Maarsen: Gary Schwartz, 1974.

Boucher, Bruce. "Mr. Humanismus." *New York Times Book Review,* December 3, 2000.

Bouwsma, William. *A Usable Past: Essays in European Cultural History.* Berkeley: University of California Press, 1990.

Brenson, Michael. *Visionaries and Outcasts: The NEA, Congress, and the Place of the Visual Artist in America.* New York: The New Press, 2001.

Brooks, David. "Without Gods." *New York Times Book Review,* March 18, 2012.

Brown, Harold O. J. *The Sensate Culture: Western Civilization Between Chaos and Transformation.* Dallas: Word, 1996.

Brown, Michelle P. *Understanding Illuminated Manuscripts: A Guide to Technical Terms.* Los Angeles: Getty Publications, 1994.

Brown, Raymond E. *The Gospel According to John: I–XII.* Anchor Bible, vol. 29. New York: Doubleday, 1966.

Browne, Sir Thomas. *The Oxford Dictionary of Quotations.* 2nd ed. Oxford: Oxford University Press, 1955.

Bruce, F. F. *The New Testament Documents: Are They Reliable?* Chicago: Inter-Varsity Press, 1960.

Bryson, Bill. *The Life and Times of the Thunderbolt Kid: A Memoir.* New York: Broadway, 2006.

Buechner, Frederick. *Telling the Truth: The Gospel as Tragedy, Comedy, and Fairy Tale.* San Francisco: Harper & Row, 1977.

Bull, Malcolm. *The Mirror of the Gods: How Renaissance Artists Rediscovered the Pagan God.* Oxford: Oxford University Press, 2005.

Burke, Marcus. "The Life of Faith and Contemporary Art." In *The Word as Art: Contemporary Renderings.* New York: American Bible Society, 2000.

Butcher, Carmen Acevedo. *A Life of St. Benedict: Man of Blessing.* Brewster, MA: Paraclete, 2006.

Cahill, Thomas. *Mysteries of the Middle Ages: The Rise of Feminism, Science, and Art from the Cults of Catholic Europe.* New York: Doubleday, 2006.

Calas, Elena, and Nicolas Calas. *Icons and Images of the Sixties.* New York: E. P. Dutton, 1971.

Calvin, John. *Institutes of the Christian Religion.* Translated by Henry Beveridge. Grand Rapids: Eerdmans, 1995.

Cantalamessa, Raniero. *Contemplating the Trinity: The Path to the Abundant Christian Life.* Translated by Marsha Daigle-Williamson. Ijamsville, MD: Word Among Us Press, 2007.

Capon, Robert Farrar. *The Supper of the Lamb: A Culinary Reflection.* New York: Modern Library, 2002.

Carey, John. *What Good Are the Arts?* New York: Oxford University Press, 2006.

Chemnitz, Martin. *Examination of the Council of Trent,* vol. 4. Translated by Fred Kramer. St. Louis: Concordia, 1986.

Chicago, Judy, and Edward Lucie-Smith. *Women and Art: Contested Territory.* New York: Watson-Guptill, 1999.

Chilvers, Ian. *A Dictionary of Twentieth-Century Art.* Oxford: Oxford University Press, 1999.

Church, Frederic C. *The Italian Reformers 1534–1564.* New York: Columbia University Press, 1932.

Clark, Kenneth. *The Nude: A Study in Ideal Form.* New York: MJF Books, 1956.

Clark, T. J. *The Painting of Modern Life: Paris in the Art of Manet and His Followers.* Princeton, NJ: Princeton University Press, 1984.

Clendenin, Daniel B. *Eastern Orthodox Theology: A Contemporary Reader.* 2nd ed. Grand Rapids: Baker Academic, 2003.

Comar, Philippe. *Images of the Body.* Translated by Dorie B. Baker and David J. Baker. New York: Abrams, 1999.

Cooper, James F. "Realism: The Path to Beauty." *American Arts Quarterly,* Spring 2002.

Cotter, Holland. "America's Portraitist." *New York Times Book Review,* July 1, 2012.

Crawford, Matthew B. *Shop Class as Soulcraft: An Inquiry into the Value of Work.* New York: Penguin, 2009.

Crouch, Andy. *Culture Making: Recovering Our Creative Calling.* Downers Grove, IL: InterVarsity Press, 2008.

Dachy, Marc. *Dada: The Revolt of Art.* Translated by Liz Nash. New York: Abrams, 2006.

Danto, Arthur C. *The Body/Body Problem: Selected Essays.* Berkeley: University of California Press, 2001.

———. *Embodied Meanings: Critical Essays and Aesthetic Meditations.* New York: Farrar, Straus and Giroux, 1994.

———. *What Art Is.* New Haven, CT: Yale University Press, 2013.

De Borchgrave, Helen. *A Journey into Christian Art.* Minneapolis: Fortress, 2000.

De Botton, Alain. *Religion for Atheists: A Non-Believer's Guide to the Uses of Religion.* New York: Pantheon, 2012.

De Hamel, Christopher. *A History of Illuminated Manuscripts.* London: Phaidon, 2005.

Deitcher, David. "Tim Rollins Talks to David Deitcher." *Artforum,* April 2003.

Delattre, Roland A. *Beauty and Sensibility in the Thought of Jonathan Edwards: An Essay in Aesthetics and Theological Ethics.* New Haven, CT: Yale University Press, 1968.

Deresiewicz, William. "The Death of the Artist—and the Birth of the Creative Entrepreneur." *Atlantic,* January/February 2015. www.theatlantic.com/magazine/archive/2015/01/the-death-of-the-artist-and-the-birth-of-the-creative-entrepreneur/383497/.

Derrida, Jacques. *Positions.* 1972. 2nd ed. Translated and annotated by Alan Bass. London: Continuum, 2002.

Diepeveen, Leonard, and Timothy Van Laar. *Art with a Difference: Looking at Difficult and Unfamiliar Art.* New York: McGraw-Hill, 2001.

———. *Artworld Prestige: Arguing Cultural Value.* New York: Oxford University Press, 2013.

Diggins, John Patrick. *The Promise of Pragmatism: Modernism and the Crisis of Knowledge and Authority.* Chicago: University of Chicago Press, 1994.

Dillard, Annie. *Pilgrim at Tinker Creek.* New York: Harper & Row, 1974.

Dillenberger, Jane Daggett. *The Religious Art of Andy Warhol.* New York: Continuum, 1998.

Donoghue, Denis. *Speaking of Beauty.* New Haven, CT: Yale University Press, 2003.

Douglas, J. D., ed. *The Illustrated Bible Dictionary: Part I.* Leicester, UK: Inter-Varsity Press, 1998.

Downing, Crystal L. *How Postmodernism Serves My Faith: Questioning Truth in Language, Philosophy and Art.* Downers Grove, IL: InterVarsity Press, 2006.

Du Bois, W. E. B. *W. E. B. Du Bois: Writings.* Edited by Nathan Huggins. The Library of America. New York: Viking, 1986.

Duncan, Carol. *Civilizing Rituals: Inside Public Art Museums*. London: Routledge, 1995.

Dyrness, William A. *Reformed Theology and Visual Culture: The Protestant Imagination from Calvin to Edwards*. Cambridge: Cambridge University Press, 2004.

———. *Visual Faith: Art, Theology, and Worship in Dialogue*. Grand Rapids: Baker Academic, 2001.

Eckhart, Christian, and Harry Philbrick. *Faith: The Impact of Judeo-Christian Religion on Art at the Millennium*. Ridgefield, CT: Aldrich Museum of Contemporary Art, 2000.

Eco, Umberto. *Serendipities: Language and Lunacy*. Translated by William Weaver. Italian Academic Lectures. New York: Columbia University Press, 1998.

Eire, Carlos M. N. *War Against the Idols: The Reformation of Worship from Erasmus to Calvin*. Cambridge: Cambridge University Press, 1998.

Elkins, James. *On the Strange Place of Religion in Contemporary Art*. New York: Routledge, 2004.

———. *Pictures of the Body: Pain and Metamorphosis*. Stanford, CA: Stanford University Press, 1999.

Elliot, Elisabeth. *Shadow of the Almighty: The Life Adventure, Witness, Testament and Glory of Jim Elliot, One of the Five Martyrs of Ecuador*. London: Hodder & Stoughton, 1958.

Endo, Shusaku. *Silence*. 1967. Translated by William Johnston. London: Peter Owen, 1976.

Engberg, Siri, Linda Nochlin and Marina Warner. *Kiki Smith: A Gathering, 1980–2005*. Minneapolis: Walker Art Museum, 2005.

Erickson, Millard J. *Truth or Consequences: The Promise and Perils of Postmodernism*. Downers Grove, IL: InterVarsity Press, 2001.

Ewen, Stuart. *All Consuming Images: The Politics of Style in Consumer Culture*. New York: Basic Books, 1988.

Fehrer, Michal, with Romona Naddaff and Nadia Tazi, eds. *Fragments for a History of the Human Body, Part 1*. Zone 3. New York: Zone, 1989.

———, eds. *Fragments for a History of the Human Body, Part 2*. Zone 4. New York: Zone, 1989.

———, eds. *Fragments for a History of the Human Body, Part 3*. Zone 5. New York: Zone, 1989.

Finkel, Jori. "Oh, What a Futurist War." *New York Times*, August 27, 2006.

Fiore, Quentin, and Marshall McLuhan. *The Medium Is the Massage: An Inventory of Effects*. New York: Bantam, 1967.

Ford, David F. *Self and Salvation: Being Transformed*. Cambridge: Cambridge University Press, 1999.

Foster, Richard J. *Celebration of Discipline: The Path to Spiritual Growth.* San Francisco: Harper & Row, 1978.

Foucault, Michel. *This Is Not a Pipe.* Translated and edited by James Harkness. Berkeley: University of California Press, 1982.

Franz, Eric. *In Quest of the Absolute.* New York: Peter Blum Editions, 1996.

Frazier, Nancy. *The Penguin Concise Dictionary of Art History.* New York: Penguin, 2000.

Freedberg, David. *The Power of Images: Studies in the History and Theory of Response.* Chicago: University of Chicago Press, 1989.

Freeland, Cynthia. *But Is It Art? An Introduction to Art Theory.* Oxford: Oxford University Press, 2001.

Frye, Northrop. *Words with Power: Being a Second Study of "The Bible and Literature."* San Diego: Harcourt, Brace, Jovanovich, 1990.

Fujimura, Makoto. *Refractions: A Journey of Faith, Art, and Culture.* Colorado Springs: NavPress, 2009.

———. *Silence and Beauty: Hidden Faith Born of Suffering.* Downers Grove, IL: InterVarsity Press, 2016.

Gadamer, Hans-Georg. *The Relevance of the Beautiful and Other Essays.* Edited by Robert Bernasconi. Cambridge: Cambridge University Press, 1987.

Gaehtgens, Thomas W., and Heinz Ickstadt, eds. *American Icons: Transatlantic Perspectives on Eighteenth- and Nineteenth-Century American Art.* Santa Monica, CA: Getty Center, 1992.

Gay, Peter. *The Bourgeois Experience: Victoria to Freud.* Vol. 5, *Pleasure Wars.* New York: W. W. Norton, 1998.

Gayford, Martin. *Man with a Blue Scarf: On Sitting for a Portrait by Lucian Freud.* New York: Thames & Hudson, 2010.

*Gilded Legacies: The Saint John's Bible in Context.* MOBIA Gallery Program. September 7–November 26, 2006.

Golding, John. *Paths to the Absolute: Mondrian, Malevich, Kandinsky, Pollock, Newman, Rothko, and Still.* A. W. Mellon Lectures in the Fine Arts, 1997. Princeton, NJ: Princeton University Press, 2000.

Greenberg, Clement. *The Collected Essays and Criticism.* Vol. 1, *Perceptions and Judgments.* Edited by John O'Brian. Chicago: University of Chicago Press, 1986.

Harries, Richard. *Art and the Beauty of God: A Christian Understanding.* London: Continuum, 1993.

Hart, David Bentley. *The Beauty of the Infinite: The Aesthetics of Christian Truth.* Grand Rapids: Eerdmans, 2003.

Hauser, Arnold. *The Social History of Art.* Vol. 2, *Renaissance, Mannerism, Baroque.* New York: Vintage, 1957.

Henry, Carl F. H. *God, Revelation and Authority.* 6 vols. 2nd ed. Wheaton, IL: Crossway, 1999. First published 1976–1983 by Word Books.

Hijuelos, Oscar. *Mr. Ives' Christmas.* New York: HarperCollins, 1995.

Hobbs, Stuart D. *The End of the American Avant-garde.* New York: New York University Press, 1997.

Hoesterev, Ingeborg, ed. *Zeitgeist in Babel: The Post-Modernist Controversy.* Bloomington: Indiana University Press, 1991.

Homer. *The Odyssey.* Translated by Robert Fagles. Introduction and notes by Bernard Knox. London: Penguin, 1996.

Hughes, Robert. *American Visions: The Epic History of Art in America.* New York: Knopf, 1977.

——. *Culture of Complaint: The Fraying of America.* New York: Oxford University Press, 1993.

——. *Rome: A Cultural, Visual, and Personal History.* New York: Knopf, 2011.

——. *The Shock of the New.* New York: Knopf, 1981.

Hunter, James Davison. *Culture Wars: The Struggle to Define America.* New York: Basic Books, 1991.

——. *To Change the World: The Irony, Tragedy, and Possibility of Christianity in the Late Modern World.* New York: Oxford University Press, 2010.

Janik, Allan, and Stephen Toulmin. *Wittgenstein's Vienna.* New York: Touchstone, 1973.

Jeffrey, David Lyle. *People of the Book: Christian Identity and Literary Culture.* Grand Rapids: Eerdmans, 1996.

Jenson, Robert. *America's Theologian: A Recommendation of Jonathan Edwards.* Oxford: Oxford University Press, 1992.

John of Damascus. *On Divine Images: Three Apologies Against Those Who Attack the Divine Images.* Translated by David Anderson. Crestwood, NY: St. Vladimir's Seminary Press, 2000.

John Paul II. *Duodecimum Saeculum* (Veneration of Holy Images), to the Episcopate of the Catholic Church on the occasion of the 1200th Anniversary of the Second Council of Nicaea. December 4, 1987.

Johnson, Paul. *The Renaissance: A Short History.* New York: Modern Library, 2000.

Jones, Richard. "The Last Book on the Shelf." *Image* 55 (Fall 2007): 92-94.

Julius, Anthony. *Transgressions: The Offences of Art.* Chicago: University of Chicago Press, 2002.

Kandinsky, Wassily. *The Art of Spiritual Harmony.* Translated by M. T. H. Sadler. New York: Dover, 1977. First published 1911 as *Über das Geistige in der Kunst.*

Kant, Immanuel. *The Critique of Judgment*. Translated by J. H. Bernard. Amherst, NY: Prometheus Books, 1969.

———. *Observations on the Feeling of the Beautiful and Sublime*. Translated by John T. Goldthwait. Berkeley: University of California Press, 2003.

Karmel, Pepe, ed. *Jackson Pollock: Interviews, Articles, and Reviews*. New York: Museum of Modern Art / Abrams, 1998.

Kass, Leon. *The Hungry Soul: Eating and the Perfecting of Our Nature*. Chicago: University of Chicago Press, 1999.

Kenan, Randall. "The Weirdness of Modern Faith; or, Quantum Christianity in the Images of Melissa Weinman." *Image* 30, 32-37.

Kentridge, William, and Rosalind C. Morris. *That Which Is Not Drawn: Conversations*. Calcutta: Seagull, 2014.

Kerouac, Jack. *On the Road*. New York: Viking, 1957.

Kimmelman, Michael. *The Accidental Masterpiece: On the Art of Life and Vice Versa*. New York: Penguin, 2006.

———. "The Intuitionist." *New York Times Magazine*, November 5, 2006.

King, Ross. *Brunelleschi's Dome: How a Renaissance Genius Reinvented Architecture*. New York: Wallace and Company, 2001.

Koerner, Joseph Leo. *The Reformation of the Image*. Chicago: University of Chicago Press, 2004.

Koren, Leonard. *Which "Aesthetics" Do You Mean? Ten Definitions*. Point Reyes, CA: Imperfect Publishing, 2010.

Krasner, Lee. Interview by Dorothy Strickler, November 2, 1964, for the Smithsonian Institution Archives of American Art. www.aaa.si.edu/collections/interviews/oral-history-interview-lee-krasner-12507.

Krauss, Rosalind E. *The Originality of the Avant-Garde and Other Modernist Myths*. Cambridge, MA: MIT Press, 1985.

Kresser, Katie. "Art and Theology—a Review Essay." *Christian Scholars Review* 43, no. 1 (Fall 2013).

Kushner, Marilyn Satin, and Kimberly Orcutt, eds. *The Armory Show at 100: Modernism and Revolution*. New York: New York Historical Society, 2013.

Kuspit, Donald B. "Conflicting Logics: Twentieth-Century Studies at the Crossroads." *Art Bulletin* 69, no. 1 (March 1987).

Laeuchli, Samuel. *Religion and Art in Conflict*. Philadelphia: Fortress, 1980.

Lane, John. *Timeless Beauty in the Arts and Everyday Life*. Foxhole, UK: Green Books, 2003.

Lasch, Christopher. *The Culture of Narcissism: American Life in an Age of Diminishing Expectations*. New York: W. W. Norton, 1991.

Latour, Bruno, and Peter Weibel, eds. *Iconoclash: Beyond the Image Wars in Science, Religion, and Art.* Cambridge, MA: MIT Press, 2002.

Lee, Philip J. *Against the Protestant Gnostics.* New York: Oxford University Press, 1987.

L'Engle, Madeleine. *Walking on Water: Reflections on Faith and Art.* Wheaton, IL: Harold Shaw, 1972.

Lewis, C. S. *The Weight of Glory and Other Addresses.* New York: HarperCollins, 2001.

Lewison, Jeremy. *Ben Nicholson: The Years of Experiment 1919–39.* Cambridge: Kettle's Yard Gallery, 1983.

Lichtenstein, Therese. *Behind Closed Doors: The Art of Hans Bellmer.* Berkeley: University of California Press, 2001.

Lilla, Mark. *The Stillborn God: Religion, Politics, and the Modern West.* New York: Knopf, 2007.

Lin, Maya. *Maya Lin Boundaries.* New York: Simon & Schuster, 2000.

Lindsell, Harold. *The Battle for the Bible.* Grand Rapids: Zondervan, 1976.

Lipsey, Roger. *An Art of Our Own: The Spiritual in Twentieth-Century Art.* Boston: Shambhala, 1989.

Lottman, Herbert R. *The Left Bank: Writers, Artists, and Politics from the Popular Front to the Cold War.* Chicago: University of Chicago Press, 1998.

Louth, Andrew, ed. *Genesis 1–11.* Ancient Christian Commentary on Scripture. Downers Grove, IL: InterVarsity Press, 2001.

Loyola, Ignatius. *The Spiritual Exercises of St. Ignatius.* Translated by Louis J. Puhl, SJ. Chicago: Loyola University Press, 1951.

Lundin, Roger. *Believing Again: Doubt and Faith in a Secular Age.* Grand Rapids: Eerdmans, 2009.

Manguel, Alberto. *A History of Reading.* New York: Viking, 2006.

Maritain, Jacques. *Art and Scholasticism with Other Essays.* New York: Charles Scribner's Sons, 1942.

Marsden, George. *Fundamentalism and American Culture: The Shaping of Twentieth-Century Evangelicalism, 1870–1925.* New York: Oxford University Press, 1982.

———. *The Soul of the American University: From Protestant Establishment to Established Non-Belief.* New York: Oxford University Press, 1994.

Mathewes-Green, Frederica. *The Open Door: Entering the Sanctuary of Icons and Prayer.* Brewster, MA: Paraclete Press, 2003.

McDowell, Josh. *Evidence That Demands a Verdict.* San Bernardino, CA: Here's Life, 1979.

Megill, Allan. *Prophets of Extremity: Nietzsche, Heidegger, Foucault, Derrida.* Berkeley: University of California Press, 1985.

Menil, Dominique de. *The Rothko Chapel: Writing on Art and the Threshold of the Divine*. New Haven, CT: Rothko Chapel / Yale University Press, 2010.

Merton, Thomas. *Thoughts in Solitude*. Canada: HarperCollins, 1956.

Miles, Margaret R. *Carnal Knowing: Female Nakedness and Religious Meaning in the Christian West*. Boston: Beacon, 1989.

Millan, Gordon. *Mallarmé: A Throw of the Dice*. New York: Farrar, Straus and Giroux, 1994.

Milosz, Czeslaw. *The Captive Mind*. 1953. Vintage: New York, 1981.

Molesworth, Helen. *Leap Before You Look: Black Mountain College 1933–1957*. Boston: Institute of Contemporary Art; New Haven, CT: Yale University Press, 2015.

Morgan, David. *Icons of American Protestantism: The Art of Warner Sallman*. New Haven, CT: Yale University Press, 1996.

———. *Protestants and Pictures: Religion, Visual Culture, and the Age of American Mass Production*. New York: Oxford University Press, 1999.

Morgan, David, and Sally M. Promey. *Exhibiting the Visual Culture of America's Religions*. Valparaiso, IN: Brauer Museum of Art, 2000.

Muschamp, Herbert. "Captivated by a Happy, Scary New Day for Design." *New York Times*, October 15, 2000.

Nehemas, Alexander. *Only a Promise of Happiness: The Place of Beauty in a World of Art*. Princeton, NJ: Princeton University Press, 2007.

Neil, Alex, and Aaron Ridley. *Arguing About Art: Contemporary Philosophical Debates*. 2nd ed. London: Routledge, 2002.

Nelson, Robert S., and Richard Shiff, eds. *Critical Terms for Art History*. 2nd ed. Chicago: University of Chicago Press, 2003.

Newbigin, Leslie. *The Gospel in a Pluralist Society*. Grand Rapids: Eerdmans, 1989.

Niebuhr, Richard. *Christ and Culture*. 1951. New York: Harper and Brothers, 1956.

Nochlin, Linda. *The Body in Pieces: The Fragment as a Metaphor of Modernity*. New York: Thames & Hudson, 1994.

Noll, Mark A. *American Evangelical Christianity: An Introduction*. Oxford: Blackwell, 2001.

———. *Between Faith and Criticism: Evangelicals, Scholarship, and the Bible in America*. New York: Harper & Row, 1987.

———. *The Scandal of the Evangelical Mind*. Grand Rapids: Eerdmans, 1994.

Norwich, John Julius. *A Short History of Byzantium*. New York: Vintage, 1999.

Nouwen, Henri J. M. *The Road to Daybreak: A Spiritual Journey*. New York: Doubleday, 1990.

Nuland, Sherman B. *Leonardo da Vinci*. New York: Penguin, 2000.

O'Connor, Brian, ed. *The Adorno Reader*. Oxford: Blackwell, 2000.

O'Connor, Flannery. *Mystery and Manners: Occasional Prose*. Edited by Sally Fitzgerald and Robert Fitzgerald. New York: Noonday, 1997.

Ockenga, Harold John. "The Challenge to the Christian Culture of the West." *Fuller Theological Seminary: Theology, News & Notes*, Spring 2014.

Olin, Margaret. "Gaze." In *Critical Terms for Art History*, 318-29. 2nd ed. Edited by Robert S. Nelson and Richard Schiff. Chicago: University of Chicago Press, 2003.

Ong, Walter J. *Orality and Literacy: The Technology of the Word*. London: Methuen, 1982.

Ozment, Steven, ed. *Reformation Europe: A Guide for Research*. St. Louis: Center for Reformation Research, 1982.

Packer, J. I. *Fundamentalism and the Word of God: Some Evangelical Principles*. Grand Rapids: Eerdmans, 1958.

———. *Knowing God*. Downers Grove, IL: InterVarsity Press, 1993.

Paglia, Camille. *Sex, Art and American Culture: Essays*. New York: Vintage, 1992.

Pedulla, Albert. "Fulfilled in Your Seeing: The Life and Work of Tim Rollins and K.O.S." *Image* 45, 22-34.

Pelikan, Jaroslav. *Jesus Through the Centuries: His Place in the History of Culture*. New Haven, CT: Yale University Press, 1985.

———. *The Vindication of Tradition*. New Haven, CT: Yale University Press, 1984.

Perl, Jed. *New Art City: Manhattan at Mid-Century*. New York: Knopf, 2005.

Pinnock, Clark H. *Biblical Revelation: The Foundation of Christian Theology*. Chicago: Moody, 1971.

Piper, John. *Desiring God: Meditations of a Christian Hedonist*. Portland: Multnomah, 1986.

Plato. *Symposium and Phaedrus*. Translated by Tom Griffith. Introduction by R. B. Rutherford. New York: Knopf, 2000.

———. *Timaeus and Critias*. Translated with an introduction by Desmond Lee. London: Penguin, 1977.

Pohl, Frances K. *Framing America: A Social History of American Art*. New York: Thames & Hudson, 2002.

Polanyi, Michael. *Personal Knowledge: Towards a Post-Critical Philosophy*. Chicago: University of Chicago Press, 1962.

Postman, Neil. *Amusing Ourselves to Death: Public Discourse in the Age of Show Business*. New York: Viking Penguin, 1985.

———. *Technopoly: The Surrender of Culture to Technology*. New York: Vintage, 1993.

Potok, Chaim. *My Name Is Asher Lev*. New York: Knopf, 1972.

Powers, Matthew. "Picking Up the Pieces in Afghanistan." *Atlantic Monthly*, March 2005.

Prescott, Catherine. "Where Have All the Realists Gone: Recent Trends in Representational Painting." Presentations from the CIVA conference, 1999.

Pressfield, Steven. *The War of Art.* New York: Grand Central, 2002.

Putney, Clifford. *Muscular Christianity: Manhood and Sports in Protestant America, 1880–1920.* Cambridge, MA: Harvard University Press, 2001.

Rabinow, Paul, ed. *A Foucault Reader.* New York: Pantheon Books, 1984.

Rachman, Carla. *Monet.* London: Phaidon, 1997.

Richardson, John. *Sacred Monsters, Sacred Masters: Beaton, Capote, Dali, Picasso, Freud, Warhol, and More.* New York: Random House, 2001.

Rinder, Lawrence. *Whitney Biennial 2002: 2002 Biennial Exhibition.* New York: Whitney Museum, 2002.

Risotti, Howard. *Postmodern Perspectives: Issues in Contemporary Art.* Englewood Cliffs, NJ: Prentice Hall, 1990.

Robinson, Marilynne. *When I Was a Child I Read Books.* New York: Farrar, Straus and Giroux, 2012.

Romaine, James. *Objects of Grace: Conversations on Creativity and Faith.* Baltimore: Square Halo, 2002.

Roob, Alexander. *The Hermetic Museum: Alchemy and Mysticism.* Köln: Taschen, 2001.

Rookmaaker, H. R. *Art Needs No Justification.* Downers Grove, IL: InterVarsity Press, 1978.

———. *Modern Art and the Death of a Culture.* Downers Grove, IL: InterVarsity Press, 1970.

Rowland, Ingrid D., ed. *Vitruvius' Ten Books on Architecture.* With commentary and illustrations by Thomas Noble Howe. Cambridge: Cambridge University Press, 1999.

Ryken, Leland, James C. Wilhoit and Tremper Longman III, eds. *Dictionary of Biblical Imagery.* Downers Grove, IL: InterVarsity Press, 1998.

Safire, William. "I Like Icon." *New York Times Magazine,* February 4, 1990.

Sayers, Dorothy. *The Letters of Dorothy L. Sayers: 1937–1943, From Novelist to Playwright.* Edited by Barbara Reynolds. New York: St. Martin's, 1998.

———. *Mind of the Maker.* London: Methuen, 1941. Reprint, San Francisco: HarperCollins, 1987.

Scarry, Elaine. *On Beauty and Being Just.* Princeton, NJ: Princeton University Press, 1999.

Schaeffer, Francis. *Art and the Bible.* 1973. Downers Grove, IL: InterVarsity Press, 2006.

Schneidau, Herbert N. *Sacred Discontent: The Bible and Western Tradition.* Berkeley: University of California Press, 1977.

Schuessler, Jennifer. "A Religious Legacy, with Its Leftward Tilt, Is Reconsidered." *New York Times,* July 24, 2013.

Scudieri, Magnolia. *San Marco: Complete Guide to the Museum and Church.* Florence: Scala, 1995.

Selz, Peter, and Kristine Stiles, eds. *Theories and Documents of Contemporary Art: A Sourcebook of Artists' Writing.* Berkeley: University of California Press, 1996.

Senge, Peter, et al. *The Dance of Change: The Challenges to Sustaining Momentum in Learning Organizations.* New York: Doubleday, 1999.

Sennett, Richard. *The Craftsman.* New Haven, CT: Yale University Press, 2008.

Shaw, Luci. "The Simple Dark." *What the Light Was Like.* Seattle: WordFarm, 2006.

Shults, F. LeRon. *Reforming Theological Anthropology: After the Philosophical Turn to Relationality.* Grand Rapids: Eerdmans, 2003.

Siedell, Daniel A. "Art and the Practice of Evangelical Faith." *Christian Scholar's Review* 34, no. 1 (Fall 2004).

———. *Who's Afraid of Modern Art? Essays on Modern Art and Theology in Conversation.* Eugene, OR: Cascade, 2015.

Siegel, Jeanne. "Barbara Kruger: Pictures and Words." *Arts* 61, no. 10 (June 1987).

Singer, Michael. "Fat of the Land." *New York Times Magazine,* March 3, 2001.

Singerman, Howard. *Art Subjects: Making Artists in the American University.* Berkeley: University of California Press, 1999.

Smith, Roberta. "Glossy Portrait of the Artist as a Young Woman." *New York Times,* July 5, 2000.

Spackman, Betty. *A Profound Weakness: Christians and Kitsch.* Carlisle, UK: Piquant, 2005.

Spivey, Nigel. *Enduring Creation: Art, Pain, and Fortitude.* Berkeley: University of California Press, 2001.

Steffler, Alva William. *Symbols of the Christian Faith.* Grand Rapids: Eerdmans, 2002.

Steinberg, Leo. *Leonardo's Incessant Last Supper.* New York: Zone Books, 2001.

———. "The Sexuality of Christ in Renaissance Art and in Modern Oblivion," *October* 25 (Summer 1983).

Steiner, George. *Lessons of the Masters: The Charles Eliot Norton Lectures 2001–2002.* Cambridge, MA: Harvard University Press, 2003.

———. *Real Presences.* Chicago: University of Chicago Press, 1991.

Steiner, Wendy. *Venus in Exile: The Rejection of Beauty in 20th-Century Art.* New York: Free Press, 2001.

Stella, Frank. *Working Space.* Cambridge, MA: Harvard University Press, 1986.

Stephens, Mitchell. *The Rise of the Image, the Fall of the Word.* Oxford: Oxford University Press, 1998.

Stevens, Mark, and Annalyn Swan. *De Kooning: An American Master.* New York: Knopf, 2004.

Stott, John R. W. *Guard the Gospel: The Message of 2 Timothy*. Downers Grove, IL: InterVarsity Press, 1978.

Swindoll, Charles R. *The Hymnal for Worship and Celebration*. Waco, TX: Word Music, 1986.

Sylvester, David. *Interviews with American Artists*. New Haven, CT: Yale University Press, 2001.

Taylor, Charles. *A Secular Age*. Cambridge, MA: Harvard University Press, 2007.

———. *Sources of the Self: The Making of the Modern Identity*. Cambridge, MA: Harvard University Press, 1989.

Taylor, Sue. *Hans Bellmer: The Anatomy of Anxiety*. Cambridge, MA: MIT Press, 2000.

Thornton, Dora. *The Scholar in His Study: Ownership and Experience in Renaissance Italy*. New Haven, CT: Yale University Press, 1997.

Thornton, Sarah. *Seven Days in the Art World*. New York: W. W. Norton, 2008.

Tillich, Paul. *Dynamics of Faith*. New York: Harper & Row, 1958.

———. *On Art and Architecture*. 1987. Edited by John Dillenberger and Jane Dillenberger. New York: Crossroad, 1989.

Trafton, Jennifer. "Bible in Brush and Stroke." *Christianity Today*, September 2007. www.christianitytoday.com/ct/2007/september/28.58.html.

Treier, Daniel J., Mark Husbands and Roger Lundin, eds. *The Beauty of God: Theology and the Arts*. Downers Grove, IL: InterVarsity Press, 2007.

Updike, John. *Just Looking: Essays on Art*. New York: Knopf, 1989.

Van der Leeuw, Gerardus. *Sacred and Profane Beauty: The Holy in Art*. Preface by Mircea Eliade. Translated by David E. Green. New York: Holt, Rinehart and Winston, 1963.

Verdon, Timothy. *Art and Prayer: The Beauty of Turning to God*. Brewster, MA: Paraclete Press, 2014.

———. *Art, Faith, History: A Guide to Christian Florence*. Translated by Timothy Verdon and Stephanie Johnson. Florence: Arch Diocese of Florence, 1999.

———. "The Body Sacred: The Representation of Man in Christian Art." In *Images of the Body: Sacred, Personal and Public*. Presentations from the CIVA Conference, 2003.

Vogel, Carol. "True to His Abstraction." Arts and Leisure. *New York Times*, January 22, 2012.

Vogt, Von Ogden. *Art and Religion*. New Haven, CT: Yale University Press, 1921.

Wallis, Brian, Marianne Weems and Philip Yenawine, eds. *Art Matters: How the Culture Wars Changed America*. New York: New York University Press, 1999.

Walter, Chip. "First Artists." *National Geographic*, January 2015, http://ngm.nationalgeographic.com/2015/01/first-artists/walter-text.

Wandel, Lee Palmer. *Voracious Idols and Violent Hands: Iconoclasm in Reformation Zurich, Strasbourg, and Basel*. Cambridge: Cambridge University Press, 1994.

Warner, Marina. *Alone of All Her Sex: The Myth and the Cult of the Virgin Mary*. New York: Vintage, 1983.

Weber, Nicholas Fox. *The Bauhaus Group: Six Masters of Modernism*. New York: Knopf, 2009.

Weil, Simone. *Gravity and Grace*. Introduction by Gustave Thibor. Translated by Emma Crawford and Mario von der Ruhr. London: Routledge, 2004.

Weyergraf-Serra, Clara, and Martha Buskirk, eds. *The Destruction of Tilted Arc*. Cambridge, MA: MIT Press, 1990.

Willard, Dallas. *The Spirit of the Disciplines: Understanding How God Changes Lives*. San Francisco: Harper & Row, 1988.

Wiman, Christian. *My Bright Abyss: Meditation of a Modern Believer*. New York: Farrar, Straus and Giroux, 2013.

Winters, Bradford. "Eat This Scroll: The Saint John's Bible and the Word Made Flesh." *Image* 53, 57-67.

Wittgenstein, Ludwig. *Philosophical Investigations*. 2nd ed. New York: Macmillan, 1967.

Wolfe, Gregory. *Beauty Will Save the World: Recovering the Human in an Ideological Age*. Wilmington, DE: ISI, 2011.

Wölfflin, Heinrich. *Principles of Art History: The Problem of the Development of Style in Later Art*. 1932. Mineola, NY: Dover, 1950.

Wolterstorff, Nicholas. *Art in Action: Toward a Christian Aesthetic*. Grand Rapids: Eerdmans, 1980.

———. "Evangelicalism and the Arts." *Christian Scholar's Review* 37, no. 4 (Fall 2010).

Wright, Alexa. "Partial Bodies: Reestablishing Boundaries, Medical and Virtual." In *Digital Desires: Language, Identity and New Technologies*. Edited by Cutting Edge, the Women's Research Group. London: I. B. Tauris, 1999.

Wright, N. T. *Simply Christian: Why Christianity Makes Sense*. New York: Harper-Collins, 2006.

Wurman, Richard Saul. *Information Anxiety*. New York: Doubleday, 1989.

Yancey, Philip. *What's So Amazing About Grace?* Grand Rapids: Zondervan, 1997.

# Image Credits

**1.1.** Andy Warhol, (1928–1987) © Copyright. Untitled from Marilyn Monroe (Marilyn). 1967. One from a portfolio of ten screenprints, composition and sheet: 36" × 36" (91.5 × 91.5 cm). Publisher: Factory Additions, New York. Printer: Aetna Silkscreen Products, Inc., New York. 250. Gift of Mr. David Whitney. The Museum of Modern Art. Digital Image © The Museum of Modern Art/Licensed by SCALA/Art Resource, NY. Used by permission.

**1.2.** Jenny Holzer, *Money Creates Taste*, 1994. © 2016 Jenny Holzer, member Artists Rights Society (ARS), New York. Used by permission.

**1.3.** From *Have You Heard of the Four Spiritual Laws?* written by Bill Bright, ©1965–2016 The Bright Media Foundation and Campus Crusade for Christ, Inc. All rights reserved. Included by permission.

**1.5.** Nina Leen, portrait of "The Irascibles," The LIFE Picture Collection. Getty Images. Used by permission.

**1.6.** Jackson Pollock, *Number 1, 1950 (Lavender Mist)*. © 2016 The Pollock-Krasner Foundation/Artists Rights Society (ARS), New York. Used by permission.

**2.2.** Kiki Smith, *Untitled: Silvered glass water bottles*, 1987–1990. Used by permission.

**2.7.** Marcel Duchamp, *Nude Descending a Staircase (No. 2)*, 1912. The Philadelphia Museum of Art/Art Resource, NY. © Succession Marcel Duchamp/ADAGP, Paris/Artists Rights Society (ARS), New York 2016. Used by permission.

**2.8.** Barbara Kruger, *Untitled (Your Body Is a Battleground)*. Courtesy of Mary Boone Gallery, New York.

**3.3.** Donald Judd, American, 1928–1994, *Untitled*, 1976, Douglas fir plywood (3/4 inch), 91.5 × 233 × 214.6 cm (36 × 91 3/4 × 84 1/2 in.). Through prior gift of Adeline Yates, 2008.11, The Art Institute of Chicago. Photography © The Art Institute of Chicago. Used by permission.

**4.3.** Giotto, *Faith*, c. 1304. Scrovegni Chapel. Wikimedia Commons.

**4.5.** Gilles Bassignac, Operation Iraqi Freedom—Day 21: US Troops Enter Central Baghdad and Topple Statue of Saddam Hussein on April 9, 2003, in Baghdad, Iraq. Getty Images. Used by permission.

**4.6.** Warner Sallman, *Christ at Heart's Door,* © 1942, 1970, Warner Press, Inc., Anderson, Indiana. Used by permission.

**4.7.** Warner Sallman, *Head of Christ,* © 1941, 1968, Warner Press, Inc., Anderson, Indiana. Used by permission.

**5.1.** René Magritte, *The Treason of Images (This Is Not a Pipe),* 1929. © 2016 C. Herscovici/Artists Rights Society (ARS), New York. Used by permission.

**5.4.** Barry Moser, engraving from The Pennyroyal Caxton Bible, 1995–1999. Courtesy of Barry Moser.

**6.2.** Bruce Nauman, *Life, Death, Love, Hate, Pleasure, Pain,* 1983. © 2016 Bruce Nauman/Artists Rights Society (ARS), New York. Used by permission.

**6.3.** Corita Kent, *Stop the Bombing,* 1967. Courtesy of Corita Art Center, Immaculate Heart Community, Los Angeles. Used by permission.

**8.2.** Claude Monet, *Rouen Cathedral.* Metropolitan Museum of Art, Theodore M. Davis Collection, Bequest of Theodore M. Davis, 1915. Wikimedia Commons.

**8.3.** Frank Stella, *Shoubeegi,* 1978. © 2016 Frank Stella/Artists Rights Society (ARS), New York. Used by permission.

**Plate 1.** Willem de Kooning, *Woman II,* 1952. © 2016 The Willem de Kooning Foundation/Artists Rights Society (ARS), New York. Used by permission.

**Plate 3.** *Ten Commandments,* Thomas Ingmire, Copyright 2002 *The Saint John's Bible,* Saint John's University, Minnesota, USA. Used by permission. All rights reserved. Scripture quotations are from the New Revised Standard Version of the Bible, Catholic Edition, Copyright 1993, 1989 National Council of the Churches of Christ in the United States of America. Used by permission. All rights reserved.

**Plate 4.** Sol LeWitt, *Objectivity,* 1962. National Gallery of Art, Gift of the Collectors Committee. © 2016 The LeWitt Estate/Artists Rights Society (ARS), New York. Used by permission.

**Plate 5.** Richard Serra, *Charlie Brown.* Photo © Peter Aaron/OTTO for Robert A. M. Stern Architects; Charlie Brown, 2000, by Richard Serra reproduced with permission: © 2016 Richard Serra / Artists Rights Society (ARS), New York. Used by permission.

# Author Index

# Subject Index

# Scripture Index

# CIVA

## CHRISTIANS IN THE VISUAL ARTS

## SERIOUS ART. SERIOUS FAITH.

Founded in 1979, CIVA's longstanding vision is to help artists, collectors, critics, professors, historians, pastors and arts professionals explore the profound relationship between art and faith. With this as a point of departure, CIVA's broad range of conferences, exhibits, programs and publications exists to help the art and faith movement flourish both in the church and in culture.

CIVA encourages Christians in the visual arts to develop their particular callings to the highest professional level possible; to learn how to deal with specific problems in the field without compromising their faith and their standard of artistic endeavor; to provide opportunities for sharing work and ideas; to foster intelligent understanding, a spirit of trust and a cooperative relationship between those in the arts, the church and culture; and ultimately to establish a Christian presence within the secular art world.

IVP Academic's Studies in Theology and the Arts (STA) seeks to enable Christians to reflect more deeply on the relationship between their faith and humanity's artistic and cultural expressions. By drawing on the insights of both academic theologians and artistic practitioners, this series encourages thoughtful engagement with and critical discernment of the full variety of artistic media—including visual art, music, literature, film, theater, and more—that both embody and inform Christian thinking.

**ADVISORY BOARD:**

- **Jeremy Begbie,** professor of theology and director of Duke Initiatives in Theology and the Arts, Duke Divinity School, Duke University

- **Craig Detweiler,** professor of communication, Pepperdine University

- **Makoto Fujimura,** director of the Brehm Center for Worship, Theology and the Arts, Fuller Theological Seminary

- **Matthew Milliner,** assistant professor of art history, Wheaton College

- **Ben Quash,** professor of Christianity and the arts, King's College London

- **Linda Stratford,** professor of art history and history, Asbury University

- **W. David O. Taylor,** assistant professor of theology and culture, director of Brehm Texas, Fuller Theological Seminary

- **Gregory Wolfe,** publisher and editor, *Image*

- **Judith Wolfe,** lecturer in theology and the arts, Institute for Theology, Imagination and the Arts, The University of St. Andrews

<div align="center">

**ALSO AVAILABLE IN THE**
**STUDIES IN THEOLOGY AND THE ARTS SERIES**
*Modern Art and the Life of a Culture*
by Jonathan A. Anderson and William A. Dyrness

</div>